OPTIONS TRADING
A COMPLETE CRASH COURSE
4 Books in 1

The Bible for Beginners to Grow
$1,000 into $5,000 in the Stock
Market Using Options.
The Best SWING and DAY Strategies
for Your Profit.

Mark Robert Rich, Matthew Bear

This Book Includes:

Options Trading Crash Course
The Most Complete Guide for Beginners with Easy-To-Follow Strategies for Creating a Powerful Passive Income Stream in 2020 Using Options.
(Trading Academy Book 1)

Stock Market Investing For Beginners
Complete Guide to the Stock Market with Strategies for Income Generation from ETF, Day Trading, Options, Futures, Forex, Cryptocurrencies and More.
(Trading Academy Book 2)

Day Trading Options
Most Complete Course for Beginners with Strategies and Techniques for Day Trading for a Living
(Trading Academy Book 3)

Options Trading For Beginners
The Most Complete Crash Course Including All You Need to Know About Options Trading Strategies for Creating a Real Alternative Income
[Second Edition 2020]

Table of Contents

6

Options Trading Crash Course (Trading Academy Book 1)

The Most Complete Guide for Beginners with Easy-To-Follow Strategies for Creating a Powerful Passive Income Stream in 2020 Using Options

Mark Robert Rich

Introduction

Financial freedom. Many seek it but few have it. That is because the secrets behind obtaining it are closely guarded by those who have it. This book is about exposing one true and reliable way that you can earn the financial security and independence you need to take control of the way you live your daily life.

Signs of Financial Slavery

The first active step needed to get started on a journey to financial freedom is acknowledging that you are not financially stable or free. This is a hard pill for some people to swallow and so they avoid acknowledging it even with the overwhelming evidence to support the state.

Facing this fact is not about demeaning your integrity or bring you down. It is about giving you a foundation to start with so that you can build the financial security you need. This knowledge is needed to show you where you currently stand financially and what your resources are so that you can develop a plan to get where you need and want to be.

The following conditions are those that chain many people to financial slavery:

- Living paycheck to paycheck. People who live this way do not have an emergency fund and typically have accompanying credit card debt because they need to subsidize their expenses, which are higher than their income. Many people live this way. In fact, more than

40% of American households could not cover a $400 expense such as medical bills or car repairs if it came up unexpectedly in 2017.

- Not having enough saved up to sustain their lifestyle if they were to lose their job. People such as these do not have enough money accumulated to take time away from working on a daily basis. This is the reason why most people are in careers and jobs that bring them no joy. They need the salary to keep a roof over their heads and food in their belly and so, they deal with the circumstances that make them unhappy.

- Not being able to pursue the activities and adventures that bring happiness while still saving and accumulating wealth. These types of people are stuck in a cycle of trading their daily hours for money while still being unable to enjoy the money that they earn because it is not enough to allow them this enjoyment and still pay the bills.

- Having inflexible schedules. Most people are stuck in a cycle of working every day and going home to come back to work the next day. They have to give this time to earn an income and therefore, become chained to their jobs.

- Not being able to retire comfortably at the desired age. The world over, the average age for retirement is 65 years old. However, many people are not expected to live even 20 years passed that age. That does not live much time to enjoy life free of accumulating wealth. The sadder fact is that most people do not retire with enough money saved up to enjoy the things that they want after retirement. Some others still have to work a job even after this age to sustain themselves. People who are financially free are able to retire at the age that they want rather than one that is dictated by someone else. They also

have the capital available to do the things they want to do and still have income coming to them on a more passive basis.

- Spending more money than earned. This results because people want to live the lifestyle that they want but cannot afford or people needing to subsidize their income to cater to their needs. To build wealth, you cannot have more money going out than coming in. Signs that your spending exceeds your income include having a budget based on your salary, having an expense list that exceeds your net income, carrying a balance on your credit card, having rent or mortgage that is more than 30% of your net income and buying things to impress or keep up with other people.

Are you slave to your finances? Would you like to use your time in other ways while still earning a steady and growing income? Can you use extra income to develop the lifestyle you want?

Answering yes to any of these income questions or relating to even just one of the conditions stated above means you can use the advice and strategies outlined in this book.

Financial Freedom – What Is It and Why Do Only A Few People Have It

Having financial freedom is more than just having a 6-month emergency fund saved up and your debt cleared. Financial freedom means taking control of your time and finances so that you can do the things that you want to do rather than what your bank account figure dictates. Being financially free means you do not need to trade your time for money.

To be able to gain this financial freedom, you need to have financial security. Financial security is the condition whereby you support the standard of living you want now and in the future by having stable sources of income and other

resources available to you. That means not living paycheck to paycheck. It means not having to worry about where your next dollar will come from. It means having a huge weight lifted off your shoulders because you know there are resources that you can leverage to get the things that you want and need.

People who have financial freedom are also financially independent. Financial independence is the state of having personal wealth to maintain the lifestyle and the standard of living you want without actually having to trade your daily hours for money. The assets and resources that you have generated will gain that income for you so that your income remains far greater than your expenses. In essence, being financially independent means that you can go for a prolonged period of time without trading time for money and still have the standard of living that you want. That you can go on a year-long vacation and still be secure in the knowledge that your wealth is still growing.

To be financially independent, you have to have:

- An emergency fund that can sustain your lifestyle for an extended period of time (years).
- Assets that produce income for you on a daily, weekly, monthly and yearly basis.
- Very little or zero debt.

Very few people on the planet are financially secure and independent. In fact, more than 1 billion people live in extreme poverty. In 2015, it was estimated that more than 10% of the global population lived on less than US$1.90 per day.

Despite these statistics, there is hope. This hope comes from the fact that this statistic goes down every year. In fact, in 2019 less than 8% of the global population lived in extreme

poverty. This is largely attributed to the fact that people being more educated about their options and are not just accepting of these poor circumstances.

Despite this improvement, most of the global population still trades their time for an hourly wage. The income earned from this is not sustainable nor will it allow them to live the standard of life that they would like. They will not be able to retire comfortably. There is no power or security in living this way.

People who are financially free have learned and harnessed the power of passive income. Passive income is wealth that is generated from little to no effort or earned in the way of exchanging time for money over the long term. While it might take a massive amount of time and effort to establish in the beginning, passive income allows you to earn money even while you sleep with little to no daily effort required for its maintenance.

The beauty of passive income is that it is not only limited to one income bracket or portion of the population. **Anyone** can develop passive income as long as they develop the right mindset and is willing to put in the time and effort to learn and be consistent in pursuing this standard of living.

Habits and Mindset of the Financially Free

I state the habits and the mindset needed for financially free in this section because no matter how effective the strategies I will outline in the rest of this book, they will be useless unless the practitioner molds his or her mind to be consistent and persistent with them. You cannot be on and off again with the strategies that you implement to gain financial freedom.

You need to get rid of the limiting belief that what you are currently is all you can be. You need to have a mindset that

promotes growth. Your mindset is your frame of mind. It is the things that you believe, your thoughts and your opinions. Your education thus far, your upbringing, your religion and many other things shape your mindset. Thus, your mindset determines how you perceived the outside world, yourself and what you can achieve.

Your attitude is a manifestation of your mindset and it shows whether your mindset is limiting you or helping your grow. A growth mindset is one that encourages making in extra time and effort to grow intelligence and experience to make a better standard of living. On the other, a fixed mindset is one where it is believed that all our qualities are fixed and born talent is the only fact determining success. This type of mindset limits a person's capacity for learning while a growth mindset is one where there is no limit to potential or success.

You need to develop a growth mindset for you to move from your current financial position to one where you are financially free. The characteristics of someone who has a growth mindset include:

- Believing that talent and intelligence can be developed through effort and learning.
- Believing that mistakes are a part of learning and that failure is an opportunity for learning and growth.
- Believing that failure is a temporary setback and not permanent feedback to ability and talent.
- Embracing challenges and change as opportunities.
- Openly receiving constructive feedback from other people for the purpose of furthering learning and development.
- Viewing constructive feedback as a valuable resource of information.
- Viewing the success of other people as a source of information and inspiration.

By opening your mind and imagining the possibilities, you can find fulfillment in not just your financial life but in your life as an entirety.

Developing a growth mindset is not something that is innately ingrained in every human being. It is something that you have to work on and the best way to do so is to develop habits that will encourage you to think differently and adaptively. Such habits include:

- Developing your mission statement. Success is a personal and individualized process. Therefore, if you would like to be financially free you have to know how this is meaningful to you and what financial success means to you on an individual basis.
- Being goal-oriented. You need to be clear on what you want out of your future and then work diligent in your effort to earn it.
- Continually learning and seeking new experiences. This allows you to broaden your horizons and gain you more experiences to shape your mind into one that is forward-thinking.
- Taking action. You will not get any results by sitting on the couch and dreaming about it. Successful people know this and get up and do something about earning the results that they would like.
- Being health-conscious. The body and mind that you have now what you will have for as long as you remain on Earth. Eat right, exercise daily, keep hydrated and keep looking to keep both your body and mind fit enough to enable you to accomplish your goals of financial freedom. Financial freedom will elude you if either of these things start to fail you.
- Being self-disciplined. Successful people have mastered themselves so that they can control their actions and thoughts. You cannot be dragged by your

wants and desires and expect to be successful in your pursuit of financial security and independence.

Trading Options to Gain Financial Freedom

Trading options has the great potential to be a form of passive income. This is the complete opposite to active income, which is what most people engage in. Active income is one where a person invests time in exchange for money. We have discussed the pitfalls of this and seen why it should not be a person's only form of income.

Passive income allows you to still enjoy your time as you dictate while earning money. It comes to you on automatic even while you sleep. While it usually takes time, effort and maybe monetary input at the beginning, over the long-term, if done right, you can sustain the lifestyle you want if you put forth that investment now.

Passive income:

- Gives you the platform to gain financial stability, security and independence.
- Gives you the freedom to do whatever you wish with your time without the worry of sustaining your financial life.
- Gives you the freedom to pursue the career, hobbies and other activities you love and enjoy rather that having to trade your time for money.
- Allows you to secure your financial future, thus getting rid of your worry, stress and anxiety in that department.
- Gives you the flexibility to live and work from anywhere in the world, typically. The bonus of this means you get to travel if that is a pursuit you would like to take on while still earning.

Trading options can give you the benefits listed above and thus, light the way to your financial freedom.

What You Will Learn in This Book

My goal when writing this book was to show you how you can take control of your finances, pay off your debt and live life on your own terms using one powerful strategy. Therefore, the topics that will be covered in the pages to come include but are not limited to:

- What it means to trade options
- The benefits and disadvantages to trading options
- Options prices and how they are determined
- Basic options strategies for going long
- The covered call strategy
- What are strangles and straddles and how you can use them to your advantage
- Credit and debit spreads
- Iron condor
- Selling naked options
- Rolling out options
- Trader mistakes and how to avoid them
- The options trader mindset

As I mentioned above, having a growth mindset means that you openly receive information from other people to better yourself and your financial life. I am sharing my knowledge with you in this insightful guide because I have implemented these same strategies with tremendous success. It is not a perfect system but it is one that works well if done right and consistently.

Before I invite you to delve in, let me say this... To gain the most benefit from reading the information to come, you need to cultivate the growth mindset mentioned above. You have to also treat this like a business, not a side gig. This is not a hobby nor something that you are just dabbling in. Make the

effort and time you invest count. Make it consistent and be persistent. Set a schedule and work on this every day. Make goals for yourself and give yourself a timeline for your accomplishments. Stay focused and committed.

The world's wealth is majorly divided in a small part of the population. Only that small percentage has financial freedom. You can put yourself and your family in that small percentile using this method for passive income. I have faith that you can do it as long as you put in that initial effort. The question is – do you believe that you can do too? Can you envision yourself as the person who has attained financial freedom in the future and is living the life you want?

Answer **YES** to both these questions and believe in that answer, I implore you!

Now, without further ado, let's jump into this invaluable guide so that you can start the future you desire today.

Chapter 1
Options Trading Basics

There are many choices available when it comes to earning passive income and developing a strategy to gain financial freedom. Investing in real estate and trading stock are common contenders. But options trading is incomparable in terms of its affordability and accessibility.

Trading options is a powerful way of gaining financial freedom whatever it may mean to you. This is not a job that you have to show up to from 9 to 5 to benefit greatly from. While there is some upfront human and monetary capital to be invested, once you get your feet wet, you will see that trading options are rather easy with the knowledge and experience under your belt. Next to real estate and stock trading, options trading is one of the most powerful ways to gain financial freedom passively.

What Are Options?

An option is a financial contract called a derivative contract. It allows the owner of the contract to have the right to buy or sell the securities based on an agreed-upon price by a specified time period.

That definition is rather complicated so I will break it down into its individual components and explain each.

28

Option

As the name suggests, there is no obligation in this type of transaction. The trader pays for the right or the *option* to buy or sell a transaction such as a security, stock, index or ETF (exchange-traded fund) by a certain amount of time. An option is a contract.

Derivative Contract

The option *derives* its value based on the value of the underlying asset hence the term derivative contract. This contract states that the buyer agrees to purchase a specified asset within a certain amount of time at a previously agreed-upon price. Derivative contracts are often used for commodities like gold, oil, and currencies, which is often in the form of the US dollars. Another type of derivative is based on the value of stocks and bonds. They can also be based on interest rates such as the yield on a specified amount of time Treasury note, like a 10-year Treasury note.

In a derivative contract, the seller does not have to own the specified asset. All he or she has to do is have enough money to cover the price of the asset to fulfill the contract. The seller also has the option of giving the buyer another derivative contract to offset the asset's value. These choices are often practiced because they are easier than providing the asset itself.

Securities

Securities come in several types. The great thing about securities is that they allow a person to own a specified asset without actually taking tenure of it. This makes them readily tradable because they are good indicators of the underlying value of the asset.

Common types of options securities include:

- Stock options, which use stock in a publically listed company as the asset associated with the contract.
- Index options. Similar to stocks, an index is a measure of the stocks, bonds and other securities a company possesses.
- Currency options. Also referred to as forex options, this type of security grants the right to buy or sell a specific currency at a previously agreed-to exchange rate.
- Futures options, which gives the trader the right to assume a certain position at a future date.
- Commodity options, which is an option with an associated asset that is a physical commodity.
- Basket options. As the name suggests, this is an option made up of a group of securities.

Agreed-Upon Price

This is also known as the strike price. It does not change no matter how much time has passed and it is so named because the trader strikes when the underlying value makes him or her the desired income.

Specified Time Period

This is also known as the expiration date because this is the date at which the option (contract) expires. The trader can exercise the option at the strike price at any time up until the expiry date reaches. In some parts of the world such as Europe, a trader can only exercise the right to the option at the strike price exactly *on* the expiry date. We will more largely focus on the American way of trading options, which allows for exercising right on or before the expiration date.

Options vs. Stocks

Trading options and trading stocks are different because stocks and options have different characteristics. Stocks represent shares of ownership in individual companies or

options. This allows the stock trader to bet in any direction that he or she feels the stock price is headed.

Stocks are a great investment if you are thinking of long-term yield such as for retirement and have the capital. They are very simplistic in the approach in that the trader buys the stock and wagers on the price that he or she thinks it will rise at a certain time in the future. The hope is that the price will increase in value, thus gaining the trader a substantial yield.

Stocks are also a great option for those who want to invest without having to keep a steady eye on the growth of the investment.

The risk of investing in stocks is that the price of stocks can plummet to zero at any moment. This means that the investor can lose his or her entire investment at the drop of a hat because stocks are very volatile from day to day. They are very reactive to world events such as wars, politics, scandal, epidemics and natural disasters.

On the other hand, options are a great option for traders who would like flexibility with timing and risks. The trader is under no obligation and can see how the trade plays out over the time specified by the option contract. In that time period, the price is locked which is also a great appeal.

Trading options also requires a lower investment compared to stocks typically.

Another great appeal for options reading is that the specified time period is typically shorter than investing in stocks. This allows for regular buying and selling as options have different expiration dates. Expiration dates can range from just a few days to several years.

The drawback that makes some people hesitate in trading options is that it is more complex than trading stocks. The trader needs to learn new jargon and vocabulary such as strike prices, calls and puts so that he can make the determination on how he or she can set up effective options. Not only does the trader have to learn new terms, but he or she also has to develop new skillsets and the right mindset for options trading.

Types of Trading Options
There are two major types of options.

Call Option
This type of option gives the trader the right to buy the asset on or before the expiration date. Also simply labelled a call, this type of option is traded because the price of the underlying asset is expected to rise within a certain timeframe. For the buyer of a call option, the profit lies in the price moving above the strike price. The trader can then sell the option to make a profit, which is the common call for most buyers or, choose the right to exercise the option on or before the expiration date.

The person who sells this type of option receives the premium from the trader to generate income. Therefore, the seller has a limited income while the buyer of such an option has an unlimited potential for profit.

Stocks are a common asset in call option transactions. An example of a successful call options transaction is specified below using stocks as the asset.

There are 100 shares of stock up for sale. Each share is priced at $100 and therefore, a stock trader would pay $10,000 to buy these.

As an options trader, you can buy a call option that will give you the right to pay this $100 per share within a specified

time period of six months. The option would cost $5 per share and so, the options trader would pay a total of $500. This is a substantially lower investment than outright buying the stock. The risk is also lower than buying the stock as there is always the risk that the stock does not increase in value.

The trader had a good feeling that these stocks would increase in value though and they do by the expiration date. They are now worth $150 per share.

If the trader had bought the stock outright, he or she would make a profit of $5,000 because the stocks are now worth $15,000. As a call option, the trader would make a profit following the following formula:

(Current Price of the Stock - Strike Price) X Number of Shares = Option Worth

Using our example, this translated into:

($15,000 - $10000) x 100 = $5000

Next, to determine the profit the options trader would make, you need to remove the cost of the option. In this example, this cost was $500 and thus, the options trader makes a profit of $4,500. While this profit is slightly lower than what the stock trader made, the investment and risk were also substantially lower than outright buying the stock.

The general terms that show whether the options trader made a profit are:

- **In the money.** This means the asset price is above the call strike price as so the options trader makes a profit on the transaction.
- **Out of the money.** This means the price is below the call strike price and so the options trader makes a loss on the transaction.

- **At the money**. This means the asset price and the strike price are the same and so the options trader does not make a profit but neither does he or she make a loss on the transaction.

Put Option

This type of option gives the trader the right to sell the specified asset at the predetermined price by the expiration date. The strike price is also predetermined with this type of option. With a call option, the trader hopes that the price of the asset increases. However, with the put option, the trader hopes that the price of the asset goes down. Only if the price of the asset goes down does the trader make a profit.

Here is how this works... The trader pays for the option to sell the asset by a fixed time. If the price of the assets goes up, the trader has to sell the assets at a higher price if he or she exercises the right to the option. This is clearly a bad deal because the gap between the strike price and the selling price has narrowed.

On the other hand, exercising the right to sell the asset when it has depreciated in value widens the gap between the strike price and the sale price.

Let us take a look at how this works with an example using stock.

The trader has a feeling that 100 shares of stock will declining value in the near future. These 100 shares of stock are worth $100 per share now ($10,000 total). The put options trader purchase the right to sell the stock at any time within the next six months. The option costs $1.50 per share and so, the options trader pays $150.

Assuming that the options trader's gut feeling pays off and the value of the stock goes down to $50 per share by the time that the expiration date arrives, this is highly profitable.

34

Exercising the right of the put option, the trader can sell the stock for the strike price of $100. The profit is calculated with this formula:

Asset Value - Option Cost = Profit

Therefore, using our example the profit that the trader would earn:

$10,000 - $150 = $9,850.

This is a much higher value than the $5,000 that would have been earned if the trader did not exercise the put option.

The general terms that show whether the options trader made a profit are:

- **In the money.** This means the asset price is below the put strike price as so the options trader makes a profit on the transaction.
- **Out of the money.** This means the price is above the put strike price and so the options trader makes a loss on the transaction.
- **At the money**. This means the asset price and the strike price are the same and so the options trader does not make a profit but neither does he or she make a loss on the transaction.

Benefits of Trading Options

There are several advantages to trading options and they include:

- The initial investment is lower than with trading stocks. This means that the options trader can benefit from playing in the same financial market as a stocks trader without paying as much upfront. This is called hedging.
- The options trader is not required to own the asset to benefit from its value. This means that the trader

does not incur the cost associated with the asset. Costs can include transportation and storage fees if applicable.

- There is no obligation to follow through with the transaction. Whether the trader is exercising a call or put option, at the end of the day, the loss is limited because the trader is only obligated to pay for the contract and nothing more. Only if the trader feels it worth it does he or she take action to move forward with exercising the contract.
- The options trader has many choices. Trading options gives the trader great flexibility. Traders can choose to:
 - Sell the options to another investor in the case of *in the money* situations.
 - Exercise the contract and buy the asset.
 - Exercise the option and sell all or part of the asset.
 - In the case of *out of the money* situations, sell the options to another investor before the expiration date arrives.
- The strike price freezes the price. This allows the options trader the ability to buy or sell the asset on or before the expiration date without the worry of fluctuating prices.
- Options can protect an asset from depreciating market prices. This is a long term strategy that can protect assets from drops in the market prices. Exercising a call allows the trader to buy the asset at a lower price.
- The trader can earn passive income from assets that he or she already owns. You can sell call options on your own assets to earn income through traders paying you premiums.

Disadvantages of Trading Options

Everything has a downside and trading options is not exempted from that rule. The potential disadvantages of trading options include:

- Option trading exposes sellers to unlimited losses. Unlike the buyer of the option, the seller of the option faces the risk of great loss because he or she is obligated to buy or sell the asset within the time frame specified by the contract even if the price makes him or her incur a loss. The potential profit for the seller is limitless as discussed earlier and so options can be a double-edged sword because the potential losses are also limitless.
- Options traders need to be qualified to begin trading. This is not a business where you can just start. To trade options, an options trader needs to be approved through a broker. This approval is based on answering questions about your financial means and investment experience as well as your understanding of the risks associated with options trading. Only after the requirements have been established will the broker assign an options trader to the appropriate level based on the answers to these questions.
- Options are typically short-term investments. The expiration date of options is typically only a few days, weeks or months long. This means that the option trader needs to play this financial game by having an exact strategy that he or she will implement in the near future. There are exceptions to this rule, such as the longer-term strategy called LEAPS, which is discussed in Chapter 12.
- There may be additional costs associated with options trading apart from the premium payments. Often an investor in options trading needs to set up a margin

account. A margin account is a line of credit that serves as collateral in the eventuality that an option incurs a loss. The settlement of this marginal account is something that your brokerage firm will guide you into opening as each has its own minimum requirements. Luckily, the interest rates on such accounts typically stay within the single digits to low double digits. Broker commission fees are also costs that need to be considered.

Successful options traders weigh the pros and cons carefully and implement strategies to minimize the costs and potential losses while leveraging ways to make maximum profit. One of the best ways to do that is by being educated about your choices.

Tips for Getting Started With Options Trading

- Develop a trading plan before getting started. You need this plan to develop consistency in your actions when it comes to trading options. This will tell you how you will trade, the monies you will allocate to trading, and defines how you will track your performance. Doing this will also allow you to understand the risks involved in options so that you can plan ahead to minimize them.

- Practicing how to earn a profit from options trading on paper first before investing actual money. This is called paper trading and it prevents you from risking your hard-earned cash before you know what you are doing. This is done a few weeks to a few months before you do the real thing. Use spreadsheets or any other tools that make it easy for you to enter practice trades so that you can evaluate their performance over the time set for expiration. The benefits of doing this include taking away the psychological pressure of

learning the mechanics without actually trading your own money.

- Open a brokerage account. This can be done in 2 ways – through online websites or more traditionally through a broker. This is something you need to consider carefully. Things that need to be considered include:
 - The reputation of the brokerage firm. Be sure to look out for scams, which can be especially prevalent online. Avoid websites that have bad reviews or have been reported for fraudulent activity.
 - The commissions that the brokerage firm charges. If you are lucky, you might even find a firm that does not charge commissions on options.
 - Be aware of the types of accounts that you need. They include a cash account and a margin account. A cash account is one that is loaded with cash to facilitate the buying of options. On the other hand, margin accounts allow the trader to borrow money against the value of the securities in the trader's account.
 - If you choose to trade options online, be sure that the brokerage firm accepts safe payment methods like a secure credit card payment gateway, PayPal, Payoneer, etc.
- Ensure that you are approved to trade options. This can be done through your brokerage firm.
- Choose a trading style. There are two main types of options traders. The two categories of traders are professional traders (traders that work on behalf of institutions and clients) and individual traders who trade strictly for themselves. Both of these types of traders pick from the same pool of trading styles

whether or not they are trading for themselves or for someone else. The different trading styles include:

- Day trading. This is the method that full time options traders use. It is more largely used by professional options traders. It involves constantly monitoring the financial markets. The name comes from the fact that the trades do not last more than a day. Profits, losses or breakeven are realized by the end of the day and so the options are closed.
- Position trading. This is a low-maintenance style that introduces low risk but requires an advanced trader's knowledge and understanding of options and the financial markets. It is mainly used by professionals.
- Swing trading. This style of options trading is particularly useful for part time trading as well as beginners who are just getting the hang of things.
- Market makers. This is done in a professional capacity. Market makers are the ones who ensure that the market is liquid and has transactions to be engaged in. Without market makers, there will a low volume of options to be transacted and the trades market would be stagnant.

- Never invest money you cannot afford or are not willing to lose. Investing is a technique used to makes your money work for you. When it is done right, the investor will receive more money than he or she started off with. However, jumping the gun can lead to losses because investing is a risk. There is no guarantee that your money will compound itself. In fact, you may lose the entire investment. That is why you should never put up money you cannot afford to do without for investing. To avoid do this, be patients, do not be greedy and keep your costs as low as possible.

- Never invest all your resources in one option. This embodies the saying, "Never keep all your eggs in one basket." Remember that investing in options is a risk. Spread that risk by not limiting yourself to one option.
- Never tie up all your capital in options trades. This goes back to keeping your options open. Sustainable income should never come from one place. Ensure than you are doing other things to build your wealth and not solely reliant on options. Diversify your options portfolio so that all your eggs are not in the same basket.
- Know your breakeven points. Breakeven describes the point at which total income equals total. We will discuss this further as we delve into options trading strategies.
- Do your research before investing in options. Always.
- Anticipate losses and plan for them.
- If you have at least 5 losing trades back to back, stop and go back to the drawing board to discover what you are doing wrong and how you can rectify this. Continuously evaluate your strategies to discover shortfalls.
- Have an exit strategy for each option and know when to implement this strategy.
- Join online forums so that you can learn from other options traders. This can be a valuable resource of support, information and development of technique. This is also a place you can learn from the successes and failures of other options traders so that you do not have to repeat the failures and you can use the success stories to advance your options.

Chapter Summary

An option is a financial contract called a derivative contract. This contract allows the owner of the contract to have the

right to buy or sell the securities based in an agreed-upon price by a specified time period. Options fall into 2 main categories. The first is called a call option. This type of option allows the trader the right to buy the asset.

The second type of option is called a put option. This type of option allows the trader the right to sell the asset.

There are several benefits to trading options versus pursuing another passive income streams such as trading stocks. These benefits include:

- The initial investment is lower than with trading stocks.
- The options trader is not required to own the asset to benefit from its value.
- There is no obligation to follow through with the transaction.
- The options trader has great flexibility.
- The strike price freezes the price at which the asset can be sold or bought.
- Options can protect an asset from depreciating market prices.
- The trader can earn passive income from assets that he or she already owns.

All things have a downside and so there are also potential disadvantages with trading options, which include:

- Options trading exposes sellers to unlimited losses.
- Options traders need to be qualified to begin trading.
- Options are typically short-term investments.
- The premium payment may not be the only cost of trading options.

Luckily, being educated about proper risk management and options trader choices can minimize these disadvantages so that the benefits far outweigh them. Having a trading plan,

knowing your choices and being aware of your breakeven point are some of the best strategies for getting started with trade options successfully.

Chapter 2
How Options Prices are Determined

Pricing is a complex subject when it comes to options trading. Not only is the price of an option based on the value of the asset, there are other external factors that have influence.

As an options trader, you want to make sure that you maximize your efforts to make a profit. Learning how to determine the prices you should pay for options is one of the basic ways that you can ensure that your yield is as high as it can be. You do not want to be stiffed by paying higher premiums than you should.

Pricing of options are determined by several factors. Each will be stated below and discussed.

The Value of the Asset
The effect this has on options prices is straightforward. If the value of this asset goes down then exercising the option to sell becomes more valuable while the right to buy is become less valuable.

On the other hand, if the value increases, the right to sell it becomes less valuable while the right to buy it becomes more appealing due to this increase.

The Intrinsic Value

When an options trader pays a premium, this sum represents two values. The premium is made up of the intrinsic value, which is the current value of the option and the potential increase in value that this option can obtain over time. This potential increase over time is known as the time value.

We are discussing the intrinsic value in this section. The intrinsic value is how much money the option is currently worth. It represents what the buyer would receive if he or she decided to exercise the option at the current time.

Intrinsic value is calculated by determining the difference in the current price of an asset and a strike price of the option.

For an option to have an intrinsic value of zero, the option must be out of money. Therefore, the buyer would not exercise the option because this would result in a loss. The common strategy here is allowing the option to expire so that no pay off is made. As a result, the intrinsic value results in nothing to the buyer.

For a buyer to be in the money, the intrinsic value has to be greater than the premium to increase the value of the option. This places the buyer in a position to make a profit. The intrinsic value of for in the money for call options and put options are calculated slightly different. The formulas are as follows:

In the money call options

Price of Asset - Strike Price = Intrinsic Value

In the money put option

Strike Price - Price of Asset = Intrinsic Value

The Time Value

This value is the additional amount an investor is willing to contribute to the premium of an option in addition to the intrinsic value. This willingness stems from the belief that an option will increase in value before the expiration date reaches. Typically, an investor is only willing to put forth this extra amount if the option expires months away. There would be little to no change in the value of an option in a few days.

The time value is calculated by finding the difference between the intrinsic value of an option and the premium. The formula looks like this:

Option Premium - Intrinsic Value = Time Value

Therefore, the total price of an option premium follows this formula:

Intrinsic Value + Time Value = Option Premium

Both time value and intrinsic value help traders understand the value of what they are paying for if they decide to purchase an option. While the intrinsic value represents the worth of the option if the buyer were to exercise it at the current time, the time value represents the possible future value before or on the expiration date. These two values are important because they help traders understand the risk versus the reward of considering an option.

Volatility

This describes how likely a price change will occur during a specified amount of time on the financial market. If a financial market is nonvolatile then the prices change very slowly or remain totally unaffected over a specific amount of

time. Volatile markets, on the other hand, have fast-changing prices over short periods of time.

Option traders can make use of a financial market's volatility to get a higher yield for their investment in the future. Options traders normally avoid slow-changing financial markets because these non-volatile markets often mean that no potential profit is available to the trader. Therefore, option traders thrive on volatility even though volatility increases the risk of option trading. As a result, an options trader needs to know how to read the financial market correctly to know which options are likely to yield the highest returns. This ability comes with experience, continuous learning and keeping up to date on the happenings of the financial markets.

There are many factors that affect the volatility of a financial market. These factors include politics, national economics and news reports. Options traders typically use one of two options strategies to gain the best yield from volatile markets. They are called straddle strategy and the strangle strategy. We will discuss these strategies in the upcoming chapters.

Interest Rates

Most people are familiar with the term interest rates. Interest rates apply to mortgages bank accounts and more. Interest rates as it applies to option trading is slightly different from the common variations.

The interest rate is defined as the percentage of a particular rate for the use of money lent over a period of time. This interest rate of an option has different effects on the call option and put option. The premiums for call options rise when interest rates rise and fall when interest rates fall. The effect is the opposite on put options. The premiums for put

options fall when interest rates rise and rise when interest rates fall.

Interest rates affect the time value of options no matter what category they fall in!

You will come across the term risk-free interest rate many times in your study of options trading. This is described as the return made on an investment with no loss of capital. This is a misleading term because all investments carry some level of risk, no matter how minute. This more serves as a parameter in options pricing models such as the Black-Scholes Model to determine the premium that should be paid.

Dividends
Dividends are distributions of portions of a company's profit at a specified period. This distribution must be decided and managed by the board of directors of a company. It is paid to a particular class of shareholders. Dividends can be distributed in the form of cash, shares of stock and other types of property. Exchange-traded funds and mutual funds also pay out dividends.

As it relates to options trading, options do not actually pay dividends. However, the associated assets attached to that option can have them and thus, options trader can receive those dividends if he or she exercises that option and takes ownership of those particular assets. While both call and put options can be affected by the presence of dividends of the associated asset, this effect on the types of options is widely varied. While the presence of dividends makes call options less expensive due to the anticipation of a drop in price, it makes put options more expensive because the price will be decreased by the amount of the dividend.

Option Pricing Models

Option pricing theory uses all of the variables mentioned above to theoretically calculate the value of an option. It is a tool that allows trainers to get an estimate of an options fair value as they incorporate different strategies to maximize profitability. Luckily, there are models that traders can use to implement option pricing strategies to their advantage. Three commonly used pricing models for option values are:

- The Black-Scholes Model
- Binomial Option Pricing Model
- Monte-Carlo Simulations

The Black Scholes Model

Also known as the Black-Scholes-Merton (BSM) model, this pricing model won a Nobel Prize in economics because of its effectiveness. It was designed by the three economists, Fischer Black, Robert Merton and Myron Scholes in 1973. Originally used to price European options (meaning the option can only be exercised on the expiration date), this is a mathematical system that has a huge influence of modern option pricing. The pricing model helps differentiate options from gambling by determining the option premium to be paid in a logical manner. It calculates the return on the income the investor is likely to earn less the amount paid. The formulation of this amount uses the factors mentioned earlier in this chapter and others.

As this is primarily used to determine a European call option, the formula used to calculate it looks like this:

SN(d1) – Xe - rt N(d2) = Call Option Premium

The letter representations in this equation stand for:

S – Current asset price

N – A normal distribution

X – Strike price

r – risk-free interest rate

t – time of maturity

While this pricing system is great, it does have limitations. One of these limitations is that it assumes that factors like volatility and risk-free interest will remain constant, which is not the case in actuality. It also does not factor in other costs to setting up the option.

Binomial Option Pricing Model
More commonly used to develop pricing for American options, this pricing system was developed in 1979. Even as popular as the Black Scholes Model is, this model is even more frequently used in practice because it is more intuitive. This pricing system allows for the assumption that there are two possible outcomes – one where the outcome moves up and one where the outcome moves down.

This system differs from the Black Scholes Model in the way that it allows calculations for multiple periods whereas the Black Scholes Model does not. This advantage gives a multi-period view, which is very advantageous to options traders.

This model makes use of binomial trees to figure out options pricing. These are diagrams with a main formula branching off into two different directions. This branching off is what gives the multi-period view that this pricing system is famous for.

For this pricing system to work, the following assumptions are made:

- There are 2 possible prices for the associated asset, hence the name of the pricing system. Bi means 2.

- The 2 possibilities involve the price of the asset moving up or down.
- There are no dividends being paid on the asset.
- The rate of interest does not change through the life of the option
- There are no risks attached to the transaction.
- There are no other costs associated with the option.

Clearly, just like with the Black Scholes Model, there is some limitation with those assumptions. Still, the pricing system is highly valuable in the valuing of American options due to the fact that such options can be exercise any time until the expiration date.

Monte Carlo Simulations

Used in multiple fields across the board like science, engineering and finance, this model allows the options trader to consider multiple outcomes due to the involvement of random factors. It allows for the consideration of risk and unpredictability unlike the first two pricing models. This is why it is also sometimes called multiple probability simulation.

A Final Word on Pricing

The reason I went into such depth on pricing options is because I want you to realize that everything related to options requires careful consideration right down to the premiums paid. This needs to be a fair trade for all the parties involved and premium pricing needs to reflect that fairness. When considering the options premium, remember to search deeper than the surface level to ensure that fairness and to ensure that you are gaining the profit that you need out of the transaction.

Chapter Summary

There are 6 factors that determine the price of options. They are:

- The value of the asset
- The intrinsic value, which is the determination of the difference in the current price of an asset and a strike price of the option.
- The time value, which is the difference between the intrinsic value of an option and the premium.
- Volatility, which is how likely a price change will occur during a specified amount of time on the financial market.
- Interest rates, which is the percentage of a particular rate for the use of money lent over a period of time.
- Dividends, which are distributions of portions of a company's profit at a specified period.

All of these factors help make up the formal pricing models used to determine option premiums. 3 common pricing models are:

- The Black-Scholes Model
- Binomial Option Pricing Model
- Monte-Carlo Simulations

Chapter 3
Basic Options Strategies Going Long

Going Long vs. Going Short

As an options trader, you will often hear the terms going long or having a long position and going short or taking a short position. The positions are polar opposites. Both terms refer to what the investor owns and what he or she needs to own to be effective at options trading.

Having a short position means that the investor does not own the assets being associated with the option. For example, there may be an option for the sale of 100 shares but the investor doing the selling does not own the shares.

On the other hand, having the long position means that the investor owns the asset associated with the option. For example, an investor who bought and adds 100 shares to his or her portfolio has a long position. This investor likely bought this asset, which can be stock, commodity or currency with the expectation that the value will rise. This is known as having a bullish view. A bullish view describes the characteristic of an investor pursuing an asset with the feeling that it will appreciate in value because they wish to limit any potential losses.

There is another view that can affect if an options trader decides to hold a long position. The trader may try to make a profit but the fall of an asset's value. This can be advantageous because the trader can obtain an option to sell that asset at a price that is advantageous to him or her.

As it relates to options trading, the long position refers to whether or not the trader will hold a long call or long put option. This is dependent on the associated asset attached to that contract. Holding a long call option means that the trader expects that the price of the asset will go up so that he or she can benefit in that regard. The option allows the trader to buy that asset at the strike price so that the upward trend is fulfilled.

With a long put option, the trader expects the asset to depreciate in price so that he or she can purchase the right to sell that asset at a predetermined price.

In both cases, the long position does not in any way refer to the time period. The focus is entirely on the associated asset and who owns it. The person who owns the asset is called the long position holder.

One of the biggest benefits of a long position is that an option of this nature locks in the strike prices. Losses are limited because the trader can base his or her bets on historic market performance.

Unfortunately, there are disadvantages to going long. Firstly, the financial market may become volatile and cause abrupt price changes. This may not be for the benefit of the options trader. Secondly, the option may reach its expiration date before the advantage the options trader was hoping to achieve is realized

Simple Going Long Strategies

Of course, there are very complicated going long strategies that can be employed but as a beginner, it is best to start off simply and get a lay of the land. This is why I have stuck to the basics in this chapter and will continue in the same way with the two most common and simple going long strategies.

Long Call

As mentioned earlier, this strategy is considered by options traders who want to make a profit from an asset that increases in price above the strike price. This is often considered so that the trader does not have to buy the asset outright so that he or she can potentially profit without having to take on the major risk of owning that asset.

This type of option can also afford the trader access to assets he or she cannot afford to purchase at that time. This is a common practice in accessing stock. Having the option to purchase is less expensive than purchasing the stock outright.

Here is a summary of how a long call works:

Outlook: Bullish

Risk: The premium paid

Potential profit: Unlimited. It increases as the price of the asset increases.

Break-even price: The sum of the strike price and premium paid **(strike price + premium paid)**

An example of a successful long call is as follows:

An options trader buys 100 shares of stock that he believes will increase in value within the next few months. Each share costs $20. He believes the shares will go up by at least $10.

Therefore, he buys the option at a strike price of $20 plus a cost of $2 for each stock, which totals $22 per stock.

As long as the stock goes above $22, this long call option is profitable to the trader. For every dollar the stock goes higher, the trader will profit $100. As the stock price increases, so does the option value. Therefore, the trader can sell the option to lock in his profit.

The best thing about such an option is that the asset can infinitely increase in value which can lead to massive profits. This is why long calls are a popular way to bet on rising stock prices.

In this case, this is also a risk that the trader will lose his or her investment in the cost of the premium and associated fees. The asset may not become advantageous before the expiration date arrives and thus, the option becomes worthless to the trader.

Long Put

This type of option gives the trader the right to sell the associated asset at the strike price on or before the expiration date. The options trader makes a profit from the asset decreasing to a price below the strike price. As you can see, this is very similar to the long call and only differs in the fact that the trader is betting on the fact that the value of the asset will fall below the strike price on or before the expiration date.

Long puts are a great way of protecting the value of assets that you already own.

Here is a summary of how a long call works:

Outlook: Bearish (Falling prices)

Risk: The premium paid

Potential profit: Unlimited. It increases as the price of the asset decreases.

Break-even price: The difference between the strike price and premium paid **(strike price - premium paid)**

An example of a successful long put is as follows:

A company is trading stock at $50 per share. An options trader feels that the price of this will fall to at least $30 per share within the coming months and so, seeks a put option with a strike price of $50 that had an expiration date of 2 months. He buys 100 shares and pays $150 to purchase each $50 share. The option is priced at $5 per share and so, the trader pays $500.

The trader was right and the price of the stock depreciates to $25 per share before the expiration date. With the current stock price, the trader with the put option will be in the money because the intrinsic value of the stock has risen. Let's say that this value is now $1500. The trader can sell the stock for that price. The trader will make a profit of $1000 after removing his investment of $500.

The great advantage in this scenario is similar to the advantage in the long call, hence why this too is a popular way of betting on declining stock values. As a result, a long put is a great option if the trader expects the price of the asset to fall significantly before the expiration date arrives. If the price falls only a little or not at all, the trader may be in the money only slightly, which is not profitable, or worse, it may not even return the premium the trader spent.

Chapter Summary
The long position in options trading refers to the fact that the investor owns the asset associated with the option. This is comparable to the short position, where the investor does not own the asset being associated with the option.

As it relates to options trading, the long position refers to whether or not the trader will hold a long call or long put option. This is dependent on the associated asset attached to that contract. Holding a long call option means that the trader expects that the price of the asset will go up so that he or she can benefit in that regard. The option allows the trader to buy that asset at the strike price if that upward trend is fulfilled.

With a long put option, the trader expects the asset to depreciate in price so that he or she can purchase the right to sell that asset at a predetermined price.

While this can be disadvantageous in that there is no guarantee that the advantage will be realized by the expiration date and this is a risky move in the short-term, the benefits include:

- Having a locked strike price even if the profits grow beyond expectations.
- The losses are limited.
- This move can rely on historical data to maximize profit.

Using both the long call and long put strategies can be highly advantageous to options traders.

Chapter 4
Covered Call Strategy (or Protected Puts)

What Is a Covered Call?

Also known as a buy write, this describes the act of selling the right to purchase a specified asset that you own at a specified price within a specified amount of time, which is usually less than 12 months. It is a two-part strategy whereby someone first purchases stock then sells it on the share by share prices.

The beauty of this type of option is that off the bat, the seller benefits by receiving a premium payment from the options holder. Risk is mitigated because the seller already owns the stock. Therefore, your costs are covered if the stock price rises above the strike price. If the trader chooses to exercise the right to purchase on or before the expiration date, you simply deliver as agreed and rip any additional benefits.

Stock is the most common asset used in this type of option.

If you choose to consider covered calls, you need to be willing to own the stock at your price it is even if the price depreciates. Remember that there is no guarantee that you

will earn greatly on the stock that you have purchased due to the volatility of financial markets. Therefore, you need to be diligent in your focus on seeking good quality stocks that you are willing to own. You need to be able to still potentially benefit from that ownership if there are down periods in the market.

As the seller of a covered call option, you need to be also willing to part with that stock if the price rises. you cannot change your mind if the price of the stock goes up if you have already entered into an option with a willing buyer. You must exercise that delivery if the trader chooses to exercise that option.

The maximum potential profit of covered calls is achieved if the stock price is met at or above the strike price of that call at or by the expiration date. The formula for this is as follows:

Sum of the Call Premium + (Strike Price - Stock Price) = Maximum Potential Profit

The seller also needs to consider the break-even point at the expiration date. The formula for this is as follows:

Purchase Price of the Stock - The Call Premium = Break-Even Analysis

The seller also needs to determine the maximum risk potential. This is equal to the purchasing price of the stock at the break-even point.

The seller also needs to be satisfied with the static rate of return and the if-called rate of return on the stocks. The static return is the approximate annual net profit of a covered call, assuming that the stock price does not change until the expiration date and until the option expires. To calculate this value, the seller needs to know:

- The purchase price of the particular stock
- The strike price of the option
- The price of the call
- The number of days until option expires
- If there are any dividends and the amount of these dividends

Calculating these factors leads to a percentile figure being determined. The formula for calculating this is:

(Call + Dividend) / Stock Price × Time Factor = Static Rate of Return

The if-called return is an approximate annual net profit on a covered call with the assumption that the stock price is above the strike price by or on the expiration of the option and that the stock is sold at expiration. To calculate this figure, which is also a percentage, the same factors need to be determined. The formula for calculating this is:

(Call + Dividend) + (Strike – Stock Price) / Stock Price × Time Factor = If-Called Rate of Return

The Benefits of Covered Call Options
The first benefit of covered call options is that the seller receives a premium payment, which can be kept as income whether or not the trader chooses to exercise the right to the option. This can be set up as a regular cash flow by serious investors in markets that are relatively neutral or bullish. The investor can set up a program for selling covered calls on a regular basis. This can potentially set up a monthly or quarterly income stream.

The second benefit of covered calls is that they can help investors target a selling price for a particular stock that is above the current price. Lastly, covered calls have the additional benefit of limiting risks as the asset provides protection to the seller.

The Risks Associated with Covered Call Options

The first major risk associated with covered calls is that the seller can lose money if the stock price depreciates below the break-even point. This is a risk that anyone who owns stock takes on.

The second risk is not being able to anticipate a huge price rise in the price of the stock. Stocks have unlimited potential for profit but if the holder of the options for that stock chooses to exercise his or her right then the seller has to hand it over to this person. This can lead to a great missed opportunity as the seller now has to hand over a tremendous asset in the transaction.

How to Create a Covered Call Option

The first step in creating a covered call is purchasing the stock. This is done by purchasing it in lots of 100 shares. Doing this allows you to sell an option for every 100 shares of stocks. The great thing about buying stock in this way is that you do not have to option all of them. For example, let's say that you bought 1000 shares of stock. You can sell 5 contracts, leveraging 500 shares and earning 5 premium payments. You will hold onto 500 shares of stock even if the holders of the options of those 5 contracts exercise their right.

The last step is waiting for the covered call to be exercised or for it to expire. If the covered calls are not exercised, then you still get to keep the premium. There is always the option to buy the option back before the expiration date arrives but sellers hardly ever do this. Remember that you have to be willing to part with the stock once you option it.

How the Covered Call Works

Covered calls work in one of three ways.

The Stock Price Goes Down

In this case the covered call will be worthless on expiration. The bad news is that the stock price goes down but the good news is that the seller gets to keep the premium and so still earned from the transaction. The decrease in the price of the stock is simply the nature of owning stocks. You should have accounted for this before you made the purchase. Remember that you need to be willing to own that stock no matter what, so choose wisely. Note though that the profit from selling the call can help offset this decrease in price of the stock.

The stock price may fall before the expiration date. This is not cause for fret because you are not indefinitely locked in this position. Even though the stock price has gone down and the call value went down as well, this is an opportunity to buy the call back for less money than you sold it for.

The Stock Price Does Not Change or Goes Up Slightly

This is not a losing scenario. While the covered call will expire as worthless, the seller still keeps the premium for the option. If you see a slight rise in the price of the stock, while the holder of the option is unlikely to exercise the right to gain that, the seller benefits from it nonetheless even if the rise is marginal.

The Stock Goes Above the Strike Price

If the stock goes up above the strike price by the expiration date, the holder of the option will exercise the right and the seller needs to sell the 100 shares of stock. It is a hard pill to swallow if the price of the stock skyrockets even if you already reconciled a willingness to part with the stock before but comfort yourself with the fact that you gain maximum profit from the transaction.

Chapter Summary

A covered call is a tactic of a seller selling the right to purchase a specified asset that he or she owns at a specified

price within a specified amount of time, which is usually less than 12 months. The main goal of creating such a covered call is to collect premium payments as a source of income against stock that is already owned.

To do this effectively, the seller must:

- Be willing to own the stock at the price it is even if the price depreciates.
- Be willing to part with that stock if the price rises.
- Be satisfied with the static rate of return and if-called rate of return on the stocks.

A covered call is created by first buying stocks in lots of 100 shares. Next, the seller creates covered calls with the 100 shares decided upon. Lastly, all the seller has to do is wait to see if the contract holder will exercise the option or allow it to expire.

The cover call will play out in one of 3 ways. Either:

- The stock price goes down. While the call will be worthless, the seller gets to keep the premium.
- The stock does not change or goes up slightly. While the call will be worthless, the seller gets to keep the premium.
- The stock goes above the strike price. The holder will exercise the right and the seller needs to sell thereby earning a maximum profit on the transaction.

The benefits of the covered call include:

- Earning a premium payment for the covered call in the form of a premium payment.
- Helping investors target a selling price for a particular stock that is above the current price.
- Limiting risks as the price of the stock provides protection to the seller.

There are also risks associated with the covered call and they are:

- The seller can lose money if the stock price depreciates below the break-even point. However, this is a risk that any stock owner takes on.
- Not being able to anticipate a huge price rise in the price of the stock, which can result in an opportunity cost.

Chapter 5
Strangles and Straddles

Both strangles and straddles are options strategies that allow the investor to benefit whether the stock price goes up or down. They carry similarities such as buying an equal number of call options (options that give the trader the right to buy the stock) and put options (options that give the trader the right to sell the stock), the same asset and they both have the same expiration date.

The difference lies in the number of strike prices. The strangle has 2 separate strike prices while the straddle has 1 common strike price.

These two strategies are called volatile strategies because unlike many strategies that bet on if options are bullish or bearish, these strategies bet on the volatility of the financial market.

Types of Volatility
There are five different types of volatility as it relates to financial markets. The first one that we will discuss is known as price volatility. Price volatility describes how the prices of assets move up or down. This type of volatility is affected by the supply and demand of that asset. There are external

66

factors that affect supply and demand. Prices may rise up and down due to the season. For example, prices may fluctuate due to whether or not it is summer or winter in the tourism industry. This factor fluctuates because of demand. Weather is another factor that can affect price volatility. For example, financial markets in the agricultural sector fluctuate due to the supply of certain crops at certain times of the year in certain regions. Emotions are also something that causes price volatility. For example, because of emotional attachment, gas prices continue to be high because there is a huge demand.

Stocks are also highly volatile. The characteristic is called stock volatility. This unpredictable nature is what makes stock a risky investment. Even though the returns on investing in stock can be quite high, the losses can be disastrous as well. This is why there is a science to picking stocks that are likely to be profitable. Investors use the measurement known as a beta to predict stock's volatility.

The financial market has a beta measure of 1.0. Individual stocks are ranked according to how they deviate away from the market. Therefore, stocks that increase more than the market over time have a beta that is greater than 1.0 while stocks that go below the market have a beta that is less than 1.0.

Stocks that have a beta of greater than 1.0 are risky to invest in but also have a higher potential for returns. Stocks that have a beta that is below 1.0 are less risky to invest in but also typically have lower returns. Beta is calculated with the following formula:

Variance / Covariance = Beta

Covariance is a measure of a stock's sensitivity relative to that of the financial market while variance is a measure of how the market moves relative to its mean.

Another type of volatility is called historical volatility. This is a measure of how a stock has performed over the last 12 months. If a stock's prices varied wildly over that time period, it is very volatile and therefore, risky to invest in. If a stock was less volatile over that time period, it becomes more attractive to invest in. An investor may, however, choose to hold onto the stock for a longer time period so that greater returns are achieved. To gain maximum profitability, the trader will study the market to see when is the best time to sell the stock at the highest value. This technique is called timing the market and as such, this technique does not work with volatile stocks because they are unpredictable in nature.

Implied volatility is a measure of how a stock will perform in the future. This is an opinion as there is no guarantee of what will happen in the future. Generating this opinion depends on certain factors that can be accounted for in the present. These factors include:

- The price of the stock
- The market price of the option
- The expiry date of the option
- The interest rate
- The strike price
- Dividends

While implied volatility in no way evaluates stock, it does evaluate how options should be prepared for selling and buying. It helps develop a fair price for the option so that it is profitable even if the price of the stock goes down. An option's price sensitivity in relation to implied volatility is known as vega. This figure represents the amount that an

option price will change in reaction to a 1% change in the implied volatility of the stock.

Vega is one of the Greeks. These are a collection of degrees that provide a measure of an option's sensitivity in relation to other factors. Other measures include delta, gamma and theta. Delta describes the option's sensitivity in relation to the price of the stock. Theta describes an option's sensitivity in relation to how time affects the premium of an option. Gamma is a reflection of the rate of change of the delta.

Other Greeks include:

- Lambda, which describes an option's sensitivity in relation to the associated asset's value.
- Rho, which describes an option's sensitivity to the interest rate.

The last type of volatility is known as market volatility and it describes the rate at which prices change on any financial market.

All of these types of volatility affect how an options trader will utilize the strangles and straddles strategies.

We will now look at the benefits and risks of each of these strategies below.

The Strangle Strategy
This strategy is employed when the trader strongly believes that the stock price will move either up or down but still wants to be protected in case he or she is wrong. There are both long and short strangles.

The Short Strangle
Also called a sell strangle, this is a neutral options trading strategy. The trader sells:

- 1 out of the money put

- 1 out of the money call

Both of these will have the same associated stock and the same expiration date. This is a tactic employed when the trader thinks that the stock will be relatively stable on the market in the short term. Profit is gained when the stock prices on the expiration date are between the strike prices of the options. This profit is limited. The formula for this profit is calculated like this:

Premium Received - Commissions Paid = Profit

Unfortunately, the risk of this type of option is unlimited. Loss is experienced if the price of the stock goes up or down sharply by the expiration date.

With a call option, this is calculated this way:

Price of Stock - Strike Price of Short Call - Premium Received = Loss

The loss with the put option is calculated with this formula:

Strike Price of Short Put - Price of Stock - Net Premium Received + Commissions Paid = Loss

There are 2 breakeven points with such a transaction. Calculated on the short call, the formula is this:

Strike Price of Short Call + Premium Received = Breakeven

The formula for the short put breakeven point looks like this:

Strike Price of Short Put - Premium Received = Breakeven

The Long Strangle
This is also called the buy strangle and it is based in a neutral position in the options trading. The trader buys:

- 1 out of the money put
- 1 out of the money call

Both of these will have the same associated stock and the same expiration date.

This is a strategy that is used when a trader believes that there will be great volatility in the market. The beauty of this strategy is that it minimizes the risk of loss and introduces the potential for unlimited profit. This profit is gain when the price of the stock takes a sharp move up or down. The formula for the call option is:

Price of stock - Strike Price of Long Call - Premium Paid = Profit

The formula for the put option is:

Strike Price of Long Put - Price of Stock - Premium Paid = Profit

The risk of this type of strategy is that the stock prices is trading between the strike prices of the options bought on the expiration date. Both options will become worthless.

Net loss is calculated with this formula:

Premium Paid + Commissions Paid = Loss

The trader can breakeven at 2 points with this strategy. The formula for breakeven on the call option is:

Strike Price of Long Call + Premium Paid = Breakeven

The formula for breakeven on the put option is:

Strike Price of Long Put - Premium Paid = Breakeven

The Straddle Strategy
With this options trading strategy, the trader protects himself regardless of if the price of the stock moves up or

down. Think of it as someone straddling a fence. This person is able to jump to either side of the fence to ensure the situation benefits him or her. There are both long and short straddles.

The Short Straddle
This is also called a sell straddle as well as a naked straddle sale. This neutral options strategy work by the trader selling:

- 1 at the money call
- 1 at the money put

The options have the same associated stock, strike price and expiration date.

These types of transactions have a limited profit just like short strangle. The profit is achieved when the stock price trades at the strike price of the options on the expiration date. The formula for calculating this is:

Net Premium Received - Commissions Paid = Profit

The risk is unlimited and is incurred when the stock prices move highly up or down by the expiration date. On the call option, the formula for calculating this is:

Price of Underlying - Strike Price of Short Call - Net Premium Received = Loss

For calculating the loss on the put option, this formula is used:

Strike Price of Short Put - Price of Stock - Net Premium Received + Commissions Paid = Loss

This strategy also has 2 breakeven points. Calculating the breakeven on the call, looks like this:

Strike Price of Short Call + Premium Received = Breakeven

Calculating the breakeven on the put, looks like this:

Strike Price of Short Put - Premium Received = Breakeven

The Long Straddle

Also known as the buy straddle, this strategy is a neutral one whereby the trader buys:

- 1 at the money call
- 1 at the money put

This strategy ensures that both options have the same associated stock, strike price and expiration date.

The profits associated with this strategy are unlimited. Because the trader has long positions on both the call and put options, profits grow when the stock prices move up or down strong enough. Profit is calculated with the following formulas:

Price of Stock - Strike Price of Long Call - Net Premium Paid = Profit

Strike Price of Long Put - Price of Stock - Net Premium Paid = Profit

Another benefit of using this strategy is that the risks are limited as the loss is incurred when the stock price trades at the strike price on the expiration date. Loss is calculated with this formula:

Premium Paid + Commissions Paid = Loss

Just like with all of the strategies mentioned above, breakeven for long straddle is calculated at 2 points. The formulas for calculating this as follows:

Strike Price of Long Call + Net Premium Paid = Breakeven

Strike Price of Long Put - Net Premium Paid = Breakeven

Chapter Summary

Both strangles and straddles are neutral options strategies that allow the investor to benefit whether the stock price goes up or down. They have similar characteristics, which are an equal number of call options and put options, the same asset and they both have the same expiration date. They only differ in the number of strike prices called on the options.

The strangle strategy is employed when the trader strongly believes that the stock price will move either up or down but still wants to be protected in case he or she is wrong.

Using the straddle strategy, the trader protects himself or herself regardless of if the price of the stock moves up or down. Both strategies have a long and a short option. They are both affected by the volatility of the financial market.

Chapter 6
Credit and Debit Spreads

Credit Spreads vs. Debit Spreads

The use of spreads is another tactical approach to options trading. The spread is described as the purchase and sale of two different options with the same associate asset attached.

Credit spreads describe the selling of a high-premium option while purchasing a low-premium option in the same class (calls or puts). This results in a credit to the investor's account. Both of these options have the same expiration date but different strike prices. The aim here is to make a profit when the spread between the two options becomes narrowed.

On the other hand, a debit spread is one where the trader buys a high-premium option and sells a low-premium option with the same associated asset attached to both options. Just like with a credit spread, both options have the same expiration date but different strike prices. The trader makes a profit when the spread between the two options widens. This results in a debit to the trader's account.

Credit Spreads

How Credit Spreads Work

A credit spread is advantageous because the seller collects more in premium than what is paid out in the options. For example, if the trader sells an option for $1000 and buys another option at a lower strike price of $75 then he or she will have a net result of $25. We refer to this as a credit because he or she is collecting more then he or she is paying out.

There are several types of credit spreads but we will focus on 2 in this section – the put credit spread and the call credit spread. The put credit spread has a bullish outlook and relies on time decay. The profit comes when the stock prices increase. Profit for 100 shares of stock is calculated with this formula:

Credit Received x 100 = Profit

The loss for 100 shares of stock is calculated with this formula:

(Width of the two Strike Prices - Credit Received) x 100 = Loss

Breakeven is calculated with this formula:

Short Put Strike Price - Credit Received = Breakeven

The call credit spread is approached with bearish outlook and it too relies on time decay. Profits are realized when stock prices decrease. Profit for 100 shares of stock is calculated with this formula:

Credit Received x 100 = Profit

The loss for 100 shares of stock is calculated with this formula:

(Width of the two Strike Prices - Credit Received) x 100 = Loss

Breakeven is calculated with this formula:

Short Call Strike Price - Credit Received = Breakeven

Types of Credit Spreads
Bull Put Spread

This is a great options strategy for beginners to implement. It is a bearish technique that relies on the price of the associated asset going down significantly enough but not by a huge jump. Two transactions are required with an upfront cost. The trader:

- Buys 1 out of the money put
- Sells 1 on the money put

They are implemented by buying a lower-premium out of the money put option while simultaneously selling one in the money put option that is of a higher premium.

Profit is achieved when the price of the associated asset is equal to the credit received from the options. The formula for this is:

Premium Received - Commissions Paid = Profit

Loss occurs when the stock prices go below the strike price on or before the expiration date. This is calculated with this formula:

Strike Price of Short Put - Strike Price of Long Put Net Premium + Commissions Paid = Loss

Breakeven is calculated like this:

Strike Price of Short Put - Net Premium Received = Breakeven

Bear Call Spread

This type of option works similarly to the one stated above and profit is reliant on the prices of the associated asset falling moderately. The trader:

- Buys 1 out of the money call
- Sells 1 in the money call

Profit is calculated with this formula:

Premium Received - Commissions Paid = Profit

Loss occurs when the stock prices go above the strike price on or before the expiration date. This is calculated with this formula:

Strike Price of Long Call - Strike Price of Short Call - Net Premium Received + Commissions Paid = Loss

Breakeven is calculated like this:

Strike Price of Short Call + Net Premium Received = Breakeven

This bearish strategy is slightly more complicated and is not typically recommended for novice options traders.

Short Butterfly Spread

This is a volatility-based strategy that is typically practiced by medium to advanced options traders. This applies to both call and put options of this type. Three transactions are involved. They are:

- Buying 1 in the money call/put
- Selling 1 out of the money call/put
- Buying 1 as the money call/put

This is not an options trading strategy that a trader should jump into lightly. This requires careful thought and

consideration. Thus, this is a strategy that is best employed by intermediate and advanced options traders. However, when done right, this strategy offers benefits like increased flexibility and the ability to profit no matter which direction the price of the asset goes. Both the profit and loss of this type of strategy are limited. This limitation is great for managing risks.

Iron Butterfly Spread

This is a neutral strategy that entails 4 transactions. The trader:

- Buys 1 out of the money call
- Sells 1 at the money call
- Buys 1 out of the money put
- Sells 1 at the money put

The two calls and puts of this options strategy are equal and the associated asset and expiration date of all of these components are the same. Due to the complexity of this strategy, it is not suitable for beginners. The higher commissions also make it less appealing to most traders. However, the benefits include a higher potential profit. This strategy is useful for making a huge payout. Thus, on such a sizable contract, the commissions' increase may be worth pursuing this strategy.

The Pros and Cons of Credits Spreads

One of the biggest advantages of using credit spreads is that they drastically lower the risk to the trader if the stock price moves against the trader. Next, the seller receives cash upfront in the form of premium payment. Losses are limited because the trader stands to benefit no matter what direction the price of the associated asset moves.

The biggest disadvantage of this type of options strategy is that it requires a trader to use a margin account. This is not

something a trader might necessarily want to do. Also, another disadvantage is that even though the losses are limited so are the profits.

Debit Spreads

How Debit Spreads Work

Unlike a credit spread where the seller receives cash into his or her account, debit spreads instead carry an upfront cost. The premium is paid from the investor's account when the position is opened, and this is referred to as a debit. This type of strategy is mostly used to offset the costs associated with having long option positions. This results because the premium received from long components is more than the premium received from short components. As a result of this, the net debit is the highest possible value for loss in this type of options strategy. Losses are thus limited.

Despite this upfront cost, debit spreads are generally considered safer to create and less complicated than credit spreads. Debit spreads are therefore more commonly used by beginners compared to credit spreads.

Just like the credit spreads, there are at least two options involved in the transaction. The trader pays for a higher premium option while selling a lower premium option. However, just like with credit spreads the number of transactions executed in this strategy can exceed 2.

Just like with credit spreads, there are call and put versions. The basic call version is set up like this – the investor:

- Buys 1 call
- Sells 1 call (this is the higher strike)

Profit is calculated with this formula:

Width of the two Strike Prices – Premium – Commissions = Profit

Loss is calculated with this formula:

Premium Paid + Commissions = Loss

With the put option, the set up looks like this:

- Sell 1 put
- Buy 1 put (this is the higher strike)

Profit is calculated with this formula:

Width of the two Strike Prices – Premium – Commissions = Profit

Loss is calculated with this formula:

Premium Paid + Commissions = Loss

All of these equations will be x100 to prepare a contract with 100 shares as the associated asset.

Types of Debit Spreads
Bull Call Spread

This is a relatively simple strategy to implement as it only requires 2 transactions. The trader:

- Buys 1 at the money call
- Sells 1 out of money call

This is a bullish strategy that is implemented when the trader believes that the price of the associated asset will rise moderately.

Profit is achieved when the price of the associated asset is equal to the strike prices of the short call. The formula for this is:

Strike Price of Short Call - Strike Price of Long = Profit

Loss occurs when the stock price goes below the strike price on or before the expiration date. This is calculated with this formula:

Net Premium Paid + Commissions Paid = Loss

Breakeven is calculated like this:

Strike Price of Long Call + Net Premium Paid = Breakeven

Bear Put Spread

This is a bearish strategy that is used when a trader believes that the price of the associated asset will go down by a moderate amount. It only requires 2 transactions and is, therefore, suitable for beginners. The trader:

- Buys 1 at the money put
- Sells 1 on the money put

This is a straightforward strategy that has limited losses and profits with comparatively low upfront costs.

Profit is achieved when the price of the associated asset is equal to the strike prices of the short call. The formula for this is:

Width of the two Strike Prices - Net Premium Paid - Commissions Paid = Profit

Loss occurs when the stock price goes above the strike price on or before the expiration date. This is calculated with this formula:

Net Premium Paid + Commissions Paid = Loss

Breakeven is calculated like this:

Strike Price of Long Put + Net Premium Paid = Breakeven

Reverse Iron Butterfly

This is a volatile strategy that is used when a trader believes that the price of the associated asset will move sharply in price but is not sure in which direction. Thus, this strategy is created to gain a profit no matter the direction. It requires 4 transactions and they are:

- Sell 1 out of money put
- Buy 1 at the money put
- Buy 1 at the money call
- Sell 1 out of money call

The profit gained in this type of strategy is limited and is achieved when the associated asset price drops below the strike price. The formula for this is:

Width of the two Strike Prices - Net Premium Paid - Commissions Paid = Profit

Loss occurs when the stock price is the same as the strike price on the expiration date. This is calculated with this formula:

Net Premium Paid + Commissions Paid = Loss

The 2 breakeven points for this strategy are calculated like this:

Strike Price of Long Call + Net Premium Paid = Breakeven

Strike Price of Long Put + Net Premium Paid = Breakeven

Butterfly Spread

This is a neutral strategy that involves 3 transactions. The trader:

- Buys 1 in the money call

- Sells 2 at the money calls
- Buys 1 on the money call

The profit gained in this type of strategy is limited and is achieved when the associated asset price remains unchanged on the expiration date. The formula for this is:

Width of the two Strike Prices - Net Premium Paid - Commissions Paid = Profit

Loss is also limited. It occurs when the stock price is the same as the strike price on the expiration date. This is calculated with this formula:

Net Premium Paid + Commissions Paid = Loss

The 2 breakeven points for this strategy are calculated like this:

Strike Price of Higher Strike Long Call - Net Premium Paid = Breakeven

Strike Price of Lower Strike Long Call + Net Premium Paid = Breakeven

This is not a strategy that is recommended for beginners but it can indeed bring in a high return on investment. Unfortunately, because of the higher number of transactions, the commissions paid on this strategy can be high.

The Pros and Cons of Debit Spreads
The benefits of debits spreads include:

- They aid in trade planning because they help the trader determined potential maximum profits and losses in advance.
- Losses are limited due to the manner in which these types of strategies are implemented.

84

- Margin accounts are not required for this type of options strategy and can be used by traders who do not have the capability to use them.
- They offer greater profit margins.

There are also disadvantages to these types of options strategies. The biggest is that the profit margin is limited just as the losses are limited.

Legging Spreads

Every options trader runs into the question of whether or not he or she should leg an option. This section is dedicated to breaking down the process and giving you legit reasons why you can consider legging as a technique to leverage opportunities as well as minimize the risks associated with the technique. Legging is a technique that is associated with having multiple transactions associated with one option. Of course, this can become quite complicated but the basic concept remains the same always.

What is Legging?

Spreads by their nature of having more than one transaction with the same associated asset make them the perfect opportunity to engage in legging. Every spread has at least two legs – the buying of one option and the selling of another. Normally these two transactions occur at the same time but there are instances where the trader separates the transactions. This process of separating the transactions is called legging.

Legging comes from the term leg, which describes a singular component on an options trading strategy. When several components are put together, it becomes legging. Legging does not only have to consist of two transactions. It can become a lot more complicated with many more transactions.

Benefits of Legging

Legging is widely used by experienced options traders and they find it beneficial for a number of reasons, including:

- It might result in losses if the transactions are done at the same time and so legging allows the components to be done individually.
- It might be possible to make a bigger profit by legging into or out of a certain position.
- The broker may not be in a position to carry out each transaction at the same time.
- The market climate may have changed and made it necessary to leg into another position for profitability's sake.
- Legging may be needed to lock in a profit or ensure losses stay to a minimum.

Luckily, using online brokerage firms has greatly reduced the likelihood of the third case being the scenario that pushes an options trader to use the legging technique but it still exists. Be careful with transacting legs with your brokerage firm as while the strategy might be profitable by its self, the fees and commissions from doing multiple transactions at the same time can stack up quickly and cut on the potential profits. Still, many online brokers allow for multiple transactions without making a fuss. It is typically a built-in feature because of its potential to greatly increase profitability by combining several transactions to build one powerful position.

How to Use Legging

Implementing legging is a matter of priority. You need to know which leg you will execute first and in what order the subsequent legs will fall. In slow-moving markets, the order may not be as important to perfect but in fast-moving markets where prices fall and rise in rapid succession, this

order is paramount. Understanding the market is what will lead to correctly determining this order. This is why options traders need to be on the ball to make legging work.

After studying the market for the right conditions for the strategies, the trader then needs to develop a plan to execute each leg.

The Risks of Legging

Legging is not a technique that typically pays off for many beginner options traders because of its complexity. While the concepts of applying it are simple, the practical application is not. The options trader needs to be well-acquainted with the market and more basic options trading techniques before attempting this one. The trader needs to also be able to follow short-term trends in the financial market as well as be able to make correct calculations based on those trends. Then the trader needs to turn those calculations into fast decisions because legging is largely a technique that relies on timing and the transactions being applied in the right order.

The biggest risk is that the trader implements this technique at the wrong time and reduces on his or her profits. Worse still, using legging ineffectively can lead to major losses. So while legging can indeed be a highly profitable technique, it can be disastrous if done wrong. The associated disadvantages include:

- Having the technique backfire on the options trader and lead to lowered profit margins
- Complete wipeout of profits
- Being legged out of a position that works for the trader.

Chapter Summary

The use of spreads, which is the purchase and sale of at least two different options with the same associate asset attached, is another tactical approach to options trading.

Credit spreads describe the selling of a high-premium option while purchasing a low-premium option in the same class. This results in a credit to the investor's account. Both of these options have the same expiration date but different strike prices. The aim here is to make a profit when the spread between the two options becomes narrowed.

On the other hand, a debit spread is one where the trader buys a high-premium option and sells a low-premium option with the same associated asset attached to both options. Just like with a credit spread, both options have the same expiration date but different strike prices. The trader makes a profit when the spread between the two options widen. This results in a debit to the trader's account.

Legging is a technique that allows for the multiple transactions associated with spreads. Every spread has two legs – the buying of one option and the selling of another. Normally these two transactions occur at the same time but there are instances where the trader separates the transactions. This process of separating the transactions is called legging.

Legging has a number of benefits that include:

- Preventing the loss due to several transactions being done at the same time.
- Facilitating a bigger profit by legging into or out of a certain position.
- The broker may be not in a position to carry out each transaction at the same time.

88

- The market climate may have changed and made it necessary to leg into another position for profitability's sake.
- Legging may be needed to lock in a profit or ensure losses stay to a minimum.

Legging needs to be done with caution because it can result in losses when not timed or ordered correctly.

Chapter 7
Iron Condor

This options trading strategy is similar to the iron butterfly and has 4 transactions. The two strategy are mistaken for each other but the iron condor allows for a great profit margin. This is a result of the iron butterfly spread requiring the associated asset to be the same price to take maximum profit while the iron condor allows for a range to reach the profit margin. The downside of this is that the maximum profit that can be earned is lowered.

The particulars of the iron condor are:

Strategy type: Neutral

Trader Level: Advance

Spread type: Credit

This options strategy requires 4 transactions. The trader has to:

- Sell 1 out of the money put
- Buy 1 out of the money put (has the lower strike)
- Sell 1 out of the money call
- Buy 1 out of the money call (has the higher strike)

All four options have the same expiration date.

The maximum profit available from this options strategy is equal to the net credit that is received upon entering the contract. Profit is earned when the associated asset prices at the expiration date falls between the call and put that are sold. The formula to calculate this looks like this:

Net Premium Received - Commissions Paid = Profit

Loss experienced with this strategy is limited and non-directional because this strategy is comparative to combining a bear call spread and a bull put spread. Loss is calculated with this formula:

Width of the two Strike Prices - Net Premium Received + Commissions Paid = Loss

Unfortunately, loss can be a lot higher than the profit with this strategy because it can occur either when the price of the associated asset falls at or below the lower strike of the put or if it rises above or is equal to the higher strike of the call.

There are 2 breakeven points. Breakeven is calculated with these formulas:

Strike Price of Short Call + Net Premium Received = Breakeven

Strike Price of Short Put - Net Premium Received = Breakeven

The Benefits of the Iron Condor Spread
- The stock can go in any direction and the trader can still make a profit.
- This is a flexible strategy that allows for minimizing risk while still potentially earning the trader profits on a monthly basis.

- Profit can be made with a broad range at the date of expiration.
- These are short-term contracts so profits can be realized in 3 months or less.
- The investor can made predeterminations of what the potential losses and profits can be before entering the contract.

The Risks of the Iron Condor Spread

The biggest disadvantage of this strategy is its complexity. The 4 legs means that this is a strategy that is best suited for advanced traders. This means that any trader who does not understand options on the level needed or understand the financial market stands to makes a loss if he or she implements this strategy incorrectly.

Chapter Summary

A great alternative to the iron butterfly spread, this options strategy is great if a trader is trying to gain a profit from having a neutral outlook. It has for legs, which look like this:

- Sell 1 out of the money put
- Buy 1 out of the money put (has the lower strike)
- Sell 1 out of the money call
- Buy 1 out of the money call (has the higher strike)

Maximum profit is achieved when the associated asset price at the expiration date falls between the call and put that are sold. This is a strategy best left to advanced options traders.

Chapter 8
Selling Naked Options

Naked options are also called uncovered options and they contrast with covered options. Naked options are so-called because the seller of the option does not own the associated asset attached to that contract. This kind of selling is known as writing or shorting an option. This is a highly vulnerable position for the seller because not having ownership of the asset means that he or she needs to acquire the asset at the expiration date should the trader of the option decide to exercise the right of ownership. The seller of this type of option is not protected from price volatility. This is why this type of option is known as uncovered or naked – due to the high level of exposure the seller faces. The seller runs the risk of having a high loss margin.

Despite this vulnerability, selling a naked option has a variety of benefits that many traders and investors find attractive, especially since this vulnerability and volatility is built into the premium. If the investor decides to exercise the right to the option, acquiring the asset creates a short sell position in the seller's account. Naked options can be further broken down into call options and put options.

Naked Call Options

The naked call option is a bearish strategy where the object of the seller is to gain a premium payment and exit the agreement.

This type of option describes the seller of the call option having an obligation to sell the asset and having no right to back out if the buyer of the option decides to exercise the right to buy. This type of agreement is entered into when the price of the asset is expected to fall at the expiration date.

Profit is calculated using this formula:

Premium Received – Costs of Trade = Profit

This profit is acquired if the price of the associated asset is less than the strike price at the date of expiration.

As mentioned earlier, there is a great potential for loss with this options strategy. In fact, the loss is potentially unlimited. It is calculated with this formula:

Price of Security – Strike Price of Short Call - Net Premium + Costs of Trade = Loss

Loss is experienced when the price of the associated asset goes above the strike price. This can clearly be disastrous because there is no ceiling for this. This is the reason why many brokers do not encourage the use of this options trading strategy, especially if physical commodities are associated.

Breakeven is calculated with this formula:

Short Call Strike Price + Premium Acquired = Breakeven

Naked Put Option

The naked put option is a bullish strategy that has the same objective as with the naked call option – to gain a premium payment and exit the agreement.

This type of option describes the seller of the call option having an obligation to buy the asset and having no right to back out if the buyer of the option decides to exercise the right to sell. This type of agreement is entered into when the price of the asset is expected to rise at the expiration date.

Profit is calculated using this formula:

Premium Received – Costs of Trade = Profit

This profit is acquired if the price of the associated asset is more than the strike price at the date of expiration.

Loss is potentially unlimited in this case as well and occurs when the price of the asset falls. It is calculated with this formula:

Strike Price of Short Put - Price of Security - Option Premium + Costs of Trade = Loss

Breakeven is calculated with this formula:

Short Put Strike Price - Premium Acquired = Breakeven

The Elements of a Naked Option

While this is a risky strategy, the naked option can be accomplished with success. The seller just has to get the elements right. These elements are:

- Timing. The seller needs to be certain the price of the asset is unlikely to move when selling a naked option. Volatility is not the name of the game in naked options trading.

- Short expiration date. Volatility is less likely in the short term so naked options traders should not develop naked options with far off expiration dates.
- Protection. A naked options trader can try to protect himself or herself by taking cash in hand for put options and physical security for call options up until the expiration date. If not, the seller should exit before the expiration date.

The Benefits of Naked Options

We have talked a lot about the risks involved with selling naked options but that is not to say that using this options strategy cannot be advantageous. The benefits include:

- Naked options allow the seller to leverage more positions without the expense of margin interest compared to covered options.
- The upfront costs are lower compared to using a covered strategy.
- The seller gets to keep the premium even if the option is not exercised.

Chapter Summary

Unlike a covered option, the naked option is one where the seller of the option does not own the associated asset attached to that contract. The aim of the seller is to gain the payment of the premium then exit. Therefore, this is a strategy that should only be implemented if the seller is fairly certain that the price of the asset will not move up until on or by expiration date.

This is a risky strategy to employ as it exposes the seller to unlimited loss because the option is not protected against price volatility and he or she will have to deliver the associated asset if the investor decides to exercise the right of the option.

Despite the risks, using naked options can be a powerful way to leverage more positions. The benefits include having a lower upfront cost compared to covered options and the fact that the seller gets to keep the premium payment no matter what direction the asset takes.

The elements that need to be considered for selling a naked option include timing, the expiration date and the level of protection the seller has.

Chapter 9
Rolling Out Options

The process of rolling out describes an expiring option being replaced with an identical option. Rolling out is a great strategy to manage a losing or a winning position. This management is facilitated by closing one option position then opening another option with a similar position with the same associated asset but varied terms.

Most times, traders use this strategy to adjust the strike price and the length of time the trader would like to hold a short or long position. This strategy is one that even a beginner needs to be aware of because any options trader who trades for an extended amount of time will encounter it at some point or the other. Rolling can be done in 3 ways. These ways are:

- Rolling up
- Rolling down
- Rolling forward

We will look at each individual rolling over type below.

How to Roll Out an Option
Rolling Up

This method of rolling up involves closing one existing option position while opening a similar position with a higher strike price at the same time. The higher strike price is the reason for the name. This method is simple and can be done in both a short and a long position. In a short position, all the trader has to do is buy to close the existing position. In the long position, the trader needs to sell to close the existing position. The next step is opening a new position with the same associated asset and a higher strike price. From a short position, the trader needs to sell to a new position. From a long position, the trader needs to buy to a new position.

The procedure remains the same regardless of whether it revolves around a put or a call option. The end result is different though for put and call options. If the trader rolls up a put option, the contract becomes more expensive thus the need for a higher strike price. If the trader rolls up a call option, the contract becomes less expensive. Therefore, the higher the strike price for a rolled up call option, the less expensive it becomes.

The effect is also affected by whether or not the put or call option is long or short. Rolling up a long put position entails selling cheaper options to make up the existing position so that the buying of more expensive options can be facilitated. On the other hand, rolling up short positions entails closing that position by buying cheaper options then writing up more expensive options.

Rolling up a long call position entails selling one position to enter into a cheaper one. This results in a profit. On the other hand, rolling up a short position means buying back cheaper options in order to write up new options with higher strike prices.

Rolling up options is done for a variety of reasons and is dependent on the trader's existing position and what circumstances surround that current position. One example where this might be a useful technique to employ is a situation where a contract is written up against stock that a trader already owns. If the price of the stock increases unexpectedly before the expiration date, the trader can roll up the option at a higher strike price that is out of money to prevent him or her from having to sell the stock.

Rolling up options is a useful strategy indeed. However, it does come with its own unique set of risks. Those risks become particularly high in volatile markets or in markets that are moving quickly in one particular direction. The changes in strike price between closing one position and entering another position can be detrimental if market value fluctuates at a high level.

There is another risk that goes by the name of slippage. Slippage is the circumstance that results when there is a time delay between two related options. This results in a price change during that time. This is a problem that many options traders face when they engage in multiple transactions that relate to one overall position. This is a problem that is particularly experienced when traders employ the use of spreads to gain multiple positions. This can be quite complex if the options trader is involved in several transactions at the same time.

Experienced traders become apt at handling this, though. To turn this problem around, the trader needs to roll up a specific transaction to close the existing position while opening up a new one at a higher strike price at the same time. Due to the complexity of this type of strategy, this is not something that is recommended for a beginner to try.

Rolling Down

Rolling down is the method that involves closing one existing position while opening a similar position with a lower strike price at the same time. It is the opposite of rolling up. It can be applied to both puts and calls, and both short and long positions. The reasons for using this method typically revolves around the trader's current circumstance and the position that he or she is in.

The first reason that he or she might use rolling down is to prevent exercising on a short put position so that the obligation of having to buy the associated asset is avoided. Next, the trader might use rolling down to minimize losses on calls while still maintaining speculation on the associated asset recovering its value. Even though the expiration date may approach, the trader may maintain the belief that the price of the associated asset will increase again and therefore, use rolling down to buy a call at a lower strike price. This provides impact protection and betters chances of getting a profit if the associated asset does indeed climb in value as speculated.

Lastly, rolling down is a consideration for many options traders because they would like to make a profit off put options while still holding a position whereby they can speculate that there will be further downward movement of the associated asset value. In this situation, the trader rolls down so that he or she can purchase puts with lower strike prices to benefit further from the fall in the associated asset's value. This allows for continued profit without risking the profit that has already been made.

Rolling Forward

There are many options that an options trader can exercise when open positions are approaching the expiration date if the maximum profit is not yet realized but is still probable,

and one of those options is rolling forward. Rolling forward involves moving an open position to a different expiration date so that the length of the contract is extended. In essence, this is closing an existing position and opening a corresponding position based on the same option characteristics with a different expiration date. This is also known as rolling over.

This can be done by closing the existing position and entering a new one or entering a new position and then closing the existing one. As you can see, these as separate transactions and as such this is a form of legging.

There are 2 common reasons why rolling forward is used by options traders. The first reason is that the trader may have taken a certain position expecting to profit in a greater way in the short-term but realizes after that a bigger profit will be realized over a longer period of time. The extension of the expiration date enables the trader to continue to profit from the option.

The second reason is that the trader may have entered into a position expecting the associated acid to move in a particular direction within a certain amount of time and later realized that this will take longer than expected. Extending the length of the contract allows the trader to profit from the contract at a later date.

The Benefits of Rolling Out
- Commission fees are lower because rolling out is conducted on one transaction rather than multiple.
- Rolling out allows the trader to save and thus, keeps more money in the pocket.
- The risk of slippage is reduced because the closing and opening of options positions are done simultaneously and not as separate transactions.

- Rolling over is a relatively simple strategy compared to other options trading strategies.

Chapter Summary

Rolling out options describes the process of an expiring option being replaced with an identical option. Rolling out is a great strategy to manage a losing or a winning position. It is facilitated by closing one option position then opening another option with a similar position with the same associated asset but varied terms like the adjustment of the strike price and the length of time the trader would like to hold a short or long position.

Rolling can be done in 3 ways. These ways are:

- Rolling up, which involves closing one existing option position while opening a similar position with a higher strike price at the same time.
- Rolling down, which involves closing one existing position while opening a similar position with a lower strike price at the same time.
- Rolling forward, which involves moving an open position to a different expiration date so that the length of the contract is extended.

The benefits of rolling over include:

- Lower commission fees.
- Increased trader savings.
- Reduced risk of slippage.
- The ease of transaction is suitable for beginners.

Chapter 10
Top Trader Mistakes to Avoid in Options Trading

As a new options trader, it is very common to easily feel overwhelmed or overzealous in your pursuit of this business. Even though the risks of such a business are relatively low, making mistakes can be very costly. This chapter is dedicated to increasing the awareness of common mistakes that are made by beginners (and sometimes by advanced traders) so that you can avoid them with practical approaches.

Mistake #1 - Not Having a Trading Plan to Fall Back On
Unfortunately, many people enter the arena of options trading out of desperation or greed with no plan as to how they will make this a successful venture. They are looking to make a quick buck and do not think things through because they are not thinking rationally. This leads to them trading with their emotions rather than with logic.

There is no place for emotions and feelings in options trading. While gut instinct has a time and a place in options trading, being led by anger, sadness and other emotions can lead to heavy financial losses.

As this book has shown, there are many factors that need to be considered if an options trader wants to make maximum profit. Therefore, going in half-cocked, desperate or greedy will only lead to failure and unnecessary losses. To make the best out of this business venture you need to have a sound trading plan before you do a single thing. Your trading plan will serve as your comprehensive decision-making guide for all your trading activities.

Developing this plan relies on asking several questions, which include but are not limited to:

- What are your goals?
- How much time will you commit to options trading?
- Which financial markets do you want to trade in?
- What strategies will you use to find opportunities in the financial market?
- How much capital do you have available to dedicate to options trading?
- How much are you willing to risk for every trade?
- What determines this risk?
- What are your risk management rules?
- When will you enter the trading market?
- What strategies will you implement to minimize your losses?
- What is your exit plan?
- How will you maintain a record-keeping system?

To answer these questions effectively, you need to take your emotions out of it and use your logical brain. Developing this plan is the only thing that will keep you moving forward and facilitate improvement as an options trader. With your plan finalized, you will realize that there is predictability and repeatability in options trading. Realizing these trends can help you maximize your profit by taking advantage of these features.

Mistake #2 - Choosing the Wrong Expiration Date for Options

Having expiration dates that are too short or too long can be costly. While you develop your trading plan, you will definitely come across the factor of how you will select expiration dates for your options. Each option is unique and this requires setting up a system whereby you can select proper expiration dates so that profits are maximized every time.

When developing your options for choosing an expiration date, relying on a simple checklist system can help. Here are a few questions that you can add to this checklist so that you choose the best expiration date for that particular transaction:

- How long is this trade likely to play out?
- Does this timeline align with my own goals?
- Do I have adequate liquidity in the timeline to support my trade for the duration of the contract?
- What is the historical and implied volatility of the financial market?
- Have I factored in the Greeks like delta and theta?
- How will my particular strategy relate to time decay and profitability?

Mistake #3 - Not Factoring In the Volatility of the Financial Market

Even the most stable financial markets can have days where they take off in an unexpected direction. This affects the value of the associated asset and so the options trader needs to be aware of this. There are also traders who only look at the reactivity of the financial markets during one time period and not others and so do not rely on historic data or focus on forecasting the future. These are costly mistakes.

Ensure that the factoring of market and stock volatility are always a consideration even after the option has been finalized. Volatility in the market is inevitable. Look at the stock market and you will see how quickly it moves up and down over the short term. It is important that you do not get carried away with short-term fluctuations. Know your strategy before you invest so that you are not distracted by short-term fluctuations.

While it is best to try to avoid volatility as much as possible when trading options, if you do decide to go the opposite route, limit your orders and ensure that you have a sound exit strategy.

Mistake #4 - Not Having a Sound Exit Plan

This is a trading strategy that many novice options skip in their eagerness to get started. While they may have a strategy in place for entering options trading, they forget or are ignorant of the fact that an exit strategy is just as important.

One of the biggest reasons for developing an exit strategy is to prevent emotions from clouding your judgement during that time when tough decisions need to be made. As a result, make the plan before things hit the fan to take out that emotional aspect.

There are two factors that need to be considered when creating an exit plan for an option. They are:

- What is the absolute point you will get out of the trade if things are not working out in your favor?
- How will you take profits if things are working in your favor?

Many experienced options traders place a percentage cap on the trade to know at which point they will back out of the trade if things are not working out in a profitable way for

them. While it is normal for the value of the transaction to fluctuate between 10% and 20%, most experienced traders will cut their losses if their fluctuation goes between 30% and 50%.

This fluctuation needs to be considered also if things are working out in your favor. If the transaction has increased in value between 30% and 50%, you need to be thinking about how you can protect your profits or how to ensure that you do not lose any money through that option.

Your exit strategy can also be time-based. You may decide that pursuing a certain option is only worthwhile for you for a certain time period and not beyond.

Having a target profit can also be the foundation of your exit strategy.

Mistake #5 - Not Being Flexible
Never say never with options trading. Many traders get stuck in their ways when it comes to options trading and refuse to try out new strategies. Remember that having a growth mindset is necessary for success in any part of life and this philosophy also applies to trading options.

You have to be willing to keep in the know when it comes to options and also be willing to learn and try new strategies. That does not mean try any strategy you come across. It simply means that when you do come across new strategies, assess them carefully to see if they have the potential to fit into your trading plan to help you accomplish your goals.

Mistake #6 - Trading Illiquid Options
Liquidity describes how quickly an asset can be converted to cash without a significant price shift. The more readily the asset can be traded, the more liquid it is. Having a liquid market means there are ready and willing active buyers and sellers.

Options that are highly liquid have certain characteristics. Being high in volume is one such characteristic. The higher the volume of options, the easier they are to enter and exit. Having the ability to move in and out of a contract is a huge advantage to an options trader. Being easily adjustable is another characteristic. Seeking out option with these characteristics makes the job of an options trader that much easier

Examples of highly liquid assets attached to options include stock and ETFs.

On the other hand, there are illiquid options and establishing such a contract is a mistake that many novice options traders make. There are not easily moved or converted into cash. They drive up the cost of doing business because of this characteristic. This makes the trading cost of that option higher and thus, this cuts on the trader's profits.

To avoid this, trade options that are higher in liquidity. For example, stocks that trade less than 1 million shares per day are liquid. Pursue such options at the beginning of your career as an options trader. Also, seek options with a greater volume and that are easily adjustable.

Mistake #7 - Not Factoring In Upcoming Events
Of course, the financial market is volatile and unpredictable. Some things cannot be foreseen. However, there are others that can be foreseen and it is the job of the options trader to keep these things in his or her foresight.

There are two major common events that an options trader needs to know in advance and these things are the earnings (the measure of how much a company's profits is allocated to each share of stock) on the associated assets as well as the dividend payout dates in these assets if they apply. Not knowing these future events can mean losing out on extra

payout like these because no action was made to ensure that the trader had a right to them.

In the case of dividends, payment on the associated assets could have been collected by the trader if only he or she had the foresight to purchase that asset before those payments were processed.

To ensure you get such extra earning, you need to be on the ball of the date of such events. Do not sell options that have pending dividends and avoid trading in the earning season to avoid the common high volatility associated with that time.

Mistake #8 - Waiting Too Long To Buy Back Short Strategies

You need to always be ready to buy back short strategies early in the game. Never assume that profits will continue to come in just because you are having a good period. The market can change any time and so your profits can be lost easily if you fail to react in a proper manner.

There are many reasons why some options traders wait to do this and they include not wanting to pay commissions, trying to gain more profits out of the contract and thinking that the contract will be worthless upon expiration. Thinking in such a manner is a mental trap that can lead to financial losses.

To avoid this, consider buying back your short strategies as long as you can keep at least 80% of your initial gain from the sale of that option. If you enter an out of money positions, reduce the risk by buying back.

Mistake #9 – Getting Legged Out Of Position

Legging out means that one leg of the option closes out and essentially becomes worthless to the trader. The leg gains an unfavorable price that does not benefit the trader. This

110

does not automatically spell the death of the option made up of several legs but it can expose the trader to loss.

Legging can be performed in several types of options including straddles, strangles and spreads. These types of options can be enhanced by multiple legs and gain the options trader a leg up. However, the complexity of using the legging technique can elude even experienced options traders. The timing and order of executing legs make this a delicate process that needs a fine eye for the market. Therefore, this is a technique that must be attempt only after a trader is confident in his or her experience, knowledge and success rate.

Mistake #10 - Trading Options on Complicated Assets without First Doing Proper Research

In their overexcitement, many new traders like to go for complex assets because they believe that this where the big bucks are. Even if this is true in some cases, if the trader does not have a good grasp of how the asset works in its market, then he or she will fail to implement the right strategies to gain profits. Never just jump into an option. Do your research first. Also, as a newbie options trader, it might be best to get your feet wet with more common options rather than jumping into the deep end of the pool.

Chapter Summary

Trading options effectively relies on setting up systems that promote growth and improvement in the arena. But many people skip developing systems in their eagerness to get started. This can be very costly in many ways.

Please avoid the following mistakes when trading options. They are commonly made by beginners and can be very costly.

1. Not having a trading plan

2. Choosing the wrong expiration date
3. Not factoring in the volatility of the financial market
4. Not having an exit plan
5. Not being flexible
6. Trading illiquid options
7. Not factoring in upcoming events such as the date of dividend payments
8. Waiting too long to but back short strategies
9. Legging into spreads
10. Trading options on complicated assets without first doing proper research

Chapter 11
The Options Trader Mindset

A successful options trader is a unique individual. This person learns how to leverage their financial position to pave a way to profitable returns that make the time and effort invested worth it. This person is strong-willed and determined.

I have tried to break down the concepts in this book as simple as possible so that anyone can do it. The truth is that though, even though everyone has the capability to understand these concepts and maybe the ability to implement these strategies, not everyone has the fortitude to stick with it until they gain the results they want – which is financial freedom. The people that do, fall into a small bracket. A strong options trader requires a unique set of skills, attitude and persona.

The Traits of a Successful Options Trader
- **Being self-disciplined.** I am sure after reading this book, you may be excited about the possibility of gaining financial freedom by using options trading. If you are willing to jump with both feet in, I applaud you. I also implore you to exercise caution and therefore, self-discipline. Do not just stop your

education on options with this book. Do more extensive research so that you can identify the best opportunities for you. Doing this will allow you to form the best strategy for your individual case and goals. Do not skip doing your homework because you are eager. Jumping the gun has led to many traders losing out. You need to rule your desires, wants and actions rather than being ruled by them.

- **Being Committed.** A successful options trader is one that does not give up. He or she does not trade on an on-again, off-again basis. This person is committed to the cause of building their financial success in this way and persists in their effort. Remember, that I stated in the introduction of this book, that this is not a hobby. This is something you embrace as a business and part of your lifestyle. Go hard or go home. Options trading has no room for being tentative.

- **Continually learning.** The financial market is continuously evolving. It changes every single day. A successful trader needs to be able to roll with the punches and have a clear understanding of what is happening now. He or she needs to be able to make forecasts about the future as well. Continuously learning about the market also allows you to see new opportunities where amateur traders will not. One of the best ways to increase your knowledge of options is to follow the action of an experienced options trader. The point is not to copy his or her moves. Rather, it is to watch a master at work so that you can develop your own style of trading.

- **Being patient.** This relates to jumping the gun. You need to carefully weigh your options before you make a move while trading options. While there are risks involved in trading options, the market typically provides signs of these opportunities if a trader knows

where and how to look. Control your emotions and strategize your entry into the trade market as well as your exit from trades.

- **Being an effective risk manager.** There is no guarantee when you trade options and as such, an effective options trader needs to be able to exploit his or her position to try to determine where he or she should take appropriate measures to capitalize his or her gain. Part of managing risks involves being able to diversify your portfolio so that all your eggs are not in one basket. A successful trader does not go chasing after every option that is available. Neither does he or she get stuck chasing China eggs that do not yield gain. Even though there is no guarantee that it will all work out, being able to effectively manage risks significantly lowers the chances of loss happening.
- **Being able to manage money effectively**. The trader also needs to know how much capital should be allocated for trading. Throwing your money at all options will not lead to effective results. Actually, this is a recipe for losing money. Part of being a good money manager means that the trader needs to be good with numbers so that he or she can calculate the vega, theta, delta and gamma of their trade options, for example.
- **Maintaining accurate records.** This will help with decision-making and allows you to allocate your money effectively as you will have a history of your options within easy reach. My suggestion is that you do this digitally for easy access, better storage and better organization. Digitally record keeping also allows for the use of specialized software that makes life a lot simpler than looking through hard copies when records are needed.

- **Being an effective planner.** While there is a level of relying on instinct in trading options, you also need to have a plan so you do not place random trades. You need to have direction to effectively move forward with obtaining financial freedom no matter which option you choose to do that. Having smart goals allow you to develop this plan. You also need to have a plan to cover any losses that may happen and a plan for how you can leverage the profit that you do make. Your plan needs to allow for flexibility and the great thing is that you can upgrade, downscale and change the plan completely if need be.
- **Being able to accept losses gracefully.** The nature of the financial market is unpredictable and every trader makes a loss at some point. Having an apt understanding of the market will minimize this loss but you also need to be able to be flexible in how you handle this so that you do not get blindsided nor do you let this weigh you down. Remember that any successful person needs to be able to find a lesson in their failure so that they come back stronger and better in the future.

Dream Big

Many people are stuck in a state of financial dependency and insecurity because they do not see themselves being any better than they are now. Therefore, they never take any actions or risks to elevate themselves

You need to be able to visualize your success to manifest it. To develop yourself into a brilliant trader, you need to be able to see yourself in the future as a successful entrepreneur who implemented a plan to gain passive income and is, therefore, able to enjoy the freedom of using your time as you see fit.

The brain has a way of manifesting action to make what it sees a reality so use that to your advantage. See yourself as a successful options trader today. Imagine the way that you would look, the way that you would feel, how you would dress and everything else that being an options trader means to you. See yourself being more than what you are today no matter your current circumstances. Do not place any limits on yourself.

The mistake that many options traders make at the beginning is that they think small. They imagine maybe making a few hundred dollars here and there to subsidize their current lifestyle. They make that the pinnacle of their success even though many options traders make hundreds of thousands and millions of dollars every day.

The people that dream so small have their own reasons but a common reason is that they do not want to be too disappointed if things do not work out. This way of thinking is limiting and self-fulfilling. You are stopping yourself from achieving greatness and reaching your true potential with such a mindset. Instead, you have to dream big, bold dreams. It is the only thing that will keep you motivated in the tough times. You have to *know* that you can do this and make this a successful business no matter the odds.

I know that at the beginning, it may be tough especially when people laugh at your dreams of becoming a success. Remember that you are not doing this for them. Those people may be your friends and family and of course, this hurts. Do not allow this to demotivate you. Keep strong and remember that you are doing this for you, not them. If you need to, make it an extra motivator to prove them wrong. Give yourself the last laugh.

Visualizing allows you to have something to work towards. The vision creates a hunger within you to manifest that

picture in your mind into reality. It builds anticipation and creates excitement. It gives you a sense of purpose. Allow yourself to be consumed by that passion.

My belief is that every person on this planet is capable of doing great things so stop limiting yourself. Stop underestimating your potential. One of the most significant attributes of an options trader is being able to follow his or her gut. You will never develop that knack for trading options if you continually doubt yourself and your purpose.

All of the traits that are stated above are things that can be learnt. So it is fine if you have not developed these traits as yet. The point is to make it a habit to develop them starting today. The first thing you need to do is picture yourself as the successful options trader that you will be in the future. Then put in the work to make that vision a reality.

Chapter Summary
A successful options trader is a special individual. This person has a special group of traits that include:

- Being self-disciplined
- Been committed
- Continuously seeking learning
- Being patient
- Being an effective risk manager
- Being good at numbers
- Maintaining accurate records
- Effectively planning and being flexible.

As great as these traits are to any options trader who aims for success, the first thing any beginner needs to do is dream big enough to achieve that success. If your mindset is limiting you, you will never be a master options trader or someone who is financially free. There are no limits to what

an options trader can achieve so stop limiting yourself with your mindset.

Chapter 12
Trading with LEAPS

The acronym LEAPS stands for Long-term Equity Anticipation Securities. They are a type of option with expiration dates that are longer than normal. They last for at least 1 year and sometimes go as far as 3 years into the future. As mentioned earlier, the expiration dates of options are typically a few months into the future. The typical option expiration ranges are 3 months, 6 months and 9 months.

This is because options are typically a short term way of investing.

LEAPS step away from the norm and have a longer shelf-life compared to your average option. They still possess the qualities as a normal option. LEAPS appeal to investors that want a long-term investment without being obliged by that investment. It also appeals to the investor who is anticipating a profitable yield from a particular market in the future but does not have the capital at hand to make that substantial investment. They are more affordable than such assets like stock because despite the longer expiration date, they are still options and thus, stick to option price ranges.

LEAPS normally have a slightly higher price than other short term contracts

LEAPS have a seat at the options table because sometimes the value of the associated asset needs more time to appreciate in value. Typical options expire in a few months. These options can yield profits in a short amount of time but there is also the risk that the transaction might not be as profitable if the stock or other associated asset does not move significantly up or down.

LEAPS are the solution that allow that time for appreciation of the associated asset. A trader can even extend the expiration on that LEAP option with another LEAP if the time period is still too short for the asset to reach profitability. For example, a LEAP with an expiration date of 2 years can be held for 1 year then be sold to replace it with a 3-year expiration date. This is called rolled LEAPS.

Rolling the option forward is normally relatively inexpensive because it still carries the same characteristics. There are other factors that can become unpredictable, though. Such factors include interest rates, dividends and volatility.

The question that stumps many traders about LEAPS is whether to use a call option or a put option. The answer to that is dependent on whether the trader expects a bullish or bearish price movement. If the trader believes that the associated asset is bullish by the expiration date, he or she should buy call options. If instead he or she believes that the associated asset will drop in value by the expiration date, then the trader should buy put options.

Best Strategies for Using LEAPs
Some strategies work best when it pertains to LEAPS and this list includes:

- **Long call.** This involves the purchase of LEAPS call options in anticipation of a long term bullish trend in the market.
- **Long put.** This involves the purchase of LEAPS put options in anticipation of a long term bearish trend in the market.
- **Rolling LEAPS options.** As mentioned earlier, this involves selling the LEAPS before expiration date while buying LEAPS with similar characteristics with at least 2-year expiration dates at the same time.
- **Bull call spread.** This options strategy is considered to reduce the initial cost of buying a call option. This can help offset the higher cost of LEAPS compared to standard options. Only use this strategy if you are confident that there will be a moderate rise in the price of the stock to send it up to the strike price.
- **Bull call spread.** This is another strategy meant to offset the higher cost of LEAPs. It is a bearish strategy. Profits are earned when the stock prices fall.
- **Calendar call spread.** This strategy is meant for a trader who wishes to benefit from the associated assets staying stagnant in the market while also benefiting from the long-term call position if the stock becomes more valuable in the future.

The Benefits of LEAPS

LEAPS have several benefits and they include:

- LEAPS are sustainable as they allow a trader to piggyback off market trends. This allows the trader to observe the movement of stock prices and have an option to buy or sell without making the full commitment of ownership.
- LEAPS are less volatility and so offer greater security. A trader who enters into such an option is looking at a stock that is increasing or decreasing in price over

the long haul. This allows the trader the time to really ponder on the profitability of pursuing the asset. This person can use data offered over that time such as the current trends, news and terms to base their future decision.

- LEAPS can serve a great security in your financial portfolio as well as provide shareholders with a greater grip of the stock.
- LEAPS allow time for improvisation because the expiration date is longer.
- Buying LEAPS is cheaper than buying several standard options back to back.

The Disadvantages of LEAPS

There are two sides to every coin. So, just as LEAPS are beneficial, there are also a few downsides. The first disadvantage of LEAPS is the strike price. Because they are priced higher, the trader needs to see movement in the asset price to gain a profit in addition to it taking longer for the option holder to breakeven.

The longer expiration dates on LEAPS make them less predictable. Therefore, pricing correctly so that a return is seen without the transaction being too costly is made can be difficult. Lastly, the trader will not benefit from any attached dividends or stock repurchase.

LEAPS are also sensitive to implied volatility and so, can lower in value when implied volatility drops.

Tips for Getting the Most Out Of LEAPS

- Pretend as if you are actually investing. This allows you to search for assets that you are actually interested in and maybe already have some know-how about. This makes it a lot easier to keep up-to-date with market trends compared to if you do not know

anything about the asset and are not interested in learning more.

- Make use of the long expiration date. The benefits of the longer expiration date have been stated so ensure that these work to your benefit.
- Choose LEAPS that are more liquid.
- Prepare for the fact that LEAPS are more volatile than stocks but less volatile than standard options.
- Set targets for the stock prices in comparison to your LEAPS. Knowing those targets will allow the trader to sell at the most profitable time.
- Have an exit strategy in case the option is not working out according to plan.
- Always be aware of your position and be prepared to leverage it. Even though the expiration date is far off, you need to keep abreast as to whether the market is playing out as you anticipated. You need to be aware of the fluctuations in the asset's price. This will allow you to make a determination that makes this transaction the most profitable it can be for you. You can implement strategies like rolling the option forward and selling the first option as a loss so that you can move to another strike price that benefits you more.

Chapter Summary

LEAPS stands for Long-term Equity Anticipation Securities. This is an option that has an expiration date that is at least 1 year, which is a deviation away from the standard short options that carry expiration dates that are only a few months. LEAPS are a great option for a long term investor who wants to experiment with options without having to be apprehensive about the volatility of the financial market in the short term. LEAPS are also a great way for investors who

do not have a great amount of capital available to them at present to enter into the market with lowered risk.

This long term maturity does have many benefits such as being sustainable, more secure and not being subject to the decay of time. However, there are disadvantages as well, like the option being higher priced than standard options, being less predictable because of the far off timeline and taking longer to breakeven compared to a standard option.

To get the most out of trading LEAPS, the trader needs to be strategic. Tips like staying abreast of market trends despite having a longer expiration date, having an exit plan if things go left field and being prepared to leverage your position will help the trader gain maximum profit.

Conclusion

Financial freedom is an elusive thing but it is still something that is attainable to any and everyone who is willing to put in the time and effort to learn how to gain that freedom. Most people remain stuck financially because they do not see a way out. Even more unfortunate is that many people do not realize that they are bound by financial slavery. However, the only sign that you need to see to know that you are a financial slave is that you are unable to use your time in the way that you would like because you are trading this time for money actively. If you depend on one source of income such as a job just to survive then you are a financial slave.

The great news is that this does not have to be your reality indefinitely.

Trading Options for Financial Freedom
One of the leading ways of gaining financial freedom is setting up passive income streams. Trading options has the potential to be a powerful form of passive income. Not only does this activity give the trader the platform to gain financial freedom but it also allows the trader to pursue hobbies, career options and other activities that he or she loves. It allows this because the trader is not actively trading time for money. Options traders have the flexibility to live

and work anywhere in the world because, when done right, trading options allows the trader to earn tens of thousands of dollars and more even while he or she sleeps.

This book was written as a comprehensive guide to show that any and everyone can earn a sizable income from options trading as long as this person is willing to develop a growth mindset, learn from the mistakes and successes of other traders and work to put in that human and financial investment upfront. Options are derivative contracts that allow the owner of the contract the right to buy or sell the associated asset by an expiration date specified. From this definition, you can see that this is not something you simply dabble in every now and then.

Are You Ready To Be An Options Trader?

Trading options is a business. Therefore, it needs to be approached with a mindset that is set for growth and development. We have talked about many topics on how you can get started such as developing your training plan, paper trading, opening a brokerage account and choosing a trading style. All of these things plus learning the language of options trading is greatly important as a beginner in this field. You cannot get through into this career and profit in the way that you would like without putting in that initial study. This book should only be your starting point when it comes to learning. Gain more advice in the form of other books, online study and from a mentor if possible.

After you have done this, you need to practically implement the strategies and techniques taught in this book. To remember what a put option and a call option are, you need to be able to see them in practice. To mentally solidify what a long position and a short position are, you need to actually be in these positions. To become familiar with volatility and interest rates, you need to put yourself in a position to learn

further. Straddles, strangles, legging, debit spreads, credit spreads, selling naked options and rolling out options... They might seem intimidating on paper and might be difficult to implement at first but practice makes perfect. All advanced options traders started as a beginner but consistent, persistent effort took them to the next level.

This is a new world for any novice and, of course, it can seem intimidating but as long as you remained committed to developing the traits of a successful options trader, you will be well on your way to obtaining the financial freedom that you crave. Just as with any new venture, there will be setbacks and failures. You will lose your footing sometimes and be exposed to things that you never have been before. The keys to getting past all these things and overcoming your circumstances to gain success are being self-disciplined, being committed, being patient and developing an eagerness for continual learning. You need to be an effective risk manager to juggle your options. You need to be able to manage your money effectively and keep accurate records that help you forecast your decisions based on sound history and knowledge. Most importantly, you need to dream big and stop limiting yourself. The sky is the limit with options trading. So stop settling for less than you deserve and visualize the future where you have ascertained that financial independence and stability. Then, do the work.

My Final Words
In closing, I would like to tell you that financial freedom is not something that is given to most. It is something that is built and developed with sound planning and execution of plans. You can see the truth in my words as most modern entrepreneurs who found great success did not come into this with a silver spoon in their mouths. Their success was not a gift from anyone else. Some of them even came from

dismal circumstances such as homelessness to build a multi-billion dollar empire.

You have the same potential just like those other people did. You just have to be willing to put into the work to develop yourself, your state of mind and a plan for creating the future that you would like rather than what a salary that does not support your desired lifestyle dictates. Yes, it might take some hard work to get your footing grounded with options trading but the payoff is more than worth it. Putting in the work upfront will allow you to gain the passive income that will allow you to pursue the other things that you would like to do with your time.

This book was written to show you that a lot of persons who are financially dependent on the broken system that society has made remain financially chained because of limited thinking. Open up your mind and visualize what you can accomplish. Then get up and do it. With the knowledge that you have found in this book, you can finally leave those shackles behind and create a future where you are financially free and happy. Good luck!

Mark Robert Rich

Stock Market Investing For Beginners
(Trading Academy Book 2)

Complete Guide to the Stock Market with Strategies for Income Generation from ETF, Day Trading, Options, Futures, Forex, Cryptocurrencies and More.

By

Mark Robert Rich

Introduction

Let me tell you a story...

Way back in 2000, there was a young man and he had just started on his life journey as an adult. He was overexcited and overzealous and did not think things through. He had big dreams about how much he would earn in income every year, where he would live, in what type of house he would live, the kind of car he would drive and where he would vacation every year. He had no strategy on how he would make any of these things happen because he thought the only thing required was having a college degree. He had done everything right according to the textbooks to have a great life, so why wouldn't his life turn out how he wanted? That was his naïve thinking.

Straight out of college, with the girl of his dream by his side, he got a mortgage and started a family, his dreams convincing him that all he had to do was work hard every day and everything on his dream list would come true.

Soon reality hit and it hit hard.

As the years passed, this man realized that having dreams was not enough and he became disenchanted that his life was not following the path that he had dreamed of. He discovered that working hard was not enough because no matter how hard he worked or how much sleep that he missed, his debt and expenses grew while his income state the same. He was barely keeping his head afloat by trading

his time for an income. His degree in Economics and International Finance was not enough to catapult him into the future that he had envisioned.

His life changed when he was 26 years old. He went to get coffee in the shop across from the office where he worked in the same position that he had for the last 4 years, and ran into an old childhood friend. The other man was wearing a nice suit and pointed out the luxury car that he had just bought, which was parked not too far away. The other man was smiling and proud of his success compared to the star of this story who was tired and down on his luck.

The two men did the usual to get reacquainted and the first man could not help but ask the second man about his life because although they had started with the same resources as children, he was clearly leap years ahead when it came to his finances.

The second man laughed and shared his secret easily. He was a stocks trader and even though he did not have a college degree, he had found a career that he loved and earned him hundreds of thousands of dollars every year even in the early 2000s.

The conversation that the two men had in that coffee shop open the first man's eyes. In fact, it opened up a whole new world because not only is he now a stocks trader, he now also gains income from several other financial markets.

I have shared this story because it is my own and I am using it as a way to pay it forward. Just as my friend advised me on how to take control of my financial security and independence, I am advising you on how to use the financial markets of the world to grow your wealth, increase your income and lower your debt. Even if you do not have a college degree or have never traded stocks or any other type

of asset, you will find the strategies and techniques that I will share with you in the upcoming pages can help you get started.

Why My Story Is Important

I share this story with you not to impress you or to boast about the fact that I now earn millions every year. I shared it to show that anyone can find success with investing in stock trading and other assets. Both my friend's story and mine are a testament to the fact that anyone can enter these markets and build a financial portfolio that supports the lifestyle and future they want rather than settling for less. We had different backgrounds. He was a high school drop out with no college degree while I had a college degree that earned me the income barely above the salary of someone with a high school diploma. Still, we both found success in the same place using the same resources. Therefore, I wholeheartedly believe that anyone can find the same level of success and greater. *You* certainly can. The sky really is the limit when you invest in the stock market and other financial tools like indices, forex, futures and options.

Trader vs. Investor

College did not prepare me for the real world as I imagined it would. Before I saw the light that day in the coffee shop, I thought that actively spending my time was the only way that I could make an income that was great enough to sustain myself and my family. My friend showed me the power of investing and trading to earn passive income.

Passive income is income that is earned from not actively trading time for money. Passive income allows you to work smart rather than work hard to earn a lifestyle that you want. By adopting an investor and trader mindset, I quickly exceeded the income that actively working could ever earn me in this lifetime or the next.

Trading and investing are different financial activities although they often get confused. While I engage in both activities now, I started off as a trader. I believe that it is important to know the difference right off the bat for proper financial goal setting and planning.

Investment is the commitment of capital with the expectation of receiving financial returns in the future. While there might be some upfront work that is needed such as finding and researching the right investment opportunity for you, investment over the long-term typically generates higher rates or return compared to the acting of trading stocks and other commodities in the short-term. Common assets that serious investors seek are mutual funds, real estate, bonds and stock to name a few.

Wise investing can gain an investor millions of dollars in returns for retirement compared to traditionally placing money in a savings account or keeping it in cash.

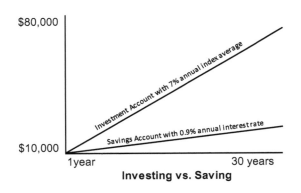

Investing vs. Saving

The chart above shows an apt comparison of how you can make $10,000 of your money can work better for you as an investment compared to putting in a savings account. It would be $0 if you just had it in cash.

136

Saving is useful for short-term goals such as making a large purchase while investing is necessary for long-term goals such as retirement and planning for children's education. Because of the long-term nature of investments, the investor needs to be patient and disciplined to tough it out through the ups and downs of market activity.

Trading is about repeatedly seeking short-term returns by buying and selling assets. Stock trading is the activity of buying and selling stocks with the expectation of the short-term profit due to the movement of share prices.

Trading wisely requires the creation of a trading plan on what the trader will buy and sell, at what time and why. This trading plan is a blueprint to which all this person's trading activities should closely align. Just as with any other financial activity, there are ups and downs. Therefore, a trader needs to figure out how much he or she can afford to trade and possibly lose. **Never trade more than you can afford to lose.** In fact, a trader should not invest more than 5% of his or her assets towards trading. This is why diversifying your financial portfolio is critical. More on that below.

I admit that I was terrified at the beginning of my trading career and I made a lot of mistakes. I will share these with you as I go along so that you can avoid them. Remember that you need to keep your eyes open at all times as a trader. You need to think fast on your feet and you always need to keep your goals in mind when you are doing your trades.

Adopting a Business Owner's Mindset

Whether you choose to be an investor, a trader or both, you are running your own business if you partake in the activities on the financial markets like the stock market. Developing an entrepreneurial mindset was one of the biggest hurdles I faced when becoming a stocks trader at the beginning of my career. I had been an employee before venturing into this

new journey in my life and did not understand that the way that I viewed finances and running my schedule had to change. I did not have a boss haggling me and telling you what I should do with my time and so, for a while I was lost.

But it was not just about managing my time effectively. I learned that my success depended on my psychology. Once I adopted the right mindset, developing my strategy became simpler. Once I changed how I thought, everything else started to fall into place. I was able to sharpen my focus while I put my abilities, time and energy into the things that helped me build my business instead of wasting time on minimal tasks that could be performed at any other time. I learned to look for opportunities in places where many people only saw roadblocks. While I had learnt about goal setting in my schooling, the way I approached it in my early adulthood was flawed and limited but I learnt to fine-tune the process into small milestones that allowed me to see how I was performing at attaining my goals and the areas I needed to work on.

The thing about being an entrepreneur is that you need to get over your own limiting beliefs about yourself. You need to stand up to your own mind and stop letting negative thoughts hinder you. My mind was constantly telling me that there was no way that I could become a millionaire in less than 5 years. It was telling me that there was no way I could build a successful business when I could not even perfect being an employee. It was telling me that someone as ordinary and as simple as I was could not live an extraordinary life with financial freedom where the main focus was not paying the bills. My mind was telling me a lot of things that I could not do but I learnt to stop listening to it and to start performing actions that took me closer to my goals. Eventually, as my actions produce results, my mind

fell into place because it could no longer tell me that I could not do something that I already did.

As I started to see results, my attitude changed. I became more determined, persistent, consistent and focused. I developed a desire to learn more, not only about trading and investing but also about many other things. I did not know that I did not know so many things but with every inkling of knowledge I gained, my confidence grew, my perspective became wider and my vision for myself and my life became wider.

I started wanting more for myself. More happiness. More fulfillment. More time for enjoyment with my family and doing the things that I love to do. Whereas before I would never have believed that I could achieve these things, as I became more solidified in my career as a trader and as an investor, my mind did not automatically reject the idea that I could have more.

Owning my own business has completely changed me for the better but I cannot lie and say that it has been all smooth sailing. Being an entrepreneur is hard. The things that I went through as a business owner are things I never went through working for anyone else. At times it has been grueling. But I would never trade it for anything else because the success I earned, and still earn, as a business owner surpassed anything I could have achieved as an employee.

The thing I want to impact upon you as you start on an entrepreneurial journey as an investor and or a trader is that success is like an iceberg. People only see part of what you achieve above the surface but the majority of that success lies underneath the surface where people cannot see. They do not see the failures and sacrifices that are needed. They do not see the dedication and hard work that are needed. They do not see the persistence and consistency that are

needed. They do not see that there are often disappointments. They do not see that you totally need to rewire your mind to develop good habits in order to have sustainable success.

I realized that it is okay that they do not see these things though because the only one who needs to understand the dynamics of my success is me. Success is an individualized process and it is different for every person. That is why you should never compare your journey to another person's journey.

However, there are secrets to building an entrepreneurial mindset that are true across the board. Traits that every entrepreneur who has achieved long-term and sustainable success have developed include:

- Developing self-awareness and awareness of the world around them
- Clearly defining what they want to achieve and setting goals
- Learning to manage their time and priorities
- Developing a growth mindset
- Having a willingness to learn
- Learning to be accountable and take personal responsibility for their thoughts, actions and feelings
- Not shying away from a challenge
- Expressing gratitude
- Associating with like-minded individuals

Every business needs development. You are your business as a trader and an investor. Therefore, you need to develop yourself. Make that a priority.

What You Will Learn In This Book – The Importance of Diversifying Your Portfolio

I started as an options trader, then moved into the buying and selling of stocks and, finally, learnt that diversification of my portfolio was in my best interest. Portfolio diversification speaks to owning or investing in several types of assets simultaneously. In essence, it is about ensuring that all your eggs are not kept in the same basket.

As your wealth and income grow in whatever market you start your trader and investment career in, ensure that you do not only limit yourself to that one market. Learn about and participate in other markets and find the ones that are best suited for you, your personality and the goals that you would like to achieve. This will help you balance rewards and risks.

In my effort to help you diversify your portfolio, I will discuss the particulars of several other markets in this book apart from the stock market. Here is a brief breakdown of what will be talked about in the chapters to come:

- What are stocks and why you should invest in them
- What is the stock market and what you need to know before you enter it
- How to find the best investment opportunities when it comes to stock trading and trading other securities
- How to protect your stock investments
- Mutual funds and how you can use them to develop your financial portfolio
- How to get started trading exchange-traded funds (ETFs)
- Trading stock options
- How to invest in forex
- How to get started on index trading
- Futures investment and how futures work

- What is a cryptocurrency and how the cryptocurrency market works
- Much more!

As a beginner trader and investor, this information can seem quite intimidating initially but I implore you to keep an open mind to receiving this knowledge to better yourself and to improve your financial life. I too struggled in the beginning and so did most traders and investors. Find comfort in the fact that the knowledge, strategies and techniques that will be shared in the chapters to come have been proven and have worked for many successful traders and investors. The processes on the financial markets are not new and do not need to be reinvented. They simply need to be implemented wisely and strategically.

Remember that there is no limit to what you can achieve with trading and investing. Put your all into this new career path and you will reap maximum benefit. Stay focused and committed despite the trials that you will face. Believe that you can do it and never stop learning because there is always more to be learnt that can improve your technique, your efficiency and your productivity.

Turn the page so that you can get started on building your wealth with smart, reliable and sustainable techniques!

Chapter 1: The Basics You Need To Know About the Stock Market

Before I started investing on the stock market, I used to hate waking up early. It was a struggle every morning and that set the tone for the rest of the day usually – everything just seemed like such a huge task that I did not want to do. I wondered how all the success gurus from different fields could preach waking early to earn that success did it. I wondered why I could not do it as effortlessly as they preached.

After I started trading on the stock market, I realized that I was seeking a flaw within myself that was not there. It was not that I could not wake up early easily. Rather, there was nothing enticing me to put forth that dedication. I hated my office job so of course, I was not in a rush to get to it. In fact, most everything within me wanted to run away from it.

But since I found trading and investing on the stock market, I can wake up long before my alarm clock goes off at 4:30 AM most mornings. The stock market allows trading from 8:30 AM EST but there is premarket work that needs to be done for a successful trading day. I am invigorated by doing that work and watching the fruits of my work accumulate later in the trading day. That invigoration has spread to other parts of my life and I even allocated time to work out and spend time with my family during those early morning hours. Having that one thing that I look forward to participating in has made me look forward to embracing the day every day.

I am not saying any of this to preach the importance of starting the day early. Rather I am letting you know the boost of confidence that can be gained from investing in the stock market. The challenges are real but it is because of them I am invigorated. This is not a career for the faint of heart yet I love it because it has ignited a fire within me!

But that fire was not an automatic state of affairs. I first had to get over the learning curve that comes with being a trader. There is a lot to learn. Even after 2 decades in this career, there is still a lot that I do not know. In fact, I feel like I learn something new every day. But that is part of the charm of this career. It is never stagnant. The stock market is continually changing as technology and the different industries of the global economy drive it forward.

The most basic thing you need to learn about on your path of education about the stock market is what stocks are and how they work to drive the stock market like a well-oiled machine. This chapter is dedicated to that first milestone in your education.

Stocks are the basic unit in the stock market, which this book is largely focused on. Therefore, it would only be right to start by defining what stocks are and why it is a good idea to invest in them.

What Are Stocks?

Stocks represent ownership in a company. Therefore, purchasing stock in a company means that an investor is purchasing a small piece of said company. This is why pieces of a stock are known as shares. Companies place stock up for sale to gain additional funds to grow the business. Investors buy stock as a way to grow their money as the hope is that the value of the stock will go up over time. If an investor so wishes, he or she can sell the stock to earn a profit. Owning stock in a company means that a person is

144

called a shareholder because this person benefits from the company's profits.

Having the value of stock go up is not the only way that a shareholder can earn a profit. Profits can also be seen through the payment of dividends. Dividends are regular payments made to shareholders as a means of distributing revenue back to persons who have invested in the company. This is typically done quarterly. This is an example of preferred stock. Dividend payments are normally fixed and generate a regular income for the shareholder. Shareholders who own preferred stock also normally earn company earnings. Earnings are profits incurred by a company over a specific amount of time. Owning preferred stock also typically means that a stockholder will receive profit in the form of liquidated assets if a company goes bankrupt. This type of stock investment is best for an investor looking to earn regular income.

The disadvantages to owning preferred stock are:

- The stockholder does not have voting rights in the company.
- There is lowered potential for long-term growth.

Not all stocks pay dividends, however. Therefore, if you are interested in earning through dividend payments, you need to be very specific about the stock that you choose to invest in. Stocks that do not pay dividends are called common stocks. If common stock does indeed pay dividends then this amount is not fixed. Also, stock prices can be volatile and the investor will likely lose all of his or her investment if the company goes bankrupt.

There are advantages of owning common stock though and these advantages include:

- Having voting rights in the company. Voting rights are divided into classes and as such some stockholders have more of a say compared to others. These classes are created based on the class of stock purchased by the stockholder.
- Increased potential for high yield in the long term.

Therefore, owning common stocks is best for the investor looking for long-term growth potential.

Types of Stock
Stocks are placed into several categories apart from common and preferred. These categories include:

Public Stocks
Public stocks are sold by public companies to the general public. Both preferred and common stock are types of public stock.

The stocks are listed on stock exchange markets and so, the company needs to adhere to government regulations as well as standard reporting systems to facilitate this. These companies are typically large in size and rely on the funds generated from selling shares to a company to grow. These companies typically also sell bonds, which is another way to raise capital to facilitate expansion. Bonds are a type of loan that is publicly held by a company that can be taken on by an investor. The company has to pay this loan back with interest but does not have to give the investor any shares of ownership in the company.

There is unlimited potential for the company's growth as it can tap into the financial market by selling more shares.

Private Stocks
Private stocks are derived from a private company selling shares to only a few willing investors. There is a common

misconception that privately-owned companies are small and unprofitable in comparison to public companies but this is false. Many of these companies are typically large in size. In fact, many people know of some of the largest private companies in the United States such as Fidelity Investments, Bloomberg and Mars.

While they are regulated by government and need to report earnings to their investors, regulation is not as heavily placed on such companies. This relaxed regulation is the biggest way in which they differ from public companies. These companies benefit by not having to answer to stockholders. This is a two-edged sword as they also cannot dip into public capital markets. Instead, these companies grow by tapping into funds invested by private investors or venture capitalists.

More Stock Types
Other types of stock include:

- **Blue Chip Stocks,** which are stocks sold by large, stable companies that expect continued profits. These stocks are typically expensive to purchase but there is very little risk in the sustainability of the increase of the price expected.
- **Cyclical Stocks**, which are stock sold by companies whose performance is dependent on economic activity. Examples of such companies include car manufacturing, electronics and airline industry companies. The value of the stocks increase during healthy economic conditions and plummet during economic conditions. They attract investment during healthy economic condition because profits can be substantial.
- **Growth Stocks**, which are sold by companies that expect a high rate of return. These types of stock

typically pay dividends if there are any to be paid but earnings are reinvested back into the development of the business. Still, many investors are happy to place the money into such companies because the business is likely to grow and so, the stock value is likely to appreciate.

- **Speculative Stock**, which are stocks sold by startup companies that have little financial history to back them. These are typically sold by companies that have tapped into unexplored markets or are testing new products that have potential for great growth. Because of the huge amount of risk that an investor takes on through such an investment, stocks in such companies are typically lower priced but the investor hopes to see a return in the stock value growing in the future.

As you can see from the few stock types listed above, there are many factors that determine how a stock is classified. One of the biggest factors includes the company size. Company size refers to the value of the company and so, it is divided into 3 categories. They are:

- **Large cap**, which has a market value of $10 billion or more.
- **Mid-cap**, which has a market value of between $2 billion and $10 billion.
- **Small cap**, which has a market value of between $300 million and $2 billion.

Stock categories can also be divided based on the industry in which the company operates, the geographic location in which the company operates and the way in which the company grows. The last factor can be further divided into growth stocks and value stocks. As mentioned earlier, growth stocks are sold by companies that are expected to

grow quickly in value and as such, investors are willing to pay higher for the stock because they expect a big return in the future.

Value stocks are sold by companies whose stocks are deemed undervalued or underpriced by investors. Investors place their money into such stock with the expectation that the price will increase in the near future.

With so many options, it can seem daunting to choose the stocks that are right for you especially when diversifying your portfolio is essential. The best advice is that you do your research before you jump into purchasing any type of stock. Remember that an analytical mind is necessary for this career. Question yourself, your motives and your moves. It was something that did not come to me naturally so I can tell you with confidence that it is trait that can be developed with time and self-awareness.

Why Invest In Stocks

There are many things that a person can invest his or her money in but why choose stocks? I will tell you. Investing is an activity done to ensure that a person means their future financial goals are met so that this person lives the kind of lifestyle he or she wants to. Even a trader who only participates in short-term activity has an ultimate objective 10 years from now, 25 years from now and 40 years from now. Inflation makes it impossible to just rely on your money growing to meet future goals. There is no telling what the economy will be like tomorrow with factors like global trade, politics and war in the mix far less 40 years from now.

Therefore, money needs to be placed into a security that has the potential for growth that far exceeds placing it into a savings account and provides protection against inflation.

Stocks have historically proven to be that steady investment tool that has that potential for growth and here are the reasons why:

High Liquidity

The liquidity of stocks refers to how easily it can be bought or sold without the price of the stock being severely impacted. There are stock with low liquidity that can be difficult to sell and buy because it can create a bigger loss for the parties associated. However, for the most part, stocks are highly liquid investments that can be bought and sold without a hefty fee being paid.

Versatility

Not only stocks are traded on the stock market. Mutual funds, derivations and bonds are examples of other securities that can be traded on the stock market. This allows an investor the luxury of investing in multiple securities from the same platform. This is great for spreading risk, diversifying the investor's financial portfolio and enabling flexibility.

Earning Higher Returns over Short Time Intervals

If an investor is smart and carefully plans of his or her stock trades, then this person can predetermine potential profits and losses and the triggers than can facilitate either. This allows the investor to potentially earn greater profits in short periods compared to other investment tools on the stock market like fixed deposits and bonds.

More Favorable Tax Conditions

As it comes to stocks and other assets, capital gain refers to an investor selling it for more than he or she paid for it. Capital gain is calculated using the formula below.

Selling Price - Purchase Price = Capital Gain

Unfortunately, just as the government wants a cut of every other income that you earn, it will expect to gain taxes from the profit that you turn on your investments. Taxes that are collected from capital assets like stocks, bonds, jewelry and residential property are known as capital gain taxes.

How much tax paid on capital gain is dependent on how long the investor holds onto the asset before selling it. Long-term capital gains, which is what is earned on assets held onto by the investor for more than a year has a more favorable tax rate compared to short-term capital gains, which are more heavily taxed as they are filed under ordinary income tax.

Diversification of Financial Portfolio

As shown above, there are multiple industries, sectors, markets and companies that an investor can purchase stocks in. Therefore, it is possible to use this one market – the stock market – to spread your money wide so that your eggs are spread across multiple baskets. A great comparison starts with an investor who invested all his or her money in real estate. If the economy tanks, then it is likely that his or her entire portfolio is at risk. On the other hand, let's say than an investor bought stock in a utilities company and a car manufacturing company. If the economic climate takes on a downward trend then it is likely that the car manufacturing stocks will decrease in value but the stocks owned in the utilities company will still retains they value. The stocks investor protected his wealth by spread his money across more than one security.

Acquiring Ownership in Companies

Remember that stocks represent ownership in a company. Therefore, every share of stock owned in a company stands for ownership in that company. That is a great feeling to say that you own pieces of huge companies.

Some stock types like common stocks potentially allow the stockholder to have a say in what happens in the company. This is facilitated through voting rights and this right can be exercised even if the stockholder only owns one share in the company. This contribution can potentially prevent major players in a company from making decisions that affect an investor's bottom line negatively.

Dividend Income Potential
Regular income can be earned by owning preferred stocks. This income can be great enough to fund major life milestone like kids' college fund accumulation and retirement.

Convenience
In this day of high and rapid movement of technological advancement, trading stock does not require that you leave your home. Typically all that is required to trade and invest in stock is a stable, reliable internet connection, an online broker and a computer with a fast processer and adequate memory. Online banking and payment processing also aid in streamlining a digital lifestyle and work life when it comes to trading and investing in stocks.

What is the Stock Market?
Now that we have taken a look at stocks and how they work, it is time to explain what the stock market is. The stock market is the place where investors buy and sell investments also known as securities. It is also known as securities exchange. Common investments or securities found on the stock market are mutual funds, exchange-traded funds, cash equivalents like treasury securities, stocks and bonds. Every stock market is heavily regulated by the government and has its own set of rules.

Some of the most popular stock markets in the world include the New York Stock Exchange (NYSE), which has a listing of

2400 companies and is worth with more than $20 trillion in market capitalization. There is also the NASDAQ (National Association of Securities Dealers Automated Quotations) market which has over 3800 companies listed and is worth about $11 trillion in market capitalization. Both of these stock markets are located in New York. Also, both open at 9:30 AM eastern time and close at 4 PM eastern time. They also offer premarket and after-hours trading sessions for investors depending on the broker that the investor uses.

More major world stock markets include:

- Bombay Stock Exchange
- Euronext
- Hong Kong Stock Exchange
- London Stock Exchange
- National Stock Exchange of India
- Shanghai Stock Exchange
- Tokyo Stock Exchange
- Toronto Stock Exchange

Just to be clear, the stock market is only one type of financial market. There are other types such as commodities markets, which exchange futures and more, foreign exchange markets and derivatives markets. We will visit a few of these other financial markets in the latter chapters of this book.

Stock markets create and maintain indices, which are indicators of the performance of the stock market. They are indicators of performance because they are an average of the collection of securities held on that market. While engaged in the stock market, you will often hear that the market is up or down. The indices of these stock markets are being referred to when these terms are used. Major indices are the Dow Jones Industrial Average and the S&P 500.

As a result, a rising index means that the average value of all the stocks in that market index went up the previous trading day. On the other hand, an index drop is an indication that the average value of the stock in that market index went down the previous trading day. Indices are a useful indication of how the economy is performing overall because marketplaces include a myriad of industries in their company listing.

Even though these stock markets have a listing of the stocks and other securities that are available for sale, an individual trader or investor cannot just come and pick one off the shelf like you would at a grocery store. The trader needs to be represented by a broker. In this age of technology, most brokers are contacted via an online platform such as their website. We will discuss further how a trader or investor can obtain a broker in the next chapter.

How the Stock Market Works
Stock markets work in a way that is similar to auction houses. This facilitates the negotiation of security prices between buyers and sellers.

The reason that the stock market is likened to an auction house is because buyers and sellers place offers and bids to facilitate the buying and selling of the stocks and other securities on the market. A bid is the price at which a buyer wishes to buy the stock or other security while an offer or asking price is the price at which the seller wishes to sell the stock or other security. The difference between what sellers are asking and what buyers are bidding is known as the bid-ask or bid-offer spread. The narrower the price spread and the larger the sizes of the offers and bids, greater the liquidity of the stock. A stock market is said to have a good depth if there are many buyers and sellers offering and bidding at higher and lower price points. Therefore, signs of

a healthy stock market include high liquidity, good depth and narrow bid-ask spreads.

When the buyers and sellers agree on a price, a trade is made.

The stock market is ruled by supply and demand. If there are several buyers bidding on a stock, then this activity drives the price of the stock up. If there are more buyers than sellers on the stock market, this also drives stock prices up. Because buyers outnumber sellers, buyers are willing to up their bids in effort to acquire the available stocks.

On the other hand, if there are more sellers than buyers on the stock markets, stock prices suffer and go down. In situations such as these, sellers are willing to accept lower offers while buyers lower their bids, conditions that drive the stock prices down.

There are specialists known as market makers who help buyers and sellers find each other to maintain a continuous cycle of bids and offers in some stock markets. This is the manual method of matching buyers and sellers but in this day and age, this can be computerized.

Bull Markets vs. Bear Markets

Bulls and bears are common terms that will be heard often when describing stock market conditions. They describe whether stock prices and other asset prices of different financial markets are moving up or down. This price movement affects the health of your financial portfolio. Therefore, it is imperative that you become familiar with these terms and how you can use them to benefit you.

A bull market is one where stock prices are on the rise in a consistent and sustained trend. These conditions indicate that the economy is sound and employment is steady and on the rise.

On the other hand, a bear market describes an economy and employment rate that is declining and so, stock prices decline in value in reflection. This means that stock prices have fallen at least 20% from the recent highs experienced on the market. Stock prices will continue to drop in such conditions and so, buying and selling slows down on the market.

Having bearish conditions does not automatically mean a losing situation for traders and investors. There are situations, such as when a trader is trading options, where these conditions might be favorable. For example, these would be favorable conditions if an options trader attained that contract in the hopes that share prices would be depreciated so that he or she could have the right to buy the stock at a lower price. There are even options strategies that can be implemented whereby an options trader stands to benefit whether stock prices move up or down.

Still, this is dangerous territory for someone to invest in because stocks are losing their values and prices become volatile after moving up and down quickly without warning. Even in the scenario where the options trader purchased the right to buy stock in a bearish market, this person likely did so with the hope that the stock prices would appreciate in the future and gain him or her a stronger position in the long run. This may not turn out as planned and if the stock prices continue to depreciate, then this would be a losing position in the long term.

However, the typical investor and trader is looking for bullish conditions on the stock market so that he or she can see positive returns over the long term. There are certain conditions that indicate whether a market is experiencing bearish or bullish conditions. One of the best indicators is the supply and demand of securities on the market. A bullish

market typically has a strong demand while having weak supply of securities because many investors are willing to buy while few person in possession of these securities are willing to sell. Both of these conditions result from the rising prices of the securities. The opposite is true in bearish markets because many more people want to sell the securities rather than buy due to the drop in security prices.

The economy is another factor that can affect whether a market performs in a bullish or bearish manner. In bullish markets, people tend to spend more money which drives and strengthens the economy. In such conditions, employment rates are high and so there is an availability of funds that can be spent. This reflects favorably in stock prices.

In bearish markets, due to the fall in economic activity and the resulting uncertainty, persons are willing to spend less. Less spending is also likely because less funds are available due to high unemployment rates. Therefore, businesses record declines in sales and profits and thus, the value of stock decline.

When bullish conditions are being experienced in the market, the best thing to do as an investor is to take advantage of rising prices by buying stocks early so that a profit can be earned by selling them when they reach peak prices. Investor and trader confidence are typically high in bullish markets because losses are typically minor and if they do occur, they are typically temporary.

There are still stocks that can be safe to be invested in bearish conditions. An example of this is the stock in utility companies. These are typically owned by the government and are only minimally affected by trends in the market due to the supply and demand not shifting very much. The supply these companies offer is a necessity and so their sales remain stable. Other scenarios where it is safe to participate

in a bearish market include buying inverse ETFs and buying put options. Both of these scenarios will be discussed in later chapters

The Fear of a Stock Market Crash – Should You Be Concerned?

There are two market conditions that cause concern for both traders and investors and they are known as stock market correction and stock market crash. I have to admit that I did not immediately take action after I had that talk with my friend in the coffee shop back in 2000. I procrastinated for several months because a fear held me back and that fear was the possibility that I might lose all the money I invested in the stock market because the market crashed. That fear was magnified by the rumors that were spreading and what was being said on the news about the stock market crashing because of Y2K. But then I did some research and learned the facts so that I could stop having my actions controlled by myths with no foundations.

Here is what I learned about the life cycle of the stock market, what it means to have a stock market correction or crash and how this affects investors and traders.

Stock Market Correction

Stock market correction occurs when stock market value drops by 10% or more. This downward movement is more gradual than a stock market crash. While stock market correction can indeed be a scary affair, it is a sign of a healthily-functioning stock market. Stock market correction occurs about every 12 months and last for about 2 months. In fact, since 1920, the stock market has recorded a 5% decrease in stock market values about 3 times a year with a complete market correction about once a year.

Of course, with the prediction that market correction occurs every 12 months, some investors try to time the market and use strategies like swing trading to build wealth during the time. Swing trading is a trading style that attempts to gain profit from stock trades over a period of several weeks. By using this method to avoid the fallout of market corrections, investors move their money around in prediction of the ups and downs of the market. This has been an effective trading method for professionals but historically, it has been shown that most investors and traders lack the discipline to make this a winning strategy. Therefore, I advise against doing this if you are a beginner stock investor or trader.

The ways in which you can protect your investments against stock market correction include:

- Developing an understanding of the level of investment risk associated with the stock that you choose to invest in.
- Developing a mix of different investment types to diversify your portfolio. Mixing up investment types is a strategy called asset allocation.
- Developing an understanding of the risk-return relationship that comes with investing of any kind. The higher the potential of returns from an investment, the greater the risks associated with the investments. As a result, the higher and fast stock prices move, the greater the risks associated with the stock when it comes to market correction. Ensure that your portfolio has a mix of higher and lower risks stock trades

Stock Market Crash
Stock market crash occurs when stock prices drop 20% or more. A stock market crash is also known as a bear market. Some of the most famous examples of this include:

- The October 24, 1929 stock market crash that kicked off the Great Depression.
- The October 19, 1987 stock market crash when the Dow Jones Industrial Average decreased by almost 23% in 1 day. That is the highest percentage loss in one day recorded in the stock market's history. That was following an increase of 43% earlier that year.
- The Asian financial crisis that occurred on October 27, 1997.
- The dot-com crash that affected the NASDAQ in 2000, starting in March.
- The February 2018 stock market crash that started in February 5.

A stock market crash occurs about every 7 years and is more sudden than a stock market correction. It is caused by an event that creates fear and panic that leads to sellers trying to get rid of their stock as fast as possible. Such events can be a global crisis, unexpected economic events or a natural disaster. The stock market crash of 2020 due to the COVID-19 pandemic is one such example of how global events can trigger a stock market crash.

Typically, stock market crashes occur after an extended bull market after stock prices have been driven high.

Stock market crashes have a ripple effect. Large public companies use stock trading as a source of income to fund their management and development. Falling stock prices force these large businesses to produce less and this have to lay off workers. Unemployment rates rise which creates a drop in demand due to less revenue. This cause the economy to contract and can lead to a recession. The Great Depression, the 2001 recession and 2008's Great Recession are examples of this.

Most people are tempted to sell their stock during a stock market crash but that is typically the wrong course of action to be taken at that time. An investor will receive rock-bottom prices for his or her stock during that time. There are two courses of action that can lead to still being profitable after a stock market crash. The first course of action is to sell before the stock market crashes. Sometimes, there are indicators that the market will crash. The next course of action is to hold onto the stock because the market typically recovers after a few months following the stock market crash.

Again, the best bet is to ensure that your financial portfolio is balanced and diversified to allow the ability to withstand these conditions. It might even be a great opportunity to buy stock during a stock market crash due to low prices. When stock prices go back up, as they inevitably do, the investor will be in a winning position.

The other strategies that work with stock market correction such as understanding risk-return potential also work with stock market crash. Also, investing in a few preferred stocks can be beneficial as they will earn you income during this time.

Of course both stock market correction and stock market crash are concerning events. But the thing to realize is that they happen. Just like hurricanes and tornadoes happen. You cannot prevent them. All you can do is prepare to ensure that the impact on your portfolio is minimal.

I have experienced many stock market crashes since I started this career in 2000. Neither stock market correction nor stock market crash are the end of the stock market though. As history has shown, the stock market always recovers and the best thing to do is ensure that you are able

to weather the storm when it happens and you are able to take advantage when it starts moving again.

Chapter Summary

Stocks are the basic unit in the stock market. Stocks represent ownership in a company. Pieces of a stock are known as shares. Companies place stock up for sale to gain additional funds to grow the business. Investors buy stock as a way to grow their money as the hope is that the value of the stock will go up over time. If an investor so wishes, he or she can sell the stock to earn a profit. Owning stock in a company means that a person is called a shareholder because this person benefits from the company's profits.

Owning preferred stocks typically allows a stockholder to earn dividend payments, possible earnings and the ability to profit in the form of liquidated assets if a company goes bankrupt. Disadvantages to owning preferred stock include the stockholder not having voting rights in the company and dealing with the lowered potential for long-term growth.

On the other hand, common stock typically do not pay dividends and if they do, the amounts are not fixed like it usually is with preferred stock. The benefits of owning common stock include having voting rights in the company and the increased potential for high yield in the long term.

Apart from preferred and common stock, there are also public stock and private stock. Public stocks are sold by public companies to the general public. Both preferred and common stock are types of public stock. Private stocks are derived from a private company selling shares to only a few willing investors.

There are several other types of stocks and the list includes blue chip stock, speculative stock, growth stock and cyclical stock.

Stocks are a great investment because it facilitates long-term growth of money as it fights inflation. Other benefits of investing in stock include:

- Its high liquidity.
- Its versatility.
- It allowing the possibility to earn high returns over short time intervals.
- It allowing tax savings.
- It allowing diversification of the investor's financial portfolio.
- It allowing investors to gain Ownership in Companies
- It allowing the possible gain of regular income like dividend payments.
- It being a convenient form of investing

The stock market is the place where investors buy and sell investments also known as securities. It is also known as securities exchange. Common investments or securities found on the stock market are mutual funds, exchange-traded funds, cash equivalents like treasury securities, stocks and bonds. Every stock market is heavily regulated by the government and has its own set of rules. Stock markets work in a way that is similar to auction houses because buyers and sellers place offers and bids to facilitate the buying and selling of the stocks and other securities on the market. The stock market is ruled by supply and demand.

The stock market can experience both bull and bear conditions. A bull market is one where stock prices are on the rise in a consistent and sustained trend. These conditions indicate that the economy is sound and

employment is steady and on the rise. A bear market describes an economy and employment rate that is declining and so, stock prices decline in value in reflection.

There are two market conditions that cause concern for both traders and investors and they are known as stock market correction and stock market crash. Stock market correction occurs when stock market prices drops by 10% or more. Stock market crash occurs when stock prices drop 20% or more. You can use a few methods to protect your portfolio from stock market correction and stock market crash. They include:

- Developing a diverse financial portfolio.
- Developing an understanding of the level of investment risk associated with the stock that you choose to invest in.
- Developing a mix of different investment types to diversify your portfolio. Mixing up investment types is a strategy called asset allocation.
- Developing an understanding of the risk-return relationship that comes with investing of any kind.

Chapter 2: How to Set Started With Stock Investing

Investing in stock is a business and you have to treat it as such. Therefore, just like with any other business, there is some preliminary work that goes into investing.

The first thing you need to do is get your finances in order. You need you know the income that you have coming, how you spend this money, the debts that you have, what you save and what you intend to invest. Your investment budget should never eat up all your money. You should never invest money that you cannot afford to lose.

Next, create a trading plan. This will serve as your business plan. It will outline your goals in the short term and the long term. Spend the time necessary to create a comprehensive plan that outline your trading moves, such how you will get started, your exits strategies and what will activate them, the funds you allocate to certain trading activities, how you will track your performance and more. This document will be several pages long and I implore not to skip on the details because you will pay for it later. This trading plan is like your blueprint for building this career and leaving out details now will become a problem in the future.

Next, you need to find a brokerage firm to represent you on the stock market. There is the traditional method of walking into a physical location and signing up but this day and age, you can find a broker online and save yourself the hassle.

When you approach a broker, there are certain things you should have been aware of prior. These details include:

- The broker's reputation and level of industry expertise.
- The commission fees and other fees that the broker charges.
- The requirements for opening a cash and margin accounts, both of which you need to start trading. A cash account is one that allows the stock trader to use cash to facilitate transactions while a margin account allows the trader to use the value of his or her securities to facilitate trades.
- The additional features that the broker offer. You may wish to have an individual dedicated to handling your accounts. In this case, you will need to approach a full-service broker that offer this. Typically the commission fees other fees deducted by the broker are likely to be higher. On the other hand, if you wish to have more control over your account and want to pay lower commission fees and the like, a discount broker might work better for you.
- How quickly the broker executes claims.
- If the brokers makes monthly statements available.
- If the broker streams real-time quotes.

These are just a few way in which brokers differ. Therefore, you need to time you time to do quality research in order to find the one that is right for you.

Before, you invest real money into trading stocks, it is imperative that you practice beforehand in the process known as paper trading. You can do this weeks or months before you do your first real trade. All you have to do is use real-life situations on the stock market to practice your actions. This will allow you to evaluate your performance

with our risking your hard-earned money. I implore you to not skip this step because this was one of the mistakes that many beginner stock traders make. In fact, I made at the beginning of my career. I jumped right in without paper trading and lost $10,000! Do not be like me.

How to Read Stocks

After you have done the groundwork, then it time to start investing! There are so many options that it can seem overwhelming to pick which stocks are right for you to invest in especially when stock trading has it very own language that you will need to learn to make a success out of this career.

The stock chart is the most basic tool used to find the stocks that you would like to invest in. They give traders a visional representation of what is going on the stock market. There are several types of stock charts and that list includes:

- **Line Charts**. These are straight-line representations of stock price movement for specific amount of time. Many traders love to use this time of price chart for analyzation because it is simple to read as the price data points are connected by a single line. On the other hand, its simplicity is also a disadvantage as it does not provide much more information such as price gap information. A price gap is an interval between and period that is completely below above a previous trading period. Such information is necessary for making effective decisions when it comes to trading stocks.

- **Open-High-Low-Close Bar Chart**. This type of chart shows price movement from the highest to the lowest point over a specific amount of time such as over the course of 1 hour or 1 day. The name is derived from the chat showing open, high, low and close prices over

the time period specified. This type of chart is more complex than a line chart. However, the additional information that it displays, such as price gaps, is advantageous in making more informed decisions.

- **Candlestick Chart**. This price chart is similar to the open-high-low-close bar chart and shows price movement over time as well. It is so named because it is reminiscent of the structure of a candle and has 3 parts, which are called the body, the wick and the color. The body shows the open to close range over the time period specified. The wick displays daily highs and lows while the color is a depiction of the price movement. Red or black indicate price decline in stocks while green or white indicate an upward price movement in stock prices. Many professional stock traders use candlestick charts as it allows them to see patterns on the stock market.

Price charts are not the only analytical tools used by stock traders. There are others including technical analysis which allows stock traders to examine sectors of the stock market to identify the weaknesses and strengths of these particular sectors. This identification allows the stock trader to zero in on niches that he or she would like to pursue. There are several technical analysis tools including Bollinger band, which is a measure of the stock market volatility, and the relative strength index (RSI), which compares profits and losses over again time.

More complex price charts and technical analysis tools allows stocks traders to also measure volume on the stock market. Volume is the number of shares of contracts that are traded over a given amount of time. This information allows the stocks trader to analyze the influence that particular stock has over market activity.

By tracking volume, a stock trader can make better decisions because he or she now also has information on support and resistance. Support refers to a downward trend being expected because of to a concentration of demand on the market while resistance refers to an expected temporary pause of an upward trend due to a higher concentration of supply.

The Factors That Affect the Price of Stocks

Stock and other security prices rise and fall for various reasons. Some traders and investors believe that changes on the stock market can be predicted while others think that many of the booms and depression period cannot be predicted. No matter what side of the fence you choose to occupy, there is no denying that stocks are volatile entities that can change in price quite rapidly. In fact, they move up and down through the space of one day. There are many factors that drive the prices of stocks up and down.

Supply and demand is one of the biggest factors that affect stock prices. If the demand for stock and other securities is less than the supply (meaning that there are more sellers than buyers) then the price of stock and other securities will decrease. On the other hand, if the demand for securities is more than the supply (meaning that there are more buyers than sellers) then the price of stock and other securities will increase.

Other factors that affect the price of stock and other securities on the market include:

- **The market place**. This refers to whether or not the market is experiencing bullish or bearish conditions. If conditions are bullish then the prices of stock and other securities will increase. If conditions are bearish then the price of stock and other securities will decrease.

- **Interest rate**. High interest rates lower the demand for stock and other securities and so negatively affect prices. Lower interest rates increases demand and therefore, increases stock and other security prices.
- **Dividend announcements**. Dividend announcements usually drives the price of stock prices higher. This can be a double-edged sword as if the dividend announcement is less than expected, it can drive the prices or stock lower.
- **Industrial relations**. This refers to the relationship between the management of the company that places talks for sale and its workers. When there is a good industrial relationship between management and workers, productivity is high. This leads to profits for the company and drives stock prices higher. In cases where industrial relations between employees and management are poor, there are incidents of lockouts, strikes and irregular production. This reflects negatively on the company's financial performance and therefore, drives stock prices down
- **The local economy**. The performance of the economy is an indicator of whether or not the stock market will perform well. During economic booms, stock prices rise to their peak while recessive and depressive periods in economy drive stock and other security prices down to the lowest point. During recovery periods of the economy, stock prices can be seen to slowly rise.
- **Politics**. Relationship between regions and the current reigning government as well as government policies affect share stock prices.

Other factors that can affect stock prices on the stock market include:

- How available credit is to investors.

- How effective government regulation is on the stock market.
- The level of foreign investment experienced.
- How optimistic or pessimistic investors and traders are on the market.
- How stable the government is.

How to Pick the Best Stock for Investment

Not all stock are created equal. Picking the stocks that you will invest in is of monumental importance because it means the difference between you experiencing a profit and dealing with a loss. Therefore, it is important that you do your homework before investing your money. You do not want to end up with a portfolio that includes stocks that have little potential for profit. It is important that you put in that initial work that will gain you value.

Before I dive into the factors that determine the best stocks for you to invest your money in, let me take a moment to again stress the importance of having firmly asserted goals. This will help you in your search for determining the right stock for your investment. You may be looking for long-term, short-term, dividends, voting rights and any number of additional features when diversifying your portfolio. Knowing what aligns with your goals and what does not will help guide your search for the best stock and other security investments for you.

Getting back on topic, here are few ways that you can ensure you gain value from the stocks you choose to invest in:

- Invest in buying stock from companies that have a history of stability. While stock is a volatile entity and every company goes through down periods, companies with long-standing friends of stability showing two weather down tools and bounce back

relatively strong. This means that the value of the stock also goes back up during these upturns.

- Research the debt-equity ratio of the company that you are interesting in investing it. To determine a company's debt-equity ratio, divides the company's total liability by the total shareholder equity. If the ratio is 0.3 or less, then this company is likely a safe bet to invest. That is not always the case though. There are companies with higher debt-equity ratios that are great to invest in. an example is companies in the construction industry that are typically great to invest in even when they have debt-equity ratios that are higher than 0.3. The key is to do your homework and search deeper.

- Investigate the management of the companies that you are contemplating investing in. Management is an important aspect how profitably a company will be, the industrial relations of the company and the consistency of the company's productivity. Well-managed companies tend to have more profitable stock due to being more adaptive, caring of industrial relations and innovation. You want to also align your investment with companies that do not have much scandal attached their name.

- Invest in stocks that come from an industry with relatively strength. You need to know that the industry that you invest in has a bright future and stands out so that he can weather the storm during downturn of the economy and the stock market.

- Investigate the price-earnings (P/E) ratio. This ratio is the measure of how well a company's stock prices are doing relative to its earnings. To determine the P/E ratio, divide the current share price by the earnings per share. Higher P/E ratios indicate growth in the future and thus, are an indicator that investing in the

company's stock is a good investment. This ratio is helpful in comparing different companies in the same industry.

- Determine whether or not a company pays dividends. The payment of dividends is often an indicator that a company as a stable financial standing. However, this is not always the case and sometimes desperation causes some companies to offer high dividends. High dividends can also mean that the company is not investing in developing itself enough which can on can mean the decrease in value of stock over time. Therefore when looking for dividends look for companies that pay regular, modest and increasing dividends over time.

How to Invest In Stock

Successfully investing in stock requires the solidification of a few components. The first component is having successfully developed on level of savings that can sustain you and your lifestyle over an extended period of time while you accumulate the wealth you desire through investing and trading. Having this cushion will allow you to avoid trading and investing out of desperation. Desperation leads to bad investment decisions. Knowing how much that needs to be saved and how long this sum must last should have been something you found out while you developed your investment and trading plan.

The second component that is necessary for successful trading and investing on the stock market is the implementation an effective strategy that allows you to balance your risk and returns. Remember that investing in the stock market requires an analytical mind and a thorough blueprint that tells you where you need to be, what you need to be doing and how you need to get your goals. This strategy will also allow you to know how you should manage

your risks as well. Successful risk management encompasses developing one of four strategies which are:

- **Avoiding risks.** Ways in which you can avoid risk include purchasing bonds rather than investing your money in common stock, selling your securities and choosing not to make an investment entirely.
- **Reducing risks.** The most common way of reducing risk includes maintaining a diverse financial portfolio. This allows you to experienced general security even if you experience loss in one or two areas of your portfolio.
- **Transferring risks.** There are measures that can be elected so that risk for investments are transferred to another party. Such measures include investing in annuities. Annuities are insurance contracts that mean an insurer is obligated to pay the insured person a regular income in the present or in the future. Common types of annuities that investors contract include equity-indexed annuities and fixed annuities.
- **Accepting risks.** A person who is fully invested in the means that he or she pursues accepts that risk is part of the transaction and is prepared to deal with any possible losses. A person typically accept risk if they feel that the possibility of getting returns is far greater than the possibility of losses being incurred.

None of these risks policies a better than the other. They simply reflect the philosophies of investors and traders, and the level of comfort they have with managing risks. It is up to you to ascertain your comfort level with risk management.

Once you have decided how heavily you want to risk your investment, you now have to pay attention to the situations that allow you to get the best possible value out of your investments. This does not only include monitoring the stock

174

market. There needs to be monitoring of technological advances, international events, local economics and the actions of the government that governs the particular region or country that you reside in. One common activity that allows you to make these observation include monitoring new developments. By monitoring these developments, you will allow yourself though leverage your trading and investing positions by adapting and adjusting your investments to gain the most benefits with the current conditions.

Lastly, when it comes to investing in stock, you need to determine what approach will work best for you. The three most common approaches are called value investing, speculation and trading. Below, we will delve into the philosophies that support each approach as well as the techniques and tools that are applicable to each. We will also address the deficiencies of each approach when investing in stock.

Value Investing Approach to Stock Investing

Some of the best-known value investors of this time are Warren Buffet, Benjamin Graham, David Dodd, Christopher Browne and Seth Klarman. Thins of the value investing approach to stock investing like buying something from a designer brand or a valuable collectible on sale and being able to gain profit from it in the future. Stamps comics and coins are great everyday example of this rise in value as time goes by. Some of the older generations purchased items such as these for only a few dollars decades ago and today, some of them are worth thousands now.

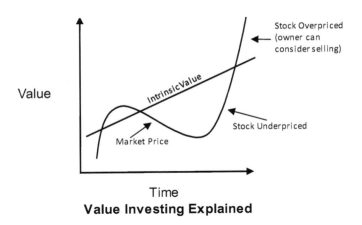

Time

Value Investing Explained

While value investing is not the exact same scenario, it is quite similar. Investors and trader buy stocks and other securities that they believe are undervalued on the market but will have their value realized in the future. Also called the buy and hold approach, this method of investing in stock involves buying stocks that appear to be trading for less than the intrinsic or "real" value in the hopes that the market price will rise greatly in the future. Intrinsic value refers to an investor or trader's perception of the inherent value of stocks or other securities on the stock market. Intrinsic value is determined using a range of tools such as the company's brands, financial situation and performances, the company's revenue, the market being targeted, the business model and the company's competition.

Price-earnings ration is used to help determined intrinsic value. Other tools that help determine stocks' intrinsic value include price-to-book (P/B) value and the free cash flow of a company. The P/E value describes a company's earnings track record. This value reflects whether or not the stock's price is on par with the earnings or undervalued. Free cash flow describes the cash that is left after a company deducts its expenditures from its revenue. Not all businesses

generate free cash flow and as such, if a business does then this is an indication that it can invest in the future operation of the business, pay its debts, pay dividends and issue other rewards to shareholders. It is also an indication that the business is growing and therefore the price of its stock is likely to reflect the same upward trend.

If a person is investing in stock and uses this approach, he or she will only buy things that he or she is perfectly happy with holding onto if the market crashes and for many years. This means searching out stocks and other securities that have a greater intrinsic value than their current market value.

This search is based on the belief that the stock will grow in value in the future because its real value has not yet been realized by the market. The investor or trader of the stock or other security is right with the knowledge that the value will grow in market value for years span. In fact, the rise in value may not come into fruition for decades. Therefore, this approach to investing takes patience and discipline. This also requires that the investor or trader have an active portfolio management system so that he or she is receiving returns from other investments and not just relying on this one stock or other security investment.

There are certain qualities that govern value investing and one of the greatest qualities is the margin of safety. The margin of safety is calculated by finding the difference between the stock or other securities intrinsic value and its current market price. The margin of safety is an indication of the potential returns that can be received from investing in the stock or other security.

Investors and traders that use the value investing approach are said to have a contrarian investing style. Contrarian describes the nature of the investor going against prevailing

market trends by buying when most investors are selling and selling one most investor are buying. They do this because they believe that the market does not always truly reflect the value of stocks and other securities. They take into account that stock and other securities may be underpriced or overpriced and this inaccuracy can be based on a variety of reasons. These reasons are what their research reveals and what they base their decisions on. As a result, financial analysis is always needed when using the value investing approach to stock investment. This is a sound investment method for an experienced and professional investor to use.

As great as this method is, there are risks. One of the risk is that if the investor is wrong, he or she can suffer incredible losses. If the investor is wrong, then he or she would have overvalued stock and therefore, overpaid in that investment scenario. The risk of the investor being wrong is upped by the fact that the rations explained above can be calculated in several manners. This means that they can be interpreted differently by different investors. Lastly, the biggest drawback of this investment approach is that it leads an investor by his or emotion, something that is strictly advised against when it comes to trading on the stock market. While there are many professional investors and traders who have a long-standing history of following their gut and reaping benefits from that intuition, this is not something that a beginner investor or trader should lean again.

Speculation Approach to Stock Investing

One of the best known investors who uses the speculation approach is George Soros. His style of investing is definitely worlds apart from the approach used by Warren Buffet and the other value investors listed above. The speculative approach to investing ignores the intrinsic value of the stock or other securities being invested and only focuses on what someone is willing to pay for it at its current price. The only

concern of a speculative investor is that a buyer is willing to pay a higher price for the stock. An investor when uses a speculative approach to investment is called a speculator. This person focuses on the price movement of the stock or other security. This person does not focus on additional income that this asset will bring such as dividends or interest payments. The entire focus is on being able to sell that stock or other security at a future date at a higher price.

This investment strategy holds the potential to gain the investor a great deal of profit. However, because the potential for such high returns is increased so are the risk. Speculators participate in this form of investing because they believe the potential for gain more than compensate for the risks involved.

Speculation is not an approach that is right for everyone because results are impossible to know predict. As a result this is not an approach recommended if an investor is looking to fund their retirement or any other long-term goal.

Day Trading Approach to Stock Investing

A day trader is one that facilitate transaction in the space of one day. When this act is mastered, it allows trading to be highly profitable as trades are opened at the beginning on the day and closed by the end of that same day. Just like speculators, investor who use the trading approach base their trades on price movement and current market conditions.

This investing practice is a result of this technological age where computers and fat internet connections streamline so much of our lives. This allows the instant gratification of knowing what works and what does not so that they can adapt and changes their techniques quickly to gain profits and to prevent losses.

The down side of this investing approach is that it attracts many people looking to make a quick buck. Many of these people do not properly research the career nor do they make the proper investing in developing a sound plan for trading and investing. They only see the lure of working from home and earning a potentially unlimited income. This mindset is one that usually leads to failure.

Chapter Summary

Investing in the stock market is a business and as such, it deserves to be treated in the same way that one would treat creating a startup. One of the first things I've done when developing a new business is creating a business plan and as such a stock market investor needs an investment plan to pave the way for success. After developing an investment plan, the investor needs to approach a brokerage firm to represent him or her on the stock market. There are many considerations that need to be made when choosing a brokerage firm such as the firm's reputation, the expertise that it offers, the commission fees it charges, the additional feature it offers and the requirements for opening a cash and margin account.

Before the investing starts testing out the stock market, he or she needs to paper trade. Paper trading is the practice of using real life scenarios in the stock market to practice before investing real money.

When the investing becomes active on the stock market, he or she need to be able to read stock to be able to find the best one to invest. Line charts, the open-high-low-close bar chart and candlestick charts all provide value data to help make these determinations. Using technical analysis tools like the Bollinger band and the relative strength index (RSI) also help.

Stock prices are affected by the market place, interest rates, dividend announcements, industrial relations, the local economy and more.

Picking the best stock to invest in is a complex process that includes investigating companies and industries. This groundwork need to be done though to avoid unnecessary losses. Risk management is also a necessary skill to minimize losses.

The approach used for investing can also be a determine fact in returns and loss. There are three main approaches that can be used when choosing stock investments. The first is called value investing. Value investing is a long-term strategy that requires patience, discipline and a thorough analysis of the stock market and other areas that affect market prices such as the local economics, government politics and company politics. The foundation of this approach is the belief that the market value is below the intrinsic value of the stock or other security. The value investor hopes to profit in the future by the market value rising to truly reflect the value of the security.

The next approach is called speculation and it does not consider the intrinsic value of the security. The only consideration is the current market value. The speculator hopes to make a profit in the future by selling this security at a higher price.

The last investing approach is called day trading and it is a relatively new approach that has risen in this digital age. It is a method of repeatedly performing trades and it suited for someone who is quick on their feet and loves being in the thick of things.

Chapter 3: Mutual Funds

I have to admit that I invested in mutual funds late in the game even though it is an investment opportunity that works very well for beginner investors. Many people believe that there is an ideal age for investing and if you have missed that gate then all is lost. That is not true. I know of investors who started their careers in their 40s and still went on to achieve their financial goals even though the window for doing so had shrunk. The key is to get a grip on your finances and take a good, hard look at your current portfolio to find the ways it needs improving.

That was why I considered mutual funds. There were holes in my financial portfolio that needed filling and mutual funds fit my needs, something I realized after I did some investigating. However late I was, I am so glad that I turned to mutual fund investing because any investor who would like a balanced portfolio understands that investing in mutual funds is a great way of spreading risk while still earning the wealth status desired. Still, mutual funds can seem complicated to understand right out of the gate. I too scratched my head when I contemplated investing in them at first and that may have been why I waited so long to invest in them. Today, I understand that the fear was unfounded and mutual funds are simple to understand once you look a little bit deeper. The entire idea of mutual funds centers on investing money with other people toward a common goal.

The formal definition of a mutual fund states that it is a pool of money collected from individual investors, companies and other entities as a way to invest in the market and spread risk so that it does not fall on the individual investors, company or other entity.

To facilitate this collective investment, a fund manager is hired to invest the funds collected from the investors, companies or other entities. The fund manager invests this money based on the type of mutual fund specified by the group to meet their goals. The intervention of a fund manager allows the fund to be professionally managed.

As an investor in this sort of transaction, this person gets a stake of ownership in the fund and whatever profit that it makes.

Types of Mutual Funds
There are two basic types of mutual funds and they are called closed-ended funds and open-ended funds. Below, we will discuss the characteristics of both types of mutual funds and the subcategories that fall within them.

Closed-Ended Funds
Closed-ended mutual funds have a fixed maturity date and allow investments only in the initial stages of developing the fund. Due to the introduction of a fixed maturity date, investors cannot withdraw from the fund until that time arrives.

There are two types of closed-ended mutual funds and they are called capital protection funds and fixed maturity plans. Capital protection funds consist of getting income from a balanced exposure to both equity and debt. This mutual fund type is largely towards debt securities and as such, investments are made heavily in bonds, certificates of deposits and T-bills to name a few. Investing in a capital

protection fund offers a great amount of risk protection compared to other types of mutual funds. They are also beginner-friendly and offer a great way to gain experience in equity investing. The negative part of capital protection funds is that returns on this type of mutual fund are limited and investors are not allowed to exit the fund before the maturity date arrives.

Just like with capital protection funds, investing in fixed maturity plans mainly uses instruments such as bonds and certificates of deposits. This is done in an effort to eliminate interest rate fluctuations that can be experienced in debt markets. The locked-in maturity dates of such mutual funds are typically varied between 30 days and 5 years.

Due to the nature of fixed maturity plans, they are often confused with fixed deposits but they differ from bank fixed deposits in that they do not carry components of equity borrowing. An investor may be interested in a fixed maturity plan if he or she wishes to generate steady returns over the fixed period specified while enjoying the protection against market price fluctuations.

Open-Ended Funds

Unlike closed-ended mutual funds, open-ended mutual funds allow investors to buy and sell at any time. There is no fixed maturity date or investment period attached to such mutual funds. Open-ended mutual funds are placed into four categories. These four categories are:

- **Debt or income mutual funds**. These are low risk and low return mutual fund types that allow investments in treasury bills and bonds. They are a good option for investors looking for a low-risk option
- **Equity or growth mutual funds**. These types of mutual funds are with the intention of generating

substantial income retaining capital gains investment in equity stocks.

- **Liquid or money market mutual funds.** These have a short maturity date of only about 90 days and investments are made in fixed income securities like short-term bank certificates of deposit and treasury bills. These are highly liquid securities.
- **Balanced mutual funds**. These mutual funds allow an aggressive investment that is curtailed by caution as it allows a balance between investment in fixed income securities and equity funds.

How to Invest In Mutual Funds

Before you wade into the mutual funds pool, you need to determine what you would like to achieve out of using that investment tool. Common goals include running a stable income during retirement allowing assets to grow in value in the process known as capital appreciation. I have stated this in the previous chapters and I will state it again - having goals that are measurable and quantifiable is paramount to having direction with your investment journey. Your goals allow you to draw a map that allows you to get to where you want to be. Having these financial goals will allow you to know what type of mutual fund would work best with the direction that you are going and how much money you would like to start with. The wonderful thing about mutual funds is that the investment amount is relatively low in comparison to many other investment strategies. Mutual fund investing also allows for the investment in a vast and diverse range of underlying securities that can easily be converted into cash.

Another important consideration that must be determined when investing in mutual funds is the timeline with which you would like to work. That again ties in with your goals so that you know in how many months or years you would like your investment to achieve its financial objective.

The amount of risk that you would like to take on is also a consideration when it comes to choosing the right mutual fund for you. As with anything else in the financial world, the mutual funds with the greatest potential for returns are also the ones that are riskiest to invest in. One of the more risky types of mutual funds to invest in is stock funds while mutual funds that generate lower returns like money market funds carry less risk.

The types of mutual funds that you can invest in are wide and varied and this list includes the three basic types that most investors start with. These three are called stock funds, bond funds and money market funds. All three of these are categorized as open-ended mutual funds.

Stock funds allow the investment in mainly stocks as the name suggests. As mentioned earlier, stock funds generally have a higher level of risk associated with them because the potential for returns is also typically higher than with most other types of mutual funds. This higher potential for returns and the associated risk are a result of the volatility of stock prices on the market. Therefore, this type of mutual fund is typically sought by investors willing to accept a higher level of risk as they seek aggressive capital appreciation. These types of investors are also typically willing to see the return on their investment over a longer timeline.

Bonds are a debt instrument and as such, bond funds allow investors to leverage their money into a pool to become a lender to a separate entity, which will have responsibility for paying the monies lent back into the fund with periodic interest applied. The risks associated with bond funds are generally lower than stock funds but this risk varies depending on the type of bond invested in. For example, investing in companies with low credit ratings or investing in long-term bonds are riskier compared to investing in short-

term bonds or bonds associated with more stable entities such as the government.

Money market funds are lower-risk mutual fund investments suitable for the short-term such as if the investor is expecting a yield in 3 years or less. Money market funds typically offer lower rates compared to stock funds or bond funds but traditionally, they offer a steady income. The instruments that are typically invested in with a mutual fund of this type are highly liquid instruments such as cash equivalent securities and cash. Instruments that are highly liquid have very low risk attached to them and therefore, the potential for high yield is lowered in reflection.

Mutual fund purchases can be done directly through a mutual fund company or through a bank. Buying mutual funds is facilitated through a brokerage firm as well but unlike stocks, which are purchased in shares, mutual funds are purchased in dollar amounts. Purchasing mutual fund needs to be facilitated by opening an account with any of the institutions that you choose to purchase the mutual fund through. In this day and age, purchasing mutual funds is not a tedious process and can be done online or over the phone if you do not feel like dealing with an in-person transaction. Purchasing the mutual fund is done by indicating the amount that you would like to spend and what mutual fund you would like to purchase. It is as easy as that and I still mentally kick myself for not investing in mutual funds sooner.

There is a feature offered by some brokerage firms that is called an automatic investment plan that allows an investor to periodically invest a certain amount on autopilot. This can be a consideration if you want to take some of the headwork out of your mutual fund investment strategy.

The Benefits of Investing In Mutual Funds

One of the biggest advantages of investing in mutual funds is that the investment is handled by the expert fund manager who has an understanding of how the market works and who knows the best techniques that will allow for maximum gain of the collective investment.

Other benefits include:

- Investment in mutual funds can be done in installments or in lump sums.
- Investing in mutual funds does not require large sums of money for investing.
- Risk is spread by being divided among the many participants.
- Risk is minimized by funds being invested in different securities such as stocks and bonds.
- Investors are allowed to choose between low, medium and high-risk mutual funds to adhere to their comfort levels when it comes to risk management.
- Open-ended mutual funds are typically highly liquid.

The Disadvantages of Investing In Mutual Funds

There are not many disadvantages to mutual funds but if there is one complaint is that mutual funds have levels of risk involved, unlike similar bank fixed deposits. Mutual fund returns depend on stock market performance and therefore, just as investors can incur profits, they can also so are also exposed to losses unlike with fixed deposits, which provide safe and steady growth of the investment made.

Chapter Summary

A mutual fund is a pool of money collected from individual investors, companies and other entities as a way to invest in the market and spread risk so it does not fall on the shoulders of one individual investor, company or other

188

entity. To facilitate this collective investment, a fund manager is hired to invest the funds collected from the investors, companies or other entities. This gives the benefit of the fund being professionally managed.

There are two basic types of mutual funds and they are called closed-ended funds and open-ended funds. Closed-ended mutual funds have a fixed maturity date and allow investments only in the initial stages of developing the fund. There are two types of closed-ended mutual funds and they are called capital protection funds and fixed maturity plans.

Unlike closed-ended mutual funds, open-ended mutual funds allow investors to buy and sell at any time. There is no fixed maturity date or investment period attached to such mutual funds. Open-ended mutual funds are placed into four categories called:

- Debt or income mutual funds.
- Equity or growth mutual funds
- Liquid or money market mutual funds.
- Balanced mutual funds.

Investing in mutual funds is as easy as opening an account with the desired mutual fund company, bank or brokerage firm an investor would like to work with then stating the amount he or she would like to invest and in what mutual fund the investment will be made. Despite the ease of investing in mutual funds though, they need to be done with careful consideration that aligns with the investor's financial goals.

Apart from the benefit of having a fund manager handle the particulars of the mutual fund, other benefits include:

- Investment in mutual funds can be done in installments or in lump sums.

- Investing in mutual funds does not require large sums of money for investing.
- Risk is spread by being divided among the many participants.
- Risk is minimized by funds being invested in different securities such as stocks and bonds.
- Investors are allowed to choose between low, medium and high-risk mutual funds.
- Open-ended mutual funds are typically highly liquid.

The only major disadvantage to mutual fund investment is the risk exposure the investor incurs.

Chapter 4: Starting with Exchange-Traded Funds

ETF stands for Exchange-Traded Fund and these funds have powerful leverage for both long-term investors and short-term traders. This is traded on the stock market just like stocks and is a way of investing in a group of securities like bonds, commodities, currency and stock by taking on a bundle offer. In essence, ETFs combine the benefits of trading stocks while mimicking the diversification of mutual funds. Because of their similarity to stock, they are traded just like an ordinary stock on the stock market. Just like stocks, ETFs also fluctuate in value throughout the trading day. The ETF value is affected by the same factors that cause the up and down movement of stock values.

Due to the pool of multiple assets in one basket, ETFs are a popular way of diversifying a financial portfolio in one transaction. It is possible for ETFs to hold thousands of stocks that fall in various industries! ETFs are often index fund so they are tracked by market indices like the Dow Jones Industrial Average.

One of the biggest reasons that persons pursue ETFs is because they have lower fees than mutual funds and just like mutual funds, they are professionally managed by an ETF manager who bundles the securities that will be allocated to that particular ETF. This is called a basket of funds and the funds that are pooled are called holdings. The ETF manager is responsible for selling and buying shares of the holdings

to investors so that the fund remains in alignment with the investment goal of that ETF.

ETFs are being launched regularly and accounts for more than $1 trillion on the market. The stock market would not be the same without ETFs so it is hard to believe that they have only been around for three decades. ETFs came to fruition in the late 1980s and started gaining popularity in the early 1990s. They were initially developed to provide access to passive, indexed income to individual investors. The first ETF created is called the S&P 500 SPDR. This was developed in 1993 and has accumulated more than $250 billion in assets under management.

Other popular ETFs are:

- The iShares Core S&P 500 ETF, which began trading in 2000 and has accumulated over $180 billion in assets under management.
- The Invesco QQQ, which began trading in 1999 and has accumulated over $70 billion in assets under management.
- The Barclays TIPS has accumulated over $20 billion in assets under management since 2003.

Types of ETFs

There are several types of ETFs and the group includes:

Alternative Investment ETFs

ETFs are just one form of alternative investments. Alternative investments are recognized as securities that cannot be categorized as a conventional investment like stocks, bonds, and cash. As a result, this sort of investment are issued by institutional investors or accredited, high-net-worth individuals.

Common characteristic of alternative investments include their typical lack of regulation, the higher level of risk associated with investing in them and the high complexity of their nature. Examples of alternative investments include venture capital, private equity, real property, commodities, and other types of tangible assets. Alternative investments tend to lean on the illiquid side.

Despite the cons of being unregulated, illiquid, high risk and difficult to value, alternative investment ETFs offer potential high returns, diversification of portfolio, a way to hedge inflation and an alternative to an investor who want to move away from traditional methods.

Bond ETFs

These types of ETFs allows an investor to easily add bonds investment to his or her portfolio while minimizing the risks associated with investing in bonds. For example, an investor can save a lot of money by investing in bonds ETFs compared to purchasing individual bonds. More benefits of investing in bond ETFs include the highly liquid nature and the transparency that comes with the investment as there is a definite value attached to the bond ETF. Bond ETFs value are publically published and updated every trading day unlike alternative investment ETFs. Bonds ETFs can be bought and sold at any time, thus why they are described as highly liquid.

Investors also have the opportunity to earn a steady income as many bond ETFs pay monthly interest even though the amount earn can vary monthly.

The ease with which they are traded and the diversification they add to a portfolio also make bond ETFs a great investment. There are several types of bond ETFs. A few of them include:

- Corporate, which are issued by corporations.
- Municipals, which are issued by local municipalities. Municipalities are towns and cities that have a corporate status in addition to a local government.
- Sovereign, which are issued by the governments of sovereign nations. U.S. Treasury ETFs are an example of this.
- Broad market, which are a combination of all the three bond ETF types listed above.

On the other hand, bond ETFs never mature and so there is a risk that the investor is not guaranteed a return on the investment in the future. Another potential disadvantage of investing in bond ETFs is that the investor is likely to experience loss as the interest rate rises. Rising interest rates cause bonds to lose their value.

Commodity ETFs

These types of ETF allow investment in physical commodities like precious metals like gold and silver, agricultural products and natural resources like oil and gas without the hassle of owning them. Typically commodity ETFs are focused on investing in a singular commodity or on futures contracts, which will be discussed later in this book.

Commodity ETFs are a popular form of investment because they allow investors to invest in commodities without having to learn how to deal with more complicated products like future contracts.

Currency ETFs

These types of ETFs allow investors to be exposed to forex or foreign exchange currencies. The main uses of currency ETFs are to diversify portfolios, hedge against currency risk and to speculate on the forex markets.

Hedging is a process that refers to buying an investment in an effort to reduce risk of loss by investing in another type of transaction. The purchasing of a put option to minimize the losses that can be experienced in a stock position are a perfect example of hedging. Put options and other types of options will be discussed in the next chapter.

Currency risk is the possibility that a currency will depreciate and so negatively affect investments, dividend payments, asset values and more. Currency risk is also known as exchange rate risk and the use of currency ETFs allows an investor to use ETFs to mitigate the risk involved in currency exchange.

Inverse ETFs

Also known as leverage ETFs, bear ETFs or short ETFs, inverse ETFs are constructed so that an investor can benefit from the decline in value of a particular security. These types of ETFs are typically invested in when there is decline in market value. In other words, they are beneficial to use on a market that is experiencing bearish condition.

Inverse ETFs typically utilize futures contracts so that profits can be realized. Futures contracts are financial agreements that allow the buying and selling of a security at a specific time in the future, hence the name. The price at which this purchase will be made is also specified in the terms of the contract. These types of contracts are made by investors that strongly believe that a security's price will move in a certain direction. In the case of inverse ETFs, the investor is betting that the market value of a security will decline.

Inverse ETFs do not require the use of margin accounts and so investors holding short positions can use this type of investment as an opportunity to profit. There are also several types of inverse ETFs that an investor can take advantage of.

The unfortunate thing about inverse ETFs is that loss can accumulate quickly if the investor is wrong about the direction in which the price will move. This high probability of loss is why inverse ETFs are typically short-term investments, typically not lasting longer than a day. Inverse ETFs also normally attract higher fees compared to conventional ETFs.

Sector ETFs

These are also known as industry ETFs because they allow the investment in stocks and other securities in specific industries. For example, an ETF may contain securities across the technology industry only. The financial, healthcare, telecommunications, utilities and energy industries are popular with this type of ETF.

The advantage to this type of ETF is that an investor may be interested investing in a particular industry and this can be facilitated with ETFs instead of trying to piece together individual securities.

More ETF Types

- **Actively-Managed ETFs**. These types of ETFs are normally more expensive to manage compared to the opposing passively-managed ETF because it requires the more active participation of an ETF managers. They are created to outperform an index, which is a feature the conventional ETF does not have.
- **Foreign Market ETFs**. These are ETFs geared toward investing in markets outside of the US like the Hong Kong's Hang Seng index or Nikkei Index.
- **Market ETFs**. These ETFs are created to track particular indices like the NASDAQ or the S&P 500.
- **Style ETFs**. These types of ETFs are designed to invest in an investment style or a company's market capitalization.

How ETFs Work

ETF bundles are assembled by an ETF provider. This provider assets the securities available via the input an ETF manager who creates a basket of these securities. The ETF manager considers the input of the investors to design the best package to cater to the needs and goals of the investor. Once the basket has been assembled, the ETF manager files the design with the Securities and Exchange Commission, also known as SEC.

Once this has been approved and the ETF has been assigned a unique ticker that allows for easy tracking, the creation process is complete. Investors have the option of buying a share of the basket of securities assembled. The process is quite similar to buying shares of stock from a company.

ETFs are traded throughout the day just like stock is.

Investors who want to sell their ETF holdings can do so by either selling the share on the open market or accumulating enough ETF shares to create a creation unit, which can be exchanged for the associated securities. The first option is typically done by individual investors while the second is usually limited to companies and greater entities because of the sheer number of shares required to facilitate it. Once the redemption of shares is complete, the creation unit is destroyed and the securities are given to the redeemer. Redemption of ETFs has a great tax implication as well.

The Benefits of Investing in ETFs

The most beneficial aspects of ETFs is they allow easy diversification of an investor's portfolio. Because of the broad range of securities that can be bundled into one transaction with ETFs, they allow investors to delve into several types of securities, industries, niches and more, easily. If those individual securities were to be invested in individually, the cost would be a lot higher.

197

ETFs are very transparent as anyone with an internet connection can investigate the activity of that particular ETF on the stock market. The holdings of the fund are disclosed publicly on a daily basis. This contrasts with mutual funds whose activity is disclosed on a monthly or quarterly basis. Therefore, investors can search the ups and downs of ETF performance at any time.

ETFs also have a tax benefit as they allow better control over the payment of capital gains tax. This is facilitated through a process known as tax efficiency, which means that ETF investors have the advantages of being taxed at a lower rate that what is normal for that type of financial transaction.

Investing in ETFs also allow the investor to enjoy many of the same benefits that stock investing allows. One such benefit is being able to place a variety of orders on the transaction. Such orders include buy on margin, stop-loss orders and limit orders.

Buying on margin is the process of using the margin account to facilitate the purchase in an investment. It is essentially borrowing money from the brokerage firm. As a result, the broker is acting like a lender and the securities invested in serves as collateral.

A stop-loss order is a command made to facilitate the buying or selling of a security when it reaches a certain price. The command is a tool designed to limit an investor's loss when investing in a certain position.

A limit order is a command that specifies a security like stock should be bought or sold at a specific price or one of better value. The buy limit order will be executed at the limit price or lower while a sell limit order will be executed at the limit price or higher.

Mutual funds do not have these types of orders attached to their makeup.

The Cons of Investing in ETFs

While ETFs have a great range of benefits that allow investor to access various securities across many industries and even international markets in a bundle order, they too have a dark side that investors need to be aware of before placing their money into the bet. These disadvantages include the trading costs. While there are many brokers that limit commission fees on ETFs to 0%, there are still others than do not offer that option. Therefore, this is something an investor needs to investigate when choosing brokerage representation. If the broker does indeed charge commission fees, they can quickly add up if the ETF is being traded often. This reduces the profit that can be earned from the ETF.

How to Shop Around for ETFs

Before shopping around for ETFs, the first thing you need to do is define your goals for trading that particular type of asset. There are many reasons why an investor might choose to invest in ETFs and these reasons include wanting to diversify his or her financial portfolio in one fell swoop, looking to invest in a cheaper alternative to mutual funds or wanting to invest in a particular company. Whatever your reasons may be, ensure that you are doing this for the right reasons so that you can stick with it in the long haul.

When you know what you are looking to achieve with the investment, choosing the right ETF for you becomes easy. Ways in which you can pinpoint the ETF investment that is right for you include by asset, location, performance and price.

Once you have narrowed your focus on a particular ETF, ensure that you have weighed the risks against the rewards and that you are prepared to accept the risks that go with

that particular ETF just as much as you would welcome the rewards that might come with it. The ETF provider also needs to be a major factor when considering ETFs. Look for an ETF provider with a proven track record and a stellar reputation.

Next, all you have to do is place your order!

Investment Strategies for ETFs

There are several strategies that can be used when investing in ETFs and they include:

Short Selling

Short selling in the process of selling securities that are not owned by the investor but instead are borrowed. The brokerage firm is normally the borrowing entity in these types of transactions. An investor may choose to utilize this strategy because he or she would like to hedge to offset his or her current position. Another reason that an investor might choose to short sell an ETF is because he or she expects that the price of the security will depreciate. By short selling the security at a higher price now, the investor can use the proceeds to buy back the securities at a lower price in the future.

Short selling also allows the investor to profit from price increases in security. Buy short selling and closing the position, the investor locks in the profit. The great thing about this is the investor does not have to sell the entire ETF position and so, can retain some of the holdings while still benefiting from the short sale.

There are two ways to go about short selling. The first way is by placing an order with your brokerage firm. The broker will place the ETF on the market with commands like a limit order or a market order. A market order serves to create incentive to buy or sell a security immediately at the current market prices. In normal conditions where there are plenty

of buyers and sellers, a market order can facilitate the ETF being bought sooner rather than later but the profit can be lowered due to market volatility. On the other hand, limit orders can provide higher profit even if they take longer to execute. If the value of the ETF falls in the time that the investor is waiting for the limit order to be executed then the sale might not be facilitate at all.

Another way to short sell an ETF is to buy an inverse ETF. The theory behind this is that it becomes a less risky trade because the investor is buying an asset. The highest risk in this scenario is that the inverse ETF gains a $0 value. While this is not the ideal situation, at least the investor does not gain additional backlash from the transaction.

Dollar-Cost Averaging

This strategy is the process of reducing risk by spacing out security purchases. This spacing is facilitated by buying at regularly scheduled amounts that are same or similar. Dollar-cost averaging allows the investor to smooth out the ETF purchases (and other investment strategies) over time rather than trying to make a lump sum purchase. This adds to huge savings over time.

This strategy is especially helpful when the market is experiencing bearish conditions. That is why it is used not just to invest in ETFs but also in investment strategies like mutual funds. The investor can make purchases when prices are at their lowest in an effort to make maximum profit.

Many investors look at dollar-cost average as a disciplined way of saving due to the regular dumping of funds to make the investment work. The biggest advantage of this strategy is that the regular input of investment allows the ETF to grow by inserting more units when prices are low and less when prices are higher.

Capitalizing on Seasonal Trends

The strategy of betting on seasonal trends is one that is great for beginner ETF trader to implement. One of the best-known and most profitable trades on the ETF market is known as the "sell in May and go away" phenomenon. This phenomenon is based on historical data that indicates that stocks underperform in the summertime months between May and October while they perform very well in the wintertime months between November and April.

By following this seasonal trend, an investor can create a strategic plan to diversify his or her holdings between May and October while investing once more from November to April. This phenomenon has been around since 1950 and has held strong up until 2013.

After 2013 though, the phenomenon has not held as strong. Still, some traders who perform proper analyzation of the market are able to pinpoint holdings that can allow them to take advantage of the seasonal trend. If an investor finds the seasonal trend is too risky to rely on, an alternative is to implement a strategy of rotation. This involves not cashing out holdings in May and the following summer months. Instead, this rotation strategy promotes diversifying your financial portfolio and focusing on ETF securities that are less affected by the summer months such as health and technology.

There is another seasonal trend that investors can jump on the band wagon of and it is the tendency of gold to become more popular in the months of September and October due to an increased demand in the Indian market. The Diwali festival of lights and many Indian weddings are typically held between the months of October and November and gold is a popular item that is used in both types of events. Beginner

ETF investor can take advantage of the seasonal trend by buying gold ETF investments.

Just as with the "sell in May and go away" phenomenon, nothing is guaranteed and using these seasonal strategies should be approached with care as with anything else in the investing game.

Swing Trading

This is a strategy of trading that uses technical and fundamental analysis to recognize trends that will allow the investor to gain profit from securities over a short period of time ranging from a few days to a few weeks. Stocks are a typical security used in swing trading but the qualities of ETFs also make them suitable for this strategy due to the high diversification and narrow bid/ask spreads that are part of their nature. As a result, investors we use this method with ETFs and looking to make a profit by the price of the ETF moving within the space of a few days to a few weeks even though there is no set time limit to how long as a trader can last. If a swing trade lasts more than a few weeks then there will be multiple up and down movements in the price, which defeats the purpose of practicing swing trading. The point is to make a profit from one up or down movement with swing trading.

To make better predictions on how the investment will play out, investors use technical analysis and follow chart movements to determine trends that they can ride the wave of. This analyzation will help investor know which ETF is right to use this method with. Using this method also entails knowing when right time is to exit the swing trade. This typically relies on stop loss orders to lock in profit.

Asset Allocation

This strategy is defined by allocating the investment in ETF to develop the assets in an investor's portfolio. Think of this

method as an all-in-one way of approaching ETF investing. This means having the ETF be developed around securities such as stocks, cash, commodities and bonds. Because of the low minimum investment nature of ETFs, this is entirely possible.

A possible drawback to this type of ETF method of investment is that it might not be as tax efficient because there a fixed income securities within the bundle.

Chapter Summary

ETF stands for exchange-traded fund. Traded on the stock market just like stocks, ETFs allow for the investing in a group of securities like bonds, commodities, currency and stock in one bundle offer. ETFs combine the benefits of trading stocks while mimicking the diversification qualities of mutual funds. Because of their similarity to stock, they are traded just like ordinary stock on the stock market and fluctuate in value throughout the trading day.

The different types of ETFs include:

- Alternative investments ETFS, which are ETFs comprised of securities that cannot be categorized as a conventional investments like stocks, bonds, and cash. This sort of investment is issued by institutions or accredited, high-net-worth individuals.
- Bond ETFs, which are ETFs that allow an investor to easily add bonds investment to his or her portfolio while minimizing the risks associated with investing in bonds. An investor can save a lot of money by investing in bonds ETFs compared to purchasing individual bonds.
- Commodity ETFs, which allow investment in physical commodities like precious metals like gold and silver, agricultural products and natural resources like oil and gas without the hassle of purchase. Typically

commodity ETFs are focused on investing in a singular commodity or on futures contracts.

- Currency ETFs, which allow investors to be exposed to forex or foreign exchange currency investments.
- Inverse ETFs, which are constructed so that an investor can benefit from the decline in value of a particular security. These types of ETFs are typically invested in when there is decline in market value. Therefore, they are beneficial to use in a bearish market.

More types of ETFs are:

- Sector ETFs
- Actively-managed ETFs
- Foreign market ETFs
- Market ETFs
- Style ETFs

ETF bundles are assembled by an ETF provider and managed by an ETF manager. The ETF manager assembles the basket of securities and files the ETF with Securities and Exchange Commission, also known as SEC in the ETF creation process.

Once the ETF has been approved by SEC and assigned a unique ticker that allows for easy tracking, investors have the option of buying a share of the basket of securities assembled. The process is quite similar to buying shares of stock from a company.

Benefits of investing in ETFs include:

- Transparency
- High liquidity
- Tax efficiency

Unfortunately, there can be high trading costs associated with investing in ETFs.

Shopping around for ETFs is as simple as:

- Defining your goals for investing in ETFs
- Setting criteria for the ETF of that you will invest in. The criteria can include details such as location and price.
- Weighing the risk and rewards of the ETF investments that you are interested in.
- Searching for an ETF provider.
- Placing in your order.

Different strategies can be implemented to invest in ETFs and they include:

- Short selling, which is the process of selling securities like ETFs that are not owned by the investor but instead, are borrowed. An investor often uses this strategy because he or she would like to hedge to offset his or her current position.
- Dollar-cost averaging, which is the process of reducing risk by spacing out security purchases. This spacing is facilitated by buying at a regular schedule in amounts that are same or similar. Dollar-cost averaging allows the investor to smooth out the ETF purchases over time rather than making a lump sum purchase.
- The capitalization of seasonal trends, which is the process of betting on seasonal trends when investing in ETFs. This is a great strategy for a beginner ETF trader to implement.
- Swing trading, which is a strategy of trading that uses technical and fundamental analysis to recognize trends that will allow the investor to gain profit from investments over a short period of time ranging from a few days to a few weeks.

Chapter 5: Trading Stock Options

Options trading is not new to the game of finance. In fact, the practice has been around since before 332 BC as its first record was mentioned in a book called *Politics,* published in 332 BC by Aristotle. This practice allowed people to purchase the right to buy an asset without actually buying the asset outright.

Aristotle introduced this topic by writing about a man called Thales of Miletus. Thales was a revered astronomer, philosopher and mathematician in ancient Greece. His practice of options trading started when he used the stars and weather patterns to predict that a huge olive harvest would come in the following year. With the first prediction, he then stated that olive presses would be in high demand to facilitate such a huge harvest. Forward-thinker that he was, Thales understood that he could turn a huge profit if he was the one to own all of the olive presses in the region.

While he did not have the kind of money that allowed him to buy all of the olive presses outright, he did use the small amount that he did have to secure the use of all olive presses in that region by using the olive presses themselves as the underlying asset to facilitate the transaction.

His prediction came true and the olive harvest was plentiful. As the one who had the option to all the olive presses in the region, Thales had the option to use them himself during harvest time (exercising the option) or sell them to other people who would pay more for the same right that he owned

at the time (selling the options to earn a profit). He chose to sell the right to use the olive presses to harvesters and thus, turned a huge profit.

Options trading found its way into modern trading practices as it moved into European classic economics and finance in 1636. Due to unregulated practices, options trading got a bad reputation. However, this did not stop investors from acknowledging that trading options allowed them to gain powerful leverage in the finance arena.

Options trading was brought into the United States in 1872 by an American financier called Russell Sage. By using options trading, Sage was able to accumulate millions of dollars in just a few years even though the practice of trading options was illiquid and unstandardized during that time. He even bought a seat in the NYSE in 1874. Unfortunately, Sage lost a small fortune during the stock market crash of 1884 and gave up trading options. Other traders and investors saw the potential that options trading had though and continued the practice.

It took about 100 years but options trading became standardized and regulated by the government as it gained increasing popularity and more advances were made in defining how the public traded options. I am ever grateful that the practice stood the test of time and became an integral part of modern stock marketing investing.

My start on the stock market came with options trading. Options trading allowed me to enter the stock market back when I did not have the finances to buy and sell stock outright. Even though the learning curb was sharp, especially since information was not as readily available back when I just started, the benefits allowed me to accumulate enough wealth so that I could turn to investing in pricier forms of

trading on the stock market like buying and selling stocks, mutual funds and exchange-traded funds.

Even though the affordability was great, it was the no obligation nature of this form of trading that pulled me in the hardest back then. By utilizing options trading, I was under no legal commitment to buy or sell anything unless it was advantageous for me to do so. As a man who did not have as many assets signed to his name back when I just started as a trader, this was great because the risks were significantly lower compared to the act of outright buying and selling of stocks.

Because of the powerful leverage trading options allows me, I still use this trading practice today as a way to keep my portfolio balanced and to enter markets I am unsure about but want to test for profitability. The best part is that getting started with options trading is not all that different than getting started with buying and selling stocks. Ensure that this practice is incorporated into your trading plan, that you have the necessary accounts and representation through a brokerage firm, get your feet wet with paper trading and then choose your trading style, then you will be all set to start trading options! Day trading is the full-time practice of stock market trading and positions trading. It is the stock market trading style most commonly used by professionals. It is also the style most used for options trading.

What are Options?

Stocks and options are two items that are often mistakenly thought to be the same but they are not the same thing. Stocks are a typical component of options. Options are a great way of investing in the stock market without outright buying stock or any other security. This method of investing allows investors to invest in the stock market with a lower

amount while still having the potential to earn the same profit that a stocks trader would.

Options are financial contracts that derived their value from the securities attached to them. The contract states that the holder of the option has the right (option) to buy or sell the security on or by a date specified at a specific price. This specified date is called the expiration date. The name option comes from the fact that there is no obligation for the holder of the contract to take any particular course of action.

The options that the option holder has include:

- Sell the option to another investor.
- Exercise the contract and buy the asset.
- Exercise the option and sell all or part of the asset.
- Allow the option to expire without following any particular course of action.

The specific selling or buying price that the option can be exercised for is called the strike price. This price does not change no matter what happens after the date of signing.

Instead of buying or selling the security, investors of options pay a premium to the seller of the option. Options premium pricing is a complex process because there are so many factors that go into developing each one. It would be a simple process if the premium was just based on the value of the stock or other securities but it is not. And there is not going around the process either because premium pricing needs to be fair to all the parties involved in the transaction.

The intrinsic value of the security also factors into the development of the option premium. This value is determined by finding the difference between the current market price of the security and the strike price of the option.

The time value is also another factor that makes up the premium of an option. Time value is the amount an investor would willingly pay in addition to the premium because there is the underlying belief that the security value will rise in the future.

Other factors that affect the creation of options premium include:

- Volatility
- Interest rates
- Dividends

Luckily, there are pricing models that help with the creation of option premiums so it does not have to be calculated manually.

The Types of Options

The option that Thales purchased was called a call option. This purchase allowed him the right to buy the olive presses on or before the expiration date. Sometimes just called a call, this is the type of option a trader will invest in if he or she expects the price of the security attached the contract to rise within the time frame specified by the expiration date. Profit lies in the price of the security moving above the strike price. The common action for call option holders to perform when the security price rises above the strike price is to sell the option for a profit.

The seller of the option receives the premium payment from the holder of the option. The income generated for the seller is limited while the holder of the option has the potential to receive unlimited profit.

The term used to describe whether or not the holder of the option has made a profit is called in the money. If the price of the security falls below the strike price, the option holder will experience a loss and this is described as being out of

the money. There is also the possibility that the options holder will break even in circumstances where the security price and strike price are the same or about the same. The holder of the option does not make a profit or a loss and this is described as being at the money.

The second type of option is called a put option. Also simply called a put, this type of option gives the holder of the contract the right to sell the security attached at the strike price by the expiration date. Unlike with a call option where the holder of the contract hopes that the price of the security increases, the holder of a put option hopes that the price of the security goes down below the strike price. Only if the price of the security goes down below the strike price does the holder of the option make a profit. In such cases, the situation is described as being in the money.

If the price of the security goes up then the holder of the contract will have to sell the security at a higher price than expected if he or she exercises the right to the contract. This cuts on the holder's profits and is described as an out of the money situation. Just like with call options, the holder of a put option can experience at the money situation where the security price and the strike price are the same or about the same. This means that he or she does not experience a loss or a profit.

When it comes to both call and put options, they can be referred to as having long or short positions. Having a long position can also be referred to as going long while having a short position can also be referred to as going short. Going long or going short is a reference to whether or not the investor owns the security being traded in the option deal. Having a long position speaks to the investor owning the security associated with the option. Having a short position

refers to the investor not owning the security attached to the option.

Going long or short can also refer to whether the holder of the option expects the price of the security associated with the contract to go up or down. Having a long call position also refers to the holder of the option expecting the price of the security to go above the strike price so that he or she can make a profit from that upward trend. Adopting a long call strategy is a common technique used for an investor to access stock that they cannot afford to buy outright at the current time. This is the strategy that allowed me to develop my wealth so that I could adopt the life I wanted rather than work the 9 to 5 job that I did not like.

The purchase of the option is cheaper and allows for the purchase of the stock in the future at the strike price, which is likely less expensive than the current market price of the stock. This shows that investors who adopt a long call strategy have an optimistic view of the future of conditions on the stock market. The benefits of using this strategy include the fact that profit is potentially unlimited as it increases as the price of the security increases while the risk is limited to the premium paid and any other fees associated with the transaction. If the security does not appreciate by the expiration date then the contract becomes worthless and hopefully, the trader would have broken even. Breakeven is calculated with this formula:

Strike Price + Premium Paid + Any Other Associated Fees = Breakeven

On the other hand, having a long put position refers to the trader expecting the price of the associated security to go down so that he or she can take advantage of that position by selling the associated security.

A trader who adopts a long put strategy has a bearish outlook on the future conditions of the stock market. Breakeven is calculated in the same way that it is with a long call strategy but the trader benefits if the price of the associated security decreases. The risk is limited to the premium paid as well as any other fees paid in association with the option. Profit is potentially unlimited as it increases the more the price of the security decreases. Using the long put strategy is a popular way of betting on the depreciating price of the stock.

Investment Strategies for Trading Stock Options
The long put and long call strategies are tried and true when it comes to option trading but they are not the only effective or popular strategies that options traders use. Other options trading strategies include:

Covered Call Strategy
This options trading strategy is also known as a buy write because it describes the act of selling the right to purchase a security that is owned by the investor at the strike price within a specific amount of time. This is a two-part strategy that involves the investor first purchasing a security such as stock then selling it to options traders. Stock is the most common type of security used in the covered call strategy.

The seller of the options not only benefits from owning an asset of value but also receives premium payments from options trader. Risk is significantly lowered because the investor already owns the associated security. As a result, the seller is covered if the stock price does go above the strike price. All the seller has to do is deliver the security to the holder of the option if the holder chooses to exercise that right.

If someone owns securities and chooses to use the covered call strategy to sell options, he or she needs to be

214

comfortable with the fact that he or she will give up ownership of that security if the price increases on the market. This person needs to also be comfortable owning that security if the price depreciates. Therefore, careful consideration needs to go into the purchase of the stock or other security type when using the covered call options strategy is on the table.

In fact, the covered call strategy can play out in one of three ways. They are:

- The stock goes above the strike price and the holder exercises the right, thereby earning the trader the maximum profit on the transaction. The seller benefits from the premium payment.
- The stock price goes down and makes the options worthless. The seller still benefits from the premium payment.
- The stock does not change or goes up slightly, which makes the options worthless. The seller still benefits from the premium payment.

In all these scenarios, the seller benefits. The covered call strategy can allow the seller of the option to set up a regular income stream from receiving premium payments, which is kept whether or not the trader chooses to exercise the right to the option. The benefit to traders is that covered calls allows them to target securities at a higher selling price than the current market price.

The disadvantage that the investor faces is the possibility that the stock price depreciates below the strike price. However, this is a risk that any stock investor faces. The seller of the covered called also faces an opportunity cost as if the price of the stock rises greatly, then he or she has to hand over the security to the trader when he or she exercises the right to the option.

Strangles and Straddles

Both of these strategies rely on volatility on the market because the investor benefits whether or not the price goes up or down. Both strategies rely on buying an equal number of call options and put options that are associated with the same security and have the same expiration date. The difference arises in the number of strike prices attached to both of these options trading strategies. The strangle strategy has two separate strike prices while the straddle strategy only has one strike price.

The strangle strategy is employed by an options trader who believes that the security price will move strongly up or down but still wants to protect his or her investment in case he or she is wrong. There are two types of strangle strategies and they are called a short strangle and a long strangle. The short strangle is a neutral options trading strategy that involves the trader buying one out of the money put option and one out of the money call option. In keeping with the qualities of the strangle strategy, both of these options have the same associated security and the same experience indeed but different strike prices. This is called a neutral options trading strategy because the trader believes that the stock will remain relatively stable on the market in the short term. Thus, the trader hopes to gain profit by having the security price fall between the two strike prices on the expiration date. Profit is earned when the security price falls between the two strike prices. Therefore, the profit potential with this type of strategy is limited. Unfortunately, the risk is unlimited because it can be experienced if the security price goes up or down sharply by the expiration date.

The long strangle involves the trader buying one out of the money put option and one out of the money call option, both with the same associated security and expiration date. The trader relies on making a profit due to volatility on the

216

market. The profit is gained if the security price moves sharply up or down. Profit potential is unlimited. Risk is limited with this strategy as it only occurs if the security price is between the strike prices on the expiration date.

The straddle strategy is employed by a trader who wants to protect his investment regardless of whether or not the price of the associated security moves up or down. Just like with the strangle strategy, there is both a short straddle and a long straddle.

The short straddle involves buying one at the money call option and one at the money put option both with the same associated security, expiration date and strike price. This is a neutral strategy that has limited profit potential. Profit is achieved when the security price trades at the strike price on the expiration date. Unfortunately, loss has unlimited potential as it can occur if the security price moves sharply up or down by the expiration date.

The long straddle involves the trader buying one at the money call option and one at the money put option with the same associated security, expiration date and strike price. The profit potential is unlimited as it only occurs if the security price moves strongly up or down. The benefit of this strategy is that risks are limited and loss only occurs when the security price trades at the strike price on the expiration date of the strategy.

Credit and Debit Spreads

Spreads are options trading strategies that facilitate the buying of two different options at the same time with the same associated security. Credit spreads involve the simultaneous selling of a high-premium option and the purchase on a low-premium option of the same type (call or put option) with the same expiration date. The options will

have different strike prices and profit is made when the spread between the two options becomes narrowed.

Credit spreads come in several different types but some of the most popular types include a bull put spread, bear call spread, iron butterfly spread and short butterfly spread. While the bull put spread and bear call spread involve the buying and selling of only two options, it gets more complicated with the short butterfly spread, which involves the buying and selling of three different options and the iron butterfly spread, which involves the four transactions. All of these strategies have the different pros and cons but the higher the transaction count, the more difficult these strategies become to implement. Therefore, using this strategy should be approached with caution especially if the trader is a beginner.

No matter what type of credit spread that an options trader chooses to use, one of the biggest advantages is that credit spreads help lower the risk if the security price moves against the bet that the options trader made. Losses are limited because the trader typically still benefits no matter what direction the price of the security moves. The seller also stands to benefit through the payment of premiums.

This is a strategy that can make a trader think twice though because it requires the use of a margin account to facilitate and profits can be just as limited as the losses.

A debit spread is an options trading strategy that involves the options trader buying a high premium option while simultaneously selling a low premium option with the same associated security attached to both options. Both options have the same expiration date but different strike prices. This type of strategy differs from a credit spread because the trader stands to profit when the spread between the two options widens. Debit spreads are typically less complicated

to implement than credit spreads and therefore, more commonly advised to be used by beginners.

Just like credit spreads, the debit spread strategy relies on at least two options been involved. Some of the different types of debit spread strategies include the bull call spread, which involve two transactions, the bear put spread, which involves 2 transactions and the reverse iron butterfly and the butterfly spread, which both involves four transactions each.

Some of the advantages of using debit spreads are that they offer a greater profit margin compared to credit spreads, losses are limited and the strategy does not require the use of margin accounts to facilitate.

The biggest disadvantage of using debit spreads includes the fact that profit margins are limited because loss margins are limited.

Iron Condor

This is a neutral strategy that involves four transactions. These transactions include:

- Selling one out of the money put option
- Buying one out of the money put option with a lower strike price
- Selling one out of the money call option
- Buying one out of the money call option with a higher strike price

All four options have the same expiration date and the same associated security. Due to the advanced nature of this options trading strategy, it is not recommended for beginners.

Profit is realized when the price of the associated security falls between the call and put options that are sold on the expiration date. Loss is incurred when the price of the

associated security falls below or at the lower strike price of the put option or rises above or is equal to the higher strike price of the call option. Profit is limited with this strategy and higher incidences of loss can be incurred because of the non-directional nature of this strategy.

This strategy appeals to many advanced options traders because profit can also be made in any direction and the strategy allows for greater flexibility. The disadvantage of this strategy lies in its complexity which is why it is not recommended for beginner options traders.

Rolling Out Options

This strategy entails replacing expiring options with similar options to manage a winning or losing position. This is done by closing the first option then opening another option with a similar position with the same security associated but with varied terms. Typically, the terms that are varied are the strike price or the date of expiration. Rolling out is done in one of three ways. These ways are rolling up, rolling down and rolling forward.

Rolling up described the process of closing an existing option while opening a similar option with a higher strike price. The higher strike price is where the method gets its name. Rolling up can be done for both a long position and a short position. While in a long position, the investors will sell the exiting position to open the new position at a higher strike price. The opposite is true for a short position. This applied to both put and call options.

Rolling down is the process of closing one option position while opening a similar option position with a lower strike price at the same time hence the name. Rolling down that can be applied to both call and put options that are in both long and short positions. This is typically done to minimized

losses while still maintaining a leg in with the associated security.

Rolling forward is the process whereby an options trader chooses to open a new position with a similar option with an expiration date that is further in the future. This is typically done because maximum profit has not been gained from the option even though conditions are still favorable for that being the case.

No matter what varied method of rolling out is used, there are several benefits to doing so and they include lower commission fees because the transaction is been rolling out has been conducted on one transaction rather than multiple. The process is also relatively simple so beginner traders can also utilize this with good results.

The Benefits of Trading Stock Options

One of the biggest advantages of trading stocks is that they allow you to be a player in the stock market without investing the maximum to actually buy stocks. This translates into an options trader benefiting from the same financial poll as stock traders without the upfront costs. The options trader does not need to own the asset to gain the potion to buy or sell it nor does he or she have to deal with the cost associated with owning the securities being traded.

The best part is that there is no obligation for the options trader to follow any one particular course of action. Only if the options trader feels that it is beneficial to him or her does he or she exercise the options or sell the options to another options trader. The only cost that the options trader has to fulfill is the payment of the premium. This greatly limits the loss that can occur when trading options even though the profits are often potentially unlimited.

Other benefits to trading options on the trade market include:

- Options traders have great flexibility in the actions they can pursue such as exercising their right through the contract, selling the option to another investor or just allowing the option to expire.
- Options can protect securities from depreciating value due to market fluctuations.
- Investors can earn a steady income by offering options on assets that he or she already owns.
- The strike price freezes the price at which the associated security can be bought or sold even if the market prices fluctuated. This can allow options trader to buy or sell assets at a steal of a price if the price movement is sharply in his or her favor.

The Disadvantages of Trading Stock Options

Just as I have discussed the good with the bad with all the other stock market entities in earlier chapter, I will reveal the same for options. The first disadvantage of trading options is that an options trader needs to be qualified by his or her broker before he or she can begin trading options. Qualification depends on the trader's financial situation and investment experienced. Based on these, the options trader is assigned to a particular level, which may not be where the options trader would like to start his or her options trading journey.

Options are short-term investments that can expire within a few hours, days, weeks or months. The only exception to this is the investment in a special type of option called LEAPS (Long-term Equity Anticipation Securities). These normally have an expiration date that is 1 year long but can sometimes be as long as 3 years. This type of option still possesses all the normal qualities on an ordinary option but

it is a good option for traders who would like to benefit from options in a longer term.

This means that the options trader needs to have an exact strategy for follow through with the options. This would have required thorough research and analysis before betting on the trade. The short-term nature of options can be turned into a benefit as it allows the trader to realize profit sooner rather than later.

Options trading also exposed the sellers of options to unlimited risk because the options trader is obligated to buy or sell the associated securities at the strike price if the options trader chooses to exercise the options even if the transaction incurs him or her a loss.

There are additional costs associated with options apart from the premium as well. Luckily, these remain relatively low and atypically associated with maintaining financial accounts, which are necessary for all types of activities on the stock market

Chapter Summary

Stocks and options are two items that are often mistakenly thought to be the same but options are financial contracts that allow for investing in the stock market without outright buying stock. Options derived their value from the securities attached to them. The contract states that the holder of the option has the right (option) to buy or sell the securities on or by a date specified at a specific price. This specified date is called the expiration date. The specified price is called the strike price.

Trading options gives the trader several options including the ability to:

- Sell the option to another investor.
- Exercise the contract and buy the asset.

- Exercise the option and sell all or part of the asset.
- Allow the option to expire without following any particular course of action.

Options are bought from sellers with a premium payment. Pricing options is a complex process that is determined by factors like:

- The value of the associated security.
- The intrinsic value of the security.
- The time value that buyer of the options is willing to pay.
- Market volatility.
- Interest rates.
- Dividends, if they are any.

Luckily premium pricing is not something that has to be done manually. Pricing models have made the process a lot simpler.

There are two basic types of options and they are the call option and the put option. A call option gives the trader the option to buy the associated security on or before the expiration date at the strike price. Profit lies in the price of the security moving above the strike price. If this happens then the trader is in a situation called in the money. If the price of the security falls below the strike price, the option holder will experience a loss and this is described as being out of the money. There is also the possibility that the options holder will break even in circumstances where the security price and strike price are the same. The holder of the option does not make a profit or a loss and this is described as being at the money.

The second type of option is called a put option. A put option gives the trader the option to sell the associated security on or before the expiration date at the strike price. Profit lies in

the price of the security moving below the strike price. This is an in the money situation.

Both call and put options have long (going long) or short (going short) positions. Having a long position refers to the investor owning the security associated with the options while having a short position refers to the investor not owning the security attached to the option.

Going long also refers to the holder of the option expecting the price of the security to go above the strike price so that he or she can make a profit from that upward trend. This is known as adopting a long call strategy.

Going short also refers to the holder of the option expecting the price of the security to go below the strike price so that he or she can make a profit from that upward trend. This is known as adopting a long put strategy.

Other common options trading strategies include:

- The covered call, which is a two-part strategy whereby an investor first purchases a security (commonly stock) then sells it to options traders. The goal of the seller is to collect premium payments while the goal of the trader is to exercise the right to buy the option if the stock price appreciates.
- Strangles and straddles, which are both strategies that rely on volatility on the market because the investor benefits whether or not the price goes up or down. Both strategies rely on buying an equal number of call options and put options that are associated with the same security and have the same experience indeed. The difference arises in the number of strike prices attached to both of these options trading strategies. Strangle strategies have two separate

strike prices while the straddle strategies only have one strike price.

- Credit and debit spreads. Credit spreads involve the simultaneous selling of a high-premium option and the purchase on a low-premium option of the same type (call or put options) with the same expiration date. The options will have different strike prices and profit is made when the spread between the two options becomes narrowed. A debit spread is an options trading strategy that involves the options trader buying a high premium option while simultaneously selling and low premium option with the same associated security attached to both options. Both options have the same expiration date but different strike prices. This type of strategy differs from a credit spread because the trader stands to profit when the spread between the two options widens.
- Iron condor, which is a neutral strategy that involves four transactions with the same expiration date and the same associated security. Due to the advanced nature of this options trading strategy, it is not recommended for beginners.
- Rolling out options, which is the strategy that entails replacing expiring options with similar options to manage a winning or losing position. This is done by closing the first option then opening another option for a similar position with the same security associated but with varied terms. Typically, the terms that are varied are the strike price or the date of expiration. Rolling out is done in one of three ways. These ways are rolling up, rolling down and rolling forward.

Benefits of trading options are:

- Options trading allows investors to participate in the stock market without investing the maximum to

actually buy or sell stocks or other more expensive securities.

- The options trader is not required to own the securities associated with the option to benefit from their value.
- There is no obligation for the options trader to follow any one particular course of action.
- Options traders have great flexibility in the actions they can pursue such as exercising their right through the contract, selling the option to another investor or just allowing the option to expire.
- Options can protect securities from depreciating value due to market fluctuations.
- Investors can earn a steady income by offering options on assets that he or she already owns.
- The strike price freezes the price at which the associated security can be bought or sold even if the market prices fluctuated.

The disadvantages of trading options include:

- Options traders need to be qualified by a broker before they can be trade options.
- Options are short-term investments that can only last as long as a few months with the only exception being invested in LEASP, which can be invested in for a term of up to 3 years.
- The seller of the option is exposed to potentially unlimited loss.
- There are additional costs associated with trading options apart from premium payment

Chapter 6: Investing in Forex

The forex market is the largest and the most liquid financial market in the world. It trades over $5 trillion in currencies every single day! This activity is a constant because currency exchange is important on a global level as it facilitates the buying and selling of goods and services. For example, if a US-based company wants to purchase an item from another country in Europe then this trade needs to be facilitated in euros because this is the currency in which the European company conducts business. Therefore, the US business needs to convert the US dollar to the euro currency to ensure that this transaction is completed. The forex market is needed to facilitate this conversion. This is only one instance in which the forex market is needed for the conversion of one currency to another currency. A family member sending financial support to another in another country, a US tourist buying a souvenir while on vacation in the US dollar in a country whose base currency is not the US dollar, a student moving away from home and paying for college in a different currency... These are all scenarios in which the foreign exchange market is an integral part of the exchange.

Forex stands for foreign exchange and can also go by the name of FX. Just as the name suggests, foreign currencies are exchanged on this financial market on a daily basis. Foreign currencies are changed into other currencies and these exchanges occur for several reasons. Some of these reasons include trading, commerce and tourism. Currencies are traded in pairs such as EUR/USD but currencies are not

the only items that exist for trading on the forex market. Other securities include futures and options. There are many reasons why an investor might choose to participate in the forex market and such reasons include diversification of his or her portfolio, speculating on geopolitics events and hedging against international currencies.

Unlike the stock market, the forex market operates 24 hours a day almost every day of the week. It opens on Sunday at 5 PM EST and closes on Friday at 4 PM EST. Those extended opening hours are needed because currency exchange is an international event that is needed by international businesses and central banks. These opening hours also ensure that at any one time there is at least one market open due to the overlap of these hours in different parts of the world. When one regional market is closing another is opening. As can be seen, the different international time zones allow this market to trade 24-hours a day.

The reason that the forex market needs to operate on such a large scale is because currency is always in demand unlike other securities such as stocks, bonds and commodities. This is why the stock market operates like a standard business with typical business hours. There is not enough demand to facilitate such markets being open 24-hours a day, unlike the forex market.

Foreign exchange is a complex market and it can be quite lucrative when invested in the right way. Before we get to the particulars of how to go about investing in the forex market, let us take a look at how this market came into existence.

The History of the Forex Market
The forex market's history goes back as early as the development of currency way back in ancient Egypt. Even in the middle ages, there was recorded texts that showed the

first network of international banks began trading currency even then. By the 17th century, there was an active forex market in Amsterdam, which allowed currency exchange between Holland and England.

The dynamics of the modern forex trading industry began to take shape in the 19th century but the single most impactful event that led to what the forex market is today happened in 1870. This was when the gold standard monetary system was created.

Before this time there was not good international control of the gold standard system. Gold was the primary form of currency exchanged before that time but from 1899 to 1913, currency exchange increased in holdings by almost 11% while there was a much slower increase in the importance of gold exchange. This time allowed an international revolution of how trading was done.

In the early 1900s, almost half of the world's foreign exchange was facilitated using pounds sterling even though they were only two foreign exchange brokers. Active forex trading centers existed in New York, Berlin and Paris at the time.

In 1944, the Bretton Woods Agreement was signed so that the US dollar could trade against gold. This also allowed the US dollar to be traded against other major currencies. For a time, the system stabilized foreign exchange rates but soon the dynamics of international economics started to change as global markets started to grow at different rates. These changes made the system obsolete and in 1971 the Bretton Woods Agreement was abolished to be replaced by what we know as the modern foreign exchange market.

Soon after, the introduction of computer monitors allowed obtaining trading quotes via phone and telex to be replaced

by modern digital means. When internet was introduced in the mid-1980s, the forex market really took off as this allowed investors to have real-time information to make decisions. This also allowed the speedier execution of these decisions. And the rest is history, as they say!

The Forex Market vs. the Stock Market

It is important that the differences between the stock market and the forex market be known to an investor who is trying to transition from stocks to forex. This was something I learned when I first entered the forex market back in the late 2000s. I had been under the mistaken assumption that the two worked in similarly ways and all I had to do was use the same thinking and strategies that I did on the stock market. I was wrong and that mistaken assumption set me back slightly until I righted my thinking and strategies. Luckily, you do not have to go through the trial and error that I did. This section is dedicated to highlighting the differences between the two markets and what adjustments need to be made to be successful on the forex market.

The first major difference between the forex market and the stock market is that the forex market does not have a central marketplace like stock markets do. Foreign exchange is done in an electronic over-the-counter (OTC) method. The over-the-counter method describes how securities are traded for companies that are not listed on a stock market like the New York Stock Exchange. Instead, trade is facilitated via a broker-dealer network whereby individual investors or firms buy and sell securities on their own or on behalf of customers.

Simply put, this means that foreign exchange trades are facilitated via the internet and computer systems globally rather than a centralized location. While the stock market is highly digitalized, there are still central locations such as on

Wall Street in New York where two of the major stock markets of the world exist.

Another noticeable difference between the forex and stock markets is the volume of trades that are conducted. The stock markets combined on a global level roughly trade about $200 billion in securities every day. The forex market far exceeds this trade volume and trades approximately $5 trillion every day. This trade volume is concentrated on major currency pairs like USD/JPY, GBP/USD, EUR/USD and AUD/USD.

The forex market's high trade volume has a number of benefits for investors which include being able to trade closer to the price that they want as well as having orders executed at a faster speed. The high liquidity of this market ensures that trades are entered and exited quickly. Being able to enter and exit positions quickly allows for better risk management as well as ensuring that an investor is more likely to profit from his or her investment.

The liquidity of the forex market is largely attributed to the low spreads between major currency pairs. This also lowers the cost of doing business on this market when compared to the stock market. One of the ways in which trading on the forex market lowers the cost of doing business is by not having as many commission fees compared to doing business on the stock market. Most forex brokers do not charge commissions. Instead, they earn their fee by getting the difference between the buy price and the sell price, which is known as the margin on the spread. This encourages a high level of transparency on the foreign exchange market as these spreads are quite publicly made.

Another major benefit to trading on the forex market compared to trading on the stock market is that it allows the investor to have a narrower focus, and thus be more likely

to earn a profit. The stock market has thousands of options to choose from at any given time while the forex market has eight major options that most investors choose to focus on. The most traded currencies globally are the:

- Australian dollar (AUD)
- British pound (GBP)
- Canadian dollar (CAD)
- European dollar (EUR)
- Japanese yen (JPY)
- New Zealand dollar (NZD)
- Swiss franc (CHF)
- U.S. dollar (USD)

Focusing on these eight major currencies on the forex market allows an investor to place his or her attention on these economies. As these currencies are traded in pairs, the investor can analyze the market for converging and diverging trends to match up these currencies in pairs that allow for better profit.

The two markets do have some similarities, however. The factors that drive price movement is one such similarity. Just like the stock market is affected by natural disasters, international relations, macroeconomics and country specifics like the unemployment rate and the prevailing interest rates, the forex market is also affected by these.

Forex vs. Stocks
Whether or not a trader chooses to invest in the forex or stock market is greatly dependent on his or her goals and his or her trading style. Below we will discuss a few trading styles and whether or not they are best applied to forex trading or stock trading.

The first trading style that we will explore is scalping. This is the trading style where trades are closed within a day. These

trades sometimes only last as long as only a few minutes. Investors take advantage of small price movements to make a profit and therefore, rely on the volatility of the market. While this practice can be very profitable, if a beginner trader is not aware of the nuances that go into making this profitable, he or she can lose more money than he or she gains.

As a result, it is recommended that scalping be applied to forex investing due to the inexpensive nature of entering positions. Scalping when it comes to forex investing is also known as beginner-friendly because it does not require a huge capital investment to start. In fact, most of the time, a forex trader only needs enough capital to maintain a margin account's requirements.

If a trader wants to hold the positions for at least one day or a few days, medium-term trading is recommended. This style of trading is attractive to persons who have a lower budget but still want to make larger trades. While it is very much attainable to earn a great profit from this strategy, the trader must be great at technical and fundamental analysis to be able to recognize trends on the market. Technical and fundamental analysis take time to consider especially if a trader is new to the investment game. As a result, medium-term trading is suitable for both forex and stock trading as it does not rely as heavily on volatility or liquidity.

On the other hand, if an investor is looking to gain success from long-term trading, stock trading may be more suitable for this form of investment. As I speak of the long term, I am referring to holding a position between a few months and a few years. Before going into such a position, there needs to be a thorough analysis and research of trends in the initial stages. However, as a long-term venture, these types of

investments do not require analysis throughout the term of the trade.

Long-term investing requires a larger capital as it is necessary to be able to cover volatile movements during the trade. Still, an investor is looking for steady growth in one direction or stability on the market to win over the long term. Foreign exchange tends to vary more in directions compared to stocks.

How to Trade Forex

As seen from the comparison above, forex trading is best implemented for short to medium term investments. There are two primary types of traders that use these methods of forex trading and they are known as hedgers and speculators.

Forex Hedging

Hedgers are traders who are looking to profit from stability on the market and are therefore, avoiding extreme price movements. The act of hedging involves buying or selling securities to offset or balance the trader's current position to reduce risk. As it relates to forex hedging the process involves strategically opening additional positions so that the trader is protected against movements on the foreign exchange market that do not benefit the position. While there is no definite protection against risks on any financial market, hedging on the forex market helps to minimize losses.

While hedging is a universal practice in the financial markets, currency hedging is a slightly different ball game when it comes to the forex market, which is in its nature a volatile entity. In fact, some forex traders are strictly against edging because of the belief that volatility is just a part of forex trading but hedging is a very viable strategy when it comes to reducing the amount of risk that a trader is willing to

accept when dealing with forex transactions. For example, if a trader believes that a forex pair will depreciate in value in the near future but will soon reverse that direction, hedging is a viable strategy to reduce the losses that will be incurred in the short term while protecting the profit that will be earned in the long term.

Hedging can be done in multiple ways. The simplest forex hedging strategy involves entering an opposing position to the trader's current trade. This process is known as a direct hedge. A simple scenario example of this includes opening a short position to minimize the risk of a long position on a currency pair. The net profit from such a direct hedge boils down to $0 but the trader gets to keep his or her original position in the hopes that the market will reverse its direction and therefore, be beneficial in the long term. Simply closing the position means a definite plus but direct hedging will allow the trader to potentially benefit when the market moves in his or her favor once more.

There is also the forex hedging practice of opening opposing positions on two currency pairs that are positively associated. A simple scenario to depict this multiple currency hedging strategy involves taking a short position on EUR/USD and hedging the USD exposure by entering a long position on CAD/USD. This strategy would allow the trader to still make a profit on the EUR/USD short position in the future if the Eurodollar were to take a dip in price in the short term. In the short-term, having a long position on the CAD/USD would have taken the loss instead.

This hedging strategy is obviously more complicated than direct hedging and as such it comes with its own set of risks. Unlike direct hedging where losses would have been reduced to a zero balance, hedging with multiple currencies can mean losses that are above zero balance from multiple positions.

236

The final forex hedging strategy that we will speak on is known as a forex option. This financial contract gives the trader the right to exchange a currency pair at a given price on or before the expiration date. Options are a popular hedging strategy because they give the trader the chance to reduce their risk by only having to pay a premium towards the option but not having the obligation to complete the exchange of currencies. If the forex position is in the traders favor then all he or she has to do is exercise the right to his or her option or sell the option to another trader. If the currency prices do not move in favor of the trader, then all here she has to do is cut his all losses with the premium payment and close the position.

If a trader is new to the forex market hedging is a strategy that should be used with caution as it requires a thorough knowledge of not only the forex market but other financial markets. As a result, hedging is a process that is typically used more often by advanced forex traders.

Forex Speculation

Speculators are the opposite of hedgers and are trying to benefit from volatility on the market. These types of forex investors buy and sell foreign currency when conditions on the market are uncertain. The most common practice is to buy currency when it is valued as weak and sell it when it is valued as strong. Speculation is a necessary strategy that helps stabilize exchange rates. This stabilization comes from a balancing act being performed by speculators buying currency when it is cheap to sell it when it is more expensive.

There are some professionals who believe that this act also destabilizes the forex market as forex speculators sell a currency when it is weak with the expectation that it will get weaker and buying currency when it is on the rise with the expectation that it will appreciate even more. This process

can upset the balance of the forex market and cause overvaluation and undervaluation of some currencies.

There are other professionals who believe that the flexibility of exchange rates on the forex market cannot be destabilized by the act of speculation.

There has been many a time that speculation has been likened to gambling but speculation is not about making random trades. Forex investors who use this method look for patterns in the market place to find commonalities about rising and falling prices. They use this information to make predictions on exchange rates in the future. Due to the complexity of getting it right, speculation is not a methodology that is recommended for beginners to try. It is something that is developed with time and experience in the forex market.

Forex Quotes
No matter what method of forex trading a trader chooses to implement, he or she starts off all transactions by reading for forex quotes. A forex quote is the price of one currency relative to the price of another currency. This is why currencies always come in pairs and it involves buying one currency by selling another. Forex brokers earn their pay by quoting two prices of any two paired currencies and pocket the difference between the two prices when the market is functioning under normal conditions. The difference between these two prices is what we call the spread.

All forex quotes have a few basic features that need to be understood by investors who want to gain maximum profit. Three of the most fundamental features are called the ISO code, the base currency and the variable currency.

ISO stands for International Organization for Standardization, which is a nongovernmental organization

238

responsible for providing standards for several industries such as currency, communication, commerce, manufacturing and technology. ISO currency is a three-letter alphabetical code that represents various currencies used throughout the world.

Therefore, the ISO code is an indication that international standards have been applied to global currencies and the abbreviations used on the forex market. These codes and standards allow for the abbreviation of currencies into 3 letters. Common examples include the US dollar being abbreviated to USD and the Euro being shortened to EUR.

The base currency is the first three-letter abbreviation on forex quotes. This is followed by the variable currency and this pairing shows how much of the variable currency is needed to buy one unit of the base currency. For example, if the pair EUR/USD is used on a forex quote, the EUR is the base currency while the USD is the variable currency. The price of exchanging one unit of EUR for USD will be stated. These prices fluctuate on the market and may not be the same today as they were yesterday due to volatility.

While we have stated the eight most commonly traded currencies on the forex market, these are not the only important currencies that will be listed on forex quotes. Other major currencies include:

- Brazilian Real (BZR)
- China Yuan Renminbi (CNY)
- Hong Kong Dollar (HKD)
- Indian rupee (INR)
- South African Rand (ZAR)
- Swedish Krona (SEK)

On the forex quote, currencies will have two different prices listed below them. The first price is the bid price, which is

also known as the sell price. The sell price is the price that traders are able to sell the currency at. The second price is called ask price. It is also known as the buy price. It is the price at which traders buy currency. Traders want to buy forex when the bid price is low and sell when the price rises again. They also want to buy forex that is depreciating to sell it back when it appreciates. As a trader, you will buy currency at the buy price and sell it at the bid price.

The buy price is typically higher than the sell price and the difference between the two prices is what constitutes the spread. The spread allows brokers to earn their fees. The spread tends to be narrower between major currency pairs because the two currencies trade at a high volume and both have high liquidity.

Factors that affect the size of the spread include:

- **Volatility**. Higher volatility tends to widen the spread.
- **Liquidity**. When the market becomes illiquid, the spread tends to widen.
- **Major economic and regional events and news.** Events that are reported in the news like unemployment rates tend to widen the spread when the news is not favorable.

While these factors can indeed have a major impact on the spread, the forex market tends to be quite stable and the spreads tend to revert to the normal within a few minutes if they do move up or down. This is something that traders need to be aware of when considering the spread as a widening spread can lead to a lower profit and a higher cost of doing business on the market. Volatile or illiquid currency pairs tend to widen the spread and so, it is advisable to avoid these as a beginner forex trader. Major liquid pairs are:

- EUR/USD

- GBP/USD
- USD/CHF
- USD/JPY

These pairs do not always trade at low spread but they typically have the lowest spread among all currencies paired on the forex market. This is largely attributed to their high trade volume.

The Pros of Trading Forex

There are many benefits that attract traders and investors to the forex market even if they are looking to do business in the long term rather than the short or medium term. One of the best reasons for investing in the forex market is the low cost of doing business. As mentioned earlier, most forex brokers do not charge commission fees and simply makeup for doing business by benefiting from the spread that is developed from opening and closing the trade. Forex trading is one of the most cost-effective ways of trading.

Forex market spreads are typically very low because currency pairs typically have high liquidity between them.

Lastly, one of the most attractive features that investors and traders to the forex market is leverage. Leveraging is the process of not paying the full amount needed for the trade but instead only having to put down a fraction of the cost upfront. Leveraging has the potential to gather a trader maximum profit. The unfortunate downside is that the risks and returns counter each other and therefore, losses can be just as bad as great profits can be. This needs to be approached with a level of caution and risk management practices need to be implemented for effective leveraging.

The Risks of Trading Forex and How to Minimize Them

One of the advantages of forex trading can also be a double-edged sword as it can lead to losses even though it has the potential to earn traders maximum profit. This is the process of leveraging. While it facilities the possibility of small traders being able to make larger trades, it also means that small traders with smaller accounts can also lose a lot of money by entering these larger trades. This losing amount is not limited to the amount deposited to facilitate the trade.

There is also the risk of quotes not being accurate as there is no uniform convention or standardized way of creating quotes on the forex market. This irregularity can cause a trader to buy and sell at prices that may not be profitable for him or her.

Chapter Summary

Forex stands for foreign exchange. It can also be called FX. Foreign currencies are exchanged on this financial market on a daily basis. Foreign currencies are changed into other currencies and these exchanges occur for several reasons such as trading, commerce and tourism. Currencies are created in pairs such as EUR/USD. Currencies are not the only items that exist for trading on the forex market. Other securities include futures and options.

Unlike the stock market, the forex market operates 24 hours a day almost every day of the week. It opens on Sunday at 5 PM EST and closes on Friday at 4 PM EST. Those extended opening hours are needed because currency exchange is an international event that is needed by international businesses and central banks.

The history of currency exchange dates back to ancient times and is even traced back to ancient Egypt but modern forex

trading really took off after the Bretton Woods Agreement was abolished in 1971. The introduction of computer monitors and the internet in the mid-1980s allowed for the development of the over-the-counter (OTC) method. The fact that the forex market relies on this method and does not have a central marketplace is one of the other major differences between it and the stock market.

Another difference between the two markets is that the forex markets trades a higher volume at an average of $5 trillion every day while the stock markets roughly trades about $200 billion every day. The forex market's trade volume is concentrated on major currency pairs like USD/JPY, GBP/USD, EUR/USD and AUD/USD.

More differences include the fact that the forex market is more liquid than the stock market and it aids in narrowing a trader's focus as there are only eight major currencies to focus on compared to the stock market where there are thousands of options to choose from.

Whether or not a trader chooses to invest in the forex or stock market is greatly dependent on his or her goals and his or her trading style. Many more long-term traders choose to focus on the stock market while short to medium-term investors prefer the volatility and liquidity of the forex market.

There are two common methods of forex trading that are used by such investors. The first method is called hedging. Hedgers are traders who are looking to profit from stability on the market and are therefore avoiding extreme price movements. There are different forms of hedging on the forex market and three of the most common methods are direct hedging, hedging with multiple currencies and using currency options.

The second method is known as speculation. Speculators try to benefit from volatility on the forex market. Speculators buy currency when conditions on the market are changing, typically buying currencies that are valued as weak and selling it when it is valued as strong.

No matter what method of trading forex investors use, reading forex quotes is part and parcel of the trading process. As such, every foreign trader needs to be able to read a forex quotes, which are quotes that depict the price of one currency relative to the price of another currency. All quotes have an ISO code, which is a three-letter alphabetical code that represents various currencies around the world. The quotes also have a base currency and a variable currency, which are the depiction of the pair of currencies that are being exchanged. The variable currency is needed to buy one unit of the base currency.

Forex quotes also show a bid price (also known as a sell price), which is the price traders buy currency at. It also states an ask price (also known as a buy price), which is the price traders buy currency at. The buy price is typically higher than the sell price and the difference between the two prices is what is known as a spread. The spread is what allows forex brokers to earn their fees. The spread is affected by the volatility and liquidity of the market in addition to major economical and regional events and news.

The benefits of trading forex include:

- The lower cost of trading currency pairs
- Liquidity and volatility which typically translates into profits for investors who implement smart strategies.
- The ability to use leverage, which is the process of not paying the full amount needed to facilitate the trade but instead putting down a fraction of that cost. This

process has the potential to earn a trader even greater profits even though it also ups the risk value.

Apart from the greater losses that can be experienced by using the leveraging process, the other disadvantage to the forex market is that the creation of forex quotes are not standardized and this can lead to a trader buying and selling at prices that are profitable for him or her.

Chapter 6: Index Trading

At the beginning of my career, there were a lot of things that I got wrong or just mixed up. Back in that time, getting information via the internet, books, etc. was not as easy as it is now. There were also not many people I could turn to for help. Even when I could ask for help, pride often kept me from doing so because I did not want to appear lacking in know-how. Understanding the differences between stock and indices was one subject that confused me in the early days of my career.

Before I get onto stating the differences between the two subjects, I will touch on how you can get the support that you need as a beginner investor and trader. We all need different types of support systems in every part of our lives including our interpersonal relationships, education and careers. In a typical 9 to 5 job, support comes from coworkers, supervisors and management to name a few but support is not so easy to identify being a trader or investor as this is a largely solitary career, especially if you choose to work from the comfort of your home. There is no one to turn to for guidance many a time.

However, not because the support system is not readily available as a trader or investor does not mean that it cannot exist. You are a business owner and therefore, it is up to you to develop that support system around you so that you not only gain the support of advice from persons who know more than you but also the camaraderie of having like-minded individuals to share and converse with. There is a

246

phenomenon of not knowing what you do not know. There is no way of knowing that you are lacking in knowledge if you do not see the shortfall in the first place. Having that support system around you can allow you to grow faster not only as a trader and an investor also as an individual as constructive criticism and insightful advice can catapult your knowledge and insight in the industry exponentially in a lot less time than if you had to seek this knowledge on your own. Therefore it is critical that you seek the company of other traders and investors to build a solid network of professionals around you. This increased knowledge boosts your confidence in your trading techniques and decisions and by extension, in yourself as an individual.

Even if you are introverted or opposed to person-to-person meetings, social media and online platforms have made it easy to connect with other traders and mentors in the field. It is important that you be active in these mediums to gain maximum value from meeting, sharing and connecting with other traders and investors.

Luckily, I got over my pride and learnt to seek the counsel of traders and investors who had more experience than I did early on in my career. Before social media made socializing on the internet so popular, I began networking and socializing with other traders and investors through business meetings, mixers and other interpersonal ventures. I have even been on a few retreats with other traders and investors.

Even in this advanced stage of my career I still seek counsel from others as I know that knowledge never stops. No one can get enough of it whether they want to be a trader or an investor, or to be proficient in another field. Therefore, soon I was able to clearly distinguish between stocks and indices.

Talking about the stock market and indices seem to be synonymous but while they are intertwined, stock and

indices are not the same things, hence why indices can be traded separately. This chapter delves into what indices are, what index trading is and what are the benefits for trading in this particular security.

What is Index Trading?

To understand what index trading is you have to understand what the stock indexes. A stock index is a representation of the current and historic performance of a group of stocks from one country, sector, currency, bond, commodity or any other method that is relevant to track. The Dow Jones Industrial Average is a popular index and includes 30 of the largest companies in the United States under that one index. 500 US companies are represented by the S&P500 while on the London Stock Exchange, the FTSE100 index represents 100 companies.

Therefore, index trading is the sum of trading a group of stocks that are accumulated through one index. Unlike stock trading, index trading does not require the services of a broker. Trading index is so easy in this day and age that it is most often done through an internet-based platform.

Many investors are attracted to index trading because it does not require as much in-depth research and analysis that individual stock investing does. All the investor has to do is research that one index as opposed to researching the individual companies within that index if he or she were stock investing.

Stock Indices and the Stock Market

Stock indices have been around since 1885. This was when the Dow Jones Industrial Average was initially created. It was created by Charles Dow. He worked on Wall Street and dedicated his time to creating a way to quickly aggregate the economy's performance at that time. The index was created and provided a measure of how the top 30 industries

248

companies in the US were performing. This performance measure also provided a gage as to how the wider economy was performing.

Index trading did not start then though. The trade came about in the 1970s where financial derivatives were introduced to the stock market. Back then, it was mostly practiced by large companies and only the most renowned traders. Technology advances have allowed index trading to be available to the everyday trader as time passed.

With both stock and indices to choose from when it comes to trading on the stock market, a trader might find it hard to choose which one is the right for him or her. Therefore, a fair comparison is necessary.

Stock trading is typically the way to go it the trader already has a particular stock or niche that he or she wants to focus on. This needs to be backed by a solid plan and the trader will be as good as gold. Stock trading is also great if the trader wants to spend more time doing technical analysis and monitoring the economic climate compared to monitoring trading positions.

On the other hand, if the trader wants to have a more hands-on approach to investing their money, index trading is more advantageous than stock trading. Trading indices is based on the movement of the stock market as a whole and therefore, investing in indices is a method that instantly diversifies a trader's portfolio. A single stock trade can never diversify a trader's portfolio. The trader would instead have to research and analyze several different stock types to have the benefit of portfolio diversification.

Also, rather than having a trader bet his or her money on a single company that can face financial hardship in the future, the index allows the trader to bet on an entire industry,

location or sector. This represents possibly investing in hundreds of stock in one transaction rather than a few stock which is typical with stock trading.

One of the best things about indices is that traders can have better assurance that trades will work out in their favor because indices on established markets allow for very little price manipulation. In fact, indices are one of the investment tools on the market that is least prone to manipulation.

Market manipulation is the illegal act of executing exploits that serve to rig the supply and demand system that applies to a particular stock or other type of security on the stock market. This is typically done by criminals who would like to earn extra cash by overvaluing or undervaluing the price of a security. Such criminals act by tricking traders and investors into believing that stock and other types of securities are performing in a certain way then capitalizing on the unawareness of the trader or investor.

Market manipulation can be done in one of several ways. The first way is known as pump and dump. This is the act of giving a trader or investor false or misleading information about a stock or other security in order for it to gain traction. The goal of the criminal is to up the demand so that the price of the stock or other security increases. The hope is that this false information gains attention from potential investors. Once these traders and investors fall for the trick, the criminal will offload the shares of the company into the stock market. Because all the information is false and the stock or other security does not have the value that was stated, traders and investors who fell for the trick tend to lose a lot of money.

Another type of market manipulation is called wash trading. This is the process of a singular major influencer or investor buying and selling the same stock in rapid succession so that

250

it increases in volume on the stock market. This tricks other investors into believing that the value of the stock is rising and this attention increases the activity on that particular stock or other security.

The poop and scoop method of market manipulation is the opposite of the pump and dump. The scammer releases false information about a company or a particular type of security in an effort to have its value be depreciated. The motive behind this is that the scammer would like investors to drop the investment so that they can scoop it up for a lower value than it is actually worth.

The painting the tape method of market manipulation involves a group of scammers banding together to buy and sell a particular security among themselves so that the price becomes inflated. This activity gives the illusion that the security has a lot of activity going on and as such, it gains the interest of other investors. The motive here is to drive the price of the security up so that it can be sold to unknowing investors who have been tricked into believing that the security is worth more than it actually is.

These are only a few ways scammers try to manipulate the system and traders need to be aware of them so that they can avoid being tricked. Luckily, indices are securities that are unlikely to be manipulated in such devious ways because the makeup of indices make it hard to achieve such manipulation. Because indices are spread across companies, industries, countries and more, it is not feasible to use the methods listed above to manipulate the value because the reach of these criminals is limited. Instead, they typically target one type of stock, one company or a set of individuals.

Indices also allow the trader the power of leveraging. The trader can start trading indices by making a deposit rather than paying the full value of the investment. Remember that

this can be a double-edged sword though as while it can allow for magnifying profits, it can also do the same for losses.

Calculating Stock Indices

Call me crazy but I like to turn things over in my head and calculating mathematical equations gets my juices flowing. Thus, the complexity of calculating index values is not a task I hate even though I have heard many a trader baulk at the idea of being confronted with performing such a job.

When calculating the price of indices, there are three approaches that can be taken. Each method is fundamental when it comes to evaluating the performance of the index in question and depends on the type of index involved. Each method of calculation is discussed below.

Price-Weighted Indices

One of the best-known price-weighted indices is the Dow Jones Industrial Average. Price-weighted indices are valued based on the trading price of the individual securities that make up the entire index. These individual securities are known as components. Due to the nature of these types of indices, their prices are driven up by higher-priced components of the index because their price is slanted higher than securities with lower prices within the index. Let us better depict this with an example. If a lower-priced component within the index moves from $10 to $20, this will not drive the price of the index up significantly. On the other hand, if a higher-priced component moves from $200 to $210 then the price of the index will be impacted more greatly.

Even though this type of index is impacted more greatly by the higher-priced components, every individual security within that index makes up a fraction of the value of that index. The value of such an index is calculated by totaling

the value of each security within that index then dividing that number by the number of companies within that index. From that calculation, you can see why higher-priced securities drive the price of such indices higher as their contribution holds a greater weight. This is why price-weighted indices are used to track the average stock value within a given industry or market.

The formal equation used to calculate price-weighted indices is as follows:

Total Members Stock Price in Index / Total Members in the Index = Price Weight

Market-Value-Weighted Indices

These are also called capitalization-weighted indices. With these types of indices, each component within the index is weighted relative to the total market capitalization. Therefore, large-cap companies or companies with larger market capitalization have a greater impact on the total value of an index compared to small-cap companies or companies with smaller market capitalization. Examples of capitalization-weighted indices are the NASDAQ and the S&P 500.

The function of such an index is to depict the values that change proportional to the price change of each component that makes up an index. Such weighted indices also factor in the shareholder base of each component within the index.

Capitalization weighted indices are calculated using the following formula:

(Market Capitalization Components / Total Index Market Capitalization) x 100% = Capitalization Weight

Unweighted Indices

Unweighted indices are the opposite of weighted indices, which allows securities within the index to have more contribution than others. Within an unweighted index, each unit of security carries equal weight and therefore, no one security's performance will have a more significant contribution over the other securities in that index.

One of the best-known unweighted indices is called the S&P 500 Equal Weight Index (EWI). It is the unweighted version of the more popular and more widely used S&P 500 Index. Unweighted indices are not a common tool found in the stock markets. Most indices are based on market capitalizations. Market capitalization describes the dollar value of a company's total number of outstanding shares of stock. This value is calculated by multiplying the total number of outstanding shares by the current market price of one share of stock.

The question of which is better – weighted indices or unweighted indices – often comes up and the answer to that is neither tops the other. They simply have different purposes. While a weighted index shows the index's performance typically on a market capitalization scale, unweighted indices are used to show the unweighted performances along the individual components that make up the index.

The disadvantage of having a weighted index is that its value is largely based on the higher-weighted components and so it does not give due diligence to the smaller components that make up the index. The higher-weighted components can give the appearance that an index is performing better than it actually is because these few higher-weighted components can be performing well while the majority of the other components are not doing as well. Many argue that this point

is moot because companies with smaller performances typically open and close at the drop of a hat. As such, it is believed that they should not be given as much weight as larger companies that typically hold the higher-weighted components.

Unweighted indices provide a better depiction of how the entire pool of securities within an index is doing and so allows an investor who is not as heavily invested in the higher-weighted components to better examine both lower-weighted and higher-weighted factors in the index.

In either case, sometimes weighted indices perform better than unweighted indices and other times, unweighted indices perform better than weighted indices. It all depends on the volatility and performance of the stock market.

Index Trading vs. Forex Trading

Between index and forex trading, the market an investor or trader chooses to pursue depends on his or her trading style and whether they are looking to make a profit in the short-term or the long-term. This dependency is created by the different natures of these two markets.

The forex market is a highly volatile market and as such, it can be difficult to predict the influence of outside factors that can cause fluctuation in the currency pairs. On the other hand, successful index trading is based on making predictions across a broad movement in the market. This requires more stable conditions.

Due to these natures, forex trading is more suited for short-term investing using the scalping technique. This technique is best for volatile conditions and low spreads between the paired currencies. Index trading is more suited for long-term investing because the spreads on indices are normally higher and indexes are relatively stable on the market.

Another factor that determines whether a trader or investor should pursue index trading or forex trading is his or her knowledge of the individual markets. If you better understand currency movement, then the forex market is your best bet. On the other hand, if you understand a particular sector or niche, then index trading is probably better for you to pursue.

Index Trading Strategies

The index trading strategy that a trader or investor chooses to employ depends on a number of factors such as how quickly this person wants to see a return on his or her investment and his or her risk tolerance. We have mentioned that scalping is one of the techniques used popularly by forex traders but it too can be applied to index trading. The short-term nature of scalping means that the trader or investor opens and closes trades within a few minutes. Because these trades are so short, profitability per trade is usually small as well. This means that a trader has to trade a high volume to make a profit that is significant.

Index trading can also be practiced through day trading, which is the act of opening and closing trades within a day. This is longer than scalping.

Another popular strategy for approaching index trading is swing trading. This longer-term strategy can last for a few days or up to a few weeks. This is the type of strategy that beginner index traders typically use as it allows for less of a hands-on approach while still allowing enough room for sufficient monitoring of the trader's position. Unlike with day trading and scalping where the trader or investor needs to monitor his or her position at all times, swing trading is not concerned with small fluctuations throughout the day but rather it is concerned with riding a trend over a longer period. Because indices are concerned with economic cycles,

swing trading is best suited for trading indices. Fundamental analysis is more widely used with this technique compared to technical analysis.

The Benefits of Trading Stock Indices

Trading stock indices allows a trader to bet on the movement of the stock market as a whole rather than on individual stocks. This instantly diversifies the trader's portfolio.

The other benefits of index trading include:

- The risk of bankruptcy is removed. An investor can lose his or her investment if the company invested in goes bankrupt. This risk does not exist with index trading because the investor is not investing in a single company but rather in a group of companies. An index cannot go bankrupt. As a result, even if one company comprised within the index tanks, the index will still continue to perform well if the market conditions are permitting it to do so.
- The risks are lower with indices compared to most other trading tools. Even though indices are susceptible to volatile conditions on the market, especially when there are natural disasters, changes in the economic and political events, index trading is still something that tends to have stable conditions.
- Index trading allows for good money management. Index trading allows for diversification and by virtue, allows the investor to spread his or her eggs across multiple baskets in one fell swoop.
- Indices are low manipulative investment tools. The prices of indices change based on price fluctuations across the companies that make up the basket of securities. Therefore, indices are less prone to be involved in scams developed to manipulate the market.

The Disadvantages of Trading Stock Indices

I have said it before and I will say it again... Anything on the financial markets of the world comes with its own set of disadvantages no matter how great it is and the same holds true for index trading. One of the disadvantages of index trading is that it has a higher cost of doing business compared to other investments like forex trading. Brokers charge fees for facilitating the trade.

Trading hours are also limited unlike with the forex market. Indices are traded on the stock market can only be access through limited opening hours unlike forex, which traded 24 hours a day five days a week. Because of the stock market's closing times, there will be more gaps in indices unlike with forex.

Last and not least important is the fact that stock indices are less liquid compared to other investment tools like forex.

Chapter Summary

A stock index is a representation of the current and historic performance of a group of stocks from one country, sector, currency, bond, commodity or any other method that is relevant to track. The Dow Jones Industrial Average is a popular index and includes 30 of the largest companies in the United States under that one index. 500 US companies are represented by the S&P 500 while on the London Stock Exchange, the FTSE100 index represents 100 companies.

Therefore, index trading is the sum of trading a group of stocks that are accumulated through one index.

When it comes to comparing stock trading and index trading, stock trading is typically the way to go it the trader already has a stock or particular niche that he or she wants to focus on. Stock trading is also great if the trader wants to spend

more time doing technical analysis and monitoring the economic climate compared to monitoring trading positions.

On the other hand, if the trader wants to have a more hands-on approach to investing their money, index trading is more advantageous than stock trading. Trading indices is based on the movement of the stock market as a whole and therefore, investing in indices is a method that instantly diversifies a trader's portfolio.

When calculating the price of indices, there are three approaches that can be taken. They depend on the type of index and include:

- Price-weighted indices, which are valued based on the trading price of the individual securities that make up the entire index. Due to the nature of these types of indices, their prices are driven up by higher-priced components of the index because their price is slanted higher than securities with lower prices within the index. The value of such an index is calculated by totaling the value of each security within that index then dividing that number by the number of companies within that index.
- Market-value-weighted indices, which are also called capitalization-weighted indices. With these types of indices, each component within the index is weighted relative to the total market capitalization. Therefore, large-cap companies or companies with larger market capitalization have a greater impact on the total value of an index compared to small-cap companies or companies with smaller market capitalization. Capitalization-weighted indices are calculated using the following formula: (Market Capitalization Components / Total Index Market Capitalization) x 100%

- Unweighted indices, which are the opposite of weighted indices Within an unweighted index, each unit of security carries equal weight and therefore, no one security's performance will have a more significant contribution over the other securities in that index.

Swing trading is the longer-term strategy that many beginner index traders typically use as it allows for less of a hands-on approach while still allowing enough room for sufficient monitoring of the trader's position. This is opposed to shorter-term strategies like scalping and day trading.

Benefits of trading indices include:

- Instant diversification of the trader's portfolio due to a group of securities being invested in at the same time.
- The risk of bankruptcy is removed as an index cannot go bankrupt and the trader does not lose his or her investment if one company within the index goes bankrupt.
- The risks are lower with indices compared to most other trading tools because they tend to have stable conditions.
- Index trading allows for good money management.
- Indices are a low manipulative investment tool.

Some of the disadvantages of trading indices include:

- It has limited opening hours as it is traded on the stock market.
- There can be more gaps in indices due to the closing hours of the stock market compared to other investment tools like forex, whose market has longer trading hours.

- Indices are less liquid compared to other investment tools like forex.
- The cost of doing business can be higher with index trading compared to other investment tools.

Chapter 8: Futures Investment

Futures are derivative contracts just like options. They derive their value from the security associated with the contract. These types of contracts specify the terms of an agreement to buy or sell an asset at a date in the future at a particular price. I initially invested in futures because I wanted to hedge a position that I had so that the risk was minimized. We will get to how you can use futures to hedge against losses while the market is experiencing volatile conditions later in this chapter. Still, futures are more commonly used as a speculative tool.

There are a variety of securities that can be traded using futures. The most common is stocks but physical commodities, bonds, forex and even the weather make the cut when it comes to futures. No, you did not read that wrong. The weather can be traded on the stock market via the medium of futures. The weather plays a big part in everyone's life. It can determine whether you have a good day or a bad day. The impact extends past the personal. Weather also has an impact on economic activities and how companies operate on a daily basis.

In this age of technology, it only made sense that there be a financial tool that allowed companies to mitigate the risks against the weather. Therefore, the weather derivative was developed. The weather derivative is a trading tool used by companies to hedge risks that are related to the weather. This is facilitated by the seller of the derivative offering to bear the risk if a natural disaster occurs or extreme weather

phenomenon and caused damage to the company's bottom line for the price of a premium. If no damage occurs before the contract expires then the seller gets to keep the premium, hence making a profit. If there is damage done to the company's infrastructure or its operations through a natural disaster, then the buyer of the derivative makes a claim and the seller has to deliver the amount agreed to in the contract. The tourism, agriculture and travel industries are often affected by natural disasters in negative ways and so, weather derivatives are commonly used in such industries. Weather derivatives work very similar to insurance. The difference lies in the fact that insurance only covers low-probability occurrences like hurricanes and earthquakes while weather derivatives cover higher-probability occurrences like weather that is rainier than expected and thus, impacting the performances of a business.

As you can see from that example, futures contracts can be big business and as result, they are most often used by trading companies, hedging funding and extremely wealthy investors.

Still, the common investor can delve into the futures pool. By virtue of having a broker account, any trader or investor can trade futures. In fact, it is highly advisable that a trader or investor consider futures if he or she wants to gain exposure to unconventional securities like the weather.

While options and futures are similar, they differ in a fundamental way. While options give the holder of the contract the option to buy or sell the associated security by the expiration date, futures require that the holder execute the action. The buyer of the futures contract *must* buy or sell the security as specified by the contract.

Here are two examples to relate the differences between options and futures. Let's start with the options example and say that a woman wants to invest in the real estate industry. She wants to buy a property she saw close to the lake with an idea that she will turn the property into an apartment complex. This is owned by a gentleman named Steve and she approaches him even though she is unsure that she wants to go through with the exchange. Steve proposes that the two people enter an options agreement that will allow the woman the right to buy the property any time within the next year for $500,000. She has no obligation to follow through with buying the property in that time.

The woman agrees to this and pays Steve a premium of $10,000 for that right. As a result, if at any point before the year is up she decides she wants to buy the property, she can do so at the agreed upon price of $500,000 even if the value of the property exceeds that price. She can also decide that she does not want the property after all and walk away from the agreement, just the price of the premium poorer.

Now, let's look at a futures example. A jam-making company wants to lower the risk to the business by locking in the price they receive for strawberries, the main product used to make the jam. As a result, they approach their main supplier and enter into a futures contract with the strawberry supplier to buy a certain amount of strawberries. The contract states that they have to buy the strawberries at the price stated on the contract in 6 months. The supplier gladly takes on the contract because this is a guaranteed income as the jam-maker must buy the quantity of strawberries specified in six months. The jam maker is happy because the company is guaranteed the supply of strawberries to continue production. This has drastically reduced the risk that production will be interrupted.

As can be seen from the scenario above, futures facilitate a transaction between a buyer and a seller. The buyer agrees to purchase the security specified in the contract at a certain price at a specific date. Unlike options where the buyer has the choice of whether or not he or she will fulfill the contract by the expiration date, futures mean that both parties are obligated to sell or buy on the expiration date of the contract.

Even though physical commodities like oil, corn and rice are commonly traded in futures, the most actively traded futures contracts are stocks. Their popularity arises because these are highly liquid, have tax advantages and can be used in the process of leverage easily. Futures contracts are even more liquid than option contracts and an investor does not have to be concerned about time decay, which occurs with options contracts.

The Anatomy of a Futures Contract

Futures contracts are wide and varied with many types of assets attached. They also very in the length of expiration dates. However, because they are regulated and have a standard format, they are consistent in the way that the contracts are set up. All futures contracts have an associated security, the quantity of that security, an expiration date and a defined leverage. Let us take a look at each component of futures contracts.

The associated asset is what the price of the futures contract is derived from, hence why the tool is called a derivative contract. As a result, the specifics of the associated security are needed to measure the value of the trade being made between the buyer and the seller. Apart from stocks, popular securities attached to futures contracts include precious metals, forex, agricultural commodities and energy products.

The quantity of the associated asset being discussed in the contract is a huge factor as it determines the size of the

265

contract. Quantity speaks to the number of units of the associated asset that is being sold or bought. Futures with larger quantities are more expensive to trade.

Just as with options, futures contracts have an end date called the expiration date. This is a date in the future, of course. The expiration date is the final day in which the terms of the contract can be executed. After the expiration date has passed, the terms of the contract must be settled as the agreement outlined. For example, as our strawberry jam manufacturing scenario has shown, if the date of expiration falls on November 12th, then the strawberries supplier must supply the jam manufacturer with the specified quantity of strawberries on that date.

The price of the futures contract is determined by the open market and reflects the value of the associated asset at the time that the contract is set up. The contract summarizes the quantity to be bought and sold at a specific price that will not change no matter how the value of the associated asset changes by the time the expiration date comes around. The futures contract also clearly states the currency in which the trade must be made.

Leveraging is also a feature that is commonly used in trading futures contracts. This means that a trader can use a margin account to facilitate the trade. Therefore, he or she only has to make a deposit on the price of the contract in order to initiate the transaction.

The delivery of the associated asset specified in the futures contract also needs to be outlined. Even though futures contracts are closed out on the expiration date, delivery of the asset can extend beyond this, especially in the case of physical commodities and trades that involve a cash settlement.

I have taken the time to explain each feature of a futures contract because sound education is the key to success with this type of investment. Ignoring the specifics of the contract can be detrimental to your bottom line as a trader or investor. Therefore, it is pertinent that a trader be meticulous when it comes to exploring the details that are outlined by a futures contract before he or she enters the trade position.

A trader also needs to ensure that the futures contract that he or she is trading has been standardized so that the futures contract can be traded on exchanges such as the Chicago Board Options Exchange and the Intercontinental Exchange. The body that standardizes futures contracts in the United States is the Commodity Futures Trading Commission.

How to Get Started Trading Futures

Getting started with trading futures is a relatively simple process just as it is with stock trading. Of course, creating a trading plan is necessary and the trader or investor needs to open an account with a broker to support the trades that he or she plans to make. The broker service needs to be a careful consideration as there is no standard commission or fee structure in place for trading futures. Some brokers charge more than others. The trader or investor needs to look out for his or her bottom line and ensure that fees and commissions are kept to a minimum.

To be a futures trader, you either fall into the category of hedgers or speculators. No matter the process used for pursuing futures contracts, the ultimate goal of the speculator or hedger is to gain a profit or to avoid loss. This person capitalizes on the uncertainty that lies in the future and so turns this uncertainty into an opportunity.

Futures Speculation

The process of futures speculation involves trying to gain a profit from price volatility in the market. In other words, speculation involves making a profit from price changes of the associated security. This is typically the process used by investors and traders.

The name comes from the fact that the trader or investor is speculating on the direction in which the price of the asset will move. The speculator makes a profit from the price of the associated asset rising above the original contract price at the date of expiration. On the other hand, if the price of the associated asset depreciates in value then the trader or investor stands to make a loss.

Futures Hedging

The process of hedging futures involves anticipating the movement of futures market with the ultimate goal of wealth preservation by eliminating unknown risks. The hedger wants to prevent losses from potentially unfavorable price changes. This is a drastic comparison to speculators who are betting on the rising of the price of the associated asset. Producers, farmers and bankers are typical examples of persons who use the process of hedging futures contracts. An example of this is a farmer who uses futures to lock in a specific selling price for future crops. This action reduces the risk and guarantees that the farmer will receive a particular selling price in the future even if the price of the crop decreases by the time the expiration date arrives.

The Pros and Cons of Trading Futures

Some of the benefits gained from trading futures is reliant on whether the trader or investor is using a hedging technique or a speculation technique. If a speculator is trading futures then the benefit is that this person can benefit if the price of the associated asset moves in a certain

268

direction. If the trader or investor is a hedger then this person benefits by using futures to protect the price of raw materials or products that they plan to sell from detrimental price movements.

Another potential benefit of using futures contracts is that it can be facilitated through the process of leveraging. Therefore, the trader or investor only has to put forth a fraction of the total cost with the broker to initiate the transaction.

As great as futures are, of course they also have their downsides. The first potential disadvantage is that fluctuations in asset prices can occur during the length of the contract. These fluctuations can be quite extreme in either direction. There are any number of factors that can cause these price fluctuations and some of them include economic changes, natural disasters and geopolitical issues. Such extreme price fluctuations will send the futures market into a spiral.

The risk of slippage is also a very real disadvantage of pursuing futures. It is typically a result of volatility on the market. Price slippage is the resulting difference between the expected price of a trade and the price at which it is actually executed. Price slippage can also occur if the buyer makes a large order but the volume at the specified price cannot be maintained at the current bid/ask spread. It should be noted that price slippage does not necessarily have to be a negative thing. Price movement in either direction still counts as slippage. So, this is also a double-edged sword that can work in the favor of the trader or against the trader.

The ability to leverage the transaction can also turn against the trader. Risk goes up exponentially when this process is used just as it allows the trader to gain more profits.

Remember that proper risk management techniques need to always be employed so that these potential downsides can be avoided as much as possible. Money management techniques, portfolio diversification and the implementation of commands such as stop-loss orders are all strategies that allow risk to be mitigated and minimized. No matter what type of tools that you choose to invest in, risk management should always be at the forefront of your mind.

Chapter Summary

Futures are derivative contracts just like options. They derive their value from the asset associated with the contract. These types of contracts specify the terms of an agreement to buy or sell an asset at a date in the future at a particular price. The body that standardizes futures contracts in the United States is the Commodity Futures Trading Commission. There are a variety of securities that can be traded using futures. The most common asset is stocks. However, physical commodities, bonds, forex and even the weather make the cut when it comes to futures.

While options and futures are similar, they differ in a fundamental way. While options give the holder of the contract the option to buy or sell the associated security by the expiration date, futures require that the holder execute the action. The buyer of the futures contract *must* buy or sell the security as specified by the contract.

Futures contracts are wide and varied with varying terms like the types of assets attached and the length of expiration dates. However, because they are regulated and have a standard format, they are consistent in the way that the contracts are set up. All future contracts have an associated asset, the quantity of the asset, an expiration date, the price that the asset will be bought at, delivery terms and a defined leverage.

Getting started with trading futures is a relatively simple process that is likened to getting started with trading stock. The trader or investor needs to have a solid trading plan in place. Then he or she needs to approach a broker. The broker service needs to be a careful consideration as there are commissions and other fees attached to trading futures. The trader or investor needs to ensure that the costs of doing business is kept to a minimum.

To be a futures trader, you either fall into the category of hedgers or speculators. The process of futures speculation involves trying to gain a profit from price volatility in the market. In other words, speculation involves making a profit from price changes of the associated security and so this technique is typically used by investors and traders.

On the other hand, futures hedging is a process that is normally used by producers, farmers and bankers. The process of hedging futures involves anticipating the movement of futures market with the ultimate goal of wealth preservation by eliminating unknown risks. The hedger wants to prevent losses from potentially unfavorable price changes.

How a futures investor or trader benefits depends on the strategy that he or she uses to pursue such contracts. The speculator benefits from the price of the associated asset moving in a certain direction while a hedger benefits from the protection of adverse price movement. Both speculators and hedgers can benefit from the use of the process of leveraging when it comes to trading futures.

The potential disadvantages of pursuing futures contracts include:

- Price fluctuations of the assets can occur due to external factors like natural disasters and geopolitical events.
- Price slippage can move against the trader.
- The process of leveraging can magnify the risks just as much as it can increase profits.

Avoiding and minimizing these risks are often quite doable as long as the trader keeps in mind risk management practices like money management, diversification of portfolio and the implementation of commands like stop-loss orders.

Chapter 9: Cryptocurrencies

The story I bring to you in this section is not my own. Rather, it is the story of how my teenage daughter turned a $2000-birthday gift from my wife and myself into a $100,000 profitable investment. My daughter has always had a good head on her shoulders. She was a bookworm and a computer fanatic from an early age. For her 16th birthday, she did not ask for a car like other kids her age normally did. Instead, she said she wanted to follow in my footsteps and become a successful trader. Of course, that was a proud moment in my life and my heart melted. But instead of turning to the stock market like I did, my little girl had her eyes set on cryptocurrency. Therefore, she asked for a $2000 gift from my wife and myself so she could wade into the digital marketplace.

The cryptocurrency market was not one I had participated in and I admit, that I was skeptical that my daughter would be as successful as she thought at first. But I remembered that I too got my start when many people were doubtful that I would make a success out of a career on the stock market. I refused to be the naysayer that got in the way of her dream.

After I got past my pessimism, I did some research on the cryptocurrency market and realized the profit that could be earned from just having the right equipment! This market allows for creating a currency from scratch. No other financial market offered that possibility and the sky was the limit.

I was amazed and proud that my daughter had the foresight and innovation to want to invest in such a market. Of course, my wife and I gladly give her the gift that she asked for.

My daughter is 20 years old now and not only has she turned that $2000 investment into $100,000 in less than one year, but she is also now a proud online business owner. Her pursuit of this financial market enticed me to explore it as well and I, too have benefited from investing in the cryptocurrency market.

I would love to claim that my daughter's story is an extraordinary one but the truth is that there are thousands of investors who have earned a fortune from investing in the cryptocurrency market. Most of these investors came in early in the cryptocurrency game but there is still hope for persons who invest in that market to find profit even today. The rest of this chapter is dedicated to explaining what cryptocurrency is, how cryptocurrency works and how you can get your foot into the market.

What Is Cryptocurrency?
A cryptocurrency is a form of currency that allows exchanges of goods and services online using payment facilitated through digital algorithms. This form of online payment is so popular that many companies have produced their own currencies, which are called tokens. These tokens are used to exchange goods and services specifically provided by that company. These tokens are likened to casino chips as real currency needs to be exchanged in order to access the good or service paid for.

Cryptocurrency is a baby compared to the other financial tools that are available on the financial markets of the world. Cryptocurrency only came into existence about a decade ago. In 2008, the domain name called bitcoin.org was registered and assigned to a mysterious man called Satoshi

Nakamoto. This person was the designer of the Bitcoin, which is the first ever cryptocurrency created. Interest in Bitcoin gathered after the publication of a paper that was called *Bitcoin: A Peer-to-Peer Electronic Cash System*.

Only a few months later in 2009, the first ever bitcoin transaction was verified between Nakamoto and Hal Finley, who was a computer programmer. 10 bitcoin (BTC) were exchanged. This was a small amount but the huge milestone laid in the fact that the transaction was completed successfully.

Even though a major vulnerability was exposed in 2010 when bitcoin was hacked, this was also the year that Bitcoin got a monetary value. A bitcoin user was able to swap 10,000 coins for two pizzas. That was quite a steal as 10,000 bitcoins are worth millions of dollars today.

Due to the popularity of Bitcoin, other cryptocurrencies started to emerge in 2011. Such popular cryptocurrencies included Namecoin, Swiftcoin and Litecoin.

Since that time, cryptocurrencies have seen a lot of development even though at one point, it operated on two separate networks. This separation led to a drop in the value of the cryptocurrency. Even the powerful Microsoft Corporation entered the cryptocurrency game. Cryptocurrency is continually being integrated into the infrastructure of the payment processing systems of many websites and even the physical locations of many businesses. Bitcoin ATMs were introduced in 2016. In 2017, Japan passed a law that allows Bitcoin to be accepted as a legal form of payment while Norway allowed the integration of bitcoin accounts in banks. Norway also allowed Bitcoin to be recognized as a form of asset investment and payment system.

With so many accomplishments within such a small time and growth still expected, the cryptocurrency market has been a game-changer and shows no sign of slowing down.

Types of Cryptocurrencies

Bitcoin has become the standard by which other cryptocurrencies are created and operate. Its success, of course, demanded that other cryptocurrencies be introduced into the market. Since Bitcoin's launch over a decade ago, many other cryptocurrencies have entered the market and some of the most popular include:

- **Litecoin (LTC),** which is a cryptocurrency that was launched in 2011 as an alternative to Bitcoin with many of the same feature such as being open source and decentralized. The two cryptocurrencies operate using different algorithms and, in many ways, Litecoin is believed to have surpassed Bitcoin as it often features faster transaction times and has a higher coin limit compared to Bitcoin.
- **Ripple (XRP),** which is a cryptocurrency that was released in 2012. It is different from Bitcoin because it also serves as a digital payment network.
- **Ethereum (ETH)**, which is a currency that was released in 2015. It is slightly different from the traditional Bitcoin structure and allows for tracking digital currency transactions as well as running code for decentralized applications.

There is a long list of cryptocurrency applications in addition to these listed above. In fact, there are more than 2000 cryptocurrencies available for buying and selling. A few more are Tether (USDT), Monero (XMR), EOS (EOS), Libra (LIBRA), Zcash (ZEC) and Stellar Lumen (XLM).

How the Cryptocurrency Market Works

Cryptocurrency is not issued or backed by a central authority like a government like traditional foreign exchange currencies are. Therefore, cryptocurrency markets are said to be decentralized. Due to this nature, cryptocurrencies are sold and bought via exchange and storage mediums known as digital wallets. There are five main types of digital wallets and they are called mobile wallets, online wallets, hardware wallets, paper wallets and desktop wallets. A wallet is not a requirement if cryptocurrency is simply being traded and not bought, stored or sent.

The function of cryptocurrency is facilitated using a technology called blockchains. Records of ownership of the cryptocurrency are stored on individual blockchains. The records of transfers between cryptocurrency users via digital wallets are also stored on the blockchain. The transactions are only finalized when they have been verified and added to the blockchain in a process that is called cryptocurrency mining. Records of ownership of the cryptocurrency are stored on a blockchain.

A blockchain is a digital form of recorded data. As it relates to cryptocurrency, this recorded data involves a transaction history of this particular unit of cryptocurrency including how it has changed ownership over time.

The function of blockchains is to record each transaction detail in blocks. New blocks are added to the front of the chain every time they are created. These blocks become linked together by complex computer and mathematical sciences that are called cryptography.

Blockchains are not normal computer files. They have a unique set of features that set them apart. They are also not stored on individual computers. Instead, they are stored on multiple computers across a huge network that allows them

to be readable by everyone that has access to this network. This feature allows cryptocurrency to have a transparent nature. In addition, it makes it very difficult to manipulate. The difficulty for altering cryptocurrency is not just based on human interference but the defense also lies against software invasion. Due to the complex nature of the links between the blocks, attempted invasion and manipulation are easily recognized by the computers within the network and alarms are sounded.

Cryptocurrency Mining

Cryptocurrency mining allows for the production of new cryptocurrency tokens. The process includes checking recent cryptocurrency transactions in addition to creating new blocks that will be added to the blockchain.

Remember that transactions in cryptocurrencies are only finalized when it is verified to be in the user's wallet. Until then the transactions are posted as pending within a pool so that it can be checked to verify that the sender has sent sufficient funds to the receiver so that the transaction can be completed. This verification system checks the transaction history stored within the blockchain well as confirming that the sender did indeed authorize the transfer of cryptocurrency from their wallet. Senders can only transfer funds using a private key that is unique to every owner of cryptocurrency.

The generation of new blocks involves the use of high-tech computer systems that compile valid transactions to create said block. This requires very sophisticated hardware and software so that the cryptographic links can be generated. Only after the computer is successful in generating the link is it added to the blockchain file. This is then updated to the network.

278

The Difference between Digital Currency and Cryptocurrency

Cryptocurrencies are often mistakenly described as digital currencies but the two are not synonymous. Digital currencies are monies used to pay for goods and services via the internet. Digital currencies do not have a physical equivalent but they act in the same way that physical, traditional money does. Digital currency can even be exchanged into other currencies. Digital currencies have no political or geographical borders and can be used to pay for any number of goods and services.

With such qualities, it is easy to see why digital currencies are often confused with cryptocurrencies. But they are not one-in-the-same. Cryptocurrencies do not have a physical equivalent and are entirely powered by computer algorithms. While they are used increasingly to pay for real-life goods and services, they do not yet have the extended reach that digital currency has. While they are used increasingly to pay for real-life goods and services, they do not yet have the extended reach that digital currency has.

There are a few other critical features that differentiate cryptocurrency and digital currency. The first critical difference is that digital currencies are centralized, unlike cryptocurrencies. Digital currencies are regularized by government agencies and the transactions are confined to a network in central locations like banks. Cryptocurrencies are not regularized by governmental agencies. Instead, they are regularized by the communities within the network.

Due to being centralized, digital currencies have a central authority that deals with any issues that arise. Therefore, the central authority can cancel transactions upon request from

the participants and even freeze accounts. Cryptocurrency is not handled in this way as there is no central authority.

Because of the centralized nature of digital currencies, there are legal frameworks that surround the function. Cryptocurrency does not have official status in many countries even though this may soon change as many governments and regulatory authorities gain a better understanding of the nature of blockchain technology.

The final difference between the two currencies is that digital currency is nowhere near as transparent as cryptocurrency. There is no way of tracking all the transactions that a digital currency has been through from the time of its inception. This information is confidential and kept under lock and key. On the other hand, cryptocurrencies have full transparency so any and every one can see all transactions made on a blockchain.

Factors That Affect the Cryptocurrency Markets

The cryptocurrency market is driven by supply and demand and is not as heavily impacted by political and economic events like traditional currencies. This is due to its decentralized nature. Cryptocurrency is a new market and is still in its infant stages. Therefore, there is a lot of uncertainty that surrounds the market despite the lower impact of traditional factors. Still, there is no denying there are particular factors that cause prices to move up and down.

As mentioned, supply and demand is the biggest factor because demand is only as strong as the supply, which is the total amount of coins that are available and the rate at which they are created, destroyed or lost.

Cryptocurrency has had such a fast growth because of how it is portrayed by the media and the huge amount of coverage that it caught in its infantile state. Therefore, the

press that cryptocurrency has and the future amount it will get also determines the growth of the market.

Other factors that affect the cryptocurrency market include:

- Market capitalization, which speaks to the value of all the coins that exist on the cryptocurrency market and how the cryptocurrency users across this network perceive the development of the market.
- Milestone events, which can include economic setbacks, potential breaches in security and the update of regulation of cryptocurrency. All of these have an impact on the relevancy and the ease with which the cryptocurrency market can operate.
- The ease of integration of cryptocurrency into existing e-commerce payment infrastructure.

How to Trade Cryptocurrency

Cryptocurrencies are not traded in single units. Instead, they are traded in batches called lots. Each lot contains token numbers of different sizes. Lot sizes tend to be on the smaller side though. They can be as small as just one unit of the base currency. Cryptocurrencies are traded in this way because they are very volatile entities.

Cryptocurrency is a derivative investment tool that can be speculated using accounts set up through a broker. To invest in cryptocurrency, the trader will be provided with a quote that is stated in traditional currencies like USD or GDP. It should be noted that even though traders purchase these investment tools, cryptocurrencies themselves can never be owned. The investor can only benefit from the value of the cryptocurrency.

Cryptocurrency quotes present two prices which are the buy price and the sell price. The difference between these two prices is the spread. When presented with these two prices,

a trader has one of two options. The cryptocurrency trader can choose to open a long position and trade at the buy price, which will be slightly above the market price of the cryptocurrency. The trader also has the option of opening a short position and trading at the sell price, which is slightly below the market price of the cryptocurrency involved.

Cryptocurrencies are also products that can be leveraged and so, the trader can open a position and make a deposit instead of paying the full value of the trade upfront. If you choose to do this, just be mindful of the risks that go with this benefit!

The process of trading cryptocurrency is actually speculative due to the fact that the trader does not actually buy tokens or coins. The trader is placing a future prediction on the price of the cryptocurrency.

Cryptocurrency can be invested in several ways. For example, there are cryptocurrency futures available for trading in addition to there being ETFs on the cryptocurrency market. A cryptocurrency trader can choose to pursue one of these types of trading in that market or can use a combination of methods to benefit. Making a profit just takes a keen eye to notice trends in the cryptocurrency market. For example, if the market is bullish an investor or trader can look into investing in cryptocurrency futures.

Chapter Summary
A cryptocurrency is a form of currency that allows the exchange of goods and services online using payment through digital algorithms. This market is decentralized. That is, it has no physical headquarters but is confined to a network of computers around the globe. The cryptocurrency market is a young market that was only founded in 2008. Despite this, the cryptocurrency market has seen

exponential growth since that time and is even legally accepted as a form of payment in some countries.

Cryptocurrency is not issued or backed by a central authority like a government like traditional foreign exchange currencies are. Therefore, cryptocurrency markets are said to be decentralized. Due to this nature, cryptocurrencies are sold and bought via exchange and storage mediums known as digital wallets.

The function of cryptocurrency is facilitated using a technology called a blockchain. Records of ownership of the cryptocurrency are stored on a blockchain. The records of transfers between cryptocurrency users via digital wallets are also stored on the blockchain. The transactions are only finalized when they have been verified and added to the blockchain in a process that is called cryptocurrency mining. Cryptocurrency mining allows for the production of new cryptocurrency tokens. The process includes checking recent cryptocurrency transactions in addition to creating new blocks that will be added to the blockchain.

Blockchains are not normal computer files. They have a unique set of features that set them apart. They are also not stored on individual computers. Instead, they are stored on multiple computers across a huge network that allows them to be readable by everyone that has access to this network.

It should be noted that cryptocurrency is not digital currency. The two currencies have a few fundamental differences. Digital currency is money that is used to pay for goods and services online as well but while they do not have a physical equivalent, they act in the same way as physical money. For example, they can be exchanged into other traditional currencies like the US dollar. Cryptocurrency cannot be directly exchanged into other currencies because they are strictly powered by computer algorithms.

Another notable difference is that digital currencies are centralized and regularized by government agencies. Transactions are confined to a network of central locations like banks. Cryptocurrency is not regularized by any governmental agency and does not have a central location. It is only regularized by the communities that exist within the network. Being centralized also allows digital currencies to have a central authority, unlike cryptocurrencies. This centralization also allows digital currencies to function within a legal framework. Cryptocurrency does not have official status in many countries even though there are plans in the work for governments and regulatory authorities to change that.

Last but not least is the issue of transparency. There is no transparency with digital currencies as all information is kept confidential and private by the authorities that handle it. On the other hand, cryptocurrency has full transparency as one anyone in the world can see all transactions that have been made on a blockchain

The cryptocurrency market is driven by supply and demand. Other factors that affect the cryptocurrency market include:

- Market capitalization, which speaks to the value of all the coins that exist on the cryptocurrency market and how the cryptocurrency users across this network perceive the development of the market.
- Milestone events that can include economic setbacks, potential breaches in security and the update of regulation of cryptocurrency. All of these have an impact on the relevancy and the ease with which the cryptocurrency market can operate.
- The ease of integration of cryptocurrency into existing e-commerce payment infrastructure.

Cryptocurrencies are not traded in single units. Instead, they are traded in batches called lots. Each lot contains token numbers of different sizes. Lot sized tend to be on the smaller side though, sometimes being as small as just one unit of the best currency. Cryptocurrencies are traded in this way because they are very volatile entities.

Cryptocurrency quotes present two prices which are the buy price and the sell price. The difference between these two prices is the spread. When presented with these two prices, a trader has one of two options. The cryptocurrency trader can choose to open a long position and trade at the buy price, which will be slightly above the market price of the cryptocurrency. The trader also has the option of opening a short position and trade at the sell price, which is slightly below the market price of the cryptocurrency involved.

Cryptocurrencies are also products that can be leveraged.

The process of trading cryptocurrency is actually speculative due to the fact that the trader does not actually buy tokens or coins. The trader is placing a future prediction on the price of the cryptocurrency.

Cryptocurrency can be invested in several ways. For example, there are cryptocurrency futures available for trading in addition to there being ETFs on the cryptocurrency market.

Conclusion

We have finally reached the end of this book. I know that this was a lot of information to digest but I believe in giving my readers the maximum value every single time. Knowledge is power and I want you to be armed with all the information needed to take the first steps necessary for implementing the techniques and strategies outlined.

The great thing about having this book in your possession is that you can always go back and refer to sections that you need clarification on or to refresh your memory. In fact, I suggest that you read this book more than once to solidify the concepts in your mind before you place them into practice. Highlight sections and make notes. Make notes on areas that you would like to research further.

The Stock Market and the Other Financial Markets Can Be Your Ticket to Financial Freedom

I told you my origin story as a trader. I was the guy who started knowing nothing about the stock market or any other financial market. I was a complete novice. I doubted myself and my ability to do this gig...

I was also the guy able to stumble my way through the dark in a time where information was not as readily available as it is today to become a successful trader who has accumulated millions of dollars in his almost decade long career as a trader and investor. Because of my humble beginnings, I know for a fact that anyone can use the stock market and other financial markets to elevate their lives to

the standard that they would like rather than what is being handed to them on a regular 9 to 5 job. Even if you have stable financial holdings, investing in the financial markets can elevate your position even more. Nothing is stopping you from achieving the success that you want in your financial life except you.

However, my advice is not given to rush you into trading in the financial markets. In fact, if you feel the need to rush, I implore you to stop, take a breath and allow your brain properly analyze the situation. Learning to control your emotions is critical to finding success as a trader and investor.

The first investment that you need to make is in yourself. Performing the actions and strategies outlined within this book will do you no good if you are not mentally and emotionally ready to handle the responsibility because it is not all sunshine and rainbows.

There are challenges and there can be pitfalls when investing and trading in the financial markets of the world. You need to be prepared for the stumbles that you will ultimately face and you also need to be able to put your game face on and tough it out so that you can see the rainbows and the sunshine at the end of the road.

I am not saying any of this to scare you. In fact, I encourage as many people as possible to invest in the financial markets of the world. I am simply preparing you for the reality of what it means to be an investor and trader on these markets.

The Stock Market and Its Limitless Possibilities

The stock market is founded on the simple units known as stocks. It is amazing that something so small can drive a trillion-dollar industry and can allow some persons to add billions to their financial portfolio. Stock investment makes it

easy to allow you to gain ownership of bigtime companies, to earn extra income yearly, to spread your money wide so that not all your eggs are in one basket and more. What other tools can you think of that allows such progress in one fell swoop?

This one investment tool is also so convenient to trade that you can do it from the comfort of your own home with just the tools of a computer and an internet connection to fall back on. Getting started is as easy as developing a trading plan and approaching a broker for guidance. After some paper trading, you can get your feet wet by actually trading on the stock market in mere weeks. You do not have to take up formal education or have a fancy degree to start trading on the financial markets. The friend who introduced me to the stock market was a high school drop out! His success story nails it in harder that anyone from any background can make this career a success.

The stock market is the medium that facilitates this. It is a place where you not only buy and sell stocks but also invest in other tools such as ETFs, indices, futures, mutual funds, options and more. The financial markets are ever-fluid and ever-changing. You can go to sleep experiencing one set of conditions and wake up to find that the conditions have completely turned around. This constant activity creates a hub for possibility and opportunity. It is what creates challenge and excitement in this career. It is what gets mine and other investors and traders' blood pumping. This movement allows someone with a small account to grow into someone who has millions of dollars in their account.

Do You Have What It Takes to Invest in the Stock Market?

Being a trader or investor is a business. It takes entrepreneurial skills, innovation and grit. You need to be

able to harness these traits so that you can manifest your maximum potential. Therefore, you need to do some soul searching and introspection. You need to know if this career is really for you. Ask yourself these questions:

- Do you have a vision of what you want your future to be like when it comes to realizing your financial goals and dreams?
- Are you motivated and willing to put in the work necessary to make those goals and dreams come true?
- Are you willing to adopt a growth mindset and continually seek learning?
- Are you prepared to take on the risks that inevitably come with starting your own business and the influences these risks have on your activities in the stock market and other financial markets?
- Are you willing to adapt your mindset, behavior and traits to achieve the life you want?
- Are you prepared to disregard the negative opinions of others when it comes to achieving your dreams?
- Are you prepared to step into a whole new world with new challenges, new possibilities and the potential for unlimited growth and income?

I hope that you answered yes to at least 90% of these questions. If you answered no, I offer no judgment because this is not a career that is suited for everyone. I did not write this book to sell anyone on anything that is not meant for them. I wrote it to appeal to people who can actually find value in the advice written in these pages, who had their interest whet and who felt a resonance to change their life by using the global financial markets.

Is that person you?

I cannot answer that question for you. Only you can answer it truthfully. So look deep within you. If the answer is yes, welcome to this prestigious club of traders and investors. You have a friend in me!

Closing Remarks

My final words are dedicated to the person who answered YES! I know that this can be a daunting path to pursue for a beginner. Even more experienced traders and investors are faced with moments when they feel overwhelmed. The trick I discovered as a beginner is to not allow analysis paralysis to keep me immobile. You will never get results from inaction. The only way to know if this will work out for you is to start doing it.

Start with your trading plan. Write down your dreams and goals. Do not hold back or censor yourself. If you want to be able to own 20 acres of land, an expensive vintage car, a retirement fund that allows you to travel the world, the security of having your kids' college fund in the bag… write it all down. Nothing is too outrageous for your dreams.

Research the particulars of how you can make these dreams come true and create goals. Develop an understanding of how the financial markets can help you tick milestones off your goals list.

This is not a step to skip because it puts the power of visualization on your side. Tease your mind with what could be and soon you will develop the attitude that tells you your dreams should be.

Once your trading plan is in order, you can see the steps needed to make your trading and investing journey as smooth as possible. I want to reinforce the fact that you can make a success out of trading and investing in the stock market and the other financial markets no matter where you

are in your life. Anyone can because anyone can develop the traits needed to be a successful entrepreneur. Success is not something that is handed out. Rather it is something that is earned through dedication, hard work and commitment. It is about believing in yourself and following through with consistent and persistent action. It is not enough to read this book. You have to gather more knowledge. You have to be hungry to change your life. So read more books, follow more experienced traders, follow the news about the financial markets, listen to podcasts, watch videos... The list of ways you can increase your knowledge is endless.

I implore you to give your feedback on how this book helped you. Leave a review on the website where you made the purchase so that you too can pay this good knowledge, advice and guidance forward! It also helps me improve the content so that you and other beginner investors and traders can benefit even more.

Good luck with your journey to financial freedom. Please do get in touch and share your story. I would love to hear from you.

Day Trading Options
(Trading Academy Book 3)

Most Complete Course for Beginners with Strategies and Techniques for Day Trading for a Living

By

Mark Robert Rich

Introduction

Day trading options gives you control of your income and your time. Your future and destiny are in your hands. You can learn what works and what does not in as little as one day. That is the nature of day trading options. It moves fast. Results are seen within hours. You can discard and adopt strategies fast. How many careers can you say allows you to see huge results in so little time? You do not have to wait months — or worse, years — to know what works for you.

I can personally attest to the wonders that this career has made in my life. I was struggling to get by at one time. I was behind on the bills and down on my luck. I was on the verge of hitting rock bottom but that was precisely where I was meant to be because desperation sent me searching for a solution to my woes. My solution: day trading options.

It was tough getting my feet wet at the beginning but I stuck with it and I could not be happier for the benefits I gained.

The Benefits of Day Trading Options
Here are just a few of the advantages that day trading options has allowed me:

- **Affordability**: Stocks and mutual funds are items worth investing in, but they can be pricey to purchase. Trading options allowed me to enter that market without buying such assets outright. This was done at

a significantly lower cost and still afforded me the benefits of being in the business.

- **No obligation**. I did not have to buy or sell anything unless it benefited me to do so. The risk was significantly lower compared to owning the assets associated with options.
- **Diverse Portfolio**. Because I do not have to buy actual assets, I can dabble in several investment opportunities at once to see what works for me and what does not. I can use the capital that I do have to increase my profit rather than worry about increasing the worth of all these assets.
- **Gaining increased profit from assets that I do own**. Day trading options allows me to leverage the assets that I do own and gain income from them.
- **Longevity**. Trading options is a part of the financial market that is amazingly resilient and can even thrive in volatile situations.

Day trading options is not something that is a one-size-fits-all. Different people have different experiences with it. I believe it takes a special kind of person to put in the work, time, effort and dedication that is needed to be a successful options day trader. Only you can answer to whether or not you have got the right stuff for this career. This book was written to help you figure that out.

What You Will Learn In This Part of the Book

This part of the book is not a textbook nor is it written for professional options day traders. It was written to help someone who is new to options and day trading discover this exciting career and ultimately make a decision on whether or not this career is right for him or her to pursue.

This **part 2** is a comprehensive guide on day trading options and a quick review of some important aspects about Options.

It's always good a quick and effective review for memorizing the concepts.

You will find:

- What options are
- The types of options
- How option premiums are priced
- What it means to be an options day trader
- How to get started as an options day trader
- The ins and out of the trading market
- The best day trading option strategies
- The power principles every options day trader needs to know
- The rules for success as an options day trader
- So much more!

The explanations in this part are straight-to-the-point with no fluff or unnecessary additives. Every word was written to create value on how to get started with options and day trading and how to create longevity with both.

Day trading options is a business. It is a venture that is made for someone who wants to start a new business or build their wealth by investing in new techniques that work in this modern global economy. It is not something that is made for playing at. Either you make a serious commitment to master it or move onto something else that you can make that kind of commitment to. You need to be serious about using this as a tool to set up the kind of future you want, financially and otherwise. When day trading options is done right, it allows you to use your time the way you want rather than being chained to a desk all day or any other 9 to 5 job. If you want to travel the world and explore new cultures, then this career should be a serious consideration. If you want the freedom to dictate what you do with your time, then this career should be an option for you. If you want an income

that far surpasses anything you can earn in the regular grind, then this career is for you.

But it will not just happen. You have to make this work for you, and that ability is what separates amateur options day traders and the professionals. This ability is not an obscure thing. It is attainable with persistence, consistency and dedication. Nothing is preventing you from capturing that success for yourself except you.

Turn the page to learn how day trading options can improve your life.

Chapter 1

Options Basics

Obviously, to become a master at day trading options you need to master options itself. This chapter is dedicated to giving you the basics of what you need to know to master the concepts of options such as the basic types of options, the anatomy of an options contract, what it means to go long and go short and the benefits of trading options compared to other types of investments.

What are Options?

Stocks and options are often confused by persons who are not involved deeply in the financial market but the two things have completely different characteristics. Stocks are a representation of ownership in individual companies. They can also be components of options.

Stocks are so popular because they represent a great investment opportunity for someone who is looking for a long-term profit yield and has the capital to invest. They are also a great investment tool for someone who would like to experience that steady growth in profit without having to keep a day to day eye on that investment.

As great as the investment in stocks is, it also comes with risks. The hope that an investor makes when investing in stocks is that the price or value will rise so that he or she obtains profit from that increase. The nature of stocks is that they can rise and fall at any time and an investor can completely lose his or her investment if stock prices plummet to zero, which can happen at the drop of a hat. Stocks are volatile entities from day to day because they are very reactive to world events such as natural disasters, wars, politics and more. As a result, an investor needs to be very picky about how he or she chooses to invest in stocks, and even that is not a soundproof process because there is no telling what can happen with stocks.

Fortunately, there is a safety net that an investor can use to ensure that this loss is kept to a minimum while still being able to reap the benefits and profits of owning stocks and other types of assets. This safety net is called trading options.

In the most basic terms, an option is a financial contract. Its main purpose is to facilitate the right to buy or sell an asset that is associated with the contract by a certain date at a specific price. The person who obtains this right is known as the holder or the investor of the contract. The person who sells this contract is known as the seller.

The contract is called an option because the holder of the contract is under no obligation to exercise this right by the date specified. This specified date is known as the expiration date. The asset associated with such a contract is typically stock but this is not limited to that type of asset only. ETF, also known as exchange traded funds, indexes, currencies and even physical commodities can be the asset associated with options.

More specifically, options are called derivative contracts because they derive their value based on the value of the asset attached to that contract. This means that the seller of the option does not have to own the associated asset. At the most basic, the seller just needs to have enough money to cover the price of that associated asset to fulfill that contract if the holder chooses to exercise the right to buy or sell. There are even situations where the seller will offer the holder of the contract another derivative contract in circumstances where this is easier to provide than the asset itself. This makes options a very versatile tool for both buyers and sellers.

The specific selling or buying price mentioned in the definition of an option is also called the strike price. It is so named because this is the price at which the trader will strike his or her right if the asset value moves in the direction that he or she would like. It remains the same for the length of the contract.

Types of Options
The two main types of options are called call options and put options. We will address the specifics of each type below.

Call Options
Most commonly just simply called a call, this type of option allows the trader of the option the right to buy the associated asset on or before the expiration date. The reason that anyone would be interested in buying the attached asset is because the price is expected to rise within the lifetime of the option. As a result, the profit lies in the price of the asset going above the strike price. The seller makes a profit from the trader paying him or her a premium for that option. In the event that the asset does rise in price then the buyer of the option has the right to exercise the option to buy the asset or sell the option. Both strategies lead to a profit for

300

the buyer. In this scenario, the buyer has the potential for unlimited income while the seller's income is limited to the premium paid for that option.

The terms that describe whether or not a trader has made a profit include in the money, out of the money and at the money. In the money describes the situation whereby the asset price has gone above the strike price. This is favorable and describes a profitable situation for the trader. Out of the money describes the situation whereby the asset price has fallen below the strike price resulting in a loss from the option. At the money means that the asset price is equivalent to the strike price and so the trader does not profit or lose from the option.

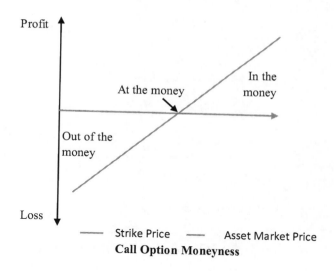

Call Option Moneyness

Put Options
Also commonly called a put, this type of option gives the trader the right to sell the asset attached to the contract at the strike price on or before the expiration date. Just like with a call option, the strike price is predetermined with this type of option. The trader is in the money when the price of

the asset goes below the strike price of the option. Only if the price goes down does the trader make a profit. If the asset price goes up then the trader is out of the money and therefore, makes a loss. If the asset price is equivalent to the strike price by the time the expiration date rolls around then the trader is at the money.

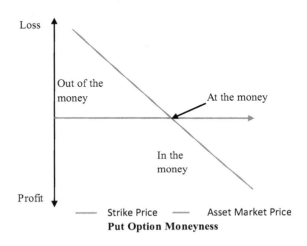

Put Option Moneyness

If the trader is in the money by the expiration date he or she has the option to sell the asset associated with the option by a fixed time or sell the option to someone else.

Going Long vs. Going Short

While they are polar opposites, going long and going short both describe the state of ownership of the asset associated with the option. Going short is also known as having a short position. It describes the state of the seller not owning the asset associated with the option. Going long is also described as having a long position. It means that the seller owns the asset associated with the option.

There is another application of long and short positions and it applies to both call and put options. Having a long call

option means that the trader expects the price of the asset to go up so that he or she can benefit. The opposite is true for having a long put option. The trader expects the price of the asset to depreciate so that he or she can exercise the right to sell the option at the strike price.

As you can see, neither of these options refer to the time period associated with that option. Rather, the focus is on the ownership of the associated asset. As such, the person who owns the asset is called the long position holder. If this person expects the price of the asset to rise, then this is called having a bullish view. This applies to a trader holding a long call option.

If this person expects the price of the asset to fall, this is known as having a bearish view. This is the scenario where a trader has a long put option.

Option Premium Prices

The pricing of options is not a one-size-fits-all scenario and it can become rather complicated. There are pricing models that can help both sellers and buyers of options come up with a fair price and that list includes:

- **The Black-Scholes Model.** This is typically used to calculate European options.
- **The Binomial Option Pricing Model.** This is typically used to calculate American options.
- **Monte-Carlo Simulations.** Not only used in the finance industry, this pricing option also calculates option premiums by allowing the consideration for multiple outcomes, unlike the first two pricing models.

All of these models make calculations possible by factoring in certain stipulations. These conditions rely on factors that include:

- The value of the associated asset.

- The intrinsic value, which is the current value of the option and the potential increase that this option has over a specific amount of time. The intrinsic value is found by determining the difference in the current price of the associated asset and the strike price of the option.
- The time value, which is the extra amount that a trader is willing to pay if the option expires a few months away. It is the combination of intrinsic value and time value that make up the cost of an option premium.
- Volatility, which describes how likely that prices are to change on the financial market over a specific amount of time.
- Dividends, which are the distribution of fractions of a company's profit at a specific time period.
- Interest rates, which are a percentage charged for the use of money lent over a specific amount of time.

Trading Options Benefits
Trading options is a great investment opportunity because:

- The initial cost of getting started is lower than your typical investment opportunity involving the financial market.
- It costs less to invest in stock options compared to investing in buying stocks. This allows the trader to benefit from being in the same financial market as a stocks trader without actually paying for stocks upfront. This process is called hedging.
- Trader profit has the potential to be unlimited as it is linked to the rise and fall of the value of the associated asset.
- The trader or seller is not required to own the asset associated with the option to benefit from its value.

- The trader is under no obligation to actually buy or sell the asset associated with the contract unless this is beneficial to him or her.
- The strike price remains fixed throughout the length of the contract so the trader does not have to worry about fluctuating prices.
- The options trader has great flexibility and several options. For example, there is the option to sell the same option to another investor or the option to exercise the right to buy or sell the asset.
- A trader can sell options on assets that he or she already owns to earn a passive income through premium payments.

Trading Options Disadvantages

As with anything that deals with finances, there are of course downsides to balance the advantages. The same is true of trading options. Some of the disadvantages of trading options include:

- Options are short-term investments with expiration dates that can be as short as one day long to only a few months long. This means that the trader needs to be on the ball with an exact strategy to profit from options. Options are typically not suited for an investor looking for long-term investments.
- There are additional costs associated with trading options apart from premium payments such as commissions to brokerage firms, etc.
- Trading options can expose the seller to unlimited losses because he or she is under contract to buy or sell the associated asset within a specific time frame if the trader decides to exercise the right to the option.
- An options trader need to be qualified by a brokerage firm before he or she can begin to trade options.

As you can see the benefits far exceed the disadvantages when it comes to trading options.

Chapter Summary

An option is a derivative financial contract that allows an investor to have the right to buy or sell the asset associated with the contract by an agreed-upon expiration date at a predetermined strike price. There are two main types of options and they are called call options and put options. Call options allow the trader to exercise the right to buy the asset associated with that contract while put options allow the trader to exercise the right to sell the associated asset by the expiration date.

Options traders also have the choice of having a long position, which is described as the seller having ownership of the asset attached to the contract, or a short position, which is described as the position of the seller not having ownership of the asset attached to the contract.

Pricing options premiums can become a complicated affair and typically relies on a pricing model to be determined. Common pricing models include the Black-Scholes Model, The Binomial Option Pricing Model and Monte-Carlo Simulations. These pricing models are typically based on factors such as the value of the asset, the intrinsic value of the option, the time value of the option, the volatility of the financial market, dividends and interest rates.

There are several advantages to trading options and they include a relatively low initial investment, no obligation to buy or sell the associated asset, flexibility, the potential for unlimited profit for the trader and the ability to earn passive income. Many traders choose to invest in options because these advantages outweigh the potential downsides of trading options, which include the short-term nature of such

investments, having to become qualified to begin trading options and the seller's exposure to unlimited losses.

Chapter 2

Day Trading Options Basics

There is more than one way to approach options trading. For example, there is the option to be a swing trader. A swing trader is one who takes on trading options as more of a part-time venture. On the other hand, if you want to really get in the thick of things then being an options day trader is the right path for you.

What Options Day Traders Do

Unlike swing traders who bet on asset value movement for months and investors who bet on asset value movement for years, an options day trader bet on the movement of asset values for only one day. They open option positions at the beginning of the day and close them by the end of the day and repeat this the next day and the next.

This can seem like a sporadic action to an outside, uninformed looker, but the short-term nature of this action is what makes day trading so profitable for options traders who have mastered the right techniques and strategies. The risk of loss is reduced due to this fast turn of events because the efficient day trader will have a plan and a forecast for the result that will be obtained before opening a position at the start of the trading day.

The downside of this is that the day trader needs to ensure the positions that he or she opens will play out by the end of the trading day. The same factor of short time that makes day trading options profitable can be a hindrance. This is why it is triply important that the day trader chooses the right options to pursue. This person needs to be efficient in this choices because having secure and reliable information is the options day trader's most powerful tool.

Options traders that partake in hedging do so to reduce the outright buying of the associated asset. They benefit from the activities on the financial market without putting down the kind of money that is needed to own the assets that are associated with the particular financial activities. Trading options is just one of the financial activities that makes use of the hedging process.

Options day traders do not hedge. They speculate. While hedgers are trying to protect themselves against asset price changes, speculators are trying to profit from price changes. Options day traders are not trying to benefit from the future of the financial market. Rather, they are trying to benefit from current conditions on the financial market. So instead of trying to protect themselves from losses by managing their positions like hedgers do, they protect themselves with proper money management and the use of limit orders. A limit order is an instruction placed with the options day trader's bid to buy or sell the trader's position when the asset prices moves in a certain direction.

How to Get Started As an Options Day Trader
Before you setup your options day trading business, there are a few things you need to have intimate knowledge of. They are your current financial circumstances, the time you are able to commit to day trading and your risk profile. Create a financial balance sheet that lists your expenses, and

any other income that you obtain. This will allow you to assess your financial health and how much you can invest into options. This also allows you to know what risks you can take while trading options. Never invest capital or resources that you cannot afford to lose and never trade beyond your trading experience level. Becoming an options day trader requires a healthy time investment at the beginning because you need to learn your way around this arena as well as set up a strong foundation for your profile. Do not rush and squander your money in an overzealous move to get started.

Next, before you risk your hard-earned money, learn to trade options on paper. This is called paper trading and allows you to use real-life scenarios to assess your performance when it comes to trading options.

When you are ready to move forward to real-time practice, find a brokerage firm to represent you. Online brokerage firms are growing in popularity but ensure that you properly research the firm to ensure reputability and that you are paying as little in commissions as possible. You may even be able to find a broken that does not charge commissions.

The brokerage firm will help you get set up as a qualified options trader at the level that is relevant for your experience as well as aid in setting up the appropriate accounts. You need to be able to process payments and other financial transfers online before you approach a broker.

Lastly, ensure that you have the tools for the trade. Ensure that your internet connection is fast and reliable. Also, ensure that your computer or laptop has a fast processor and adequate memory to prevent crashes as trading programs rely on a fast-moving computer. Most traders have a need for at least 2 monitors to keep abreast as to what is happing on the financial market.

Planning for Success

Options day trading is a business. You need to treat it as such. You will not wake up one day and just start any other type of business with no plan. Therefore, you need to approach day trading options with the same foresight and planning. Just as you would create a business plan for any other type of business, you need to create a trading plan. This will serve as your guide with step-by-step details on how you will approach day trading options, how you will measure your success and how you will grow your business and income. As a result, here are a few vital categories that need to be developed in your trading plan:

Your Goals

Goal setting it a necessary life skill that everyone needs to learn and it will serve you well in this area. These need to be both long-term and short-term. You need to be very specific. Vague notions like "I want to be as successful as I can be," have no place in your trading plan. Your goals need to be quantifiable and trackable.

Visualize where you want to be in the future and determined what needs to be done to make that mental picture a reality. Next, outline where you feel your career will be in the next 3 months, 6 months, 9 months, 1 year, 3 years, 5 years and 10 years from today as you reach for that ultimate goal. As you are in this to succeed, you need to also outline the income that you would like to make and what you will do with the profits that you make.

Setting your goals also allows you to outline what areas you need to improve your knowledge so that you become a better options day trader. You need to develop a system for rewarding yourself when you hit milestones on your goal's list.

As an entrepreneur, you may find that your goals for your career overlap with your personal goals. This is no cause for concern because you are your business.

Entry into the Options Trading Market
There are several different types of options that a day trader can pursue but it makes no sense to try to pursue all of them as this will stretch you and your resources thin. The best thing to do is pinned down one or two niches that you will pursue at the beginning to find the ones that fit best with you and your trading style. Popular niches that day traders pursue include stocks, foreign exchange and exchange traded funds.

An Efficient Workspace
You need to develop a plan for where you will work as well as the equipment that you will need. This does not have to be fancy. All you need is an adequate internet connection, a computer setup and a working filing system. Ensure that you have plans to upgrade your equipment as needed.

Developing a Time Schedule
Financial markets do not close even though many have set trading hours. Therefore it is up to the options day trader to define his or her work hours. Some options day traders find it best to work in the early morning while others find it best to work late at night. The great thing about trading options is that it is a flexible career and you can trade at almost any time of the day.

It is important to set regular trading hours to ensure that you do not become burnt out and that you maintain your perspective of your career and life. All work and no play leads to sickness. While you are setting working hours, also allocate time off, vacation and sick leave. Working yourself to the bone will remove the sense of fulfillment that you will find with this job. Therefore, finding balance is key.

Personal Development

As you are your business, you need to ensure that you invest in yourself so that you continuously expand your knowledge of trading and develop yourself as an individual. Schedule time for further reading, seminars and other learning tools.

Your trading plan is not set in stone. In fact, it is something that you should continuously evaluate and revise based on the conditions and circumstances that you experience as an options day trader. At the very least, your options trading plan should be re-evaluated once yearly.

The Qualities of an Effective Options Day Trader

As mentioned earlier, it takes a special kind of person to be an effective and profitable options day trader. This is a fast-paced career and, as such, it cannot be done effectively if a person becomes undone easily by stress or has an inability to concentrate on the market and the figures in front of them. This figure needs to develop effective systems to help them keep on track and to make decisions that are not confounded by emotion. In essence, an options day trader needs to be able to keep a clear mind while still being analytical even under the most strenuous mental conditions.

As another pitch to help you know if options day trading is right for you, I have compiled a list of traits that an effective and efficient options day trader must have to be successful.

The first trait is being able to work well under pressure. Emotions can get to a trader in the form of fear, doubt and hope when it comes to trading options. Remember that decisions need to be made with a clear head and these emotions need to be brushed aside because they are not relevant when it comes to opening option positions. The options trader needs to be able to unwind as well because

keeping these emotions pent-up can lead to detrimental mental, emotional and physical health symptoms. This person needs to be able to find ways to get rid of this excess energy and this can be in the form of initiating social contact with other persons outside of trading hours and engaging in physical activities such as yoga, meditation and exercise.

An effective options day trader is also a highly independent person because this person spends most of their time working by themselves. This is an age of technology and, so, day traders do not need to leave their house to be able to perform well at this career. In fact, options day trading can be performed from any part of the world as long as the options day trader has access to internet and a computer. Some people cannot handle the isolation of this career and crack under the pressure. An effective options day trader knows how to channel that energy so that he or she can be productive with the time alone so that time with others can be more enjoyable and filled with quality.

An effective options day trader is an entrepreneur at heart. Being an options day trader means being your own boss. There will be no one hounding you to get things done on time. Therefore, if you cannot handle developing and maintaining an effective schedule to get work done then this is not the career for you. As an options day trader, you need to be able to manage your time effectively so that you make the most profit in as little time as possible.

An effective day trader is also decisive. Remember that many things can happen in the space of a day. An options day trader cannot afford to be paralyzed by over analysis. This person needs to be able to think quickly on their feet and make decisions just as fast because there is no luxury of waiting for tomorrow to make those decisions. An options

day trader needs to be able to seize opportunities as soon as they come.

Chapter Summary

Unlike other types of options traders that assess value movement for months and, rarely, years, day traders bet on the movement of asset values for only one day. They open option positions at the beginning of the day and close them by the end of the day and repeat this the next day and the next.

Before you get started as an options day trader, you need to assess your current financial circumstances, the time you are able to commit to day trading and your risk profile. Also, practice paper trading before committing real money to trading options just so that you get the hang of it before you risk your hard-earned capital.

Ensure that you have a trading plan that outlines your goals, how you will start day trading options and a time schedule. An efficient options day trader also has an effective workspace that at least contains a computer with fast processor and memory, a fast, reliable internet connection and a working filing system.

An options day trader has a few definitive traits to make this career lucrative and they include:

- Being able to work efficiently under pressure
- Being independent
- Being entrepreneurship-minded
- Being decisive

Chapter 3

The Trading Market

You need to know your way around the options market to leverage your daily investments. Many day traders begin with the stock market simply because there are many similar nuances between options and stocks. In fact, trading stocks is what most people immediately think of when they hear day trading. Therefore, it is in every options day trader to become familiar with the stock market as well even though the trader should never confuse the two entities. This chapter is dedicated to gaining you information on the market influences that affect your success.

Deciding What Market to Trade In
Before you jump into the market looking for options to trade, you need to decide what type of assets are good for day trading options. Not doing so will only leave you feeling dazed and confused because the market can seem endless. Yes, stocks are the easy, popular choice but they are not the only choice and they might not be the right choice for you. Futures, forex, cryptocurrencies and even corn are also good options for day trading options. Stock trading is facilitated by the buying and selling of shares in a company's portfolio and day trading stock options means that all positions must be opened by 9:30 AM EST and closed by 4 PM EST on the American stock market.

The future market is one where the contract is created between the seller and the trader to buy or sell a predetermined value of the associated asset at a future date. An options day trader can profit due to the price fluctuations that can happen in the space of a day. The day trader needs to be cautious with the futures market working hours because they can vary. As such, the trader needs to be aware of the time his or her position needs to close.

The forex market is accessible at any time of day and is the biggest financial market in the world. This market allows for the exchange of different currencies.

There are many more markets to choose from when starting your options day trading career but it all boils down to your circumstances and the resources you have available to you. For example, startup fund can be an issue. This is particularly prevalent with the stock market. On the stock market, a trader needs to have an excess of $20,000 on his or her trading account to participate while the forex market allows trades that are as low as a few hundred dollars. Therefore, you can only pursue options in the stock and futures market if you have the capital to back you.

Time is another consideration. Remember that some markets like the stock market only function at certain times of day, some fluctuate in time operation and others operate 24 hours a day.

Strategy is also a factor. We will speak on this in a later chapter but some strategies work best in certain market at certain times of day. Therefore, if there is a particular strategy that a day trader is great at then he or she might have better results in certain markets.

How to Find the Best Options to Day Trade

After you have set your sights on a particular market, then you can move on to determine which particular assets you will pursue options in. You need to be able to pinpoint niches that work and luckily there are systems in place that can help you do that. Such tools include:

Technical Analysis

This is the first tool that we will discuss. It allows day traders to examine market sectors to identify strengths and weaknesses. By identifying those strengths and weakness, the options day trader can narrow down the options niches he or she would like to pursue within a given market.

There are several types of tools for performing technical analysis and they include:

- **Bollinger Band**, which is a measure of market volatility.
- **Intraday momentum index (IMI)**, which is an indicator of how options will play out within 1 day.
- **Open Interest (OI)**, which indicates the number of open options contracts to determine trends in options.
- **Money Flow Index (MFI),** which indicates the flow of money into assets over specific amount of times.
- **Relative Strength Index (RSI)**, which allows the trader to compare profits and losses over a set period of time.
- **Put-Call Ratio (PCR)**, which indicates the volume of the put options relative to call options.

Price Charts

These tools gives visual representation of price and volume information so that market trends can be determined. More precisely known as price charts because they show price

318

movement over a specific amount of time, charts come in different types. Common types include:

Line Charts

These easy-to-interpret charts document price movement over a specific period of time such as months or years. Each price data point is connected using a single line. While the biggest advantage this type of chart is the simplicity, this also causes a disadvantage to day traders as they provide no information about the strength of trading during the day.

The line chart also does not provide price gap information. A price gap is defined as the interval between one trading periods that is completely above or below a previous trading period. This price cap information is critical for options day traders to have to make effective decisions.

Line Chart

Open-High-Low-Close Bar Chart

This type of chart illustrates price movement from highest to lowest over as specific amount of time such as 1 hour or one day. It is so named because it shows open, high, low and close prices for the time period specified. The low to high

trading range is displayed with a vertical line while the opening and closing prices are displayed on a horizontal tab. All four elements make up one bar on the chart and a series of these bars show movement over an extended period of time.

**Example of Single Bar on
Open-High-Low-Close Bar Chart**

This type of bar chart is advantageous as an options day trading tool because it provides information over 1-day trading periods as well as price gap knowledge.

Candlestick Chart
This is the kind of chart that is used by professional options day traders. It is similar to the open-high-low-close bar chart and is represented by price on the vertical axis and time on horizontal axis. As such, it depicts price movement over time.

The structure of the candlestick chart has individual components. They are called candlesticks, hence the name of the chart. Every candlestick has 3 parts. They are called:

- **The body**. This depicts the open-to-close range.

320

- **The wick**. This represents the daily highs and lows. It is also called the shadow.
- **The color**. This depicts the direction of price movement. White or green indicate an upward price movement. Red or black indicate a price decline.

Example of Candlestick on Candlestick Chart

Using the candlestick chart allows day traders to see patterns on the market. There are several types of candlestick charts.

Factors that Affect the Options Market

After you have analyzed the options market and decided on the options that you will pursue, it is time to navigate the market and make a bet on the options you have decided on.

The first thing you need to do is execute a trade. If you are using an online broker as most options day traders do these days, you will make an order through the broker's digital system. When this is done, the options day trader needs to identify whether or not, he or she will be opening a new position or closing an existing position.

After this has successfully been executed, the trade details will be sent to the options day trader electronically.

Factors that affect how the option will play out include interest rates, economic trends and market volatility.

Chapter Summary

An options day trader needs to know his or her way around the options market to be effective at this career. The first thing the day trader needs to do is decide on the particular market that he or she will trade options in. The stock market is a popular choice but it requires a high initial investment and has set hours for options trading.

The futures and forex market are also popular options trading markets with different operating times and lower initial investment amount requirements. These might work better for some options day traders.

After the options day trader has figured out the particular market that he or she will trade options in, he or she has to pick a particular niche within that market to trade options in. Using technical analysis and price charts like the line chart, open-high-low-close bar chart and candlestick chart help options day traders decide on the best options to pursue.

After this decision has been made, the day trader will execute the options trade via the brokerage firm he or she works with. This is typically done online as most options day traders turn to digital means in this age of technology. The success of how this options trade will play out is affected by factors like interest rates, economic trends and market volatility.

Chapter 4

Options Day Trading Styles

No matter what style or strategy an options day trader chooses to use, he or she needs to factor in three important components every single time. These elements are:

- **Liquidity**. This factor describes how quickly an option or other asset can be bought and sold without the current market price being affected. Liquid options are more desirable to an options day trader because they trade easier. Illiquid options create more resistance in the ease at which a trader can open or close his or her position. This extends the time needed to complete the transactions involved and thus can lead to a loss for the options day trader.
- **Volatility**. This describes how sensitive the assets attached to the options is to price changes due to external factors. Some assets are more volatile than others. Stocks and cryptocurrencies are volatile assets. Volatility has a great impact on an options day trader's profit margin.
- **Volume**. This describes the number of options being traded at a specific time interval. Volume is an indication of the associated assets price movement on the market because it is a gage of the asset's interest in the market. The higher the volume, the more

desirable traders typically are in pursuing an option. Volume is one of the factors that make up open interest, which is the total number of active options. Active options have not been liquidated, exercised or assigned. If an options trader ignores taking action on options for too long, this can make circumstances unfavorable, which can lead to unnecessary losses. An options trader needs to always be on the ball about closing options positions at the appropriate time.

To take advantage of the options day trading choices listed below, the day trader needs to be very familiar with these factors and how he or she can use them to his or her advantage.

Breakout Options Day Trading

Breakout describes the process of entering the market when prices move out of their typical price range. For this style of trading to be successful, there needs to be an accompanying increase in volume. There is more than one type of breakout but we will discuss one of the most popular which is called support and resistance breakouts.

The support and resistance method describes the point at which the associated asset price stops decreasing (support) and the point at which the associated asset price stops increasing (resistance). The day trader will enter a long position if the associated asset price breaks above resistance. On the other hand, the options day trader will enter a short position if the associated asset breaks below the supported price. As you can see, the position that the trader takes depends on if the asset is supported or resisted at that new price level. As the asset transcends the normal price barrier, volatility typically increases. This usually results in the price of the associated asset moving in the direction of the breakout.

324

When contemplating this trading style, the options day trader needs to carefully deliberate his or her entry points and exit strategies. The typical entry strategy depends on whether or not the prices are set to close above the resistance level or below the support level. The day trader will take on a bearish position if this price is said to be above the resistance level. A bullish approach is a typical maneuver if prices are set to close below the support.

Exit strategies require a more sophisticated approach. The options day trader needs to consider past performance and use chart patterns to determine a price target to close his or her position. Once the target has been reached, the day trader can exit the trade and enjoy the profit earned.

Momentum Options Day Trading

This options day trading style describes the process of options day trading relying on price volatility and the rate of change of volume. It is so called because the main idea behind the strategy is that the force behind the price movement of the associated asset is enough to sustain it in the same direction. This is because when an asset increases in price, it typically attracts investors, which drives the price even higher. Options day traders who use this style ride that momentum and make a profit off the expected price movement.

This style is based on using technical analysis to track the price movement of the associated asset. This analysis gives the day trader an overall picture that includes momentum indicators like:

- **The momentum indicator,** which makes use of the most recent closing price of the associated asset to determine the strength of the price movement as a trend.

- **The relative strength index (RSI)**, which is a comparison of profits and losses over a set period of time.
- **Moving averages**, which allows the day trader to see passed fluctuations to analyze the trends in the market.
- **The stochastic oscillator**, which is a comparison of the most recent closing prices of the associated asset over a specified period of time.

Momentum options day trading is highly effective and simple as long as it is done right. The day trader needs to keep abreast of the news and earnings reports to make informed decisions using this trading style.

Reversal Options Day Trading

This style relies on trading against the trend and is in essence, the opposite of momentum options day trading. Also called trend trading or pull back trending, it is performed when an options day trader is able to identify pullbacks against the current price movement trends. Clearly, this is a risky move but it can be quite profitable when the trade goes according to plan. Because of the depth of market knowledge and trading experience that is needed to perform this style effectively, it is not one that is recommended for beginners to practice.

This is a bullish approach to options trading and entails buying an out of the money call option as well as selling an out of the money put option. Both profit and loss are potentially unlimited.

Scalping Options Day Trading

This options day trading style refers to the process of buying and selling the same associated asset several times in the same day. This is profitable when there is extreme volatility on the market. The options day trader makes his profit by

326

buying an options position at a lower price then selling it for a higher price or selling an options position at a higher price and buying it at a lower price depending on whether or not this is a call or a put option.

This style of options trading is extremely reliant on liquidity. Illiquid options should not be used with this style because the options day trader needs to be able to open and close these types of trades several times during the space of one day. Trading liquid options allow the day trader to gain maximum profitability when entering and exiting trades.

The typical strategy is to trade small several options during the course of the day to accumulate profit rather than trying to trade big infrequently. Trading big with this particular style can lead to huge losses in the space of only a few hours. This is why this style is only recommended for disciplined options day traders who are content with seeking small, repeated profits even though it is a less risky method compared to the others.

Due to the nature of this style, it is the shortest form of options day trading because it does not even last the whole day – only a few hours. Day traders who practice this style are known as scalpers. Technical analysis is required to assess the best bets with the price movement of the associated assets.

Scalping is an umbrella term that encompasses several different methods of scalping. There is time and sales scalping, whereby the day trader uses passed records of bought, sold and cancelled transactions to determine the best options to trade and when the best times for these transactions are. Other types of scalping involve the use of bars and charts for analysis of the way forward.

Using Pivot Points for Options Day Trading

This options day trading style is particularly useful in the forex market. It describes the act of pivoting or reserving after a support or resistance level has been reached at the market price. It works in much the same way that it does with support and resistance breakouts.

The typical strategies with this particular options day trading style are:

- To buy the position if the support level is being approached then placing a stop just below that level.
- To sell the position if the resistance level is being approached then placing a stop just below that level.

To determine the point of pivot, the day trader will analyze the highs and lows of the previous day's trading and the closing prices of the previous day. This is calculated with this formula:

(High + Low + Close) / 3 = Pivot Point

Using the pivot point, the support and resistance levels can be calculated as well. The formulas for the first support and resistance levels are as follows:

(2 x Pivot Point) − High = First Support Level

(2 x Pivot Point) − Low = First Resistance Level

The second support and resistance levels are calculated with the following formulas:

Pivot Point − (First Resistance Level − First Support Level) = Second Support Level

Pivot Point + (First Resistance Level − First Support Level) = Second Resistance Level

328

The options trading range that is most profitable lies when the pivot point is between the first support and resistance levels.

The options day trader is vulnerable to sudden price movements with his style of trading. This can result in serious losses if it is not managed. To limit losses with this strategy, the options day trader can implement stops to marginalize losses. This is typically placed just above the recent high price close when the day trader has taken on a short position. This is placed just below a recent low when the day trader had taken on a long position. To be doubly safe, the options day trader can also place two stops, such as placing a physical stop at the most capital that he or she can afford to part with and another where an exit strategy is implemented.

Where these stops are placed is also dependent on volatility.

Chapter Summary
No matter what style or strategy an options day trader chooses to use, he or she needs to factor in three important components every single time. These elements are:

- Liquidity, which describes how quickly an option or other asset can be bought and sold without the current market price being affected.
- Volatility, which describes how sensitive the asset attached to the options is to price changes due to external factors.
- Volume, which describes the number of options being traded at a specific time interval.

The different types of options day trading styles include:

- Breakout options day trading, which describes the process of entering the market when prices move out of their typical price range. There is more than one

type of breakout. One of the most popular methods of breaking out is called support and resistance breakouts. The support and resistance method describes the point at which the associated asset price stops decreasing (support) and the point at which the associated asset price stops increasing (resistance).

- Momentum options day trading, which describes the process of day trading relying on price volatility and the rate of change of volume. It is so called because the price movement of the associated asset is enough to sustain it in the same direction. This is because when an asset increases in price, it typically attracts investors, which drives the price even higher. This style is based on using technical analysis to track the momentum indicators like momentum indicator, the relative strength index (RSI), moving averages, and the stochastic oscillator.

- Reversal options day trading, which relies on trading against the trend. It is performed when a day options trader is able to identify pullbacks against the current price movement trends. This style is only suitable for advanced options day traders.

- Scalping options day trading, which is the process of buying and selling the same associated asset several times in the same day. This is profitable when there is extreme volatility on the market. The options day trader makes his profit by buying an options position at a lower price then selling it for a higher price or selling an options position at a higher price and buying it at a lower price depending on whether or not this is a call or a put option. This style of options trading is extremely reliant on liquidity.

- Using pivot points for options day trading, which describes the act of pivoting or reserving after a support or resistance level has been reached at the

market price. This options day trading style is particularly useful in the forex market and works in much the same way that it does with support and resistance breakouts.

These options day trading styles can be mixed and matched so that a day trader knows the ones that work best for him or her and in what combination.

Chapter 5

Trading Options Strategies Every Day Trader Should Know

There are plenty of options trading strategies to choose from. Some are suitable for beginners while others should only be practiced by advanced options traders who know the market well and have the experience to back them. Even if a beginner is advised not to practice a particular strategy at that point in his or her career, being aware that the strategy exists is useful as this allows the trader to be aware of alternatives as well as gives this person strategies to work toward to make their daily trading more efficient and profitable.

The strategies listed below and expanded into an overview have been placed in alphabetical order for easy reference.

Covered Call Strategy
This strategy is also known as a buy write because it relays the fact that this is a two-part process whereby the trader first buys the associated asset then sells the right to purchase that asset via an option. Stock is the most common associated asset with this strategy. The trader lowers the risk to himself or herself because he or she owns the asset and receives a premium payment from the holder of the contract. While the asset may still be in the owner's possession after

the contract has expired if the trader decides not to exercise the right, the owner needs to be willing to part with the asset if the trader does indeed decide to exercise that right.

The profit earned by the seller is achieved if the asset price meets or goes above the strike price on or by the expiration date. This is calculated with this formula:

Premium + (Strike Price - Asset Price) = Potential Profit

This profit is limited.

Breakeven is calculated like this:

Purchase Price of the Asset - Premium = Breakeven

This strategy appeals to many investors because there is guaranteed payment of the option premium whether or not the option holder decides to exercise the right to the option. The seller can set up a regular income stream in markets that are bullish or comparatively neutral. There is also the benefit of the seller being covered from risk due to ownership of the asset.

The risks include the seller losing due to the asset price potentially decreasing below the breakeven point and potentially experiencing an opportunity cost if the price of the asset skyrockets.

Credit Spreads

This strategy describes the selling of a high-premium option while purchasing a low-premium option type, which is a call or put, in an effort to make a profit when the spread between the two options narrows. The options will have the same expiration date but different strike prices, hence the potential for profit.

The appeal of credit spreads is that they have lowered risk if the price movement goes against the trader, making losses limited. The seller benefits from the premium payment.

The disadvantage is that profits are limited just like losses.

There are different types of credit spreads. They include:

- **Bear call spread**, which is a beginner-friendly strategy. It employs a bearish outlook that relies on the price of the associated asset decreasing modestly. The trader buys 1 out of the money call option and sells 1 in the money put option. Profit is gained by finding the difference between the option premium and the commissions paid. Loss occurs when the asset price increases below the strike price.
- **Bull put spread**, which is a beginner-friendly strategy with a bearish outlook that relies on the price of the associated asset decreasing substantially. The trader buys 1 out of the money put option of a higher premium and sells 1 on the money put option of a lower premium. Profit is gained by finding the difference between the option premium and the commissions paid. Loss occurs when the asset price decreases below the strike price.
- **Iron butterfly spread**, which involves 4 transactions. The options trader is buying 1 out of the money call option, selling 1 at the money call option, buying 1 out of the money put option and selling 1 at the money put option, all with the same expiration date and associated asset. This is a complex strategy that is not recommended for beginners.
- **Short butter spread**, which entails 3 transactions. The transactions are buying 1 out of the money call/put option, selling 1 out of the money call/put option and buying 1 at the money call/put option.

They all have the same expiration date and associated asset. This is also a complex strategy that is not recommended for beginners.

Debit Spreads

This strategy describes the buying of a high-premium option while purchasing a low-premium option type in an effort to make a profit when the spread between the two options widen. Just like with credit spreads, the options will have the same expiration date but different strike prices, which leaves the potential for profit.

The benefits of debit spreads include limited losses and being able to better predict losses and profits. The disadvantage is that profits are limited.

There are different types of debit spreads as well. They include:

- **Bear put spread**, which is a bearish strategy that requires 2 transactions, which are the buying of 1 at the money put option and the selling of 1 on the money put option. This is done because the trader is betting that the price movement of the associated asset will go down. Profit is earned when the price of the associated asset is the same as the strike price of the put option.
- **Bull call spread,** which is a bullish strategy that includes 2 transactions, which are the buying of 1 at the money call option and the selling of 1 out of money call option. A trader implements this strategy when he or she thinks that the price movement of the associated asset will go up modestly. Profit is gained when the price of the associated asset is the same at the strike price of the short call option.
- **Butterfly spread**, which is a neutral strategy that involves 3 transactions whereby the trader buys 1 in

the money call option, sells 2 at the money call option and buys 1 on the money call option. Both profits and losses are limited with this type of spread strategy. Profit is gained when the price of the associated asset remained the same on the date of expiration.

- **Reverse iron butterfly**, which is a volatile strategy that involves 4 transactions. These transactions are the selling of 1 out of money put option, buying 1 at the money put option, buying 1 at the money call option and selling 1 out of money call option. Profit is gained when the price of the associated asset falls.

Iron Condor

This is a neutral strategy that is best practiced by advanced options traders because of its complex nature. It is comprised of 4 transactions. They are:

- Selling 1 out of the money put option
- Buying 1 out of the money put option (has the lower strike)
- Selling 1 out of the money call option
- Buying 1 out of the money call option (has the higher strike)

All of these transactions have the same expiration date and are attached to the same associated asset. Profit is gained when the price of the associated asset is between the call and put options that are sold. Loss is limited just as profit is with this strategy.

Many traders use this strategy because the asset price can go in any direction and the trader can still make a profit, it is flexible and potential losses and profits can be predetermined.

This strategy has 4 transactions and as such the complexity can be off-putting to some traders.

Rolling Out Options

This strategy involves closing one option then replacing it with an identical option to manage a winning or losing position. This management comes in the form of the newly opened position having the same associated asset but varied terms. These terms are typically the adjustment of the strike price and how long the trader would like to hold a long or short position.

Rolling can be done in 3 ways. They are:

- Rolling up, which is the process of closing an existing option position and simultaneously opening a similar position with a higher strike price.
- Rolling down, which is the process of closing an existing option position and simultaneously opening a similar position with a lower strike price.
- Rolling forward, which is the process of moving an open position to a different expiration date so that the length of the contract is extended.

This strategy is easy enough to be practiced by beginners.

Straddle Strategy

This strategy is employed so that the options trader protects himself or herself from loss whether the asset price moves up or down. There are short straddles and long straddles.

The short straddle is also called a sell straddle or a naked straddle. It is a neutral strategy that entails the trader selling 1 at the money call option and 1 at the money put option with the same expiration date, same strike price and having the same associated asset. Profit from this strategy is limited and is calculated by finding the difference between the options premium and commissions paid.

Loss has the potential to be unlimited if the asset price moves sharply up or down.

The long straddle is also called a buy straddle. It is a neutral strategy and involves the trader buying 1 at the money call option and 1 at the money put option with the same expiration date, strike price and associated asset.

Profit potential is unlimited and the risk of loss is limited.

Strangle Strategy

This is a strategy that is used when a trader bets that an asset price will move up or down but still gathers protection in the event that he or she is wrong. Strangles come in both a long and short variety.

The long strangle is also called a buy strangle and it is a neutral options trading strategy. This strategy entails the trader buying 1 out of the money put option and 1 out of the money call option. This is done because the trader expects volatility on the market. Profit is potentially unlimited and happens if the asset price moves sharply up or down. Loss is limited and is the combination of the options premium and the commission paid.

The short strangle is also called a sell strangle. It is used as a neutral trading strategy and so the trader sells 1 out of the money put option and 1 out of the money call option. Both of these options have the same expiration date and the same asset associated. This is a short-term strategy used when the trader expects the asset price to remain relatively stable on the market. Profit is limited and is the difference between the option premium and commissions paid for that option. Risk is unlimited. Loss can be experienced if the price of the asset goes up or down sharply.

Chapter Summary

There are a lot of options trading strategies to choose from. There are strategies that are appropriate for all levels of day

338

options trading including beginner, intermediate and advanced. Some of these strategies include:

- Covered call strategy, which is a two-part process whereby the trader first buys the associated asset then sells the right to purchase that asset via an option.
- Credit spreads, which describes the selling of a high-premium option while purchasing a low-premium option to make a profit when the spread between the two options narrows.
- Debit spreads, which describes the buying of a high-premium option while purchasing a low-premium option type to make a profit when the spread between the two options widen.
- Iron condor, which is a neutral strategy that is best practiced by advanced options traders because of its complex nature. It is comprised of 4 transactions.
- Rolling out options, which is the strategy that involves closing one option then replacing it with an identical option to manage a winning or losing position so that varied terms are applied to the same associated asset.
- Straddle strategy, which is employed so that the options trader protects himself or herself from loss whether the asset price moves up or down. The short straddle is a neutral strategy that entails the trader selling 1 at the money call option and 1 at the money put option with the same expiration date, same strike price and having the same associated asset. The long straddle is a neutral strategy that involves the trader buying 1 at the money call option and 1 at the money put option with the same expiration date, strike price and associated asset
- Strangle strategy, which is used when a trader bets that an asset price will move up or down but still

gathers protection in the event that he or she is wrong. The long strangle entails the trader buying 1 out of the money put option and 1 out of the money call option while the short strangle entails the trader selling 1 out of the money put option and 1 out of the money call option.

Chapter 6

Power Principles to Ensure a Strong Entry into Day Trading Options

I cannot stress this enough - you need to have a plan if you want to be successful at day trading options. You are putting your money on the line every day. I am sure squandering those hard-earned funds is not the plan but that is exactly what will happen without a proper plan in place. Obviously, having a trading plan in place is a given as we discussed earlier but that plan is not enough. You need to take it a step further by applying principles that will reinforce that plan. Think of that trading plan as the foundation of your house of success. The principles that we will discuss below are the bricks to develop your house into what you want it to be.

Power Principle #1 – Ensure Good Money Management
Money is the tool that keeps the engine of the financial industry performing in good working order. It is essential that you learn to manage your money in a way that works for you instead of against you as an options day trader. It is an intricate part of managing your risk and increasing your profit.

Money management is the process whereby monies are allocated for spending, budgeting, saving, investing and other processes. Money management is a term that any

person with a career in the financial industry, and particularly in the options trading industry, is intimately familiar with because this allocation of funds is the difference between a winning options trader and a struggling options trader.

Below you will find tips for managing your money so that you have maximum control of your options day trading career.

Money Management Tips for Options Traders

- Define money goals for the short term and the long term so that you can envision what you would like to save, invest, etc. Ensure that these are recorded and easily accessed. Your trading plan will help you define your money goals.
- Develop an accounting system. There are a wide range of software that can help with this but it does not matter which one you use as long as you are able to establish records and easily track the flow of your money.
- Use the position sizing to manage your money. Position sizing is the process of determining how much money will be allocated to entering an options position. To do this effectively, allocated a smart percentage of your investment fund toward individual options. For example, it would be unwise to use 50% of your investment fund on one option. That is 50% of your capital that can potentially go down the drain if you make a loss in that position. A good percentage is using no more than 10% of your investment fund toward individual option positions. This percentage allocation will help you get through tough periods, which eventually happen, without having all your funds being lost.
- **Never**, ever invest money that you cannot afford to lose. Do not let emotion override this principle and cloud your judgement.

- Spread your risks by diversifying your portfolio. You diversify your portfolio by spreading your wealth by investing in different areas, add to your investments regularly, being aware of commissions at all times and knowing when to close a position.
- Develop the day trading styles and strategies that earn you a steady rate of return. Even if you use scalping where the returns are comparatively small, that steady flow of profit can add up big over time.

Power Principle #2 – Ensure that Risks and Rewards Are Balanced

To ensure that losses are kept to a minimum and that returns are as great as they can be, options day traders should use the risk/reward ratio to determine each and to make adjustments as necessary. The risk/reward ratio is an assessment used to show profit potential in relation to potential losses. This requires knowing the potential risks and profits associated with an options trade. Potential risks are managed by using a stop-loss order. A stop-loss order is a command that allows you to exit a position in an options trade once a certain price threshold has been reached.

Profit is targeted using an established plan. Potential profit is calculated by finding the difference between the entry price and the target profit. This is calculated by dividing the expected return on the options investment by the standard deviation.

Another way to manage risks and rewards is by diversifying your portfolio. Always spread your money across different assets, financial sectors and geographies. Ensure that these different facets of your portfolio are not closely related to each other so that if one goes down, they do not all fall. Be smart about protecting and building your wealth.

Power Principle #3 – Develop a Consistent Monthly Options Trading System

The aim of doing options trading daily is to have an overall winning options trading month. That will not happen if you trade options here and there. You cannot expect to see a huge profit at the end of the month if you only performed 2 or 3 transactions.

You need to have a high options trading frequency to up the chances of coming out winning every month. The only way to do that is to develop a system where you perform options trades at least 5 days a week.

To have consistently good months, you need to develop strong daily systems that keep your overall monthly average high. Therefore, creating a daily options trading schedule is key. Here is an example of an efficient options day trading schedule:

1. **Perform market analysis.** This needs to be done before the markets open in the morning. That means that the options day trader needs to get an early start on the day. This entails checking the news to scan for any major events that might affect the markets that day, checking the economic calendar and assessing the actions of other day traders to assess volume and competition.
2. **Manage your portfolio.** The way that an options day trader does this is dependent on the strategies that he or she implements but overall, it is about assessing positions that you already have or are contemplating for efficient management of entry and exits that day. It also allows for good money management.
3. **Enter new positions.** After assessing the market and fine tuning your portfolio, the next step is to enter new trades that day. Research and efficient decision-

making go into this step. The options trader who has already determined how the market was doing and forecasted for performance that day, would have noticed relevant patterns. The key here is to enter trades frequently via a sound strategy. To narrow done which positions you would like to pursue, keep an eye on the bullish, bearish, neutral and volatile watch lists and run technical scans.

4. **Incorporate learning during the day.** Continual learning is something that an options trader needs to pursue but this does not always have to be in the way of formal classes or courses. You can up your knowledge of options and day trading by following mentors, reading books, listening to podcasts, reading blogs and watching videos online. Such activities are easy to incorporate into your daily routine. Even just a few minutes of study a day can considerably up your options day trading game in addition to stimulating your mind. Being in regular contact with other options day traders is also a great way of increasing your information well.

Power Principle #4 – Consider a Brokerage Firm That is Right for Your Level of Options Expertise

We touched briefly on brokerage firms in the beginning chapters of this book but I want to again stress how important this decision is on an options day trader's profit margin. There are four important factors that you need to consider when choosing a broker and they are:

- The requirements for opening a cash and margin account.
- The unique services and features that the broker offers.
- The commission fees and other fees charged by the broker.

- The reputation and level of options expertise of the broker.

Let's take a look at these individual components to see how you can use them to power up your options day trading experience.

Broker Cash and Margin Accounts

Every options trader needs to open a cash account and margin account to be able to perform transactions. They are simply tools of the trade. A cash account is one that allows an options day trader to perform transactions via being loaded with cash. Margin account facilitates transactions by allowing that to borrow money against the value of security in his or her account. Both of these types of accounts require that a minimum amount be deposited. This can be as few as a few thousand dollars to tens of thousands of dollars depending on the broker of choice. You need to be aware of the requirements when deliberating which brokerage firm is right for you.

Broker Services and Features

There are different types of services and features available from different brokerage firms. For example, if an options trader would like to have an individual broker assigned to him or her to handle his or her own account personally, then he or she will have to look for a full-service broker. In this instance, there minimum account requirements that need to be met. Also, commission fees and other fees are generally higher with these types of brokerage firms. While the fees are higher, this might be better for a beginner trader to have that full service dedicated to their needs and the learning curve.

On the other hand, if an options trader does not have the capital needed to meet the minimum requirements of a full-service broker or would prefer to be more in charge of his or

her own option trades, then there is the choice of going with a discount brokerage firm. The advantage to discount brokerage firms is that they tend to have lower commissions and fees. Most internet brokerage firms are discount brokers.

Other features that you need to consider when choosing a brokerage firm include:

- Whether or not the broker streams real-time quotes.
- The speed of execution for claims.
- The availability of bank wire services.
- The availability of monthly statements.
- How confirmations are done, whether written or electronic.

Commissions and Other Fees
Commission fees are paid when an options trader enters and exits positions. Every brokerage firm has its own commission fees set up. These are typically developed around the level of account activity and account size of the options trader.

These are not the only fees that an option trader needs to consider when considering brokerage firms. Many brokerage firms charge penalty fees for withdrawing funds and not maintaining minimum account balances. Obviously, the existence of fees such as these cuts on an options trader's profit margin. The payment of fees needs to be kept to a minimum to gain maximum income and as such, an options trader needs to be aware of all fees that exist and how they are applied when operating with a brokerage firm. This needs to be done before signing up.

Broker Reputation and Options Expertise
You do not want to be scammed out of your money because you chose the wrong brokerage firm. Therefore, it is important that you choose a broker that has an established and long-standing reputation for trading options. You also

want to deal with a brokerage firm that has great customer service, that can aid in laying the groundwork for negotiating reduced commissions and allows for flexibility. Options trading is a complex service and your brokerage firm needs to be able to provide support when you are handling difficult transactions.

A list of reputable online brokerage firms include:

- E*Trade
- OptionsXpress
- Scottrade
- Ameritrade
- Train Station

You can look up any of these brokerage websites and find that they have a long-standing reputation for quality service. Even though most are based in the United States, many accept international accounts.

Power Principle #5 – Ensure That Exits are Automated

Even though I have stated that emotions should be set aside when trading options, we are all human and emotions are bound to come into the equation at some point. Knowing this, it is imperative that systems be developed to minimize the impact of emotions. Having your exits automated is one such step that you can take to ensure that emotions are left out when dealing with options day trading. Using bracket orders facilitates this.

A bracket order is an instruction given when an options trader enters a new position that specifies a target or exit and stop-loss order that aligns with that. This order ensures that a system is set up to record two points – the target for profit and the maximum loss point that will be tolerated before the stop-loss comes into effect. The execution of either order cancels the other.

Chapter Summary

Strength your options day trading plan and strategies with these power principles:

- Ensure good money management
- Ensure that risks and rewards are balanced
- Develop a consistent monthly options trading system
- Consider a brokerage firm that is right for your level of options expertise
- Ensure that exits are automated

Chapter 7

11 Options Day Trading Rules for Success

There is more to options day trading to just having a style or a strategy. If that was all it took, then you could just adopt those that are proven to work and just stick with them. Yes, options day trading styles and strategy are important but they are not the end-all-be-all of this career.

The winning factor is the options day trader himself or herself. *You* are the factor that determines whether or not you will win or lose in this career. Only taking the time to develop your expertise, seeking guidance when necessary and being totally dedicated allows a person to move from a novice options day trader to an experienced one that is successful and hitting his or her target goals.

To develop into the options day trader you want to be, being disciplined is necessary. There are options day trading rules that can help you develop that necessary discipline. You will make mistakes. Every beginner in any niche does and even experienced options day traders are human and thus, have bad days too.

Knowing common mistakes helps you avoid many of these mistakes and takes away much of the guesswork. Having rules to abide by helps you avoid these mistakes as well.

Below, I have listed 11 rules that every options day trader must know. Following them is entirely up to you but know that they are proven to help beginner options day trader turn into winning options day traders.

Rule for Success #1 – Have Realistic Expectations
It is sad to say that many people who enter the options trading industry are doing so to make a quick buck. Options trading is not a get-rich-quick scheme. It is a reputable career that has made many people rich but that is only because these people have put in the time, effort, study and dedication to learning the craft and mastering it. Mastery does not happen overnight and beginner options day traders need to be prepared for that learning curve and to have the fortitude to stick with day trading options even when it becomes tough.

Losses are also part of the game. No trading style or strategy will guarantee gains all the time. In fact, the best options traders have a winning percentage of about 80% and a losing average of approximately 20%. That is why an options day trader needs to be a good money manager and a good risk manager. Be prepared for eventual losses and be prepared to minimize those losses.

Rule for Success #2 – Start Small to Grow a Big Portfolio
Caution is the name of the game when you just get started with day trading options. Remember that you are still learning options trading and developing an understanding of the financial market. Do not jump the gun even if you are eager. After you have practiced paper trading, start with smaller options positions and steadily grow your standing as

you get a lay of the options day trading land. This strategy allows you to keep your losses to a minimum and to develop a systematic way of entering positions.

Rule for Success #3 – Know Your Limits

You may be tempted to trade as much as possible to develop a winning monthly average but that strategy will have the opposite effect and land you with a losing average. Remember that every options trader needs careful consideration before that contract is set up. Never overtrade and tie up your investment fund.

Rule for Success #4 – Be Mentally, Physically and Emotionally Prepared Every Day

This is a mentally, physically and emotionally tasking career and you need to be able to meet the demands of this career. That means keeping your body, mind and heart in good health at all times. Ensure that you schedule time for self-care every day. That can be as simple as taking the time to read for recreation to having elaborate self-care routine carved out in the evenings.

Not keeping your mind, heart and head in optimum health means that they are more likely to fail you. Signs that you need to buckle up and care for yourself more diligently include being constantly tired, being short-tempered, feeling preoccupied and being easily distracted.

To ensure you perform your best every day, here a few tasks that you need to perform:

- Get the recommended amount of sleep daily. This is between 7 and 9 hours for an adult.
- Practice a balanced diet. The brain and body need adequate nutrition to work their best. Include fruits, complex carbs and veggies in this diet and reduce the consumption of processed foods.

352

- Eat breakfast lunch and dinner every day. Fuel your mind and body with the main meals. Eating a healthy breakfast is especially important because it helps set the tone for the rest of the day.
- Exercise regularly. Being inactive increases your risk of developing chronic diseases like heart disease, certain cancers and other terrible health consequences. Adding just a few minutes of exercise to your daily routine not only reduces those risks but also allows your brain to function better, which is a huge advantage for an options day trader.
- Drink alcohol in moderation or not at all.
- Stop smoking.
- Reduce stress contributors in your environment.

Rule for Success #5 – Do Your Homework Daily

Get up early and study the financial environment before the market opens and look at the news. This allows you to develop a daily options trading plan. The process of analyzing the financial climate before the market opens is called pre-market preparation. It is a necessary task that needs to be performed every day to asset competition and to align your overall strategy with the short-term conditions of that day.

An easy way to do this is to develop a pre-market checklist. An example of a pre-market checklist includes but is not limited to:

- Checking the individual markets that you frequently trade options in or plan to trade options in to evaluate support and resistance.
- Checking the news to assess whether events that could affect the market developed overnight.
- Assessing what other options traders are doing to determined volume and competition.

- Determining what safe exits for losing positions are.
- Considering the seasonality of certain markets are some as affected by the day of the week, the month of the year, etc.

Rule for Success #6 – Analyze Your Daily Performance

To determine if the options day trading style and strategies that you have adopted are working for you, you need to track your performance. At the most basic, this needs to be done on a daily basis by virtue of the fact that you are trading options daily. This will allow you to notice patterns in your profit and loss. This can lead to you determining the why and how of these gains and losses. These determinations lead to fine tuning your daily processes for maximum returns. These daily performance reviews allow you to also make determinations on the long-term activity of your options day trading career.

Rule for Success #7 – Do Not Be Greedy

If you are fortunate enough to make a 100% return on your investment, do not be greedy and try to reap more benefit from the position. You might have the position turn on you and you can lose everything. When and if such a rare circumstance happens to you, sell your position and take the profits.

Rule for Success #8 – Pay Attention to Volatility

Volatility speaks to how likely a price change will occur over a specific amount of time on the financial market. Volatility can work for an options day trader or against the options day trader. It all depends on what the options day trader is trying to accomplish and what his or her current position is.

There are many external factors that affect volatility and such factors include the economic climate, global events and news reports. Strangles and straddles strategies are great for use in volatile markets.

354

There are different types of volatility and they include:

- Price volatility, which describes how the price of an asset increases or decreases based on the supply and demand of that asset.
- Historical volatility, which is a measure of how an asset has performed over the last 12 months.
- Implied volatility, which is a measure of how an asset will perform in the future.

Rule for Success #9 – Use the Greeks

Greeks are a collection of measures that provide a gage of an option's price sensitivity in relation to other factors. Each Greek is represented by a letter from the Greek alphabet. These Greeks use complex formulas to be determined but they are the system that option pricing is based on. Even though these calculations can be complex, they can be done quickly and efficiently so that options day traders can use them as a method of advancing their trades for the most profitable position.

The 5 Greeks that are used in options trading are:

Delta

This Greek defines the price relationship between an option and its associated asset. Delta is a direct translation of a change in the price of the associated asset into the changing of the price of an option. Call options deltas range from 1 to 0 while put options deltas range from 0 to -1. An example of delta as it relates to a call option is a call option with a delta of 0.5. If the price of the associated asset increases by $200, then the price of the call option will increase by $100.

Vega

This Greek is a measure of the sensitivity of the price of an option to the implied volatility of the associated asset. Option prices are greatly impacted by the volatility of the associated

asset's prices because greater volatility translates in a higher chance that the price of the associated asset will reach or surpass the strike price on or before the expiration date of the option.

Theta

This Greek is a measure of the sensitivity of the price of an option to time decay of the value of the option. Time decay describes the rate of deterioration in the value of the contract because of the passage of time. The closer the expiration date becomes, the more time decay accelerates because the time left to gain a profit narrows. Therefore, the longer it takes to reach an options' expiration date, the more value this option has because it has a longer time period to gain the trader a profit. The theta is a negative figure because time is always a diminishing factor. This figure becomes increasingly negative the closer the expiration date becomes.

Gamma

This Greek measures the rate of change of the delta of an option. At its most basic, it tells the likelihood of an option reaching or surpassing the strike price.

Rho

This Greek is a measure of an option's value compared to changes in interest rate. Options with longer expiration dates are more likely to be affected by changes in interest rates.

Rule for Success #10 – Be Flexible

Many options day traders find it difficult to try trading styles and strategies that they are not familiar with. While the saying of, "Do not fix it if it is not broken," is quite true, you will never become more effective and efficient in this career if you do not step out of your comfort zone at least once in a while. Yes, stick with want work but allow room for the consideration that there may be better alternatives.

Rule for Success #11 – Have an Accountability Partner or Mentorship

Day trading options can be a rather solitary career. That means it becomes easy to sleep in if the urge strikes or just not put in a day of work. While there is nothing wrong with doing that when you have established a solid career in day trading options, this is a slippery slope that can become a harmful habit to your career. Having an accountability partner is an easy way to keep you on track with your trading plan and goals. It keeps you consistent with your actions. This can be a fellow trader, your spouse or romantic partners, a friend or family member.

Finding a mentor is also a great way to incorporate accountability as well as learning in your career.

Chapter Summary

There is more to options day trading than just having a style or a strategy. The factor that makes all the difference in whether or not the options day trader will thrive or not is the options day trader himself or herself. Dedication, hard work and having a solid trading plan are given rules for seeking success in this career but they are not the only ones. Other rules for success as an options day trader include:

- Having realistic expectations.
- Testing the day trading options waters by starting small and gradually increasing your operations.
- Knowing your limits so that you do not overtrade or under trade.
- Caring for yourself mentally, emotionally and physically so that you perform your best every day.
- Doing your homework every day with pre-market preparation.
- Analyzing your performance at the end of every options trading day.

- Not being greedy and carefully researching and analyzing positions before entering them.
- Using market volatility to your advantage.
- Using the Greeks of delta, vega, theta, gamma and rho to perform the calculations that will help you decide on how to proceed with option positions.
- Being flexible.
- Having an accountability partner or seeking a mentor.

Conclusion

Financial freedom is an elusive thing but it is still something that is attainable to any and everyone who is willing to put in the time and effort to learn how to gain that freedom. Most people remain stuck financially because they do not see a way out. Even more unfortunate is that many people do not realize that they are bound by financial slavery. However, the only sign that you need to see to know that you are a financial slave is that you are unable to use your time in the way that you would like because you are trading this time for money actively. If you depend on one source of income such as a job just to survive then you are a financial slave.

The great news is that this does not have to be your reality indefinitely.

Trading Options for Financial Freedom

One of the leading ways of gaining financial freedom is setting up passive income streams. Trading options has the potential to be a powerful form of passive income. Not only does this activity give the trader the platform to gain financial freedom but it also allows the trader to pursue hobbies, career options and other activities that he or she loves. It allows this because the trader is not actively trading time for money. Options traders have the flexibility to live and work anywhere in the world because, when done right, trading options allows the trader to earn tens of thousands of dollars and more even while he or she sleeps.

This book was written as a comprehensive guide to show that any and everyone can earn a sizable income from options trading as long as this person is willing to develop a growth mindset, learn from the mistakes and successes of other traders and work to put in that human and financial investment upfront. Options are derivative contracts that allow the owner of the contract the right to buy or sell the associated asset by an expiration date specified. From this definition, you can see that this is not something you simply dabble in every now and then.

Are You Ready To Be An Options Trader?

Trading options is a business. Therefore, it needs to be approached with a mindset that is set for growth and development. We have talked about many topics on how you can get started such as developing your training plan, paper trading, opening a brokerage account and choosing a trading style. All of these things plus learning the language of options trading is greatly important as a beginner in this field. You cannot get through into this career and profit in the way that you would like without putting in that initial study. This book should only be your starting point when it comes to learning.

Gain more advice in the form of other books, online study and from a mentor if possible.

After you have done this, you need to practically implement the strategies and techniques taught in this book. To remember what a put option and a call option are, you need to be able to see them in practice. To mentally solidify what a long position and a short position are, you need to actually be in these positions. To become familiar with volatility and interest rates, you need to put yourself in a position to learn further. Straddles, strangles, legging, debit spreads, credit spreads, selling naked options and rolling out options... They might seem intimidating on paper and might be difficult to implement at first but practice makes perfect. All advanced options traders started as a beginner but consistent, persistent effort took them to the next level.

This is a new world for any novice and, of course, it can seem intimidating but as long as you remained committed to developing the traits of a successful options trader, you will be well on your way to obtaining the financial freedom that you crave. Just as with any new venture, there will be setbacks and failures. You will lose your footing sometimes and be exposed to things that you never have been before. The keys to getting past all these things and overcoming your circumstances to gain success are being self-disciplined, being committed, being patient and developing an eagerness for continual learning. You need to be an effective risk manager to juggle your options. You need to be able to manage your money effectively and keep accurate records that help you forecast your decisions based on sound history and knowledge. Most importantly, you need to dream big and stop limiting yourself. The sky is the limit with options trading. So stop settling for less than you deserve and visualize the future where you have ascertained that financial independence and stability. Then, do the work.

My Final Words

In closing, I would like to tell you that financial freedom is not something that is given to most. It is something that is built and developed with sound planning and execution of plans. You can see the truth in my words as most modern entrepreneurs who found great success did not come into this with a silver spoon in their mouths. Their success was not a gift from anyone else. Some of them even came from dismal circumstances such as homelessness to build a multi-billion dollar empire.

You have the same potential just like those other people did. You just have to be willing to put into the work to develop yourself, your state of mind and a plan for creating the future that you would like rather than what a salary that does not support your desired lifestyle dictates. Yes, it might take some hard work to get your footing grounded with options trading but the payoff is more than worth it. Putting in the work upfront will allow you to gain the passive income that will allow you to pursue the other things that you would like to do with your time.

This book was written to show you that a lot of persons who are financially dependent on the broken system that society has made remain financially chained because of limited thinking. Open up your mind and visualize what you can accomplish. **Then get up and do it**. With the knowledge that you have found in this book, you can finally leave those shackles behind and create a future where you are financially free and happy. Good luck!

Glossary of Terms

To make your entry into the options trading world as easy as possible, I have provided an alphabetically ordered list of terms with the corresponding definition for easy reference. Please reference this section any time you need clarification on the jargon of options trading.

Active Income: The state whereby a person has to actively trade time for an income.

Asset: A property that is considered valuable and accessible to meet financial obligations and development.

At The Money: This means the asset price and the strike price are the same and so the options trader does not make a profit but neither does he or she make a loss on the transaction.

Basket Option: Options that use a group of securities as the asset associated with the contract.

Bear Call Spread: A bearish trading strategy for advanced options traders.

Bear Put Spread: A bearish trading strategy for beginner options traders.

Beta: A Greek measurement that helps predict stock volatility.

Bearish Outlook: Characterized by the decreasing value of the associated asset attached to an option.

Binomial Option Pricing Model: An options premium pricing model commonly used for pricing for American options.

Black Scholes Model: An options premium pricing model commonly used to price European options.

Breakeven: The state whereby a trader does not make a profit or loss from an option.

Bull Call Spread: A bearish trading strategy for beginner options traders.

Bull Put Spread: A bullish trading strategy for advanced options traders.

Bullish Outlook: Characterized by the rising value of the associated asset attached to an option.

Butterfly Spread: A neutral strategy for advanced traders.

Calendar Call Spread: This strategy is meant for a trader who wishes to benefit from the associated assets staying stagnant in the market while also benefiting from the long-term call position if the stock becomes more valuable in the future.

Call Options: This is the type of option that gives the trader the right to buy the asset on or before the expiration date.

Cash account: An account that is loaded with cash to facilitate the buying of options.

Commodity Options: Options that use physical commodity as the asset associated with the contract.

Covariance: A measure of a stock's sensitivity relative to that of the financial market.

Covered Call: This describes the act of selling the right to purchase a specified asset that you own at a specified price within a specified amount of time, which is usually less than 12 months. Also known as a buy write.

Credit Spreads: This describes the selling of a high-premium option while purchasing a low-premium option in the same class (calls or puts).

Currency Option: Options that use the type of security grants the right to buy or sell a specific currency at a previously agreed-to exchange rate. Also referred to as a forex option.

Day Trading: A method of options trading involving trades that do not last more than a day as profits, losses or breakeven are realized by the end of the day and so the options are closed.

Debit Spreads: This describes the buying of a high-premium option while selling a low-premium option with the same associated asset attached to both options.

Delta: A Greek that describes an option's sensitivity in relation to the price of the stock.

Derivative Contract: A contract that derives its value based on the value of the underlying asset.

Dividends: The distributions of portions of a company's profit at a specified period.

Earnings: The measure of how much a company's profits are allocated to each share of stock.

Emergency Fund: A reserve of cash or other assets developed to help navigate away from financial problems or unexpected financial pitfalls.

ETF: Exchange-traded fund.

Expiration Date: The date at which the option (contract) expires.

Financial Freedom: The ability to make decisions without being limited by finances.

Financial Independence: The state of having personal wealth to maintain the desired lifestyle and the standard of living wanted without having to trade daily hours for money.

Financial Security: The condition whereby a person supports their standard of living presently and in the future by having stable sources of income and other resources available.

Financial Slavery: The state of having decisions and opportunities limited by finances.

Fixed Mindset: A state of mind whereby a person believes that their qualities are fixed traits that cannot be changed.

Futures Option: Type of option that gives the trader the right to assume a certain position at a future date.

Gamma: A Greek that reflects the rate of change of the delta.

Greeks: A collection of degrees that provide a measure of an option's sensitivity in relation to other factors.

Growth Mindset: A state of mind whereby a person believes that their most basic abilities can be developed with hard work, continuous learning and dedication.

Historical Volatility: This is a measure of how a stock has performed over the last 12 months.

Implied Volatility: This is a measure of how a stock will perform in the future.

In The Money: This means the asset price is above the call strike price and so the options trader makes a profit on the transaction.

Index: A measure of the stocks, bonds and other securities a company possesses.

Index Options: Options that use a company's index as the asset associated with the contract.

Interest Rate: The percentage of a particular rate for the use of money lent over a period of time.

Intrinsic Value: The difference in the current price of an asset and the strike price of the option.

Iron Butterfly Spread: A neutral strategy for advanced options traders.

Iron Condor Spread: Neutral options strategy. Similar to the iron butterfly spread.

Lambda: A Greek that describes an option's sensitivity in relation to the associated asset's value.

LEAPS: The acronym stands for Long-term Equity Anticipation Securities. They are a type of option with expiration dates that are longer than normal.

Legging: The process of separating the individual transactions in an option.

Legging Out: One leg of the option closes out and becomes worthless to the options trader.

Liquidity: This describes how quickly an asset can be converted to cash without a significant price shift.

Long Call: This is an options strategy considered by options traders who want to make a profit from an asset that increases in price above the strike price.

Long Position: The investor owns the asset associated with the option.

Long Put: This is a type of option that gives the trader the right to sell the associated asset at the strike price on or before the expiration date.

Long Straddle: This is a neutral position in options trading. Also known as the buy straddle.

Long Strangle: This is a neutral position in options trading. Also called the buy strangle.

Loss: The negative difference between the amount earned from an option and costs associated with that option.

Margin Account: An account that allows an options trader to borrow money against the value of the securities in the trader's account.

Market Makers: Options traders who ensure that the market is liquid and has transactions to be engaged in by buyers and sellers.

Market Volatility: This describes the rate at which prices change in any financial market.

Monte Carlo Simulations: An options premium pricing model that allows for considering multiple outcomes due to the involvement of random factors.

Options: A derivative contract that allows the owner of the contract to have the right to buy or sell the securities based on an agreed-upon price by a specified time period.

Out Of The Money: This means the price is below the call strike price and so the options trader makes a loss on the transaction.

Naked Options: This is an option where the seller of the option does not own the associated asset attached to that contract.

Naked Call Option: A bearish options trading strategy.

Naked Put Option: A bullish options trading strategy.

Paper Trading: The act of practicing how to earn a profit from options trading on paper before investing actual money.

Passive Income: The state whereby a person earns income without the active input of time as an exchange.

Position Trading: This is a low-maintenance options trading style that introduces low risk but requires an advanced trader's knowledge and understanding of options and the financial markets.

Premium: The price paid by the buyer of the option.

Price Volatility: This describes how the price of an asset moves up or down.

Profit: The positive difference between the amount earned from an option and costs associated with that option.

Put Options: This is the type of option that gives the trader the right to sell the specified asset at the predetermined price by the expiration date.

Reverse Iron Butterfly: A volatile strategy for advanced traders.

Rho: A Greek that describes an option's sensitivity to the interest rate.

Rolling Down: This is the method that involves closing one existing position while opening a similar position with a lower strike price at the same time. It is the opposite of rolling up.

Rolling Forward: This involves moving an open position to a different expiration date so that the length of the contract is extended. Also known as rolling over.

Rolling LEAPS Options: This involves selling LEAPS before the expiration date while buying LEAPS with similar characteristics with at least 2-year expiration dates at the same time.

Rolling Out Options: The process of rolling out explains that an expiring option is replaced with an identical options.

Rolling Up: This involves closing one existing option position while opening a similar position with a higher strike price at the same time. It is the opposite of rolling down.

Securities: The assets attached to options. Examples include stock, currencies and commodities.

Short Butterfly Spread: A volatility-based strategy that is typically practiced by medium to advanced options traders.

Short Position: The investor does not own the asset being associated with the option.

Short Straddle: This is a neutral options trading strategy. Also called a sell straddle.

Short Strangle: This is a neutral options trading strategy. Also called a sell strangle.

Slippage: This is the circumstance that results when there is a time delay between two related options, which results in a price change during that time.

Stock: A representation of shares of ownership in individual companies or options.

Stock Option: Options that use stock in a publically listed company as the asset associated with the contract.

Stock Volatility: A stock price's sensitivity to the financial market.

Straddles: This is an options trading strategy whereby the trader protects himself or herself regardless of if the price of the stock moves up or down.

Strangles: This is an options strategy employed when the trader strongly believes that the stock price will move either up or down but still wants to be protected in case he or she is wrong.

Strike Price: The price the trader strikes against the underlying value of the asset associated with the options to make a profit. Also called the agreed-upon price.

Swing Trading: A style of options trading that is particularly useful for part-time trading as well as beginners who are just getting the hang of things.

Theta: A Greek that describes an option's sensitivity in relation to how time affects the premium of an option.

Time value: The difference between the intrinsic value of an option and the premium.

Trading Plan: A comprehensive decision-making guide for an options trader.

Uncovered Call: A two-part strategy that describes the act of selling the right to purchase a specified asset that the investor owns at a specified price within a specified amount of time, which is usually less than 12 months. Also known as a buy write.

Variance: A measure of how the market moves relative to its mean.

Vega: A Greek that measures an option's price sensitivity in relation to implied volatility.

Volatility: Describes how likely a price change will occur during a specified amount of time on the financial market.

Options Trading for Beginners

The Most Complete Crash Course Including All You Need to Know About Options Trading Strategies for Creating a Real Alternative Income [Second Edition 2020]

By
Matthew Bear

Introduction

Welcome and thank you very much for downloading *Options Trading For Beginners*!

In this book, I am going to introduce and demystify the world of options trading for you. Options trading sounds mysterious and complicated but the reality is it is pretty simple and you just need someone to explain it to you.

We are going to start this book by explaining the basics of what options really are and how they are used to earn profits. Of course, all investing carries risk and that includes options trading. But one of the best things about options is they require relatively small amounts of capital to get started. You can experience some losses without causing total devastation. If you are careful, you can avoid losses most of the time.

The key, of course, is understanding when to get in and out of trades and what strategies should be used to both minimize losses and increase the probability of making profits. Developing a solid options trading plan will make it fairly easy to protect your investment account.

I will cover this type of information for you in this book using plain English explanations so that you can get started trading as soon as possible. We will also explain some of the big reasons that people end up losing money and how you can avoid following this path.

Options trading is not for everyone. It does require active involvement in the market, and you're going to have to follow the markets fairly closely in order to make profits. Let me state upfront that if you are the kind of investor who just

wants to set it and forget it, options probably are not going to be of interest to you. They have a limited lifetime and they can gain or lose value very quickly and it requires a lot of diligence and keeping up with what is going on with the markets to be successful.

That being said, options are not nearly as complicated as people imagine. If you are a little bit leery about becoming actively involved in your trading, let me suggest that you give it a chance and read the book before deciding whether or not options trading is something that you can include as part of your investment plans.

Finally, a word about investing and trading in general. If you are brand-new to options, one thing that you need to understand is that options trading is done for the purpose of making profits over the short-term. We are talking about her in cash over a 2 to 3-week period, generally speaking. Options trading is not about long-term investing or even something like swing trading over the course of months. Although, there are some options that last up to two years and we will talk a little bit about those as well.

Let's go ahead and get started by introducing the concept of options in addition to going over an overview of some of the trading strategies that will be covered in the later chapters.

Chapter 1: An Introduction to Options

An option is an agreement on the underlying shares of stock. It is an agreement to exchange shares at a fixed price over a certain timeframe. Options can be bought or sold. The first thing that you should understand about options is the motive of the investment. Why would someone get involved with options trading in the first place? Most people come to options trading with the hope of earning profits from trading the options themselves. And that is probably going to describe most readers of this book. But to truly understand what you are doing, you need to understand why options exist, to begin with.

There are three main reasons that options on stocks exist. The first reason is that it allows people that have shares of stock to earn money from their investment in the form of regular income. It can be an alternative to dividend income or even enhance dividend income. As we are going to see later, if you own a minimum of 100 shares of stocks, it is possible to earn extra income from that ownership. You can sell options against the stock and earn income from that over time intervals lasting from a week to a month, generally speaking. Such a move entails some risk, but people will enter positions of that type when the risk is relatively low.

The second reason that people get involved with options is that they offer insurance against a collapse of the stock. An option involves being able to trade shares of the stock at a fixed price that is set at the time the contract is originated. One type of contract allows the buyer to purchase shares. The other allows the buyer to sell shares.

Options allow people who own large numbers of shares to purchase a tool that protects their investment as it facilitates them selling the shares at a fixed price. This is done in the event that the stock declines greatly on the market. The concept is similar to paying insurance premiums. The trader pays the seller a premium to secure the right to buy the stock at a fixed price in due time. If the share price drops significantly, the trader avoids huge losses by not exercising the right.

The third reason for the existence of options is that it provides a way for people to make arrangements to purchase shares of stock at the prices that they find attractive, which aren't necessarily available on the market. There is a degree of speculation here. But let's just say that a particular stock of interest is trading at $100 a share. Furthermore, let's assume that the outlook is bullish on the stock and it is expected to rise by a great deal in the coming weeks. This is a scenario that can occurred in earnings season.

During earnings season, stock can move by huge amounts. But before the earnings call, nobody knows whether the stock is going to go up or down or by how much it is going to move. An options contract could allow someone to speculate and set up a situation where they could profit from a huge move upward without having to actually invest in the stock.

In that situation, if the stock declined instead the trader would not be out of much money. Just for an example, let's say the trader buy an options contract that allows them to purchase the shares of the stock currently at $100 for $102, and the option costs $2 per share. The stock would have to go to $104 or higher to make it worth it. Typically, options contracts involve 100 shares. If the speculator bets wrong, the most they would be out would be $200.

Let's just say, after the earnings call, the share price jumps to $120. The speculator can exercise the option, which means the speculator buys the shares at $102 per share. Then the trader can sell the stock on the market at the price of $120 per share. Taking into account the investment to buy the options contract that leaves the trader with a $16 per share profit.

Why did the trader not just buy the shares at $100 a share? The reason is if they did that, they would actually be exposed to risk by to the fullest extent possible. Like we said, earnings calls can go both ways. Just recently, Netflix announced that it lost subscribers. In after-hours trading alone, the stock lost $43 per share. As it related to our example, we could say that the stock dropped instead of gaining. Let's say this was to $80 per share. In that case, our speculator would have been in a major point of pain had they actually purchase the shares ahead of time. By doing the option instead, they set themselves up for profit while only risking a $200 loss. There are even options strategies can be used to profit no matter which way the stock moves.

Types of Options

Options agreements come in two varieties. The first type of options contract is known as a call. A call option gives the buyer the possibility to buy shares of stock at a fixed price. Usually, it is 100 shares. The agreed-upon value used to trade the shares is called the strike price. Every option comes with an expiration date, and so, if the buyer decides to purchase the shares, they must do so before the option expires. If the buyer decides to buy the shares, they are said to exercise the option. The option is said to be assigned if someone exercises the contract.

Options can be classified by the way they can be exercised. The possibilities are American-style and European-style. If

you can exercise the option on any date, it's known as American style. If the contract is a European style, the option can only be exercised on the day it expires. It is important to note that these terms do not necessarily mean that the option is trading in Europe or America. Although most options in America are American-style, some are European style. Two examples are SPX and RUT. These are options used to follow the S&P 500 index and the Russell 2000 index. But the vast majority of options you are going to come across are going to be American style. If you sell options, this is something you need to be aware of. Any time that the option is an open position, the options can be assigned.

The basic rule for a call option is that this is a bullish purchase. If you invest in a call option, your expectation is that the price of the shares will rise. There are two ways that you can take advantage of this. The first way is to simply trade the option. As we will see later, small moves in the stock price translate into big moves for options prices. So, if the stock goes up in price, you can sell the option and make a profit.

The second way to profit would be to actually exercise the right to buy the shares. In that situation, you would buy the shares for the price per share given by the strike and then sell them on the open market to make a profit. In order to make money, the price on the market must rise to a level greater than the strike price added to the amount you paid to buy the position.

If you purchased a $50 option for $1, meaning the strike price is $50, the price on the market would have to rise above $51 to make exercising the option profitable.

The rule is that call options increase in price or value primarily when stock prices are rising. But, as we will see, options are impacted by other factors as well. But the

general bet with a call option is earning profits when the underlying stock goes up in value.

Before we move on to consider the other major class of options, we need to make a clear distinction between selling and buying options. We can loosely use this language but we are applying it in very different contexts. First, let's consider a trader simply entering a position by purchasing an option. In market jargon, we would say that you are *buying to open*. In other words, you open your position by purchasing an option. If you buy an open option, you are never at risk of being assigned the shares of stock. You can sell the option and that carries no risk to you whatsoever. The only risk that you would face would be having to sell the option for a discount compared to what you paid to enter the position.

In contrast, you can also sell to open an options position. When you do that, you are at risk for the assignment of the shares of stock. That does not entail risk but there are many reasons that people choose to sell to an open options position. We will be exploring those later because selling an open position is an important part of options strategies. Also, you can sell to open positions in order to earn income from the premium.

The second type of option is called a put. A put option is a contract that allows the buyer to sell shares to the writer of the contract. This would be 100 of stock with a price given (strike price). A put option has a strike price and expiration date just like a call option.

Put options actually increase in value if the market price of the stock declines. If you buy a put, you are shorting the stock. If you intend to exercise the option, it would work in the following way. To use specific numbers, consider an example with the strike price of the option at $100 dollars per share. Suppose that the company had a negative

earnings call and the share price drop to $70 a share overnight. If you hold the put option, you can buy the shares on the market at $70 a share, thereby exercising the option. You would sell the shares at the price of $100 a share because that was the strike price on the contract. You would make nearly a $30 profit per share by engaging in this trade.

The profit is given by the strike price minus the premium paid to buy the option minus the price you purchase the shares for on the market. Imagine that the option costs $2 a share, the profit, in this case, would be $100 - $2 -$70 = $28 per share. Since there are 100 shares per option contract, that would mean a profit of $2800.

The general rule for put options, is that they increase in value when the share price drops. Many options traders are not looking to actually exercise the option. What they want to do is hold the put option with the belief that the share price will decline. This scenario allows for trading the put option on the market at a profit if the share price actually drops.

Why would someone sell to open a put option? People sell put options in order to make money from the premiums. This can be done alone or in conjunction with a special option strategy that can involve both types of options. If you sell a put option, obviously you are hoping that the share price is not going to drop far enough to make it worth it to exercise. And in most circumstances, that is actually going to be the case. A higher risk here would be selling to open a put with a strike price that is near current market prices.

Some Industry Jargon
Let's get some jargon out of the way so that you can navigate the options markets and understand what the experts are talking about. We have already mentioned a few of the terms, but it does not hurt to go over them again.

Strike Price

If an option is actually exercised, shares are traded at the strike price. This is the price per share that the shares of stock would be sold to a buyer if we are talking about a call option. If instead, it is a put option, this is the price per share that the trader who sold to open the contract agrees to pay in order to purchase the shares from the buyer of an option. The strike price is set when the contract is opened and is good until the option expires.

Expiration Date

Every option comes with an expiration date. When trading options, it's important to know when the expiration date is. If you are only trading options with no intent to exercise them, you do not want to ever be stuck with an option on the expiration day. Options typically expire on Fridays, but for heavily traded options on exchange-traded funds, they expire Monday, Wednesday, and Friday.

A standard option is one that lasts a month. These options will expire on a Friday. It will be the third week of the month, but there are options that only last for one week (called weeklies) and there are also options that last several weeks to two years. An option that lasts for more than a year is called LEAPS, which means Long-term Equity Appreciation Security. There is nothing special about them other than the expiration date. Otherwise, they are just like other options.

Time Decay

This is the property of applying less value the less time that is available on the contract. Options are priced based largely on the extrinsic or time value. The smaller the amount of time remaining on the contract, the lower the time value. If the stock is moving in a favorable direction, however, the value of the option that is related to the current market cost of the stock and other factors can overwhelm time decay.

To know what the time decay is, you can look up a quantity called theta that will be listed for every option. It will tell you how much the option price is going to drop when the market opens the following day. If an option has a theta of -0.11, it's going to drop in price by 100 shares x $0.11 = $11 at the next market opening. This may or may not be important. Other factors can swamp that $11 and make it irrelevant. But you need to be aware of it.

In the Money

If the strike price is favorably positioned with respect to current market prices, it is known by this term. For a call option, it will be *in the money* if the share price of the stock is greater than the price known as the strike price. For a put option, it will be *in the money* if the price that would be paid for the stock is less than the strike price. When an option is in the money, its value is heavily influenced by the price that the stock is trading at. In an ideal situation, which can happen as an in the money call option approaches expiration, a $1 increase in the stock price will translate into a $100 change in the price of the option. This can also mean a $100 loss if the share price is moving the other way.

At the Money

If the strike price is the same as the share price on the market, it is known by this phrase. At the money options can offer a relatively low-priced way to enter a trade and take advantage of the movements in share prices that go in the money.

Out of the Money

For a call option, it is said to be in this state if the strike price is greater than the market price. If the option expires out of the money, it is said to *expire worthlessly*. For a put option, it will be out of the money if the share price is above the strike price.

Options Strategies

The fact that options allow you to profit when the market prices increase or decline means that you can use clever strategies for options trading that simply are not available to people who invest in stocks. We will be discussing these strategies in detail in later chapters and will just briefly summarize the main strategies that are used below.

- **Call Option**: If you are sure the share price of a stock will increase, you can buy a call option with the hope of turning it around for a profit. When you buy to open a call option, you obtain a long call. Your total risk is capped by the price paid (premium) for the option. Advanced options traders do not buy call options in isolation. The reason being you can never be 100% sure of the direction the price of the stock will go. Still, you can ride short-term trends and profit by purchasing call options.
- **Put Option**: If you are sure that the share price of the stock is going to go down, you buy a put option.
- **Call Debit Spread**: In this scenario, you buy and sell two call options simultaneously. This caps potential gains, but limits losses and increases the probability of profit.
- **Put Credit Spread**: This is an options selling strategy. You sell a put option to enter this position. But you also buy a put option of lower value at the same time. Your profit is the fixed premium received from selling the option minus the price paid buying the lower value put. You pocket the profit if the market price remains the same or rises. Otherwise, you face a fixed loss.
- **Put Debit Spread**: This entails buying and selling a put option, but this setup is used when you expect the share price to drop. It caps possible profits but with

the benefit of increasing the probability of profit and minimizing potential losses.

- **Call Credit Spread**: This entails buying and selling a call option at the same time, with the hope that the share price will drop. Similar to a put credit spread, you earn a premium from the option you sell less the expense of buying a second call option that shields you from potential losses.
- **Straddle**: This strategy is used when the stock price can move either way. You buy a put option and a call option together with equal strike prices. If there is a large move in the share price, you will earn a profit. This is a strategy typically used before earnings calls, but it can also be used at any time.
- **Strangle**: Also used before earnings calls, this strategy is used when you do not know which direction the stock is going to move. In this case, the strike prices for the call and the put are not the same.
- **Iron Condor**: This strategy is used for a share price that is ranging in between two values. An iron condor is a sell to open strategy that involves two put options and two call options. It is similar to putting together a put credit spread and a bear credit spread (two calls). If the share price stays within the range defined by the strike prices, you collect the premium when the option expires. If it goes outside, you will take a capped loss.
- **Covered call**: This is a way to earn income from shares of stock that currently exist in your portfolio. You can sell a single contract for every 100 shares of stock.
- **Secured or protected put**: This is another way to earn options income. You must deposit cash that is held in reserve in the event the put option was exercised and you have to buy the stock. You earn the

premium from selling the put option, which will be a profit if the put option expires worthless.

- **Naked Put**: This is a strategy of selling a put option without full cash backing. Brokers require you to put a cash deposit to back it, but it is a far lower amount. A naked pull sale is an income strategy.
- **Naked Call:** This involves selling to open a call option when you do not actually own the shares of stock.

Brokerage Levels

Prospective traders need to have some familiarity with brokerage trading levels that are assigned to options traders. There may be some slight variation but generally, they follow these rules:

- **Level 1**: You can sell covered calls and protected puts. You cannot buy to open or trade options.
- **Level 2**: You can do what a level 1 trader can do, and you can also buy to open call and put options and trade them.
- **Level 3**: A level 3 trader can do anything a level 1 and a level 2 trader can do. Level 3 traders can do all options strategies except selling naked calls and puts. This is the level most traders want to get to. Check with your broker for specific requirements.
- **Level 4**: A level 4 trader can sell naked puts and calls, and must have a margin account.

Chapter 2: How Options Prices are Determined

Options prices are determined in part by the price of the underlying stock. But options prices are also influenced by the time left to expiration and other factors. We are going to go over all the different ways that the price of a given option can change and what will be behind the changes. It is important to have a firm grasp of these concepts so that you do not go into options as a naïve beginning trader.

Market Price of Shares

The largest factor that impacts the price of an option is the price of the investment known as the stock that is behind the option. However, it's not a 1-1 relationship. The amount of influence from the underlying stock changes with time. Furthermore, it depends on whether the option is in the money, at the money, or out of the money. The fraction of the options price that is due to the price of the underlying stock is called the options *intrinsic value.*

If an option is the same as the market pricing or not be comparatively favored, it has no intrinsic value. An option has to be priced in the money in order to have an intrinsic value.

For a call option, if the market price is lower than the strike price or the same, the option will have no value intrinsically. If the share price is higher than the price used to trade shares via the option, the option will have intrinsic value.

For a put option, if the share price is at or above the strike price, the option will have no intrinsic value. If the share

price is below the strike price, then the option will have intrinsic value.

However, even when an option is at or out of the money, the price of the underlying stock has some influence that can change the value of the option. The amount of influence that the market price of the stock has on the price of the option is given by a quantity that is called *delta*. Delta is given as a decimal value ranging from 0 to 1 for call options. It is given as a negative value for put options. The reason for the negative value for put options is that this reflects the fact that if the stock price is found to increase, the price of a put option will be reduced. In contrast, if the stock price declines, the value of the put option will increase. It is an inverse relationship, and thus, the delta is negative for put options.

To understand how this will play out, let's look at a specific example. Suppose that we have a $100 option. That is, the strike price is set to $100. If the price of the underlying stock is $105, delta for the call option is $0.77.

If the dollar value of the stock increases by $1, the value of the option will rise by approximately $0.77. This is a per-share price change. For an option that trades 100 underlying shares, a $0.77 price rise will increase the value of the option by $77.

For a put option with the same strike price, the option will be out of the money because the share price is higher than the strike price. In the case of the put option, the delta is -0.23. The put option will lose approximately $23 if the share price went up by $1. On the other hand, if the share price drops by $1, the put option will gain $23.

The intrinsic value of the call option described in this theoretical exercise is $5 per share. The total cost of the option is $6.06 per share, reflecting the fact that the call

387

option has $1.06 in extrinsic value. In contrast, the put option has no intrinsic value. It has almost the same extrinsic value, however, at $1.03.

I used a 45-day time frame prior to expiration for this exercise. Options prices are governed by mathematical formulas, so it is possible to make estimates of what the option price is going to be ahead of time. There are many calculators and spreadsheets available free online for this purpose.

Now, let's say that instead, the share price is $95 so that the call option is out of the money and the put option is in the money. In this case, the call option has no intrinsic value, and it has a $0.94 extrinsic value. Therefore, the option would be worth $94. In this case, the delta is 0.25. If the share price rose to $96, with everything else unchanged, the price of the call option would rise to $1.21 per share. This illustrates that you can still earn profits from cheaper out of the money options.

If the share price stays at $95, the put option will have a delta of -0.75. Notice that if we take the absolute value and add the delta for the call and the put option, they sum up to 1.0.

If a call option has a strike that is lower than the market price and has a delta of 0.8, the put option with the same strike price and expiration date will have a delta of -0.20.

Delta does more than give you the prediction of changes in the underlying share price and price movements of the option. It also gives a rough estimate of the probability of an option to expire in the money.

If you sell to open, you do not want the option to expire in the money. Therefore, you are probably going to sell options that have a small delta. On the other hand, if you buy to

388

open, you want the option to go in the money, if it is not already. So, you would buy an option with a higher delta.

If a given call option has a delta of 0.66, this indicates that if the underlying stock price rises by $1, the price of the option on a per-share basis will rise by $0.66. It also tells us that there is a 66% chance that this option will expire in the money.

Something else you need to know is that delta is dynamic. If the price of a share increases on the market, delta rises for the call option and gets smaller for the put option. A declining share price will have the opposite effect.

The amount that delta will change is given by another Greek called the gamma. Most beginner traders probably are not going to be too worried about gamma. What we have described so far is actually all you need to know to enter into effective options trades. But gamma will tell you the variation in the value of the delta with a change in stock price. So, if gamma is 0.03, this means that a $1 rise in the stock price will increase delta by 0.03 for a call option. The inverse relationship holds for a put option.

If an option is at the money, the delta is going to be about 0.50 for a call option and -0.50 for a put option. That makes sense as if the strike price is equal to the share price on the market, there is a 50% probability that the market price will move below the strike price, and there is a 50% probability that the market cost of shares will move above the strike price.

Implied Volatility
One of the most important characteristics of options after considering delta and time decay is the amount a stock price varies with time. Volatility will give you an idea of how wide the price swings of stock are. If you look at a stock chart,

you will see the price go up and down a lot giving a largely jagged curve. The more that it fluctuates and the bigger the fluctuations in price, the higher the volatility. Everything is relative and so, you can't say that any stock has an absolute level of volatility. The volatility of a stock is compared to the volatility of the market as a whole. This quality is called beta.

If the stock generally moves with the stock market at large, beta is positive. A 1.0 beta means that stock has the same volatility as the market. This is a stock with average volatility.

If beta is less than 1.0, then the stock is less volatile than the market. An amount below 1.0 tells you how much less volatile the stock is in comparison to the market as a whole. If the beta is 0.7, this means that the stock is 30% less volatile than the market average.

If beta is greater than 1.0, then the stock is more volatile than the average. If you see a stock with a beta of 1.42, this means the stock is 42% more volatile than the average of the market.

If beta is negative, the stock moves against the market. When the market goes up, it goes down and vice versa. Most stocks do not have a negative beta but they are not hard to find either.

Volatility is a dynamic quantity, so when you look it up, you are looking at a snapshot of the volatility at that given moment. Of course, under most circumstances, it's not likely to change very much over short time periods. There are exceptions to this, including earnings season.

Implied volatility is another quantity that is given to options. Implied volatility is a measure of the coming volatility that the stock price is expected to see over the lifetime of the option. That is, until the expiration date.

One of the things that make options valuable is the probability that the price of the stock will move in a direction that is favorable to the strike price. When an option goes in the money, or moves even higher relative to the strike price of a call, or lower relative to the strike price of a put, the value of the option can increase by a large margin.

More volatile stocks have a higher chance of this happening. This is a result of the price going through larger price swings. Therefore, the higher the implied volatility, the higher the price of the option.

Let's consider a hypothetical situation to illustrate. This time, we will look at an option that would have a strike price that was set to $100 and $100 share price. The option is at the money. Here are the prices that you will see for different values of implied volatility:

- Implied volatility = 40%: Option price is $562.
- Implied volatility = 20%: Option price is $282
- Implied volatility = 10%: Option price is $142
- Implied volatility = 80%: Option price is $1,119

That is for a call option.

As you can see, implied volatility has quite a large influence on the price of an option. For this reason, professional options traders look at implied volatility just as much as they look to the comparison between the strike price and the market stock price. One way to make profits is to seek out options that have higher implied volatility.

Each quarter, companies report their earnings. This is a time when implied volatility is really important. As mentioned earlier, earnings calls can fluctuate the price of a stock up or down by large amounts. Prices can move in one direction or the other depending on whether the earnings call beat

expectations or not. This also depends on whether or not there is good or bad news thrown in with the earnings report. This is a highly volatile situation indeed!

This offers opportunities for profits. Many professional traders handle this by purchasing options on companies that will have upcoming earnings calls. Typically, this purchase is made about a week ahead of the earnings call. At that time, the implied volatility is going to be relatively low. It may be in the range of 15-20%.

As time passes and it gets closer to the earnings call, implied volatility will go up by a lot. In fact, for the examples above it was no accident that I selected implied volatility of 80%. Recently, I noticed that the implied volatility on some Tesla options shot up to 82%. As implied volatility goes up, the value of the option increases. This provides an opportunity for profits.

Time Decay
As we discussed earlier, the time left until expiration has a large influence on the price of an option. If an option is valued so that it is the same as the share price, or if it is out of the money, time decay is going to have a significant influence over the value of an option at any given time. For an option that is in the money, the influence of time decay is much less. The closer the expiration date gets, the less influence time value has on the overall price of the option.

In such a case, the option is more influenced by implied volatility and the underlying share price. For example, an option with a 4-day expiration date, a $100 strike price on an underlying stock when the market price is equal to $110 per share will have $10 in intrinsic value with $0.56 in extrinsic value and a total price per share of $10.56. The price is heavily weighted to the underlying price of the shares. However, theta is -0.23, meaning that on a per-

392

share basis, at market open the following day, the option will lose $0.23 in value, all other things being equal. Of course, all other things are not equal, and changes in share price and implied volatility may wipe that out or add to it.

The important thing to do is check theta every afternoon so you can estimate what the cost is going to be for holding the option overnight. Time decay is an exponential phenomenon, so decay occurs faster the closer you get to the expiration date. The important fact to remember is that when other factors are going to be more important than time decay, do not simply sell the option because it is going to lose value from time decay the following morning.

Risk-Free Rate

The risk-free rate quoted for an option is the interest rate that you can earn on an ideal safe investment. Generally speaking, this is the interest you can earn on a 10-year U.S. treasury over the time period of the option. In normal times, this is an important factor to consider. Rising interest rates can lower the value of options. In recent years, interest rates have been very low and changes in interest rates have been small and very conservative.

Summary: The Greeks

The Greeks describe the sensitivity of factors that impact the price of the option.

- **Delta**: This measures how much the price of the option will vary if there is a single dollar move in the share price. It also gives the probability that the option contract will come to an end favorably (in the money) for the buyer.
- **Theta**: This is a measure of the options' price decline by a single day. Its impact is felt when the market opens.

- **Vega**: This measures how responsive the option is if there is an alteration in implied volatility. It tells you how much the price of the option will change in response to a 1% change in the implied volatility.
- **Rho**: This tells you how responsive the option is to a variation of the risk-free interest rate. It estimates how much the price of the option will change in response to a 1% change in interest rates.
- **Gamma**: This tells you how much delta will vary as a result of a change in the underlying stock price.

Before you invest in an option, you should check the values of the Greeks. Then determine their relationship of the options' strike price. Determine if it is in the money or out of the money situation and what the implied volatility is.

Volume and Open Interest

Volume and open interest are factors you need to consider when trading an option. You also need to consider how difficult it is going to be when exiting a position. If you sell to open, as we will discuss later, you might need to buy the option back as part of your strategy. If you buy an option, you want to be able to sell it quickly in order to take profits at a level that you are comfortable with.

Some options might look appealing on the surface, but if you cannot buy and sell them quickly, they might be more trouble than they are worth. Therefore, the trading activity needs to take place at a reasonable level.

Open interest will tell you the number of option contracts that are out there on the market. This is for a single strike price. It will also be for the same expiration date and one type of option. For example, if I have a Tesla call option, let's consider the possibilities. Suppose that the strike price of $250 expires on August 2. I can look at the open interest to

see how many of these contracts are on the market. Generally speaking, you want the open interest to be 100 or higher. For some highly traded securities, the open interest can be in the thousands. This is a dynamic quantity. It will change if more traders sell to open. But the rule of thumb is that 100 or higher gives you enough action on that your contract can be bought or sold later without a long waiting time to close the position. If open interest is really low, you might not find a buyer or seller at all.

Volume is a measure of how many times that option was traded on the current or previous trading days. So, in addition to checking all the factors we have described in this chapter, you should take a look at open interest as well.

Chapter 3: Basic Options Strategies Going Long

If you were to first open your contract by selling, you are going short. If you buy to open a position, you are going long. The simplest way to trade options is to take a long position on a call or a put. Although when buying and selling stocks, it is said that the trader shorts the stock when they are hoping to profit from a decline in the share price.

The strategy for profiting from going long on a call or put option is simple. The hope is that the price of the stock will move in your favor so that you will earn a profit. The industry is full of naysayers that downplay this basic strategy. However, the reality is you can definitely earn profits in this way. The key to success when doing this type of trading is to stay on top of it and do not buy options on a whim. You need a good reason to buy a call or a put option by itself. It is important to pay attention to the financial news surrounding the company, earnings reports, and looking at simple market trends. This will allow you to determine when you have a reasonable probability of earning a profit.

Day Trading and Options
Watching the movement of a stock price over the course of a single day can provide opportunities to ride a short-term trend in price and profit handsomely. Rising and falling share prices are magnified in the price of the option, so when the share price goes up a few cents, you might profit by $65 or $75 in a single day.

Be aware that the rules for day trading apply to options as well. In order to be a day trader approved by your broker in the United States, you need to have a margin account with a $25,000 deposit. Since options trading often takes place on the level of tens or hundreds of dollars at a time, the vast majority of beginning options traders are not going to be looking to be a day trader. But you are going to be tempted to get out of some trades on the same day that you enter the trade because there a trend in one direction or the other to significant profits. The trend might not continue the following day and you do not want to eat some of your profits from the theta or time decay.

If you make four-day trades over a five-day period, you will be labeled a pattern day trader. To keep your account open, you have to fund it with $25,000. This is a situation that you are probably going to want to avoid. In order to avoid being pulled under by this, simply limit the number of day trades to 3 per week.

The five-day rule means five consecutive trading days, so weekends do not count. If you made a day trade on Friday, the following Monday, which is the day trade, still counts against you.

Call Options Basic Strategy

The basic strategy behind making profits with call options is to buy low and sell high. You can profit from this strategy riding a single day's price movements or by swing trading the option over the course of one or more days. This means that you will hold the option overnight. You are not going to hold the option until expiration unless you have the intention of buying the stock.

The time to sell the option is the point at which you have made an acceptable level of profits. You should set this level beforehand so that you are not letting the emotions of the

moment rule your decisions. It's not uncommon to make $50 or $100 profits in a few days or even in a single day off of one option contract, but many traders get dollar signs in their eyes. They get overcome with greed. As a result, they hold their positions for too long. That can mean lost profits, being defeated by time decay or even seeing the option wiped out.

One lesson that you are going to learn is that options prices can fluctuate dramatically. This is because the underlying stock is 100 shares. A small change in the stock price is magnified by 100 in your investment in the option. Using a one-to-one pricing relationship for the sake of simplicity, if the price of the stock moves up by a mere $0.45, the price of the option will go up by $45. On the other hand, if it drops by $0.30, the price of the option would drop $30.

Although the situation of using one-to-one pricing is not realistic *(see the previous chapter for details)*, it is pretty clear that small price changes in stock mean significant price changes in your investment.

The key to success with trading options is to have a trading plan that you follow. This plan will have specific rules. We will cover that at the end of the chapter.

One skill you are going to need to develop when it comes to call options is the ability to read stock charts. There are three basic skills that I recommend you have:

- Learn how to read and interpret candlestick charts.
- Learn how to use moving averages.
- Learn how to use and interpret Bollinger bands.

Let's briefly discuss each of these in turn.

A candlestick chart divides a stock chart into time intervals that you specify. The time interval you are going to use is

going to depend on the time frame over which you are hoping to trade. I have had some success trading call options using a buy to open strategy. I cannot say what the situation is in all cases but what I will tell you is that I do not stay in these trades very long. What I do is I check the early morning financial news for any surprise and when the market opens, I look for early indicators of how it's going to move.

If the other aspects of the stock look good and indicate that I can buy options with a high level of open interest, then I enter a position if it looks like there is going to be a strong move over the course of the day or the next few days.

Let's give a few specific examples so that you will have some practical advice for the situation. You can trade index funds like the Dow Jones Industrial Average (trade options on DIA), the S&P 500 (trade options on SPY), or the NASDAQ (trade options on QQQ). These index funds are very sensitive to general economic and political news. So, if you see that a good jobs report has come out, that is a good signal to get in on one or more of these funds. In fact, it is often worth the risk to get in on options for these index funds the day before. Then you can wake up and see the results. It is possible to double an investment overnight. Since you are not day trading in that case, it is a simple matter to exit your positions for a profit. But keep in mind that there is the risk that this can work against you as well. We will discuss strategies to use to cover both movements soon. If you buy a call but the early indication is a market sell-off, then get rid of the put first thing when the market opens.

This is a good example of why open interest is important to look at. If you were to buy an option on something with a small level of open interest, you might not be able to get rid of your options before the put lost a lot of money. With

something that is very heavily traded like SPY, however, it's a sure bet that you can unload the put quickly.

You should also pay attention to the news about specific companies. For example, if there is news coming out in the early morning hours that the government is going to investigate the social media companies, that is a good indication that going long on a put option would be a reasonable strategy. Conversely, recently, the FTC announced a settlement with Facebook, and this sent the stock soaring.

You are not going to be getting the news first as an individual retail investor, but the good news is that with options trading, if you are staying on top of things, you are going to be able to get in and out of your trades and take profits if you are careful about it.

Reading the Charts
As an options trader, you are going to have to learn how to read charts. The first thing to do is look up candlestick patterns so that you can recognize when a trend reversal might be coming. Candlestick patterns are not absolute rules or truth-tellers. They act as indicators. Take the candlestick charts into consideration and use the entirety of the information that you have available to make your decisions.

As we said earlier, a candlestick can be divided into different timeframes. If you are looking to ride a trend over a single day, a five-minute timeframe is good to use. In this case, each candlestick is going to tell you what the price action was over the five-minute period.

The candlesticks are going to be colored green or red. If a candlestick is green, it is a bullish candlestick. Over the period of interest, the closing price had risen to a larger higher than the opening price. By itself, it does not tell you

400

where the price is headed. For a bullish candlestick, the top of the candle is the price at the end of the trading session, and the bottom of the body is the price at the start.

Each candlestick has wicks that come out of the top and bottom of the candlestick. The top wick gives you the high price for the time interval. The bottom candlestick gives you the low price of the time interval.

If a candlestick is red, that is a bearish candlestick. In that case, this means that the closing price was lower than the opening price. So, the top of the body is the opening price in this case, and the bottom of the body is the closing price because the price closed lower than what it opened at. The meaning of wicks is the same.

A complete investigation of candlesticks is beyond the scope of this book, so please see online resources or books specifically addressing the topic. Researching day trading will also allow you to learn about the patterns that you need to be looking for.

That said, here are the general rules for entering and exiting trades. In the event of big news that is likely going to cause a massive move in the share price, you want to just get in early in the trading day.

If you are looking at a stock under normal conditions, that is no earnings report or other huge news, you want to wait for a downtrend in the share price so that you can enter a position at a relative minimum. You buy the option at the lowest possible price given current market conditions. Then you wait until the price rises and the trend peaks out so that you close your position.

For beginners, I have to say get ready for the ride. If you are thin-skinned, this kind of trading is going to put you on pins and needles. As you know, stock prices do not follow a steady

curve. They move up and down a lot. And as we have mentioned several times, a small move in share price can have a big impact on options prices. It is not uncommon to get into a trade and see your option lose $75 or $100 over the course of a couple of hours only to see it rise to a $50 or $100 profit a few hours later. Options trading is not something for the faint of heart to get involved with. But to avoid panic, you should rely on the indicators to help you make your decisions rather than relying on emotion.

The second big tool you need to use in your trading is the moving average. I like to use a 9-period case. This will be for an exponential moving average. Then for the long one, I will use twenty periods. Again, it will be an exponential moving average on the same chart. Moving averages smooth out the stock prices to show the overall price trend. Using two moving averages allows you to get signals that indicate when a trend is going to reverse. This works quite well in practice. The signal for a reversal is when the moving averages cross.

A short period moving average crosses above a long period moving average indicates a coming uptrend. In my case, I look for the 9-period moving average to cross above the 20-period moving average. This can be used to either reinforce your conviction that you should say in the trade or to enter a trade if you are looking to take advantage of a coming price movement for call options.

If the short period moving average crosses below the long period moving average, this indicated that a downward trend is coming. If you have been riding a trend with a call option, this might be an indicator to sell to close your position.

You can also add a tool called the RSI to your charts. RSI stands for relative strength indicator. This tells you if a stock is overbought or oversold. If the RSI is 70 or above, then the

stock is considered to be overbought. This is an indicator that it is a good time to exit a long call position.

If the RSI is 30 or below, this is oversold. This is an indicator that it is a good time to enter a long position for call options. I take the RSI with a grain of salt because I have seen it indicate overbought conditions which were then followed by continually rising prices all too often. But it is still something that you can consider looking at.

Finally, there are the Bollinger bands. These give you a moving average along with the standard deviation both above and below the moving average. The main reason to use this is to establish levels of support and resistance. A level of support is a low price level where the stock is unlikely to break below over a short time period. A level of resistance is the maximum price you will see for the stock over a short time period. These are guidelines, a stock can suddenly break out of a range at any time.

Another reason to use Bollinger bands is as a guideline when selling to open a position. In this case, you can use one or two standard deviations to give you a boundary above and below to cater to extreme stock price moves. We will talk more about that later.

Put Option Strategy

The strategy for put options is a little bit different than what most people are used to thinking of. In this case, if you take a long position with a put option, the expectation is for the market value of the shares to drop. The cost of the shares must drop below the strike price of the put in order for it to be in the money. You will use the same tools used to analyze stock charts when going long on calls. The only difference is that you are going to enter and exit your positions in the opposite manner.

Spotting an uptrend is the time to enter into a position by buying a put option. When a downtrend is spotted, close your position by selling the put option. Put options can be a consideration just as much as call options. Just remember that profit is realized with puts when the stock price fall.

No matter whether you invest in calls or puts, be ready to profit no matter which way the share price is moving. This will massively expand the opportunities you have available even if you just stick to buying and trading call and put options without using any advanced strategies.

Can You Profit With at the Money or Out of the Money Options?

The short answer is yes. Out of the money options have a lot of appeal because they are cheap, relatively speaking. They also get a large percentage of movements from share prices when there is a dramatic move over a short time frame. Here is an apt comparison using SPY options. The S&P 500 went up the day that I am writing this and was priced at $299.70 a share. The more in the money the option, the smaller its gains. When compare the gains you would get from any other financial investment, they are massive. An in the money, a $299 call rose in value by 84.76%. The $299.50 call, went up by 94.6%.

Now, look at the out of the money options. The $300 call is slightly out of the money, and it went up in value by 104.69%. The $301 call went up by 118.1%.

This comparison shows that you trade out of the money options. You just need to have an effective strategy when doing so. If you buy an option for $40 and it goes up 100%, you could sell it for $80. That is a good deal! If you traded 10 of them, that would be a $400 profit.

The $300 call has a theta of -0.126. It is currently trading at $1.31, for a total of $131. When market opens, the price is going to drop by almost $13 to $118. But if you had purchased it in the morning before it had made the 104% gain, you can still sell it the following day for a big profit. If the share price keeps rising the next day, it may make even more significant profits the following day that will overcome the $13 lost to time decay, and possibly drive your profits much higher.

You can also trade out of the money put options but the time to buy out of the money options is when the stock is making a significant move one way or the other. As we'll see, out of the money options also have important roles to play in many advanced options strategies.

The only caution I would offer here is to not go too far out of the money. You can buy a $310 call on SPY for just $1 but be prepared if it declines in value by 50%.

Having a Trading Plan

Having a trading plan in place is going to be important no matter what you do in the stock market. A trading plan should include the following:

- **Your overall goal.** This can include your reasons for investing as well as your goal for annual profits or ROI (return on investment).
- **How much you are willing to put at risk.** It should go without saying that you shouldn't bet the family farm on your trades. Set aside a fixed amount of money that you are willing to lose. If you are smart about your trading, you are unlikely to lose all of it and hopefully, you don't have a string of losing trades. With options, you can start small and learn the ropes without risking large amounts of money. Start with something like $500. If you lose $500, it's not going

to be the end of the world. If that happens, you can replenish it later and it's probably not going to put you in a position where you can't eat.

- **Have a profit level for the trade.** This is done on a per-contract basis. The level I like to use is $50. It's true that you are going to miss out on some big gains some of the time, but having a fixed level ensures that overall you have a string of profitable trades. Remember that it is per contract, so you can trade five contracts on the same option and if you reach the $50 profit level, this is $250 in overall profit.
- **Have an exit strategy**. This is a personal tolerance level of risk. For me, it's a $100 loss on one contract, provided there are no signs of a turnaround coming. This is harder to quantify because options move up and down by large amounts over short time periods. So, if you are not somewhat flexible, getting out on a price move that is too small is going to cause you to lose out on a lot of trades. Remember that a $100 loss on a trade is only a price movement of $1-$2 on the underlying stock. It goes without saying that a stock that drops by $1 is just as likely to reverse course and go up by $1.
- **Always watch time decay.** You can profit on options at any time but if you buy an option that you intend to hold for a period of several days, potential losses from time decay must be taken into account. One mistake that many beginners make is not paying attention to time decay.
- **Never let options expire.** Another beginner mistake is holding onto options for too long, just waiting to see what's going to happen. Never hold onto an out of the money option. Get out of it if the expiration date is approaching. When it comes to in the money options, you might sell the day before expiration. You are

probably not going to want to keep an in the money
option past that unless you want it exercised.

Chapter 4: Covered Call Strategy (or Protected Puts)

In this chapter, we are going to switch gears and look at selling to open options contracts. There are many ways that you can sell to open options contracts, but in this chapter, we are going to look at the two most conservative strategies. The strategies are not going to be available for everyone, but these are the strategies that are allowed for a level one trader. The reason that they're allowed for level one trader is that these types of options are backed with collateral. In order to use the strategies, you must either have the asset on hand or in the case of a put option, you must have money in your account to completely cover the purchase of shares should it come to that.

The main purpose of the strategies is to generate a monthly income. If you already own many shares of one particular stock, this can be an appealing way to earn income off the stock. Of course, there are risks involved. These will discuss later in the chapter. But let's get started by looking at how the strategy works.

Covered Calls

The first strategy that we are going to consider is known as a covered call. When you write a covered call, you are selling an option against shares of stock that you already own. In order to sell one options contract, you have to cover it with your own shares of stock. And you must have 100 for each contract. In return for writing the options contract and selling to open, you will receive a premium payment that you are allowed to keep no matter what happens.

408

When selling covered call, chances are you're going to want to keep the shares of stock. Selling an in the money call option is probably not going to be something that you will risk doing. A word of caution is in order here. If you look online, you're going to see article after article which will tell you that 85% of options expire as worthless. This statistic gives a very false impression. Those options that expire as worthless were probably out of the money. If you sell a call option and it expires in the money, you are going to be assigned. What this means in the case of a call option, is that you will be required to sell the underlying shares of stock. Since you have invested in the stock, and you're trying to make a monthly income off the shares, chances are you want to avoid selling the shares. You are more likely going to be interested in selling and out of the money option on the shares.

Let's have a look at some examples, so that we can get an idea of how much money could be generated. For our first example, I'm going to be a bit optimistic and assume that you own 100 shares of Amazon. If you do, that could be a pretty good deal because the options are expensive. In our example, 1 share of stock is priced at $53.85. If we sold one call option, we could get a monthly income of $5385, which is the premium that will be required to purchase this option.

This option is out of the money. But consider examining delta, so that we can get an idea of the risk involved in selling a covered call that has a strike price as given. Delta is given at 0.4563. This means that there is a 46% chance that this option will expire in the money. The breakeven price is $2053.85. The breakeven price of an option is something you need to pay attention to when you're selling to open. This will give you an idea of the actual share price that will be required in order for someone to exercise the option. That gives us a little of room, as long as Amazon doesn't move

too much over the time period before the expiration of this option.

When selling options, oftentimes, you want to take advantage of the time decay. Time decay is our friend if we are selling to open an options contract. Let's consider an alternative, and look at some options that are about to expire. At the time of writing, the share price of Amazon's $1971.90. Consequently, a $200 call that expires in three days is currently selling at $36.85. In theory, you could make around $3600 within one week by selling a call option on your Amazon shares.

But remember that there is always the risk of assignment if the option expires in the money. This is where Bollinger bands can come in handy. You can look to see what the one standard deviation price levels are, and then you can sell options that are at least one standard deviation away from the current share price. This reduces your risk significantly since there is a 68% probability that the market value is going to state within one standard deviation of the current price. Also, with time decay working in our favor, selling an option with just a few days left before expiration is a pretty safe move most of the time.

Of course, Amazon is an extreme example because of the very high share price. Let's take a look at something that has a more reasonable price like Facebook. It's currently trading at $199 a share. The prices of Facebook are actually pretty high right now and the reason is there is an upcoming earnings call. But we can look at the chance of profit when choosing a call option that we can use to sell to open. Your broker will estimate the chance of profit for selling an option. Under normal circumstances, I would be willing to sell it $205 call that expired in two weeks. Under the current circumstances, I probably wouldn't do it because the earnings call might send this share price skyrocketing. In any

case, there's a 72.4% chance of profit with the $205 dollar call and the price for the call option is $5.95. For every 100 share option that we sold, we will earn $595 in premium. This is actually a pretty nice income as well. And of course, the more shares you own, the more money you can make. If you own 1000 shares of Facebook, you could put a portion of your portfolio at risk, and you could still potentially earn a full time living selling covered calls.

Consider the Low Level of Risk if You Own Shares For a Long Time

Many investors have numerous shares that they can use for covered call writing invested in those shares some time ago in the past. This means that even if you're selling a covered call and it ends up being exercised, you can still walk away with a profit. Just as an example, sticking with the $205 call for Facebook, let's say that I have bought the shares in Facebook years ago for $140 a share. If I sell the $205 call if the option is exercised, I would have to sell the 100 shares at $205 a share. The breakeven price for this option is $210.95. The share price would rise to at least $210 or so, and I would be missing out on some potential profit by having to sell at the strike price. However, it's clear that we still benefit from the sale. This is because the shares were purchased at a low price, and even though the strike price is going to be below the current value at the time the option is exercised, we still benefit by making a substantial profit on our overall investment. And we will have some money they can be reinvested in other stocks.

Covered calls are a relatively safe way to earn income provided that you are careful when choosing the strike price that you are going to use for the sale. You don't want to choose a strike price that is in the money. Instead, choose a strike price that is going to be close so that you can make

profits. If it's out of the money there is the risk of having to sell your shares is actually reasonably low.

There is no guaranteed rule that you can use. But most brokers will give you the probability of profit. Therefore, you can either go by that or read Delta. I prefer to use the probability of profit that is 70% or higher. This will amount to a pretty good outcome, if you did 100 trades, you would win on 70% of the trades and then you would have to sell the shares on 30 of the trades. But since we are talking about covered calls, you are probably still selling the shares almost 30 trades at a profit. This is a very safe way to sell calls for income. The only obstacle, of course, is that you must own shares of stock in order to take part in the strategy.

To buy 100 shares of Facebook and earn $600 a week routinely by selling calls against the shares require a $20,000 investment. In the grand scheme of things, that's actually pretty reasonable. And let me tell you, there's no way that you would make that kind of return putting that $20,000 somewhere else. But for those readers who are not able to invest in purchasing that much stock, or who don't have that much stock in their portfolio at the present moment, this strategy is not going to be accessible.

As an aside, you always want to check the open interest and volume even when selling options as well. When this case for the Facebook $205 call that expires in two weeks, the open interest is 3075. If you remember, the general rule of thumb is you want an open interest of 100 or greater. The volume for the last trading day was 4059. This is an option that has attracted a high level of interest. If you were to sell it at the market open tomorrow, you would probably close the sale very quickly.

Selling Options Strategy: Buy It Back

Now, we are going to talk about a defense mechanism that you can use to protect yourself when selling options. It doesn't matter what type of option or strategy that you're using. But we will introduce it in the case of covered calls.

Chances are even if you could make cold hard cash selling the shares at the strike price, you probably want to hold onto the shares. The first thing to realize is that if an option goes in the money, although it can't be exercised at any time, in most circumstances, it is not going to be exercised until it's very close to expiration or actually at the expiration. This fact gives option sellers a strategy they can use to protect themselves from being assigned. In the case of call options that would mean that you would be able to earn an income off of the shares, while at the same time getting some reasonable protection as far as being able to keep the shares.

This strategy relies on the time decay of options. If an option is out of the money, all the value of the option is extrinsic value. This implies that the option does not get direct value from the stock market price, although its price can fluctuate based on changes in the stock price. But the main thing about this is that when an option has 100% of its value locked up in extrinsic value, it is very sensitive to time decay. As the option approaches expiration, its value is going to decline rapidly. Remember that time decay is nonlinear. The closer you get to expiration, the faster it's going to drop.

To take advantage of this, you can actually buy back the option that you sold. It's not going to be the exact same option. You only have to buy back an option that has the same expiration date and strike price. Your broker probably has this set up for you anyway. In that case, you will probably be able to access a close button from your

dashboard which will allow you to close the position by purchasing the option back. This is going to lower your profit somewhat. For some options, you might have sold it for $500, and then you have to buy it back for $150. Of course, this is not ideal because you're cutting into your profits. But you still walk away with the $350 premium.

If there is no risk going to the end of the expiration date that is to be exercised, then this strategy really isn't necessary. Some people are more conservative than others, and so they will use this strategy as a matter, of course. I have to admit that is a smart way to do it, even though you are cutting into the profits you could make. However, some people are willing to take that risk of just letting the options expire. That way, they get the full profit from the $500 premium. This can be a reasonable approach in the situation that there is no real chance that on the last day of the option contract the price is going to suddenly shift and put your option in the money. Therefore, this is going to have to be a situation that you would evaluate for each individual situation. It's also going to depend on the amount of risk that you are able to tolerate. But I just wanted to go through this process, so that readers could understand the way that you get out of having the option exercise on you.

Options that Expire In The Money Will be Exercised
Therefore, this is an important point to make because so much material out on the Internet makes it sound like there is little to no risk that an option is going to be exercised. Here are the facts. If an option expires in the money, the probability that it will be exercised is 100%. This is because the broker will exercise the option. If you are selling options, and they're in the money, you don't want to let them expire.

Protected Puts

The next strategy that we are going to examine is called a protected put. A protected put is an analog to a covered call. In order to sell a protected put, you must have enough capital in your account to cover a possible sale of the stock. This will be sold for the strike price used to sell the option. If you were to sell a $195 put on Facebook that expired in 17 days, you would need to have $19,500 in cash in your account, in case the option was exercised. You would receive a premium payment of $438. The premium is yours to keep, but a lot of people would be leery of tying up that much capital to make $438. Of course, to be fair you would need to compare that to putting the money in the bank or in bonds, and seeing how much interest you would earn over 17 days. Selling a protective put is probably not the best strategy to use when trading options, but it is going to generate a lot more income than most other available means to do so in the present environment.

If you have the capital to cover the sale, this is not a bad move. The rule that is usually given is that you should be willing to own the stock. The price that you must be willing to pay would be the strike price. Think about this before selling a put option. In this example, walking away with 100 shares of Facebook is not a bad deal. You still end up with a solid asset in your portfolio. Of course, the option wouldn't be exercised unless Facebook stock had dropped significantly, making exercising the option possible and desirable. But over the long term, this is probably a good deal because the Facebook stock is going to appreciate down the road.

Dividend Warning

One problem with selling options contracts is considering stocks that have dividends. If a stock pays a dividend, this could be an additional risk. Some traders will exercise an

option to get the dividend payment. This still isn't going to happen unless the trader is going to profit from the deal, so you are going to be looking at options that are in the money. When selling covered calls on stocks that pay a dividend, you will want to avoid selling around the ex-dividend date. If the transfer of shares occurs with the buyer as the shareholder of record, you will miss out on the dividend payment.

Who Should Use these Strategies?

The two strategies outlined in this chapter have introduced us to the notion of selling options. However, we are going to find out that there are different ways of selling options and you can do it without tying up shares of stock or large amounts of cash.

That said, if you are a level one options trader who is relatively conservative, and you either have the cash or shares to back up these particular trades, you can use these strategies in order to sell options. The goal of using these strategies is to generate income.

Chapter 5: Strangles and Straddles

Options allow you to create strategies that simply are not possible when investing in stocks. One strategy that we are going to discuss in this chapter is earning a profit, no matter which way the stock moves. There are two ways that you can do this, they are known as strangles and straddles. This is a more complex strategy than simply buying a long call option or a long put. But it's not that complicated. You just have to understand some basics on how to set them up in order to make a profit.

The strategy that is used in this case is dependent on a large move by the stock. There are many situations where this might be appropriate. But mainly, this is something you will consider using when you are looking to profit from an earnings call.

Earnings calls cause major price shifts in the big stocks. The price shift is largely determined by what the analysts' expectations are for earnings, and so this is not always a rational process. If the company beats the analyst expectations when it comes to earnings per share, this creates a positive surprise that will usually send the stock soaring. The amount of surprise is given by the percentage difference between the actual value and the expected value. If you had bought a call option, you stand to make amazing levels of profit from the option by selling it in the next day or two, as long as the new higher price level is maintained.

But the problem is, you have no idea beforehand whether the earnings are going to exceed or fail to meet the analyst

expectations. The silly thing about this is that even if the company is profitable, and they fail to meet analyst expectations, this results in massive disappointment. You might see share prices drop from a sell-off even if the company is profitable. This is negative surprise.

The impact of failing to meet expectations can be magnified if the company also has some bad news to share. A recent example we mentioned in chapter one was an earnings call from Netflix, where they revealed that over the past quarter they had lost subscribers. This news hit Netflix stock hard, it dropped by a walloping $42. If you had purchased a put option, that allowed the possibility of a $4000 profit.

The problem is that you don't know ahead of time which way the stock is going to go. It's one thing to look back and say you could have had a put option and made $4k in a day, but often companies reveal information in earnings calls that have been under wraps. Nobody had any inkling that Netflix was going to be losing subscribers until the earnings call.

Second, analyst expectations are somewhat arbitrary. Defining success or failure in terms of them is actually pretty silly, but that is the way things work right now. But the point is that it is impossible to know whether these arbitrary expectations are met prior to the earnings call. It's also impossible to gauge the level of reaction that is going to be seen from exceeding or failing to meet expectations.

Since we don't know which way the stock is going to move, it is that a good strategy to use is to buy a call and a put at the same time. That is precisely the idea behind a straddle and a strangle.

That way, you profit no matter what happens, as long as the price on the market changes fairly strongly in one direction or another. When you set up a straddle or a strangle, there

is a middle red zone that bounds the current share price over which you are going to lose money. But if the share price either goes above the boundaries of this zone or below it, you will make profits.

If the stock shoots upward, this means that the put option is going to drop massively in value. This is a write off for you. But if the stock makes a strong move, as they often do after positive earnings calls, you stand to make enough profits from the call option that was a part of your trade to more than make up for the loss of the put. The potential gain is, in theory, unlimited. Of course, in practice, share prices don't rise without limit. Instead, they might rise, $10, $20, or $40, and that could potentially earn profits of roughly $1,000 to $4,000. This more than covers any loss from the now worthless put option.

The opposite situation applies as well. If the stock drops by a large amount, you make profits. Profits to the downside are capped because a stock price cannot decline below zero. That said, if the stock drops by a significant amount, you can still make hundreds to thousands of dollars per contract virtually overnight.

Doing this requires some attention on your part. You are going to have to think ahead in order to implement this strategy and profit from it. Remember that you can use a straddle or strangle any time that you think the stock is going to make a major shift one way or the other. An example of a non-earning season situation where this can be a useful strategy is a new product announcement. Think Apple. If Apple is having one of their big presentations, if the new phone that comes out disappoints the analysts, share prices are probably going to drop by a large amount. On the other hand, if it ends up surprising viewers with a lot of new

features that make it the must-have phone again, this would send Apple's stock soaring.

The problem here is you do not know which way it is going to go. There are going to be leaks and rumors, but basing your trading decisions on that is probably not a good approach, often, the rumors are wrong. A strangle or straddle allows you to avoid that kind of situation and make money either way.

Other situations that can make this useful include changes in management or any political interaction. We mentioned the government recently made a privacy settlement with Facebook. If you knew when the settlement was going to occur but wasn't sure what it was going to be, using a strangle or straddle might be a good way to earn money from the large price moves that were sure to follow.

The same events that might warrant buying a long call such as a GDP numbers or job reports, are also appropriate for strangles and straddles.

Implied Volatility Strategy
Implied volatility is very important when a big event like an earnings report is coming. This gives you a way to make profits. In fact, we are going to call this the implied volatility strategy.

Let's review how this would work. Remember, implied volatility is a projection of what the volatility of the stock is going to be in the near future. When there is an earnings call, the volatility is going to be extreme on the day after the call. Therefore, you are going to see the implied volatility growing as earnings day approaches.

At the time I am writing this, it is 24 hours before Facebook's earnings call. The implied volatility is 74%, which is very high. In contrast, for Apple, which is more than a week away

from its next earnings call, the implied volatility is only 34%. This is for a $207.50 strike put, with a share price of $207.9.

The strategy is to profit from the implied volatility. You want to enter your position one to two weeks before the earnings call or big announcement. As implied volatility increases, this is going to swamp out time decay and cause a big rise in the option price.

Using that Apple put option, if we assumed that there were only 4 days to expiration, but the implied volatility had risen to about where Facebook is and there were no other changes. Therefore, we will leave the share price where it was. The price of the put option will increase by about $330.

If nothing else, you can profit from the change of implied volatility. It will probably go highest the day before the earnings call.

This is going to be magnified if you trade a strangle or straddle. Prior to the earnings call, both the put and the call option are going to increase a great deal in value because of implied volatility. You can sell the strangle the day before the earnings call and book some profits then. Since a strangle or straddle can earn big profits if there is a large move in the share price, you won't find any problems locating a buyer.

Estimating Price from Implied Volatility
If you know the implied volatility, you can estimate the price range of the stock. This can be done using a simple formula.

(Stock price x implied volatility) / SQRT (days in a year)

If you don't want to do the calculation, if we take the square root of 365, it is about 19.1. For example, we use Facebook with a share price of $202.50 and an implied volatility of 76%.

Facebook	
Stock Price	$202.50
Implied Vol.	0.76
Days in a year	19.1049732
Expected Change	$8.06
Upper Range	$210.56
Lower Range	$194.44

The implied volatility gives us an idea of what traders are thinking, in regard to the upcoming earnings call. But of course, we can never be sure what is really going to happen until it does. But this gives us upper and lower bounds. Using the information that we have available, we can guess that Facebook might rise to $210.56 a share after the earnings call, or it might drop to $194.44 per share after the earnings call. You can use these boundaries to set up your strategy. However, remember that if there is a big surprise, it can go well past these boundary points in one direction or the other.

What is a Long Straddle

To set up a straddle, you buy a put option and a call option simultaneously. Buying means taking a long position. The maximum loss that you can incur is the sum of the cost to buy the call option plus the sum of the cost to buy the put option. This loss is incurred when you enter the trade.

With a straddle, you buy a call option and a put option together. And they will have the same strike price. By necessity, one option is going to be in the money and one option is going to be out of the money. When approaching an earnings call, the prices can be kind of steep, because you want to price them close to the current share price. That way, it gives us some room to profit either way the stock price moves.

422

A maximum loss is only incurred if you hold the position to expiration. If it looks like it is not going to work out, you can always choose to sell it early and take a loss that is less than the maximum.

There is a total premium paid for entering into the position. This is the amount of cash paid for buying the call added to the money paid for buying the put. This is called the total premium. There are two breakeven points:

- To the upside, the breakeven point is the strike price plus the total premium paid.
- On the downside, the breakeven point is the strike price less the total premium paid.

It the price of the stock moves up past the breakeven point, the put is worthless. However, the call option will earn substantial profits. On the other hand, if the stock price moved down past the lower price point, it would breakeven. The call option would be worthless and the put option would earn substantial profits.

For example, suppose that we buy a $207.5 straddle on Apple 7 days to expiration with an implied volatility of 35%, and the underlying price is $207. The total cost to enter the position is $8.03 ($803 total). At 1 day to expiration, the share price breaks up to $220 a share after the earnings call. The put expires worthless, but the call jumps to $12.50. The net profit is then $12.50 - $8.03 = $4.47, or $447 in total per contract.

If instead, the share price had dropped to $190, the call expires as worthless, and the put jumps to $17.50 per share. The net profit, in this case, is then $17.50 - $8.03 = $9.47 per share or a total of $947.

This is not to say that the straddle would be more profitable for a stock decrease. It is not. The profit will be the same no matter which way the share price moves, in our examples, we used two different sized moves. The point is to illustrate that no matter which direction the stock moves, you can profit.

If the stock is at the money at expiration, we can still recoup some of the investment and sell the straddle for a loss. In this case, the call and the put will both be priced at $152. We'd still be at a loss, but we could recoup $304 by selling both at $152.

Short Straddle
If you sell a straddle, then you are taking the opposite position. This means you will be betting that the share price stays inside the range. The hope is that the stock does not make a big move to the upside or the downside. To sell a straddle you'd have to either be able to do a covered call and protected put, or be a level 4 trader who can sell naked options.

Long Strangle
A strangle is similar to a straddle, but in this case, the strike prices are different. In this case, you will buy a just barely out of the money call option, while simultaneously buying a slightly out of the money put option. The two options will have the same expiration date. The breakeven points for a strangle are going to be calculated in a similar way as the breakeven prices for a straddle, but you are going to use the individual strike prices for the call and put because they are different. You calculate the total premium paid, which is the total amount paid for the call option plus the premium paid for the put option. Then the breakeven points are given by the following formulas:

- To the upside, the breakeven point is the strike price of the call plus the total premium paid.
- On the downside, the breakeven point is the strike price of the put minus the total premium paid.

Similar to a long straddle, the maximum loss is going to occur when the share price ends up in between the two strike prices. Therefore, you might want to choose strike prices that are relatively close to minimize the range over which the loss can occur. There is a tradeoff here. The closer in range the strike prices are, the more expensive it is going to be in order to enter the position. But, it's going to increase your probability of profit because if the strike prices are tight about the current share price. There is a higher probability that the share prices are going to exceed the call strike plus the premium paid, or decrease below the put strike price less the price paid to enter the contract (the premium).

Chapter 6: Credit and Debit Spreads

In the last chapter, we saw how to set up a trade that could profit no matter which way the stock moves, with a fixed loss that is set at the outset of entering the trade. In this section, we are going to look at some more advanced strategies including credit spreads. Your broker is probably going to require that you are a level 3 trader in order to implement these strategies. This is because they involved selling to open options without owning the share of stock or putting up the capital to cover the purchase of shares from a put option. The only capital that is required to put up in these cases is the maximum loss that might be realized from the trade.

There are four different strategies that can be put in place here, and we are going to examine each in turn. When you enter into a credit spread, this is a sell to open trade and you are looking to earn a regular income. These types of trades are not always going to go your way. However, they are considered to be relatively safe ways to sell premium in order to earn money. A put credit spread is somewhat equivalent to selling a naked put. You will see how that works out as we go through the details, but selling naked puts is one of the most common and profitable income strategies with options. To sell naked puts, you have to be a level 4 trader with a margin account, however. Selling a put credit spread removes the margin requirement and you can be a level 3 trader and use this strategy. The difference between a put credit spread and a naked put as far as money earned is that per trade, a put credit spread is going to earn less money than selling a naked put.

Conversely, you can sell a call credit spread as well. We will explore the reasons that you would choose to sell this instead of the put credit spread below. What you need to be aware of is that selling a put credit spread is the same bet as buying what is known by the name of call debit spread, and selling a call credit spread is the same bet as buying a put debit spread.

In the strategies used in this chapter, we are going to be betting, to a certain extent, on the directional move of the stock. However, as we will see it isn't going to matter how much the stock moves, as long as it's past the breakeven point.

The beauty of these strategies is that anyone can use them, as long as you can round up a few hundred dollars. You can start generating income from these types of options strategies fairly quickly. We will be discussing this as well as we move along to examine each case. We will get started by looking at the put credit spread.

Put Credit Spread

The idea behind a put credit spread is to earn money from selling a put option. But in order to mitigate the risk, you buy a put option simultaneously. This is different than selling a naked put option, where you just sell one option and that is the end of it. Since the option that you buy is going to mitigate your risk a little bit, you are not held to the same standards as someone who is selling naked put options. That said, you still have to have a level 3 trading account in order to use this strategy.

The first thing to realize about the put credit spread is that you are selling to open the position. This is selling, not buying to trade options. Theoretically, there is a risk of assignment, but as we'll see, it's not a real risk in practical terms, and because the trade is mitigated by the second put

which you buy to open the trade, the practical impact of this is minimal.

The two options are bought and sold in one trade, so this is considered a single trade and is not two separate trades. You can buy a put debit spread, so the other party to the trade is doing that when you sell to open your position.

The belief that is behind this type of trade is that you are expecting the price of the stock to stay about where it is now, only minimally decrease in price, or increase in price. It is considered a bullish move, and so sometimes, goes by the name bull credit spread. However, a put credit spread is far more descriptive.

Second, it's not really a bullish move, in the sense that you are hoping that the stock price is going to increase by a lot. Certainly, you will be better off if that does indeed happen. If you set it up right, you will earn the maximum possible profit right off the bat and give some room for the stock to fall before that situation changes.

One of the unique properties of a put credit spread that we have not seen yet in our examination of options is that when the price reaches a certain level, movement ceases. A further increase in share price is not going to increase our profits. In the example below, consider a put credit spread for Amazon. When you sell to open the position, you get a credit to your account of $4.92. For 100 shares that is $492 total. The share price is currently in the maximum gain zone. If the share price moved up by $100, it will have zero impact on the seller of this credit spread, other than having them breathe a sigh of relief that they are definitely going to profit from the trade.

This a somewhat bullish strategy where the hope is that the price does not fall. You are using out of the money put

options to set up the trade, and the hope here is that they are going to expire out of the money and that you will pocket the net premium paid on the deal.

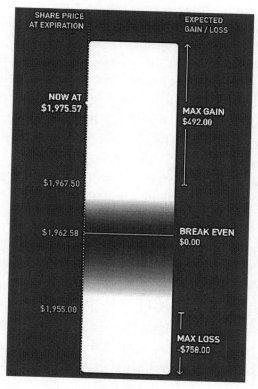

Notice that the amount of loss for the trade is capped as well. These amounts can vary considerably depending on how you set them up. In this case, the share price of Amazon is $1,975.57. The strike prices used are $1,967.50 and $1,955.00, both with the same expiration date.

Remember, these are both put options. When a put option is exercised, the trader who sells to open the position must buy 100 shares of the stock. However, the price for the exchange will be at the strike price.

This can sound a little scary because, in the way that this trade is set up, you are selling a put option so could, in

429

theory, have an obligation to buy the stock. But because of the way these are set up, you really aren't in any danger, even if the option is exercised. We will see how that works out in a little bit.

Collateral Requirements

You will notice from the figure that there is a calculated max loss. We are going to learn how to calculate the maximum loss in a little bit, but for now, let's note that this is an amount of cash you are going to need to have on hand in order to complete the trade. It's important to remember that, in this case – you are not buying anything. Consequently, the cash that you put up in order to enter the trade functions as collateral would be used to cover your position should a loss occur.

In this case, the maximum loss is given as $758. In order to enter the trade, $758 has to be deposited into the account. We would, in turn, receive a credit for $492 for each contract, but that is not cash you can utilize until one of two situations happens. The first thing that would happen is that you close the position early. If you recall when we discussed covered call options, you could close the position in order to avoid the risks that could occur if the option was to expire.

In this case, we are not really worried about the options being exercised. But, the worry might be that the stock could do a dramatic move on expiration day, and by then, you can't get out of the trade. In our example, the breakeven price is $1,962.58. If Amazon suddenly dipped down to that price on expiration day, we'd end up with nothing. If it didn't drop any further, we'd get to keep our collateral. You can buy it back and close your position before it gets to that point. This would work just like with the covered call.

As time goes on and we get closer to expiration, time decay is going to wipe out the value of these options. We can

430

purchase it now at a lower price than we sold it for, and the difference will be our profit.

Let's take a look at the higher strike price, which is $1,967.50. At nine days left until the contract comes to an end, the implied volatility is 29%. The market price is $33, so the total cost for this option is $3,300. You are *selling* this option. We are focusing on the price change and if it stays out of the money toward expiration.

Now let's fast forward to 1 day prior to expiration and estimate the price. We will assume that the implied volatility stays the same. If the share price stays the same (which is extremely unlikely), the put option has dropped all the way to $833. You can buy it back and still have a profit of $2,467. This is complicated by the fact we also bought a put option.

But what if the price of the shares increased by $10? That would be a minor move for a stock with a share price that is that high. In that case, the value of the put is even lower, dropping to $519.

Of course, we also bought a put as a part of this transaction. The other put had a strike price of $1955. If a day before expiration the share price is up to $10, the value of this put is $247. When we close our position, we will get value back. It would help to mitigate the $519 spent to close the other position. The total hit would be around $272. The profit would be $492-$272 = $220, in the event we bought it back under those conditions.

But if the stock price was rising, I would probably just let it expire. The idea that it would rise to $10 and then would fall back down again, and then would fall into territory that would wipe out our profits, and have this happens without any external events, strains credulity.

But every person has their own risk tolerance.

The point is the same as it was with the call options, you can mitigate your risk or you can take a chance to let the options expire and take maximum profit. What actually transpires is going to depend on the situation on the ground at the time.

Buying back your options is more important with negative puts, because of the risk of assignment. The risk with a put credit spread just isn't all that significant.

How to Sell a Put Credit Spread

Many trading platforms allow you to sell a put credit spread in a single trade. The idea is to sell a put option that has a strike price set to a larger value, and then simultaneously buy a put with a lower strike price, but with the same expiration date.

The profit from a put credit spread comes from selling a put option with a larger value for the price, which is called the strike.

There are trade-offs to be made with this trade. The first trade-off is to consider the collateral required and the amount of money you will make with the trade. If you choose put options that are far apart in cost, you increase the amount of money that you can make from the trade. But the further apart the strike prices, the more collateral you will have to put up because that increases the maximum possible loss. Let's look at three specific examples.

We will consider Apple expiring in 9 days. The share price is $207.90.

For the first put option – which we will sell – we will pick the $207.50 strike price. If we buy a put option that has a $200 strike price at the same time, the net credit is $238, because we receive $4.40 per share by selling the $207.50 put, but have to spend $2.02 to buy the $200 put. The collateral

required is $497.20 which would give us the maximum loss on the trade.

Now we will stick with selling the $207.50 put in the next two examples. But suppose that this time, we buy the $202.50 put. This time the net credit drops to $175, but the collateral required drops as well, to $309.

The more money you want to make, the more collateral you have to put on the trade. If it's a short-term trade of a week or two, that is probably not a big deal.

Now let's say that instead, we buy a nearby put option. Going with the $205 put, we lose the collateral requirement to $140, but we also lower the credit received to $0.95. The profit will be $95 this time around.

If you think the trade is low risk and you have enough collateral to put on the deal, you can increase the amount of profit that you could earn by selecting two put options that have a lot of distance between them, as far as the strike prices.

Watching Losses

The risk is that the share price will drop low enough so that the put option becomes in the money. Let's consider the same example, using Apple stock again with the share price at $207.90. This time consider selling an option that a $207.50 strike price, which is a put and buying the put option with the $202.50 strike price. Remember that we get a $1.75 credit for this trade.

The breakeven point is $205.75. To get this value, you use:

Strike price of put you sell – credit received = $207.50 - $1.75 = $205.75.

Let's say that the share price drops to $204. What would happen then?

Well, you would have to buy the shares at $207.50. This means that you would buy them when assigned for the higher strike price put option at $207.50, then sell them on the open market at $204. The net proceeds would be a loss, given by:

Strike price – market price – credit received

$207.5 - $204 - $1.75 = $1.75.

For 100 shares, your total loss would be $175. This sounds a little scary, but all this happens automatically. The broker is going to do all the buying and selling for you, and stick you with the $175 loss. So it is not catastrophic by any means.

The share price drops all the way down less than the lower put strike price, in that situation you would face a maximum loss given by:

High strike price – Low Strike Price + Credit Received

$207.50 - $202.50 - $1.75 = $3.25

The maximum loss is $325.

The maximum amount you make is the credit received. If it seems unlikely that the share price is going to drop very much, you can take a little risk with a larger possible loss in order to make a higher upfront premium. We could instead sell the $207.50 put and buy the $172.50 put. This results in a net credit of $4.15 per share or $415 total. But in order to do that trade, we'd have to deposit $3,069 in collateral. This trade might actually be worth the risk because it's unlikely that Apple is going to drop very far under normal circumstances. The one time when you might want to avoid this type of trade is when an earnings call is around the corner because a negative surprise could get you in some trouble.

Why Use a Put Credit Spread

The primary reason to sell to open a put credit spread is to earn income. You will set these trades up by choosing strike prices that are unlikely to go in the money before the options expire. This can be done by looking at the probability of profit that the broker gives you or by checking delta. Remember that delta is going to be giving you an estimate that the option can end its life with it being in the money. In order to assure profits, many traders will pick low delta values. A cutoff that is often mentioned is a delta of 0.20 or lower. Some conservative traders will go with a delta of 0.16. This means smaller income per trade, but you might be able to sell multiple trades to make up the difference. Always check the open interest. If you are planning on getting into multiple contracts, make sure that there is a high value of open interest, in order to enter the position quickly. Be assured of being able to close the position if you need to get out of it. Of course, with a delta of 0.20 or 0.16, my guess is going to be needing to get out of the trade is going to be a very rare occurrence, and you are probably going to be able to get by letting the options go to expiration.

When a share price is rising, traders also use a put credit spread to earn profits. Although a call option could make higher levels of profits, in this case, many traders prefer the security that a put credit spread gives them, trading the capped profits for a higher probability of profit combined with capped losses as well.

Call Debit Spread

A call debit spread would be an approach that is selected when you think that the share price of a stock is going to go up. In this type of scenario, you are buying a call option and selling a call option to enter into a single trade. But rather than getting a net credit the way that you do with a put credit

spread, you are going to have a net debit in this case, so this is a buy to open position.

With a call debit spread, the two options have the same expiration date, and the spread comes from the options having different strike prices. In this case, you buy a call with a lower strike price. Then you sell a call with a higher strike price. You receive a credit for that, which lowers the amount that is spent on buying the lower strike price call. This will limit the amount of profit that can be made from the trade. The amount of profit is limited, but the risk is limited as well. This is because the call option that you sell will partially offset any losses you incur from the call option that you buy. The profit, in this case, is made from the call option with the lower strike price that you purchase.

The maximum loss that can be incurred buying a call debit spread is going to be given by the premium paid to enter the position.

Breakeven, in this case, is given by:

Lower call strike price + debit paid to enter the position

You pick a strike price for the lower call that you think is going to be profitable. The hope is that the share price goes above this strike price. To reach the maximum profit, the share price has to reach or exceed the higher call strike price.

For example, we use Apple a second time. This time we are buying a call debit spread that has a lower strike price of $217.50, and a high strike price of $220. Maximum loss is incurred for any share price at expiration, which is below the bottom strike price that is $217.50. It costs $0.54 to enter the trade, so the breakeven price is $217.50 + $0.54 = $218.04. In order to make maximum profit, the share price has to go above the higher strike price, in this case, $220.

436

The maximum gain for this trade is $196, and the most you can lose is the credit paid to enter the trade, which is $54.

To be clear, you would buy the lower strike price call. Therefore, you purchase the $217.50 call. Then you sell the higher strike price call, which means for this example, you would sell the $220 call option.

To see how the upper-priced call option lowers the cost of entry, buying the $217.50 call on its own would cost $1.64, for a total of $164. The most money than can be lost when buying a call is the price paid, so it would be $164. However, the maximum profit is theoretically unlimited.

Call Credit Spread

A call credit spread is analogous to a put credit spread, but this is a trade that you would use when you think that the stock price is going to drop. A call credit spread is a sell to open position. You make a profit by selling a call option, and you mitigate potential losses by buying a call option with the same date to end the contract date but a different strike price. In this case, you sell a call with a lower strike price. The risk is mitigated by purchasing a call with a higher strike price.

The maximum profit is the credit received from selling the position.

If the stock price goes above the lower strike price, then you are going to start losing money. To see how this works with an example, we will use Facebook. The current share price is $199.27. You can enter into a call credit spread by selling a call option with a strike price of $202.50 and buying a call option with a strike price of $210. The credit you would receive for this transaction would be $3.30, or $330 for all 100 shares. The breakeven point is easy to calculate. You do

this by using the lower strike price and add it to the credit received:

$202.50 + $3.30 = $205.80.

As long as the share price stays below the lower strike price call, in this case, $202.50, the maximum profit is earned. That is the credit received or $330. Maximum loss occurs if the share prices rise above the higher strike price call, so in this case, there is a $420 loss if the share price rises above $210. Maximum loss is given by the differences in the strike prices minus the credit received. In this case:

$210 - $202.50 - $3.30 = $4.20

Put Debit Spread
If you think that the stock is going down but you would rather buy to open a position, you can use a put debit spread. This is similar to a call debit spread, but in this case, you are hoping that the share price will drop. Losses are mitigated and limited to the cost to enter the position. However, profits are also capped. When you limit potential losses, you also limit potential profits.

In this case, you buy a put at a strike price that you think is going to be profitable. To lower your total risk and reduce the amount you are paying to enter the position, you sell a put option at a lower strike price.

For example, we can enter a put debit spread on Facebook with a cost to enter the position of $1.26. The higher strike price in this example is chosen to be $192.50 – we buy this put option. Then we sell a put option with a lower strike price. In this case, it's $187.50.

Maximum loss is capped at the cost required to enter the position, so we can lose $126 per contract.

Breakeven is given by the higher strike price minus the credit received, so in this case, that would be $191.24.

Maximum profit occurs when the share price drops below the lower strike price. The share price of Facebook would have to drop to $187.50 or below, in order to realize maximum profits.

It's possible that could happen after a bad earnings call, but it's unlikely to happen under normal circumstances without some really bad news. Of course, that does happen from time to time. However, you should enter trades like this carefully. Do not do it without giving it a lot of thought and putting in the required preparation. You should have a solid idea about the trade before getting into one like this.

Chapter 7: Iron Condor

So far, we have covered several different situations. If you are convinced that the share price of a stock is going to rise, then you would buy a call option. If you think that the share price of a stock is going to rise, but you want to reduce potential losses and you are willing to reduce profits in the process, you would buy a call debit spread.

We also talked about the case of declining stock prices. If you believe that stock prices are going to drop, you can simply buy a put option. As we saw at the end of the last chapter, if you think that you would prefer to limit potential losses, and you are willing to cap possible profits in exchange for doing so, then you can buy a put debit spread.

Then, we discussed the situation where you want to earn income from stock, and you believe that it's probably going to go up or stay about the same. In that case, you would sell a put credit spread. This is a solid way to earn income when a stock is not dropping by a large amount.

On the other hand, if you think the share price is going to drop but you still want to sell a position in order to learn income, then you could sell a call credit spread.

Finally, we've also seen how you can set up an options trade to take advantage of significant price movements when you don't know which direction the stock is going to move. These types of trades are known as strangles and straddles.

Examining all of these basic strategies, there is one situation that we haven't covered yet. What if the share price of a

stock is ranging? That is, it's staying within two bounded price points over a significant time period. In this case, significant is going to mean the lifetime of an options contract.

Options traders have figured out how to handle virtually every situation, by combining calls and puts in different ways. This is a powerful medicine that is not available to stock investors and traders. For stock investors, they can buy shares and hope that the share price rises.

Some big players could short the stock, but even then they can't do the kinds of things that we have been talking about with options. Options are simply very powerful tools that will help you earn money, no matter what the situation is that presents itself.

Think about that. You can earn profits from options if the stock price rises and if the stock price declines. And you can earn money if the stock price moves strongly in one direction but you don't know what it is, and now we are saying that you can also earn money if the stock prices stay about the same.

Crazy, isn't it?

The thing is, it's important to know when the right time is to put on this trade or that trade. You might not always guess right with that, which is why some options traders stick to one thing, which is selling premium for income.

But let's take a look at the iron condor.

The Logic Behind the Iron Condor
The iron condor is based on combining a put credit spread and a call credit spread into a single trade. I know, it sounds extremely complicated. We are talking about four options in

a single trade. But the truth is that it is not really that complicated once you understand the logic.

So to set this up, you estimate what the range of the stock is. So you want to look over a reasonable period of time, and then determine what the lowest share price the stock is going to hit has been. This doesn't predict what is going to happen in the future, but it does give us a boundary point that we can use. This is all about playing the probability game. The estimation is that the stock is probably going to stay within some range of values.

Now we do the same for the upper bound. If the price of a stock doesn't change very much, then it's going to be ranging between these two values without having any breakout.

This is the secret of the success of the iron condor. The first step to set it up is to sell a call option at a higher boundary price. Then, we sell a put option at the lower boundary price.

Selling these two options gives us a net credit.

The iron condor is another limited risk strategy though. In order to minimize the risk, we are going to buy two options that lie on the outside range. You will buy a put option with a lower strike price than the put option that we sold. You can see now that we have set up a put credit spread.

Next, we buy a call option with a higher strike price than the call option that we sold. This sets up a call credit spread.

But when you combine the two into a single trade, you set up and interior boundary for the stock to move around in.

Suppose that a stock is trading at $100 a share. We could sell a call option with a strike price of $105. Then we could sell a put option with a strike price of $95. This sets up our zone of profitability. As long as the stock stays within the

range of $95 to $105 per share until option expiration, we are in a profitable situation. To mitigate the risk, we buy two options with outside strike prices. We could go with a call option with a strike price of $110, and then buy a put option with a strike price at $90.

The strategy on these is to wait. Hopefully, the stock price does not break out. If it does not, you can let the options expire to earn a profit from the net credit received. The net credit is going to be given by:

Credit received selling high strike put + credit received selling low strike call – debit paid for high strike price call – debit paid for low strike price put

There is some argument as to whether or not you buy or sell an iron condor, but people arguing about this are confused. You are selling an iron condor. This is because you are selling to open and you receive a net credit for the trade.

If things go bad, that is the stock does have a breakout one way or another, you will have losses but they will be capped. If it's not working out, you can always buy back the iron condor to close the position. As with other trades, if you are really risk-averse and worried about something amazing happening with the stock on expiration day, you can always buy back the iron condor to close the position early, but remember that this move will cut down on your profits, which are limited already by the credit received for entering the position.

When to Use an Iron Condor
You want to use an iron condor when a stock is not expected to move very much. Some people pick options that have very low delta values like 0.16, so they are far outside the money. This can give the stock a wider range of values to oscillate around in, but you are going to make smaller profits per

option contract. That said, it increases the probability of earning a profit. Once again, we have a tradeoff.

You are not going to want to put an iron condor on when the stock has a high amount of implied volatility. High implied volatility is going to mean that there is a higher probability that the stock is going to move outside one of the boundaries that you have setup with the iron condor.

One situation that definitely would not be used with an iron condor is before an earnings call. You do not want to have an iron condor on a stock prior to the earnings call. If the stock rises up to a new range, then after it has settled down, it might be possible to use an iron condor to earn income off the stock.

You might choose low volatility stocks for iron condors. For example, a relatively stable stock like IBM (outside of earnings season) could be a possible choice. But like any options trade, you are going to want to see what the open interest is on the options that you are considering for your iron condor.

Why Use an Iron Condor

Traders use iron condors because it's a limited risk strategy that can be used to generate regular income from trading. Selling an iron condor is analogous to selling a put credit spread in that you are going to need a certain amount of collateral in order to cover the trade. While the iron condor is in your account, the money you use to cover it will be tied up until you either close the position or let the options expire. This is assuming that you don't incur losses because the share price remains in the range that you've set up for the trade.

Let's consider a real-world example. This will show that unlike the spreads that we considered in the previous

chapter, an iron condor has losses on the upside and the downside, with a range of profitability in between. The losses are not necessarily equal. In this example, we consider an iron condor on Facebook with strike prices of $192.50 and $212.50. This is quite a wide range – in fact, it's wide enough that it might survive the upcoming earnings call. Maximum losses occur when the share price goes above the high strike price call or below the low strike price put. In this example, the high strike price call is $215. The low strike price put is $187.50.

To the upside, if the share price rises above $215, there is a maximum loss of $55.

On the downside, if the share price goes below $187.50, the maximum loss is $305. The collateral that is required is always the larger of the two potential losses, so in order to enter into this trade, you'd have to deposit $305 into your account.

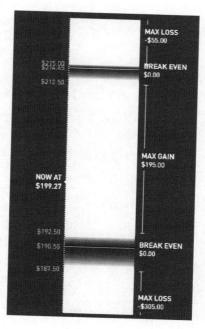

You can see that if the share price stays in between the inner strike prices, the maximum profit of $195 (the credit received for selling to open the position) is realized.

The risk of assignment is the same as for a put credit spread or call credit spread but it is not something you have to worry about. If an assignment occurs, that is all handled automatically by the broker and the stocks are going to be quickly bought and sold without you even noticing.

So the credit received on a per-share basis is $1.95. The breakeven point on the downside is given by the upper put strike price minus the credit received, which would be $192.50 - $1.95 = $190.55. The upper breakeven point is given by the lower call strike price plus the credit received, so in this case that would be $212.50 + $1.95 = $214.45.

For the strike prices, you choose out of the money values. An iron condor is considered a non-directional strategy. Your only care is that the share price stays within a given range of values. It does not if it goes up or goes down within that range.

Review: Options Strategies
There are many choices available to options traders in order to either profit from stock moves or earn income. Different strategies are used in different situations. If you want to become a successful options trader you need to memorize which trades are used in which situation.

Some traders specialize in only doing one or two types of trades. For example, a trader might only go long with calls and puts. That is a simple strategy that is easy to understand, but there is also the highest risk of entering a losing trade when following that type of strategy.

Many traders only trade for income. These types of traders who are level 3 and below will only use iron condor, put credit

446

spread, call credit spread, covered calls, or protected puts among the strategies that we discussed in this book so far.

However, among those, traders tend to specialize. There are traders who will do nothing but iron condors, while other traders will do nothing but put credit spreads. This approach can have its advantages because you will become an expert on one type of trade. When you become an expert on one type of trade, then you will have a higher probability of success with it.

This is will give a summary of the types of trades for different situations.

- Non-directional Trade but stock not moving much: Used for a stock expected to range between two values. Use the iron condor. Stock not expected to move by a large amount.
- Stock will move by a large amount in a non-directional trade: Use strangles and straddles.
- You think a stock will go up, and you want maximum profits: Buy a call option.
- You think a stock will go up, but you want to limit risk and are willing to limit profits to cut risk: Buy a call debit spread.
- You think a stock will go down, and you want maximum profits: Buy a put option.
- You think a stock will go down, but you want to limit risk and will trade limited profits for your protection: buy a put debit spread.
- You want to earn income but think the stock will go up or stay about the same: Sell a put credit spread.
- You want to earn income but think the stock will go down or stay about the same: sell a call credit spread.
- You own shares of stock, and want to earn money against them: Sell covered calls.

- You have cash on hand, and want to earn money without buying stock: Sell protected puts against the cash.

Chapter 8: Selling Naked Options

The next strategy we are going to consider is the most advanced strategy, at least as far as the broker is concerned. This is the so-called selling naked strategy. A selling naked strategy is actually simple because you only sell one option by itself. But it is considered advanced because you have a high chance of losing your investment in this situation. The risk involved is that you could be in a position where you have to buy or sell the shares of stock if the buyer decided to exercise it. Unlike credit spreads, there is little to nothing to mitigate the situation.

As a result, you must be a level 4 trader with a margin account in order to sell naked options.

However, the risks for selling naked options are actually seriously overblown. That is if you are careful. If you are a sloppy trader who is not going to keep a careful eye on the markets, and you are just going to let your options expire, then selling naked options is not something you should be looking into.

This is a strategy that is only good for people who are careful and disciplined with their trading.

The Why of Selling Naked Options
Naked options are sold in order to generate regular income. If you have a large enough margin account, then you can generate a large amount of income selling naked options. Some traders earn $1 million a year following this strategy. But that doesn't mean everyone will earn a million dollars,

you have to really know what you are doing in order to sell naked options.

What is a Margin Account?

A margin account is an account where you can borrow money from the broker. Generally speaking, you must have 50% of the money in your account to borrow the other 50% in order to buy shares of stock. Margin requirements are lower for options. Generally, the margin requirement to buy options is 25%.

To open a margin account, you must deposit at least $2,000 cash. The more cash you deposit the more you can borrow, but you should not use a margin account recklessly. Too many people have done so and ended up broke. This is not a path that you should be interested in pursuing.

Cash Collateral Requirements

When talking about selling options with reckless abandon, the term naked is thrown around. The truth is they are not really naked. Just like with a credit spread, you must deposit a certain amount of cash in order to sell naked options.

The amount of cash first depends on whether it is a penny stock or not. In modern terms, a penny stock is one trading at $5 a share. To be completely honest, there is absolutely no reason to invest in options for a penny stock. You must cover options with cash to 100% of value when penny stocks are concerned, but you are wasting your time getting involved in options for these low priced shares.

For shares that are normal stocks, that is $5 a share and above, brokerages will apply either the 25% or 10% rule. The hidden rule is that they will choose the rule that requires the most money. In the vast majority of cases, this is going to be the 25% rule.

This is the formula used to calculate the amount of cash you must deposit to sell a naked put option to sell one contract:

(25% of the market share price + option ask price – out of the money amount) x 100

Let's use some examples. First, let's look at Facebook. We can sell a $197.50 put expiring in about 2 weeks for $5.30 per share. The market price is $199.27, so first, we have 25% of the stock market price per share:

25% of the market price per share = 0.25 x $199.27 = $49.82.

The option is out of the money by $199.27 - $197.5 = $1.77

The capital requirement for one contract is going to be:

($49.82 + $5.30 - $1.77) x 100 = $5,335

Compare this to a protected put. This would require a deposit of $19,750 in order to cover the entire lot of 100 shares in the event the option was exercised. Having to put up $5,335 seems like a lot of money, but it's far less than the requirement for a protected put.

You wouldn't need to put up the entire amount of cash since, in a margin account, you could borrow money from the broker.

But just for comparison, consider that we could sell a put credit spread with a $5 per share credit, and only need to put up $2,486.20 in collateral.

In my opinion, with put credit spreads, there isn't really a need to sell naked puts, but they are less complicated since you can focus on one option. With the put credit spread, it's a little bit more complicated, but not really by much.

Selling Naked Calls

Selling naked calls is essentially the same as selling naked puts, but it's a strategy that you would employ in different market conditions. You will tend to sell naked puts when you think that the risk of the stock dropping down to the level of your strike price is low. If the stock is dropping in price by a large amount or there is a bear market, then selling naked calls might be a strategy to earn options income as prices are falling. Believe it or not, even in these conditions, people are willing to buy call options for various reasons.

However, in the 2008 market crash, we learned that many people were able to sell put options even as share prices for many stocks cratered. You will just have to evaluate each situation on its merits. You will have to find out if you can sell put options that have low strike prices. They would be far out of the money so that the risk of the option being exercised is low. Still, you are able to make a profit from the trade.

Chapter 9: Rolling Out Options

A rollout is a strategy that is used to extend the lifetime of an option that hasn't quite worked out. This is going to be a strategy used by options sellers. A rollout might be something you would consider doing when you've sold a naked call, and the share price is closing in on your strike price, creating a risk that the option will be exercised. By doing a rollout you can keep the trade going longer, and possibly make some changes to give the trade better odds of being profitable. Typically, you will choose to do a rollout when it is close to the expiration date.

Definition of the Rollout Strategy

A rollout strategy works in the following way. You will close your current option contract by buying it back, and simultaneously open a new contract of the same type, with changes. One way to change is by altering the strike price. Another method that is more common is to move up the expiration date. A common practice is to open the new contract with an expiration date that is further out in the future. For example, you could close a naked put option that is expiring in two days by buying it back and opening a new contract by selling a new naked put option. You would use the same stock and the same strike price, but with an expiration date that is three weeks into the future.

This is a standard strategy where we say that the option contract was rolled out.

You can also follow the same strategy choosing either a higher strike price or a lower strike price. For example, if we

have an Apple naked put with a strike price of $205, we could roll up the option by closing this position and selling a new naked put on Apple with a strike price of $206. Alternatively, you could choose a lower strike price. Using the same example, instead of going with a $206 strike price, we could go with a $203 strike price. Maybe, in that case, the Apple share prices are dropping and it got a little too close for comfort. When you select a lower strike price, they say that you have rolled down the trade.

It's also possible to roll out and roll up or down. In other words, you can close your current contract and open a new one that has a further expiration date, but you also change the strike price.

Types of Options Where Rolling Strategies are Used

You can use a rollout, roll up, or roll down strategy on any type of option, including options that you buy to open (long calls and puts). However, the vast majority of options contracts that are rolled are short (buy to open) options. You can use rolling techniques on any of the major strategies covered in this book, such as put credit spreads, strangles, or iron condors.

Why Roll an Options Contract

The main reason that options traders roll an option contract is that they are in the money and there is an assignment risk. By rolling it out, you can keep the trade going but avoid assignment. Sometimes just moving the expiration date is good enough to accomplish this. An option can be assigned at any time, but in most cases, it has to reach expiration in order to be assigned. By using a rollout, the trader can avoid this situation.

Of course, rolling up or rolling down can also help avoid assignment, since changing the strike price might allow you

to move from an in the money situation to an out of the money situation.

There are other reasons that are sometimes used to justify rolling an option. For example, when you are selling for income, you can roll the trade to keep generating more money. Changing market conditions might also be a reason to roll a trade.

When rolling a spread, strangle, or iron condor, there are many possibilities that exist for altering the trade. Suppose you have a put credit spread with strikes of $207 and $204. We could change one or both of the strike prices, and we could also change the expiration date. Maybe we want to tighten or widen the spread, so we could roll out and also roll down the lower strike price, and have a new spread with strike prices of $207 and $202, for example.

A Rollout is a Single Trade
It's important to note that a rollout is one trade, and not two. You are simultaneously closing one option (possibly with multiple legs) and opening a new contract in its place.

Chapter 10: Top Trader Mistakes to Avoid when Options Trading

Options trading is an entirely different animal as compared to normal stock market investing. Let's think for a moment about the common wisdom that is dispensed with regard to stock market investing. The general idea is to buy and hold, keeping your investments for a very long period of time. In fact, basically, you're expected to keep your investments until retirement. People do various strategies such as rebalancing their portfolio to match their goals, diversification, and dollar-cost averaging.

Options trading is a totally different way of looking at things. First of all, even if you are a day trader or engaging in activities like swing trading, the general goal, when it comes to stocks, is to buy when the price is at a relatively low point and then sell at a high price. In reality, the day trader, the swing trader, and the buy-and-hold investor are no different. Buy-and-hold investors think that they are special and above everyone else, they are in reality just trying to make money off the stock market too. The only real difference, unless you are a dividend investor, is the time frame involved. Your buy-and-hold investment is going to hold the stocks for 25 years, and then they are going to start cashing them out for money. A swing trader makes money in the here and now.

In that sense, options trading is more like swing trading. And in fact, in many cases, you're looking for the same price swings that the swing trader seeks. But as we've seen, options allow many strategies that are not available for any type of stock market investor. I suppose that in theory, you could buy huge numbers of shares of stock and try to set up

similar arrangements, but it just wouldn't work. And besides that, even if it did it would require an enormous amount of capital.

The point of this discussion is to lay out the groundwork and acknowledge that most of us come to options with a completely different mindset. Therefore, it takes some getting used to and many beginner options traders are going to make mistakes. That's just the nature of the market because it's so different than what people are used to.

In this chapter, we are going to review some of the top mistakes are made by beginning options traders. There isn't really a comprehensive list, I picked out the ones that I've noticed most people make the mistake of doing.

Going into a Trade Too Big

One of the mistakes that people make when they start out options trading is making their positions too big. Since our options don't cost all that much relative to the price for stocks, people aren't used to trading in small amounts. Even people who are not rich or anything thinking terms of the stock price and how much 100 shares with the cost. This can set up people for trouble. The temptation is going to be there to move on a large number of contracts when you start doing your trades if you have the capital to purchase or sell them. This can actually get people into trouble. It's not really the dollar amount that's a concern, but it could get you in a position where you're not really ready to act as quickly as you might need to depend on the situation. If you find trade and decide to sell 20 contracts, in the event that the trade goes south trying to buyback does 20 contracts might be problematic. Or you might end up buying a bunch of call options and have trouble getting out of them on the same day. It's actually better to have a few different small positions with the options than it is to have multiple positions

when they are a large number. Remember that options prices move fast. You don't want to over-leverage your trades and be in a position where you can't find a buyer to pick up all 10 or 20 contracts.

Not Paying Attention to Expiration

This is probably one of the most common mistakes made by beginning traders. The expiration date is one of the most important factors that should be considered as you enter your trades. And once you've entered a trade, you need to have the expiration date of the options tattooed on your forehead. This is something that is not amenable to being ignored. First of all, choosing the expiration date when entering the position is just as important as picking the strike price of the option. But one of the things that beginners do is to focus too much on the price of the option and the price-setting for the strike. The cost of the option and the strike price are obviously very important, the expiration date is important as well.

Unfortunately, far too many beginning traders ignore the expiration date when their trades are not working out. And so, they end up just letting the option expires. Of course, when that happens if it's out of the money, you are totally out of luck. It's just going to be at 100% loss. We need to be paying attention to expiration dates before we actually enter the trade, and we also need to pay attention expiration dates when we are managing the trade.

Buying Cheap Options

There is a saying that says you get what you pay for. There are reasons to buy out of the money options sometimes, but you shouldn't go too far out of the money. Unfortunately, many beginning traders are tempted to go far out of the money for the sake of buying a low-priced option. The problem with these options is that even though out of the

458

money options can make profits. If they're too far out of the money, they simply aren't going to see any action. There's no sense buying a cheap option just because you can pick it up for $25. You don't want to be sinking your money into options where a massive price move would be necessary in order to earn any profits. It's fine to buy options that are near at the money. Options that are close to being in the money can be very profitable even though they are out of the money. If you're looking to save a little bit of money when starting out your investing, that is always something to consider. But to make profits, the basic rule is there has to be some reasonable chance that's the stock prices going to move enough, in order to make the option you purchase going the money.

Failing to Close when Selling Options

If you want to remember just one thing from our discussion about selling options, whether it's selling put credit spreads or naked puts, you should keep in mind that it's always possible to exit the trade. The way that you exit the trade when you sell to open is you buy to close. You want to be careful about doing this because it's too easy to give in to your emotions and panic and prematurely exit a trade. However, you need to be aware at all times of the possibility of needing to close the trade. Riding out an option all the way to expiration is a foolish move unless it's very clear that it's going to expire out of the money.

New options traders often come to the market and they focus on hope as a strategy. When it comes to investing, hope is definitely not a strategy. Hope is something that belongs to a casino playing slot machine games. When you're trading options, you should make as rational a decision as you can, given the circumstances. So when the expiration date is closing and it's clear that the trade is not going to be

profitable, don't give in to the temptation to wait around for a reversal in direction.

When you say something like that to yourself, this opens up the temptation to stay in the trade far too long. At some point, you might not be able to recover at all. What you do not want to do is hope that there is going to be a turnaround and waiting to see what happens.

For those who are buying options to open their positions, this is the worst of all possible strategies. Remember that when you buy to open a position, time decay is working against you at all times. Unless the stock is moving in a good direction, there is no reason to hold the option. For sellers, time decay actually works in your favor. But there can be situations when it is just smart to get out of the trade. Let's look at a couple of examples.

If you sell to open an iron condor, and for some reason, the stock has a breakout to one direction or the other, it's better to get out of the iron Condor now. We aren't talking about a one or two dollar change. If the stock goes in such a direction that one of your options goes in the money by a small amount, that type of trade is worth waiting out to see what happens. But if there is a big break to the upside or the downside, it would be foolish to stay in the trade. For one thing, there would be at risk of assignment, but the most likely situation is that you're just going to lose the maximum amount of money. But if you have a good strategy and only getting involved with options that have a high level of open interest, almost no matter what the situation is, you should be able to buy and sell that option pretty quickly.

The other obvious example is if you were selling a put credit spread already naked put, and you noticed that the share price is declining right towards your strike price. You don't have to panic right away because remember that in order for

exercising the option to be worthwhile, the share price has to move enough, so that not only does the option go in the money, but the price move also accounts for the money that was paid for the premium to buy the contract. If you have a strike price of $100 and someone paid two dollars to buy the option, if the share price is $99, they are going to exercise the option. Even if it drops to $98, they still might not exercise the option, unless there was some factor to indicate that the stock was about to turn around so they can sell it at a profit. But that's an unlikely scenario. It's only when it starts going strong and that there's a problem.

Trading Illiquid Options

This is such an important issue I will say it again. Liquidity is very important when trading options. What liquidity means is the ability to buy and sell financial security quickly, and turn it into cash. It's not enough to like the company in order to start trading options on the company. If the open interest for an option is only 8, 10, or even 45, that is going to throw up obstacles when you need to move to get rid of an option fast. The largest companies generally have liquid options, but you should always check. Index funds also have liquid options. Avoid any companies that have small open interests. The only way that you would trade when the open interest with small is if the probability of losing out on the trade is minuscule. Besides the strike price, share price, an expiration date, you need to be looking closely at open interest. You do not want to get in a situation where you cannot exit a position.

Not Having a Trading Plan

One of the best things about options trading is that it's very easy. You have a relatively low-cost way to get involved in the stock market. It is also relatively easy to manage on your own. These are positives generally speaking, but there is a

downside. That downside is the fact that it's so easy people just start trading on a whim.

Make no mistake, just because it's easy, that doesn't mean the money and potential losses are not real. So you need to treat this with the utmost seriousness. Take some time to develop a trading plan. The trading plan should include many of the things we mentioned earlier, such as the level of profit that you're willing to accept on any trade. It should also set up a limit that is used to determine when to exit your positions.

But I forgot to mention one thing that is really important. Your trading plan should also pick out a maximum of five financial securities that you are going to focus on when trading options. In my opinion, doing more than five financial securities is more than your mind can handle. The reason I say this is because you should be keeping close watching over each of the companies for index funds that you were trading.

If you have more than five, that isn't really going to be possible. And as I've said before, one of the things about options trading is that the pricing can move very quickly. If you're trying to spread your attention in 20 different directions, you're probably going to end up losing money because you simply are not able to keep track of everything.

You should also include some diversity in your trading plan. When you pick out the five securities that you are going to use for the next year to trade your options, don't pick them all from the same sector. You can pick a couple from the same sector, but be sure to have a couple that is different. I also actually recommend trading one or two index funds. Some of the index funds that are available, in particular, SPY and QQQ, are great for options trading because they are super liquid. There is only one danger that you have to worry

about with index funds. And that is that there is a certain sensitivity of the major market indices to news and political events. The problem with that is political and news events tend to be pretty random. This can make it hard to enter a position like a puts credit spread. However, generally speaking, index funds are great to include the financial securities that you're willing to trade options on.

Failing to Have an Exit Plan

As I mentioned earlier in the book, you should have an exit plan for every one of your trades. I prefer to have an overall exit plan and have every trade follow the same basic rules. An exit plan will help you minimize your losses. This goes back to the problem of beginning traders holding onto an option until the expiration date. That is more likely to happen if you haven't formulated a strategy to exit your position.

It is helpful to keep a notebook to record all your trades and write down the rules for each trade. That way you can refer to it when things are fluctuating about, and possibly putting you into a situation where there are catastrophic losses. Now, of course, they aren't really catastrophic, assuming that you are reasonable in the number of options contracts that you trade in a single move. But you want to have some kind of rule so that you will exit the trade if the losses exceed a certain amount.

Of course, sometimes, you're going to make a mistake. In other words, if you have some kind of rules such as you are going to sell to close if the loss reaches $50, something I can guarantee is at some point, you are going to do that but the stock is going to rebound and if you had stayed in, you would've made $200 or something like that. You just have to accept that, sometimes, if you are going to miss out on situations like that. But on average, that's not really likely to happen. If an option is going south and you have a $50 exit

rule, it's a good idea to just follow it and live with the consequences.

A similar situation happens on the other side. As I suggested, I maintain a $50 profit rule. Whenever I've invested in options and it reaches $50 dollars per contract profit, I exit the trade. There are going to be times when the profit could've been $100 or even $200. So, when you have a rule like that you are going to miss out on some upside once in a while. But most of the time, what happens is traders stay in the trade too long. And then they end up losing money, so maybe you are losing $25 instead of having been a little bit conservative and making a $50 profit. The level of profit that you choose is entirely up to you. But the point is you should have some fixed value and always follow that rule the matter what.

Chapter 11: The Options Trader Mindset

As I said in the introduction, options trading is not something that is for everyone. Options trading is most suitable for a certain personality type and mindset. But if you are intrigued by the concept of options, but you simply have not had a chance to develop the correct mindset before, there are a few tips that we can rely on in order to get in the right frame of mind.

Be Able to Weather the Storm

Options prices can move a lot over the course of short time periods. Someone who likes to see their money protected and not losing any is not going to be suitable for options trading. We all want to come out ahead. I am not saying that you have to be happy about losing money in order to be an options trader. What you have to be willing to do is calmly observe your options losing money, and then be ready to stick it out in order to see gains return in the future. This is akin to riding a real roller coaster, but it is a financial roller coaster. Options do not slowly appreciate the way a Warren Buffett investor would hope to see. Options move big on a percentage basis, and they move fast. If you are trading multiple contracts at once, you might see yourself losing $500 and then earning $500 over a matter of a few hours. In this sense, although most options traders are not day traders technically speaking, you will be better off if you have a little bit of a day trading mindset.

Do Not Make Emotional Decisions

Since options are, by their nature, volatile, and very volatile for many stocks, coming to options trading and being really

emotional about it is not a good way to approach your trading. If you are emotional, you are going to exit your trades at the wrong time in 75% of cases. You don't want to make any sudden moves when it comes to trading options. As we have said, you should have a trading plan with rules on exiting your positions, stick to those rules and you should be fine.

Be Math-Oriented

In order to really understand options trading and be successful, you cannot be shy about numbers. Options trading is a numbers game. That doesn't mean you have to drive over to the nearest university and get a statistics degree. But if you do understand probability and statistics, you are going to be a better options trader. Frankly, it's hard to see how you can be a good options trader without having a mind for numbers. Some math is at the core of options trading and you cannot get around it.

Be Market-Focused

You don't have to set up a day trading office with ten computer screens so you can be tracking everything by the moment, but if you are hoping to set up a trade and lazily come back to check it three days later, that isn't going to work with options trading. You do need to be checking your trades a few times a day. You also need to be keeping up with the latest financial and economic news, and you need to keep up with any news directly related to the companies you invest in or any news that could impact those companies. If the news does come out, you are going to need to make decisions if it's news that isn't going to be favorable to your positions. Also, you need to be checking the charts periodically so you have an idea of where things are heading for now.

Focus on a Trading Style

As you can see, there are many different ways that you can trade options. In my opinion, sticking to one or two strategies is the best way to approach options trading. I started off buying call options, but now, I focus on selling put credit spreads and iron condors. You should pick what you like best and also something that aligns with your goals. I moved into selling put credit spreads and iron condors because I became interested in the idea of making a living from options trading with regular income payments, rather than continuing to buy calls and hope that the share price would go up. There is no right or wrong answer, pick the trading style that is best suited to your own personal style and needs.

Keep Detailed Trading Journals

It's easy to fool yourself when trading options, especially if you are a beginner. I hate to make the analogy, but this is kind of like going to the casino. If you have friends that gamble at casinos, then you are going to notice that they tend to remember the wins, and they will forget all the times that they gambled and lost. I had a cousin that won a boat, and she was always bragging about how she won a boat at the casino. I remember telling her that yes she won a boat, but she paid $65,000 more than the boat was worth to the casino over the years. You don't want to get in the same situation with your options trading. It can be an emotional experience because trading options is active and fast-paced. When you have a profitable trade, it will be exciting. But you need to keep a journal to record all of your trades, in order to know exactly what the real situation is. That doesn't mean you quit if you look at your journal and find out you have a losing record, what you do is figure out why your trades aren't profitable and then make adjustments.

Be Flexible

I have said this before, but one thing you need to remember about options trading is you can make money no matter what happens to the stock. You need to avoid falling into the trap of only trading options to make money one way. Most frequently, people do what they have been brainwashed to do and they will trade call options hoping to profit from rising share prices. If you are in that mindset now, you need to challenge yourself and begin trading in different ways, so you can actually experience making money from declining stock prices, or in the case of iron condors, stock prices that don't even change at all. You need to be able to adapt to changing market conditions in order to profit as an options trader. So don't entrap yourself by only using one method. Earlier, I said to use one or two styles, but you should be ready to branch out when market conditions change. Remember this – market conditions always change. As I am writing this, we are in the midst of a long-term bull market, but it won't last forever.

Take a Disciplined Approach

Don't just buy options for a certain stock because it feels good. You need to do research on your stocks. That will include doing fundamental analysis. This is going to mean paying attention to the history of a stock, knowing what the typical ranges are for, stock in recent history is, and also reading through the company's financial statements and prospectus. Remember, I suggest picking three companies to trade options on for a year and also two index funds. The index funds require less research, but for the three companies that you pick, you should get to know those companies inside and out. Stick with them for a year, at the end of each year, evaluate each company. Then decide if you want to keep them and bring them forward into the following

468

year's trades. If one company is not working out for you, then move on and try a different company.

Chapter 12: Trading with LEAPS

Leaps are interesting options. They expire a year or more into the future. This is different than the short-term options that most people are trading. LEAPS are more expensive, but they can also represent money-making opportunities. LEAPS also give you an indirect way to control stock.

Profiting from LEAPS
LEAPS have high prices because they have a lot of extrinsic value. Looking at June 18, 2021, Facebook call options, the $195 call is priced at $42.13 a share. That represents a $4,213 options contract. According to the chart, it made 3.4% today, which isn't a huge amount, but I challenge you to find a bank or mutual fund that has a return of 3.4% per day. The open interest is 133. This meets our minimum criteria for getting involved in a trade. It's quite small compared to Facebook options that expire in the next month, but it has enough open interest that it is going to be possible to get in and out of a trade in a reasonable amount of time. The implied volatility is a solid 33%. For comparison, the $195 call that expires in three weeks is priced at $12.48.

Although LEAPS are expensive, they have a lot of potential for profits. You can get into a LEAP and if the stock makes a solid move, you can close your position and make large amounts of money. For that $195 call that expires in June 2021, the delta is 0.64. Even though the option has a huge extrinsic value because it expires a long way into the future, it is very sensitive to price changes in the stock. If the share price goes up to $1, the option price will go up by $64. LEAPS don't suffer much from time decay. Theta for this option is only 0.03. If the share price goes up to $20 after an earnings

call, the option is going to go up by $1,280. You can make pretty good profits. The barrier to entry is the high price to buy one.

Poor Man's Covered Call

One of the interesting things that you can do with a LEAP is you can use it to sell covered calls. That sounds crazy, but it works. You can use the LEAP to cover call options that you sell to open. You can invest in LEAPS at a fraction of what it costs to actually invest in the stock, and then start selling calls against the options to generate income. Although it might cost $4,600 to buy a Facebook LEAP, it would cost nearly $20,000 to buy 100 shares of stock. Buying a LEAP gives you de facto control over a hundred shares of stock at a much smaller price than the investment cost.

For the price of 100 shares of Facebook, you could invest in 4-5 LEAPS, and have a lot more room to work with as far as selling call options. Therefore, you could end up having a higher income.

BONUS Chapter: A Crash Course on Options Day Trading Styles

With the ability to open and close options within the space of one business day, it is easy to see why so many options traders adopt this method of options trading. There is no one right way to make this work and this bonus chapter is dedicated to showing you how you can benefit from any one of the options day trading styles that have been tried, tested and proven true by many successful options traders.

Before we dive into these styles of options day trading, let us take a moment to refresh our minds about the factors that affect the success rate of an options day trader. The first factor is the liquidity of the option. This means that the stock must be traded often and must be in high volume. The daily volume of an option describes how many times the contract has been traded on a specific day. For example, if a $15 call option has a daily volume of 12, this translates into this contract being traded 12 times for that particular day. Options with higher daily volume means higher liquidity. High liquidity is important as it allows the options day trader to buy and sell the option without the price being affected greatly. This keeps the cost of doing business to a minimum. I have seen many rookies do this – they trade a high number for the day but the task of buying and selling is a hassle that takes too much money out of their pockets.

Volatility is an important factor as well. While the day trader does want some volatility, it cannot tip the scales too much. Too much of a good thing can turn into a bad thing in this case. Price movement is necessary for the day trader to earn

a profit in the space of a few hours but if the price swings too wildly in those hours, the trader might lose too much. The appeal for many options traders to day traders is that predictions are easier to make in a few hours compared to longer periods like days, weeks and months.

Open interest also affects the liquidity of options. Open interest tells the number of options of that type that have not been closed or exercised. If open interest stands at 750 in our $10 call option example, this means that there are 750 of that contract type still active on the market. This is an indicator of the number of investors that are interested in the option. Remember that options can be created at any time and many more are created on a daily basis.

Now that we are reacquainted with the factors that determine how options can perform, now it is time to delve into how these factors play into some of the most popular options day trading styles that you can use to find success.

Scalping Options Day Trading

The first style of options day trading that we will discuss entails opening and closing options positions several times in one day. Scalping can last for just a few minutes but does not last past an hour or two. This style of options day trading is reliant on volatile market conditions. The options day trader is hoping to profit by buying options at lower prices and selling them at a higher price in the case of call options. When it comes to put options, the options day trader is hoping to sell options at higher prices while buying them at lower prices.

Obviously, the stock associated with this style of options day trading needs to be extremely liquid to allow the trader to open and close positions so quickly. Options day traders who use this style do not normally try to take on huge trades. Instead, the norm is to make profits by trading a large

number of small options. Trying to trade big can lead to big losses but making small trades frequently significantly lowers the risk. It just takes a disciplined, meticulous options trader to make it work. Such traders gain the experience necessary to show that the profit is not as heavily weighted in the small price moves but instead in the bid/ask spread.

Thorough but quick analysis is needed to pick the trades that are worth entering a position on. A keen eye needs to be kept on the price movements.

It should be noted that there are several different types of scalping methods. One of the most popular is the use of the moving average. It is as simple as calculating the average of the closing price of the stock over a certain amount of time. Let's take the example below:

21.23 + 22.22 + 20.15 + 20.23 + 21.50 = 105.33

This total then needs to be divided by the total number of days. In this case, it is 5 days. The calculation for this looks like this:

105.33 / 5 = 21.07

This simple math's calculation provides a benchmark that allows the options day trade to determine trends and the likelihood that a profit can be made by entering an options position on the stock.

It should be noted that scalping is not an options day trading style that is appropriate for every options day trader. This method of options day trading takes a particular amount of perseverance in addition to there being a few drawbacks that need to be managed effectively for profits to be as high as they can be. One of the drawbacks is that commissions can quickly add up if the options day trader is using a commission-based broker as there are so many trades

involved. Imagine doing 20 trades for the day and having your broker charge commissions such as $5 for each. That adds up to $100 for doing business in one day. You can see how this can quickly eat at your profits. Now, place that scenario on the scalpers that do hundreds of trades in a day. Clearly, this is not a sustainable way to do business.

Another reason why this method is not for every day trader is because it can be rather tedious because there needs to be a constant focus on technical analysis in addition to making the same kinds of trades repeatedly.

Still, the upsides to scalping options cannot be denied. In this day and age, advanced charting tools have allowed options day trader more sophisticated and quicker methods for technical analysis. If the options day trader is smart about it, profits can start up quite quickly even if there are a few fees associated with each transaction. This is especially prominent in cases where smart scarpers transact business with zero commissions brokers or at least use the trading services provided by a discount broker. If you think quickly on your feet and are known for your endurance, then scalping is a great method for practicing options day trading.

Breakout Options Day Trading

This day trading style is a description of the options trader entering a position when prices move out of their normal price range. An example of this would be the option on stock that normally averages a price of $300 but moves sharply out of that range to have a price of $350.

This trading style relies on an increase in volume to accompany that price movement. This price range is described as the support and resistance levels. The point at which the options price stops decreasing is the support while the price at which the options stops increasing is the resistance.

The type of position the day trader will enter depends on support and resistance with this methodology. If the price goes above the resistance level then the options day trader will enter a long position. If the price goes below the support level then the options day trader will enter a short position. These positions are based on the fact the volatility increases when the normal price of the options moves outside of these levels.

Success with this style of options day trading is highly dependent on the options trader entry and exit strategies.

Finding entry points are relatively simple. The most traditional way is to close above the resistance level in a bullish position and close below the support level with a bearish position. When determining the method of entry, the options day trader needs to ensure that the situation is not a fakeout. A fakeout is the situation whereby a trader enters a position in anticipation of an anticipated price movement but the anticipation does not pan out. The price either does not move or it moves in the opposite direction of the anticipated move. Obviously, this can lead to losses for the trader. In this instance, the price can start off beyond the support or resistance level but quickly move back to the normal price range. Therefore, ensure that proper technical analysis is needed before a position is entered with this options day trading style. Techniques for avoiding that loss include looking for signs of a high probability of that price movement. Signs include an above average volume. Another technique is waiting to observe the closing period of the trade to determine if the price will be sustained at the extreme levels they reached.

Exit strategizing is a little bit more complicated and requires thought in advance. Remember than exit strategies should always be part of your game plan. When it comes to breakout

options day trading, there are specific exit strategies that are particularly effective. When exiting to ensure a profit, establishing a price target is typical. You can also average out the recent price swings on the market to gain a relative price target.

Once the target has been achieved, either use stop-loss orders to lock in the profits gained or exit the position partially and allow the remaining to run.

If exiting with a loss, the first step is being able to determine when the position is not beneficial. A good indicator is when former resistance levels now act as support levels and vice versa. Maintain your objectivity by activating stop-loss order here to exit the losing position neatly.

The most beneficial part of using the breakout options day trading style is that it allows the trader to see rather quickly if it is the wrong decision to pursue that position. This allows for cutting losses quickly.

Let us look at an example of a profitable implementation of a breakout options day trading style. Let's say that a stock opened with a range between $112.63 and $110.52. To enter a position on this would mean breaking at the $110.52 price and placing a stop-loss order at the $112.63 price point. This is a straight-forward scenario that can rake in the profits.

Momentum Options Day Trading

This is another options day trading style that relies greatly on volatility. It is also reliant on the rate of change of volume. The basis of this strategy is that the trader believes that the force that initiated the price movement of the stock will be great enough to sustain it in the same direction in a specific amount of time. This is normally predicted on stocks that are rising in price because under typical circumstances, stocks

that are rising in price attract investors. This attraction drives the price even higher. By using this momentum, an options day trader can hop onto the trend and make a profit off of the anticipated upward price movement. Therefore, highly liquid stocks are the best bet when it comes to using this method.

A quick example of betting on price movement based on the momentum options day trading style is stock that grows from $100 to $150. The options trader can enter a position that allows for purchasing the right to buy this stock. The trader can then sell the stock to make a $50 profit, which translates into a 50% profit. That is not bad for one day's work, especially if the options trader is able to enter many such profitable trades in the same day.

Of course, making such a bet takes careful technical analysis so that indicators of momentum can be determined. One of the most common indicators is known as the momentum indicator. This helps determine the strength of price movement as a trend by taking a look at the most recent closing prices of the stock. Moving averages are also used in addition to the relative strength index, which is a comparison of the losses and profits made on that stock over a set amount of time.

This options day trading method is one of the most effective and profitable when it is performed correctly by an options day trader. The first part of the strategy entails identifying the upward trend in price movement. Charts and bars are some of the best tools to look for an upward trend in the price movement of the stock. This movement needs to be backed by momentum and studying the true price of the stock attached to the contract of interest. Remember that day trading options is a short-term style that involves buying the options during that upturn so that they can be sold as

478

soon as they start to lose the momentum that pushed the price up. The trader closes the trades when it is profitable and looks for the next opportunity. It is a rinse and repeat cycle that has the potential to quickly accumulate profits.

Traders need to be careful to not open positions too early and to not close too late. The mistake that many beginners with this style make is moving into a position before the momentum has been confirmed. The rookie mistake that is made when it comes to exiting such a trade is waiting until the market has been saturated and the momentum has been lost.

As can be seen, it is necessary to time trade positions just right if the potential profits are to be earned. This management requires consistent charting to ensure that the price is maintained until time for closing. Watching the news to anticipate events that can change the price movement is a great tactic in addition to watching out for reversals.

Reversal Options Day Trading
This options day trading style is the opposite of the momentum options day trading style. While the momentum options day trading style relies on playing on the price movement of the stock, this style relied on going against it. The options trades bets against the current price movement to make a profit. Because of this play on opposition, the reversal options day trading style is also called pull back trending or trend trading. The trader can bet on this price movement changing to a downward trend after an uptrend or moving up after a downward trend.

This might seem like an unnecessarily risky bet to the untrained options trader but experts options traders learn to spot the opportunities that lie is betting against the current trend in the market. This opportunity arises because the typical practice is to make bigger trades with this style.

Therefore, when this style pans out, the trader stands to make bigger profits compared to styles like scalping.

With all things being equal, because the potential for profit is bigger, the risk also grows larger. Therefore, the reversal options day trading strategy is one that is typically reserved for experienced options traders. Still, it does not hurt for a novice options trader to know that the option exists as he or she gets more experienced.

This is a strategy with a bullish outline. The trader buys an out of the money call options in addition to selling an out of the money put options. As you can see, this strategy is complicated by the different legs that are involved.

The trader capitalizes on the market situation by using daily pivots. This involves the purchase and selling of the day's lows and highs based on the reversal logic. Pivot points are points that define rotation of price movement. This is calculated using the stock price information based on a short time frame. The price information entails the stocks high and low price from the previous day. The formula for this calculation looks like this:

(High + Low + Close) / 3 = Pivot Point

The support and resistance levels also need to be factored when using pivot points. Two formulas are needed to find the values. The first one looks like this:

(2 x Pivot Point) – High = First Support

(2 x Pivot Point) – Low = First Resistance

The second set of formals look like this:

Pivot Point – (First Resistance - First Support) = Second Support

Pivot Point + (First Resistance - First Support) = Second Resistance

The trader is able to earn profits when the pivot point falls between the first support and resistance levels.

The many steps involved in this process is what makes it something that professionals use rather than novice. Another reason why beginner options day traders also steer clear is because losses can be high by virtue of the fact that profits have the same high potential.

No matter the style an options day trader chooses to practice, this person needs to carefully weigh the risk and rewards before jumping in. As you can see, different options day trading are better suited for difference personalities and experience levels. Be guided accordingly. Nothing beats trying each out to see what works best for you.

I hope that this chapter has been beneficial to you and shows that options trading is a careers that allows you to be active on a day to day basis. The rush can truly be addictive. You can possibly pull in profits every hour of the day when you are on a roll! Be sure to remember your risk management techniques though.

Conclusion

Thank you for reading *Options Trading for Beginners*. I hope that I have successfully met my goal of being able to describe options trading in layman's terms. If you came into the book without knowing what options are and how they work, I hope that now you have a good enough understanding now so that you can actually start trading.

Besides understanding the basics of options, the most important thing to learn is the wide range of strategies that can be used when it comes to options. These strategies open a lot of doors for traders to make profits. These door would not be available otherwise.

When you are learning, you should try out all the strategies to see what works best for you. Everyone is going to have their own tastes, but options trading is so different that you need to try things out before you get stuck only buying or selling one type of option. This is a mistake that happens to a lot of beginners who are afraid to try the many different strategies that options trading has to offer.

One of my favorite things about options is that you can get involved in options trading without having very much money. If people are smart and disciplined about it, options trading could even provide a way out of a low-income situation. You can start trading with a small account, and if you are careful with it a year from now, there is no reason that you could not significantly grow that into a large trading account.

Even though options trading is a serious business, it can be fun and exciting too. There is no reason why making money

has to be tedious or difficult. You can get involved at the highest levels of our economy with the best companies by trading options. Hopefully, you will be able to ride the wave on the stock market and earn some of your own profits.

Remember that options trading is flexible, so if the market enters a downturn, do not stop trading! You can keep going and earn profits as the share price goes down and everyone else is panicking.

Thank you again for taking the time to read this book, and if you have enjoyed the book, please leave a review on Amazon. I will enjoy hearing about your trading experiences!

Made in the USA
Columbia, SC
06 May 2021